RODIN
in Perspective

Edited by

RUTH BUTLER

A SPECTRUM BOOK

Prentice-Hall, Inc., Englewood Cliffs, New Jersey

Library of Congress Cataloging in Publication Data
Main entry under title:

RODIN IN PERSPECTIVE.

 (Artists in perspective series) (A Spectrum Book)
 Includes bibliographical references and index.
 1. Rodin, Auguste, 1840–1917—Addresses, essays,
lectures. I. Butler, Ruth, (date)
NB553.R7R69 730'.92'4 80-13888
ISBN 0-13-78236-6
ISBN 0-13-782318-5 (pbk.)

For H. W. J. on his 65th birthday

A SPECTRUM BOOK

Printed in the United States of America

10 9 8 7 6 5 4 3 2 1

PRENTICE-HALL INTERNATIONAL, INC. *(London)*
PRENTICE-HALL OF AUSTRALIA PTY., LTD. *(Sydney)*
PRENTICE-HALL OF CANADA, LTD. *(Toronto)*
PRENTICE-HALL OF INDIA PRIVATE, LIMITED *(New Delhi)*
PRENTICE-HALL OF JAPAN, INC. *(Tokyo)*
PRENTICE-HALL OF SOUTHEAST ASIA PTE., LTD. *(Singapore)*
WHITEHALL BOOKS, LIMITED *(Wellington, New Zealand)*

CONTENTS

Preface and Acknowledgments *xi*

INTRODUCTION 1
Ruth Butler

The Age of Bronze *32*

Review of the Exhibition at the Cercle Artistique (1877) *32*
Anonymous

Review of the Exhibition at the Cercle Artistique (1877) *33*
Jean Rousseau

Review of the Sculpture at the Paris Salon (1877) *34*
Charles Tardieu

Review of the Sculpture at the Paris Salon (1877) *34*
Charles Timbal

1882 and 1883—*Saint John,* the Portraits, and the Portal *36*

Review of the Exhibition at the Royal Academy (1882) *36*
Arthur Warren

Review of the Paris Salon (1882) *37*
Louis de Fourcaud

Review of the Paris Salon (1882) *37*
Paul Leroi

Review of the Sculpture at the Paris Salon (1882) *38*
Philippe Burty

Review of the Exposition des Arts Libéraux in the rue Vivienne
(1883) *39*
Gustave Geffroy

Review of the Exposition Nationale (1883) *39*
Paul Lefort

Review of the Exposition Nationale (1883) *40*
G. Dargenty

Review of the Salon and of the Exposition des Arts Libéraux
(1883) *41*
Charles Frémine

Review of the *St. John* at the Royal Academy (1883) *43*
Anonymous

The Gates of Hell and *The Burghers of Calais* *45*

The Future Museum of Decorative Arts (1885) *45*
Octave Mirbeau

"The Man Who Returns from Hell: Auguste Rodin" (1886) *48*
Félicien Champsaur

"Visiting Rodin's Studio" (1886) *52*
Edmond de Goncourt

"Rodin and Zola" (1886) *54*
Robert Louis Stevenson

A Visit to Rodin's Studio (1888) *55*

Rodolphe Darzens

1886–1889—Major Success at Georges Petit, the Salons,
and at the Exposition Universelle *58*

Review of the Exposition Internationale at Georges Petit (1886) *58*
G. Dargenty and Armand Silvestre

Review of the Exposition Internationale at Georges Petit (1887) *60*
Alfred de Lostalot

Review of the Exposition Internationale at Georges Petit (1887) *61*
J. K. Huysmans

Review of the Brussels Salon (1887) *62*
Octave Maus

"The Sculptor Rodin" (1889) *62*
Gustave Geffroy

Review of the Monet/Rodin Exhibition at Georges Petit
and Rodin's Work at the Exposition Universelle (1889) *74*
Félix Jeantet

Review of the Exposition Universelle (1889) *77*
André Michel

Rodin Enters the History of Sculpture *78*

"The New Movement in Sculpture" (1892) *78*
W. C. Brownell

"Contemporary Masters" (1895) *81*
Louis Gonse

Rodin's Fame in America (1896) *82*
Lorado Taft

The Late 1890's: A Critical Backlash *85*

"The Failure of Genius" (1896) *85*
Félicien Champsaur

"Sculpture at the Paris Salons" (1897) *87*
M. H. Spielmann

An Interview with Sarah Bernhardt (1897) *88*
Jacques Daurelle

"The Truth About the Salons of 1898 and 1899" (1899) *88*
Paul Leroi

Balzac: Public Battle *91*

"Le Vernissage" (May 1, 1898) *91*
Jean Villemer

A Letter to Robert Ross (1898) *92*
Oscar Wilde

"Rodin's Victory" (1898) *93*
Jean Rameau

Rodin's Defense (May 12, 1898) *94*
Auguste Rodin

Rodin's *Balzac* (1898) *94*
Arsène Alexandre

"Precious Ridiculousness" (1898) *96*
Henri Rochefort

"A Masterpiece of Modern Art" (1898) *97*
Frank Harris

1900: World Renown

A Letter for Rodin's Exhibition Catalogue (1900) *100*
Claude Monet

The Exposition Universelle (1900) *101*
Edmond Picard

"Notes on Rodin's Sculpture" (1900) *101*
Rudolf Kassner

"The Gates of Hell" (1900) *105*
Anatole France

"Hands in Rodin's Work" (1900) *106*
Gustave Kahn

"The Centennial Exhibition of French Sculpture" (1900) *107*
Gustave Geffroy

"Auguste Rodin, His Work, His Life, and His Influence" (1901) *108*
Camille Mauclair

Letters (1902) *112*
Rainer Maria Rilke

The Meaning of Rodin's Art *116*

"Rodin" (1902) *116*
Arthur Symons

Speech delivered for the Inauguration of Rodin's *Thinker* in front of
the Panthéon (April 21, 1906) *119*
Dujardin-Beaumetz

"Our Trajan's Column: Rodin's *Tower of Labor*" (1907) *121*
Ricciotto Canudo

"Auguste Rodin" (1907) *125*
Charles Morice

Rodin's German Public *127*

"Rodin's Work as an Expression of the Modern Spirit" (1911) *127*
Georg Simmel

"Auguste Rodin" (1904) *131*
Julius Meier-Graefe

"Auguste Rodin" (1917) *139*
Adolf von Hildebrand

Rodin and the Younger Masters of Early Modern Sculpture *144*

"A Great Contemporary Artist" (1908) *144*
Antoine Bourdelle

"A Promenade through the Salon d'Automne" (1905) *145*
André Gide

"The Sculptures of Maillol" (1910) *146*
Roger Fry

An Interview with Aristide Maillol (1930's) *148*
Judith Cladel

On Rodin (c. 1937) *149*
Henri Matisse

"Homage to Rodin" (c. 1950) *150*
Constantin Brancusi

Rodin's Writing *151*

"The Movement of Ideas: Rodin's Discourses on Art" (1911) *151*
André Chaumeix

"Rodin Interprets the Cathedrals of France" (1914) *153*
Emile Mâle

Rodin's Work: Posthumous Assessment *155*

"The Last of the Romantics is Dead" (1918) *155*
Elie Faure

"Rodin and the Problem of Sculpture" (1921) *160*
Carl Burckhardt

"Romantic Decadence" (1928) *163*
Luc-Benoist

"Realism in Sculpture" (1929) *163*
Agnes Rindge

"Rodin's Superb One-Sidedness" (1937) *166*
Carola Giedion-Welcker

The Rediscovery of Rodin *167*

"Rodin's Modernity" (1963) *167*
Albert Elsen

On Rodin (1963 and 1971) *172*
Leo Steinberg

"Rodin Is a Rodin Is a Rodin . . ." (1967) *183*
John Tancock

"Rodin: The Language of Sculpture" (1973) *187*
William Tucker

"Rodin's *Walking Man* as Seen by Henry Moore" (1967) *190*
Albert Elsen

Notes on the Contributors *192*

Index *200*

PREFACE
AND ACKNOWLEDGMENTS

When I began research on Rodin as a graduate student in the 1950s, two things struck me as odd. One was large and obvious: in spite of Rodin's fame, there was very little scholarly publication about his work. I would have been even more surprised had I known that in the beginning of this century Rodin was the most famous artist (not sculptor but artist) in the world. It took a few years before that fact was clear to me. The other oddity was smaller, yet it bothered me: my enormous dependence on a book for which I felt considerable antipathy—*Rodin: sa vie glorieuse, sa vie inconnue* by Judith Cladel. It was well documented and full of facts about Rodin's life, a book written by a woman who knew Rodin as well as anyone who ever wrote about him, but the intensity of the personal feelings and the nature of the anecdotes in the book made it unappealing to me. Again, I would have been surprised had I known that when the book appeared in 1936, it was almost a literary event in France; it was praised in scores of reviews and Cladel was constantly photographed and interviewed by the press in homage to the book. In the process of preparing *Rodin in Perspective,* I have come to understand the reasons behind these two issues that perplexed me long ago. A chronological reading of the vast amount of writing about Rodin makes clear a "Rodin myth," a special view about him and his work that was nurtured and fostered cooperatively by Rodin and the press, which helps to explain why the most scholarly book written during the twenty years following Rodin's death was a biography and not a study of his work.

New perceptions about familiar material gives pleasure; mine has been enhanced by loans and leads from friends and scholars who share my interest in Rodin, nineteenth-century sculpture, and its sources, especially Albert Elsen, Daniel Rosenfeld, John Hunisak, H. W. Janson, and Elizabeth Holt. The book has greatly benefited from the French translations that were done by John Anzalone and Sabina Quitslund's translations of Rudolf Kassner and Carl Burckhardt. I am grateful to colleagues who have helped me with various aspects of the manuscript, especially Tom Brown, Richard Freeland, Deborah Litwack, and Kathryn Greenthal. Madame G. Faure is the person in Paris who makes it possible for me to publish anything at all about French art. Kathleen Cunningham has been the perfect typist for such a complicated and slow project. *Rodin in Perspective* would have been far more difficult to do had it not been for John Tancock's excellent catalogue of the Rodin Museum in Philadelphia, published in 1976. I am grateful to those who have given permission to reprint excerpts, particularly Madame Dufay-Bourdelle, and Albert Elsen and Leo Steinberg, two friends who have taught me so much about Rodin. A National Endowment for the Humanities summer stipend allowed me to do my research in the archives of the Musée Rodin during the summer of 1976.

For Madame Monique Laurent, Conservateur of the Musée Rodin, I reserve my greatest thanks. In 1973 she opened the Rodin archive. Until that time this vast repository of archival material, in its own way as unique and as special as the collection of sculptures and drawings at the Hôtel Biron in Paris and the Villa des Brillants in Meudon, was not available to scholars and writers. My work there has equipped me to grasp what I had not understood before: Rodin's unusual relationship to the contemporary press. In a certain sense, Rodin himself has determined the character of *Rodin in Perspective*—that it would consist primarily of literary and critical writing done during his lifetime and not scholarly and analytical writing done in the twentieth century.

Rodin's public career began in the 1870s. It coincided with the first years of the Third Republic, a time that has been spoken of as "the golden age of the French press," when it enjoyed more influence and prosperity than it had ever known.[1] Beginning with the exhibition of *The Age of Bronze* in 1877, the press was a major factor in Rodin's life. One manifestation of that fact was his subscriptions to the newly created clipping services. As early as 1882, Rodin was receiving articles from the Artistic Correspondence agency in London and the Agence Artistique Universelle in Paris. During his lifetime, he dealt with at least six different agencies, receiving thousands of articles, which were arranged and boxed by the secretaries he employed in his later years. One of them, Anthony Ludovici, was amazed at Rodin's orderliness and love of red tape.

> Having lived among artists all my life, I had grown to associate with the artistic temperament a certain carelessness and impatient hurry where the more tiresome details of everyday life were concerned, and I was therefore all the more surprised when I found in my chief a veritable *monstre paperassier*. Two whole rooms in the Villa des Brillants were given up to this passion for the accumulation and preservation of the letters, invoices vouchers, estimates, and receipts of a lifetime, and these papers, stored in little white deal boxes, specially made for the purpose by a local carpenter, and arranged according to genus, species, date, and their order in the alphabet, represented an imposing documentary record of all Rodin's relations with the outside world. . . . and I have often wondered what the French State did with these little white boxes stuffed with papers, when they took over the Musée Rodin.[2]

We all wondered, so now it is with considerable relief that we watch the Musée Rodin, under Madame Laurent's direction, unstuffing the boxes and forming a fine and functioning archive at the Hôtel Biron.

Figure 4 is used through the courtesy of the Fogg Art Museum, Harvard University. Bequest - Grenville L. Winthrop.

[1] Claude Bellanger, *Histoire générale de la presse francaise* (Paris: Presses Universitaires de France, 1972), 3, 137.

[2] Anthony M. Ludovici, *Personal Reminiscences of Auguste Rodin* (Philadelphia: J. B. Lippincott, 1926), pp. 52–53.

INTRODUCTION[1]

Ruth Butler

Rodin cared about words. And he had a deep sense of his own impor-
tance as an individual as well as an artist. These are the two most important
things to know in order to put Rodin "in perspective" with regard to the
written word. When Sir Kenneth Clark reflected on Henry Moore's career,
he commented that "Henry never reads the profound things said about him,
it is part of an instinct for self-preservation that has saved him from the fate
of Rodin."[2] It is clear that Clark believed something bad happened to Rodin
because he read what was written about him, that it would have been better
had he not done so. This is a difficult speculation; if Rodin had ignored the
critics and the writers, his entire career would have been different from the
one we know. Rodin read everything he could, and he often responded
either by changing something or by reinforcing what he felt the critics he
most respected favored in his work. Conversations with writers were critical
experiences for Rodin, and they substantially influenced his life and his
work.

Rodin's first real showpiece was the work we know as *The Age of Bronze.*
He exhibited it in Brussels during the winter of 1877. Critics focused upon it
immediately. It had "life," the kind of "realism" you would expect to find in
the best Greek sculpture. Although it was by an unknown artist, they singled
it out. But they saw problems, and two were particularly troubling: it was *too*
lifelike—they suspected it might have been made through a process of
casting from the live model—and the subject matter was not clear. The
statue was titled *The Conquered Man (Le Vaincu)*, and, although it had origi-
nally held a spear in its left hand, which made the idea of a nude youth seen
as a conquered warrior understandable, by the time Rodin sent it to the
exhibition, he had removed the attribute. One critic saw it as "a man on the
verge of suicide," while another thought it might be "a sleep-walker." Rodin

[1]Bibliographical citations are provided in the footnotes of the Introduction only for works that
are not included in the present volume.
[2]Kenneth M. Clark, *Another Part of the Wood: A Self-Portrait* (London: John Murray, 1974), p.
256.

1

was attentive to this criticism, and by the time the statue arrived in Paris, he had changed the title to *The Age of Bronze*. The change of name did not seem to help, however, and when Charles Timbal wrote about it, he felt that if the public was "curious about anything it is to know the reason the sculptor calls the piece *The Age of Bronze*."

The second criticism—that it might have been cast from life—was far more serious. Four days after it was mentioned in *L'Etoile Belge* (January 29, 1877), Rodin sent a letter to the editor: "If any connoisseur would do me the favor to assure himself of this, I will take him to my model who can establish undeniably how distinct is my artistic interpretation from being a servile copy." The editor printed Rodin's letter along with his own reply: ". . . we did not dream for an instant of calling his statue a servile copy and we find it a bit strange to see him profit from our very kind review in order to respond to a few doubts that have been spoken at the Cercle."[3] If the critic for *L'Etoile Belge* made his comment somewhat idly, Rodin took it extremely seriously.

In March Rodin packed his plaster statue for shipment to Paris. He went ahead so he would be there when it arrived. Although the Salon did not open until May 1, submissions had to be at the Palais des Champs-Elysées early in order to be examined by the jury. Rodin wrote to Rose, his companion who had remained in Brussels: "I want to work a little more on it before the jury sees it, which will be on the 5th or 6th of April. At times I am discouraged, for it seems to me that my figure is not as good as I thought."[4]

Falguière and Chapu, sculptors who were only a few years older than Rodin, but winners of the Prix de Rome and men who had been successful during the Second Empire, were among the members of the sculpture jury under Eugène Guillaume, director of the Ecole des Beaux-Arts. The jury voted to admit *The Age of Bronze* to the Salon, but their decision was not unclouded. Rodin wrote to Rose: "I am truly sad, Falguière found my figure very beautiful, but they are saying that it is cast from nature . . . he says this is praise, but it makes me suspicious!"[5] When Rodin heard that this accusation had been spoken, he went immediately to Guillaume and "suggested that the man who had posed for me should be sent for; he advised me to have casts taken from life. In addition, I had photographs taken both of my model and of my statue in order to make the comparison. . . ."[6] He also collected testimonials from friends about the statue's authenticity. When he went to pick up the materials he had assembled for examination, he found "the seals of the envelope in which all this was enclosed had not even been broken."[7] Again, he wrote to Rose: "I am rejected; they say that I have put a corpse on

[3] Judith Cladel, *Rodin, sa vie glorieuse et inconnue* (Paris: Editions Bernard Grasset, 1936), p. 116.
[4] These letters from Rodin to Rose are in the archive of the Musée Rodin and parts of them are cited in Cladel, p. 117.
[5] Ibid., p. 117.
[6] From a letter of January 13, 1880 in the Archives Nationales. Quoted in John Tancock, *The Sculpture of Auguste Rodin* (Philadelphia Museum of Art, 1976), pp. 347, 351.
[7] Ibid.

its feet (what nonsense). . . ."[8] Reviewers for the two major monthly art journals, *Gazette des Beaux-Arts* and *L'Art,* showed awareness of the accusation. Charles Tardieu in *L'Art* said that:

> We are convinced of the emptiness of this reproach, and we can call upon disinterested testimony in favor of the sculptor's honesty. But without insisting upon the point, we must agree with one thing that does explain, though without justification, the insinuations or the feelings of jealousy toward him: the work of M. Rodin is a study rather than a true statue, it is a slavish likeness . . . that has neither character nor beauty. . . .

Rodin was discouraged, but he also knew his statue's worth, and late in May he wrote to the Director of the Ministry of Fine Arts requesting that the State purchase his statue. In June the Director informed him that for budgetary reasons such a purchase was not possible. Two and a half years later, when Edmond Turquet, a man who had already shown himself well disposed toward Rodin and his work, became Undersecretary of State for Fine Arts, Rodin tried again. He asked Turquet to establish a committee to look into the affair. Turquet did so and the committee sent him their report on February 5, 1880: "This examination has convinced us that if this statue is not a life cast in the absolute sense of the word, casting from life clearly played so preponderant a part in it that it cannot really be regarded as a work of art."[9] This report was followed by a letter from yet another group of artists. The second group was far more impressive than the committee; it included Chapu, Falguière, and Carrier-Belleuse, Rodin's employer and a major figure during the Second Empire. They had gone to Rodin's studio to look at *The Age of Bronze* and wrote to Turquet that this statue "testified to an energy and a power of modeling that is extremely rare, and, even more important, it has true character."[10] Their letter had the desired effect, and finally the State purchased the plaster model of *The Age of Bronze,* committing itself to pay for the bronze cast. After the closing of the Salon of 1880, where the statue, now cast in bronze, won a third class medal, it was erected in the Jardin du Luxembourg (Fig. 1).

This is the story of Rodin's first *succès de scandale.* The offensive comment was a single off-hand sentence in the press. Rodin might have ignored it, but he could not, for *The Age of Bronze* was his "masterwork." He had spent eighteen months trying to create the perfect figure. Instead of ignoring the comment, he made a point of it when he wrote his letter to the editor. It became an issue, and in Paris the press indicated their knowledge of the charge against the statue, even though they did not believe it. Three times Rodin asked for an investigation. His determination and belief in his work won him a just reward, for it brought his work to Turquet's attention.

[8]Cladel, p. 119.
[9]The letter is in the Archives Nationales and it is quoted in Tancock, pp. 347, 352.
[10]Letter of February 23, 1880 in the Archives Nationales; see Tancock, p. 352.

In the course of the three years between the initial exhibition of *The Age of Bronze* and its purchase by the State, Rodin began to understand what the press could do to help or to hurt his career.

Once Rodin was permanently back in Paris in the fall of 1877, he lost no time in beginning a new salon figure—*St. John the Baptist Preaching*. Part of Rodin's impulse to create this figure was his anger about *The Age of Bronze*: "I had been accused of using casts from nature in the execution of my work, and I made the 'St. John' to refute this, but it only partially succeeded."[11]

From 1879 to 1883, Rodin struggled to obtain recognition through the two statues, along with his earlier head, *Man with the Broken Nose* (1863–64), and his *St. John* in the form of a bust (Fig. 2). The latter won him his first salon recognition—an honorable mention in the Salon of 1879. He put both *The Age of Bronze* and the full-length *St. John* in plaster in the Salon of 1880. Then the *St. John* went to Nice and *The Age of Bronze* to Ghent, where it won a gold medal. In 1881 Rodin placed a bronze cast of *St. John* in the Paris Salon, along with another "grand homme," *The Creation of Man (Adam)*, which he had made in 1880. In the fall, *St. John* was seen at the Salon des Vingts in Brussels where it appeared: "superb in its biblical rusticity and its unconscious naïveté, a magnificent and noble piece. . . ."[12] The following year, *The Age of Bronze* and *St. John* spent the summer in Vienna, and the *Bust of St. John,* along with a bronze cast of the *Man with the Broken Nose,* introduced Rodin's work to the London public.

By 1882 critics began to indicate that Rodin's work was in a class by itself: ". . . we stand before a very determined artist, one who is capable of succeeding over all the other débutants who smell of an academic eclecticism that leaves them powerless to respond to the modern spirit's pressing demand for truth." (Burty) Such recognition came to Rodin, not for his statues on which he himself had lavished so much attention, but in response to the portraits he made of his contemporaries and which he exhibited at the salons between 1882 and 1885.

By far the greatest number of works of sculpture to be seen each year at the salons were portrait busts. They were the most conventional kind of sculpture and the easiest to evaluate in a period when naturalism was the norm. When Rodin's busts of contemporary artists and writers began to appear, critics were quick to express enthusiasm. "Among all the young sculptors, he is the one I would place in the highest rank," said Louis de Fourcaud after he had seen the *Jean-Paul Laurens* (Fig. 3) in the Salon of 1882. Paul Leroi also found this bust to be an accomplishment "for which there only exists one name—that of chef d'oeuvre." When Rodin's bust of Victor Hugo was exhibited in 1884, W.E. Henley found that "It is not the

[11]Truman H. Bartlett, "Auguste Rodin, Sculptor," *American Architect and Building News,* 25 (1889). This series of articles has been reprinted in Albert Elsen, *Auguste Rodin: Readings on His Life and Work* (Englewood Cliffs, N.J.: Prentice-Hall, Inc., 1965), p. 69.
[12]Pierre Gervais, "Sur le Salon de Bruxelles," *Journal des Beaux-Arts et la Littérature,* October 15, 1881.

least of the many felicities of M. Hugo's career that has lived to pass to posterity as the original of what might be an antique bronze."[13]

Along with a general growing admiration for Rodin's work, evident in the press during the early 1880s, came a sensitivity to the hardships he had endured in the course of his career. Sometimes the information given in reviews would be mixed up or exaggerated in a way that solicited sympathy from the readers, as we find it in the earliest American notice of Rodin's work (1882): "By far the finest thing . . . is a grand 'Head of St. John,' by Auguste Rodin, French sculptor who has worked for forty years unknown in the people's studios, and even now does not seem likely to receive the attention which his work undoubtedly merits." Rodin was in fact only forty-two when that review was written. There was a strong desire to recognize in Rodin the persecuted genius in the tradition of the nineteenth-century Romantic view of the artist. This was particularly true on the part of the critics who wrote for new journals such as *L'Art* (founded 1875) and the *Magazine of Art* (founded 1878), which became strong advocates of Rodin's work.

Although Rodin received his greatest early critical success in response to his portrait busts, they constituted but a minor part of his creative life in the early 1880s. Beginning in 1880 Rodin's most important work was the commission he had received for a set of portals for the new Museum of Decorative Arts in Paris. Secretary Turquet was responsible for it; partially he gave it to Rodin in recognition of the unjust suffering the artist endured over *The Age of Bronze*. By 1881 the press knew about the project and that it was based on Dante's *Inferno*. In 1883 Rodin gave the public its first glimpse of the kind of figure he intended to include when he showed two female figures (Fig. 5) at the Exposition des Arts Libéraux in the rue Vivienne. Rodin, like the Impressionists, made use of the new alternative for exhibiting in private galleries, and during the 1880s, while putting safer works in the official salons, he showed more experimental pieces in galleries. When Charles Frémine saw Rodin's figures at the Exposition des Arts Libéraux, he was full of reservation, warning that the new works "make me fear for his talent. . . ." In fact, he "told Monsieur Rodin . . . what [he] thought of these two works. . . . Contortion does not make character any more than a grimace makes expression. . . ." But Gustave Geffroy, the writer who was to become Rodin's most enthusiastic and perceptive critic in the early years, tells us that "people are saying wonderful things of these works. . . ." And 1883 is also the year that some of Rodin's drawings for the portal were first published (Fig. 4).

Octave Mirbeau published the first substantial review of the portal early in 1885. Mirbeau was an important critic who published on art and literature in all the major daily papers of Paris, and he became one of Rodin's first defenders. He probably made Rodin's acquaintance in 1884 while

[13]W.E. Henley, "Two Busts of Victor Hugo," *Magazine of Art*, 7 (1884), p. 132.

collecting material for his article in *La France,* and the two men became close friends.[14] Mirbeau firmly believed that Rodin would enter into immortality through this portal. He described it as being well along in the winter of 1884–85, mentioning that there already existed "more than three hundred figures." He spoke of them individually, especially the figure of Dante whose "pose recalls, to a degree, that of Michelangelo's *Thinker"* (Fig. 6). Probably we must credit Mirbeau for the permanent name that has been given to the naked giant.

To get to know the portal as well as he did, Mirbeau had to spend a great deal of time in Rodin's studio at the Dépôt des Marbres. He indicated that others had done so as well: "Those who have been able to admire the finished studies in the artist's atelier, as well as those now being completed, agree that the door will be the principal work of the century." Visiting Rodin's studio was to become one of the major artistic experiences a person could have in the city of Paris during the next three decades. Not since Canova, whose studio had been so important to visit in Rome early in the century, had any sculptor's studio been so often described or so meaningful for so many people. Long after Rodin's death, Stefan Zweig remembered a visit in 1904 when he watched Rodin at work: He "was so engrossed, so rapt in his work that not even a thunderstroke would have roused him. . . . A sort of wildness or drunkenness had come over him; he worked faster and faster." As Zweig left he

> grasped his hand in gratitude. I would have preferred to kiss it. In that hour I had seen the Eternal secret of all great art, yes, of every mortal achievement, made manifest; concentration, the collection of all forces, all senses, that *ecstasis,* that being-out-of-the-world of every artist. I had learned something for my entire lifetime.[15]

Even in the 1880s the general sense of visitors to Rodin's studio was that they were there not just to look at the work but to find the man. The young critic-novelist, Félicien Champsaur, went in the winter of 1885–86 to meet this sculptor who was "almost unknown" and who was finishing the "bronze portal for the future Museum of Decorative Arts." He found a "valiant man . . . a small shy blond man with a flowing beard, short hair and very soft blue eyes. . . ." He was happy to have found in Rodin an "artist of integrity, who scorns money, has no other passion than the attainment of his creative dream." Here we have the beginning of the myth of Rodin, the belief that he was not only a superior artist, but a superior human being and that the two were linked. This was not, of course, a perception unique to Rodin (Monet, for example, was understood in much the same way by some of the

[14]Rodin modeled Mirbeau's portrait in 1889, he made drawings of him in 1894, and he contributed twenty drawings as illustrations for Mirbeau's *Le Jardin des Supplices,* published in 1902. See the Musée Rodin catalogue, *Rodin et les écrivains de son temps* (1976), p. 98.

[15]Stefan Zweig, *The World of Yesterday* (New York: Viking Press, 1943), pp. 148–49.

nineteenth-century critics), but this often-expressed view of his nature was particularly intense.

This is not to say that everyone who went to Rodin's studio so idealized him. Edmond de Goncourt also visited him for the first time in 1886. What he found was "a man of the people, a fleshy nose, clear eyes blinking under lids that are sickly red, a long yellow beard. . . . He strikes me also as a man of projects, sketches, fragmenting himself in a thousand imaginings, a thousand dreams, but bringing nothing to complete realization."

By the late 1880s, Rodin's life bridged two realities: a hardworking artist who lived in a modest house in the rue de Bourgogne, and "the most hotly discussed as well as one of the most passionately admired sculptors of modern France . . ."[16] who had entrée into the most interesting salons and clubs of Paris. Edmond de Goncourt captured something of its flavor and complexity in his journal in 1887: "Wednesday, January 5. I have Bracquemond and the sculptor Rodin to lunch today. Rodin, who is full of faunishness, asks to see my Japanese erotics, and he is full of admiration before . . . all the sculptural twining of bodies melted and interlocked in the spasm of pleasure." Goncourt also shared a meal with Rodin at the end of 1887: "After dinner I chat with Rodin, who tells me of his laborious life, rising at seven, going to his studio at eight, his work interrupted only by lunch and continuing until dark, work carried on standing or perched on a ladder, which leaves him worn out at night and ready for bed after an hour's reading." Rodin told Goncourt that he was illustrating Baudelaire's poetry for a collector, but that he was "being paid too little," that he felt "no enthusiasm, none of the excitement he would have for illustrations commissioned by a publisher."[17] Rodin understood very well the terms of success in its different aspects, and he wanted them all. Two days after his dinner with Goncourt, on New Year's Eve, Rodin received the Cross of the Chevalier of the Legion of Honor. He became "a man who has been decorated," as an excited and humble Cézanne was to describe Rodin a few years later when he met him for the first time.[18] In the winter of 1887–88 Rodin also found time for the American sculptor Truman Bartlett and the young Symbolist writer Rodolphe Darzens, both of whom were writing important articles about him. Rodin put his clipping file at Bartlett's disposition and the American proceeded to write the fullest account of Rodin's life, work, and reception to the work yet to appear in print. He brought it up to the present, describing the banquets given for Rodin when he received the Legion of Honor decoration: "one by a select company of friends, and the other by eighty of the more distinguished artists and writers of Paris. The sculptor's praises were sung by no fewer than four poets on these occasions, and their words confirmed

[16]Claude Phillips, "Auguste Rodin," *The Magazine of Art,* 2 (1888), 138.
[17]*Paris and the Arts, 1851–1896: From the Goncourt Journal,* edited and translated by George J. Becker and Edith Philips (Ithaca, N.Y.: Cornell University Press, 1971), pp. 238, 247.
[18]Gustave Geffroy, *Claude Monet* (Paris: Les Editions G. Crès, 1924) 2, 66.

by orators and men of state."[19] Darzens focused upon the work. What impressed him was that Rodin was "the first and almost the only sculptor to study *movement*," and Rodin's ability to set "in stone the fleeting, almost elusive character of thought." When Darzens published his description of visiting Rodin's studio in *La Jeune France* in 1888, he stressed that the "pen cannot explain the chisel or the sketch," and he called for "a special exhibit which will bring together various groupings."

By the time his article was in print, the exhibition was being planned, and in June 1889 the great Monet/Rodin show opened at the Galerie Georges Petit in the rue de Sèze. Rodin showed thirty-six works: busts, figures, groups, and bas-reliefs in plaster, wax, terracotta, bronze, and marble. Monet showed 145 paintings; for him it was a true retrospective. Working out the arrangements for the joint enterprise apparently was not always easy: ". . . it appears that some terrible scenes have occurred in which gentle Rodin, suddenly exhibiting a Rodin unknown to his friends, shouted: 'I don't give a damn about Monet; I don't give a damn about anybody; I care only about myself!' "[20] But the show was an enormous success and it firmly established the reputation of both artists. Gustave Geffroy's essay for the catalogue was the most sensitive study on Rodin's work yet to appear in print. Octave Mirbeau wrote the complementary essay on Monet. Geffroy reported: "We indulged in an impressive rivalry and I believe our exaggeratedly long comments, especially mine, made the catalogue rather heavy. If we had not been given a limit, we could have written a whole book, so great was our enthusiasm."[21]

Geffroy began his essay with a quotation from "The Life of Michelangelo" in Stendhal's *History of Painting in Italy* (1817).

> For two centuries a certain politeness has banished strong passions. In the process of restraining them, it has annihilated them. . . . But the nineteenth century is going to take back what is rightfully its own. If a Michelangelo were born to us today, to what point should he succeed? What torrent of new sensations and pleasures he would lavish upon this public so well prepared by theater and novels![22]

The choice of this particular quotation from Stendhal had an enormous effect: "If a Michelangelo were born to us today. . . ." stuck in everyone's mind, and it was repeated over and over again in reference to Rodin.

In his essay, Geffroy covered all the aspects about Rodin with which the public was becoming familiar: the studio at the Dépôt des Marbres—"a great *porte-cochère*, like the wide cartway into a farm-yard, leads us into an immense court, paved with moss-grown flagstones, the corners green with grass. . . .

[19]Bartlett in Elsen, p. 109.
[20]*Paris and the Arts 1851–1896: From the Goncourt Journal*, p. 274.
[21]Geffroy, *Claude Monet*, 1, 214–15.
[22]*Claude Monet, A. Rodin*, Introduction by Gustave Geffroy and Octave Mirbeau (Paris: Galerie Georges Petit, 1889), p. 47.

On every side lie massive blocks of marble of every conceivable shape, recalling, in full daylight, a stone-mason's shed . . . ;" the sculptor—"the man who stands before you, his hands covered with wet clay, his clothes splashed with plaster, is short and sturdy as to figure, peculiarly tranquil as to manner. . . . Framed by the close-cut hair and the long fair beard that floats upon his breast, we see a mobile face, that in a few minutes passes from absorption to anxiety, from anxiety to smiling calm" (Fig. 7 and cover photo); and the portal—"pervades the whole studio . . . throughout the vast room are scattered pell-mell statuettes of every dimension, upturned faces, twisted arms, contorted legs." Geffroy said that it was "standing" in the studio and throughout his essay referred to it as *La Porte de l'Enfer.* By 1889 *The Gates of Hell* had become the accepted title.[23]

Geffroy's essay remains one of the most penetrating discussions of what Rodin was attempting to do in *The Gates of Hell.* He showed how Rodin realized form and idea at the same time, that he had discovered an infinite variety of new poses, and that he depended on poetic ideas and love as inspiration, not in a rhetorical fashion as in an academic art, but according to a new and unrestrained kind of symbolism: "A kneeling fauness rocks her spare and supple body like a flower-stalk, with a feverish gesture full of seductive raillery, and laughs all over her gruesome deathly face, half-woman, half-animal" (Fig. 8).

The summer of 1889 was the right time for a major exhibition at Georges Petit, which was just off the Grands Boulevards, for it was the centenary of the Revolution and Paris was celebrating with a great Exposition Universelle. Rodin contributed seven works to the sculpture section at the Exposition (earlier and safer pieces such as *The Age of Bronze, Man with a Broken Nose,* and *St. John the Baptist*) at the Champ-de-Mars. In the context of the general survey of nineteenth-century French sculpture shown in the Fine Arts Hall, Rodin was seen as "the last word in sculpture" (Jeantet).

All the critics of 1889 mentioned *The Gates of Hell*—and its absence. Félix Jeantet explained that the "conscientious craftsman has not allowed its exhibition this year . . ."—implying that Rodin wanted to do more work before he could permit it to be seen. André Michel also mentioned *The Gates:* "I will not hide that several of his friends were somewhat disappointed by the absence, at this exhibition, of the door for the Museum of Decorative Arts. . . . We must continue to wait—but we are among those who wait confidently." Confident or not, Michel felt: "Had I the right to give him one bit of advice, I would tell him to shut his doors, to stop reading the papers, and to work alone. . . ." Here is one of the first hints that the pleasure Rodin received from his intense relation to the press was potentially problematic.

Rodin's accomplishments during the nine years since he had received

[23]Throughout the 1880s, most critics referred to *The Gates* simply as "une porte" for the new Museum of Decorative Arts. The first reference I have found where it is spoken of specifically as the *La Porte de l'Enfer* was in Arsène Alexandre's column "Le Mouvement Artistique" in *Journal des Artistes,* September 23, 1888.

the commission for *The Gates* were considerable. He had executed an unbelievable number of sculptures and had skillfully planned the progress of his career, taking into consideration what to exhibit, where, and what friendships to cultivate. Increasingly he sought out influential persons in the world of literature and politics. We can follow the shifting focus of Rodin's life and career by considering the portraits he executed: in the 1860s and 1870s his family and close friends were his models; by the late 1870s and early 1880s he was primarily portraying his artist friends—Jean-Paul Laurens, Alphonse Legros, Carrier-Belleuse, Jules Dalou, and Maurice Haquette—and by the mid-1880s he was portraying significant figures in public life.[24] His bust of Victor Hugo was his initial attempt at capturing the likeness of a public figure ("The first time I saw Victor Hugo, he made a profound impression on me; his eye was magnificent; he seemed terrible to me. . . ."[25]). The *Hugo* was followed by the bust of Henri Becque, a playwright whose acquaintance Rodin had made at the Bon Cosaque club. In 1884 he did Henri Rochefort and W.E. Henley, director of the *Magazine of Art*, a journal that was particularly attentive to Rodin's career throughout the 1880s. In the same year he modeled a bust of Antonin Proust. Proust was a central figure in the arts in France and responsible for the Fine Arts Exhibition at the Exposition Universelle (his portrait was one of the seven works Rodin showed there). While working on *The Burghers of Calais*, Rodin executed a portrait of Omer Dewavrin, mayor of Calais. In 1889 he did two portraits: Roger Marx, a man who was not only a critic but a well-placed official in the Fine Arts administration, and the critic Mirbeau (who described Rodin in 1889: ". . . before nature this silent man becomes a great talker, full of interest, with an understanding of many things which he has learned on his own, ranging from theogonies to the procedures in various *métiers*. . . ."[26]).

The year 1889 was critical for Rodin, now well advanced in transforming his life from that of a modest Parisian without a high school diploma, permanently rejected by the Ecole des Beaux-Arts, into that of a Grand Officer of the Legion of Honor, a holder of an honorary degree from Oxford, and a man sought after by the most famous people in the world. The combination of 1889 was perfect—a large selection of new and experi-

[24]In 1889 Edmond Bazire published an account of the part he had played in helping Rodin enter the prestigious literary circles of Paris. They had become friends after Bazire saw Rodin's work at the Exposition des Arts Libéraux. Bazire told Rodin that if he would do busts of famous people it could be very advantageous for his career: "Victor Hugo and Rochefort, for example." Rodin told him that he did not know these people, and Bazire said that he would arrange it. Although he could not get Hugo to agree to sit for Rodin, he did get Rodin a dinner invitation to Hugo's house and permission to make sketches at the dinner table. With Rochefort he was more successful, and he arranged sittings that took place in Rochefort's apartment in the Cité Malesherbes. Edmond Bazire, "Auguste Rodin," *Art et Critique*, July 6, 1889.

[25]Dujardin-Beautmetz, *Entretiens avec Rodin* (Rodin: Paul Dupont, 1913), translated and published in Albert Elsen, *Auguste Rodin: Readings on His Life and Work*, p. 169.

[26]Edmond de Goncourt, *Journal*, July 3, 1889.

mental works at the Galerie Georges Petit and a few works at the Exposition Universelle placed within the context of the entire century. Thereafter, critics put Rodin into a new historical framework. Throughout the 1880s it had been natural to discuss him in terms of nineteenth-century French art: Rude, David d'Angers, Préault, Barye, and Delacroix were the artists most often mentioned as his predecessors, and the writers for whom his work appeared to offer the best comparison were Baudelaire, Hugo, and Zola. Now, nineteenth-century French art—particularly sculpture—seemed too limited a setting for such a giant. Michelangelo was almost everyone's principal point of reference. Even that was not without debate.

> Rodin strikes so many crude apprehensions as a French Michael Angelo, whereas he is so radically removed from him in point of view and in practice that the unquestionable spiritual analogy between them is rather like that between kindred spirits working in different arts, and because, also, it shows not only what M. Rodin is not, but what he is. The grandiose does not run away with him. His imagination is occupied largely in following out nature's suggestions. . . . M. Rodin's sculpture is far more closely related to that of Donatello and the Greeks. (Brownell)

Twentieth-century critics and historians have been sensitive to the fact that Rodin received harsh criticism. The harshest and the most controversial view of him is to be found in the 1890s. During those years a considerable portion of the popular press was hostile to Rodin, partially in reaction to the myth established during the 1880s—Rodin as the simple, naïve workman who was determined to remain alone and to seek no honors. This image of Rodin continued to grow outside of France. We find Lorado Taft writing in Chicago in 1896: "He has always stood alone, as unmoved by the adulations and flattery of the present hour as he was by the sneers and oppositions of those younger days." But Taft was remembering Rodin's reputation in the 1880s when he had lived in Paris. Paris knew better.

In the 1890s Rodin had the most fascinating group of commissions held by any sculptor in the world: not only *The Gates of Hell* and *The Burghers of Calais* (exhibited for the first time in full dimension at Georges Petit in 1889), but the *Monument to Victor Hugo*, the *Monument to Claude Lorrain*, and the *Balzac*, a commission he received from the Société des Gens de Lettres in 1891. He had an enormous staff of gifted assistants and a lovely country residence in Meudon. The whole tenor of his life had changed. He now had to contend with endless committees and engage in tasks that tried his patience and required the kind of diplomacy at which he was not very adept. And a great deal of envy began to surround Rodin's activity. There was a general atmosphere of too much publicity and too many unfinished works. In 1895 Louis Gonse, the first French art historian to include Rodin in a big survey of French sculpture since the Middle Ages, pointed out that "He has had the indiscretion to open wide his atelier doors to writers. . . . The press has been almost fatal to Rodin for wanting to serve him too well."

It must have been painful to Rodin, accustomed to support from the most intelligent critics, to read articles written by men who had once hailed him as a genius and who now turned against him. With an energy equal to that of his enthusiasm in 1886, Félicien Champsaur wrote a mocking piece in 1896, referring to *The Burghers of Calais* as "a group of giants in shirtsleeves" and to Rodin's supporters as having "lined up single file to follow the lead of Panurge's sheep to jump into the sea, like Dingdon's flock."[27] Even Rodin's friend Paul Leroi, who had recognized the remarkable nature of his work as early in 1882, felt that "He has discouraged all the true friends of his brilliant beginnings." Leroi was fed up with a portal that "remains unfinished year after endless year"; in his judgment the *Monument to Claude Lorrain* clearly demonstrated that Rodin "will never be able to claim groupings as his strong point," and he was disgusted with the way Rodin exploited his practitioners. Worst of all: "He has become a landlord in Meudon."

It is in this context that we must see the "Battle of the *Balzac.*" The public exhibition and the refusal of the *Balzac* by the Société des Gens de Lettres came at a time when Rodin's career was at a critical low point. In 1898 one could say almost anything about Rodin and get away with it. "He could have had a military medal, or he could have made an excellent night watchman, or even a well-decorated senator. Who knows? He might even have made a half-decent sculptor! But he didn't want to. Or, rather, others didn't want him to." (Rameau)

When the *Balzac* appeared at the Salon on May 1, public interest was enormous (Figs. 9 and 10): ". . . no one could talk of anything but Rodin's *Balzac.* . . ." But the major discussion in the press began only after May 11, the day on which the Société revealed its intention not to accept Rodin's monument. From that moment Rodin and *Balzac* ceased to be confined to the art pages of the journals and became front-page news. *Le Figaro* had daily coverage; the report of the activities in Rodin's studio on May 13 sounds like a council of war. ". . . at 4 P.M. a secret meeting of those persons Rodin considered to be friends of the work assembled at the Dépôt des Marbres. He spoke to them in that sense. In view of the situation various propositions were made and he said they would meet on Monday for the final decision." On Monday *Le Figaro* reported that the situation "threatened to be resolved" *(menace d'être résolue*—it must have sold quite a few newspapers).

Now it was Rodin's turn. Whatever he said was quoted on the front pages of the major Parisian dailies. He was able to be very grand.

> There is no doubt that the decision of the Société is a financial disaster for me, but my work as an artist will continue to be my supreme satisfaction. . . . People may find errors in my *Balzac;* the artist does not always realize his dream; but I believe in the truth of my principle; and *Balzac,* rejected or not, is

[27]Panurge's sheep and Dingdon's flock (Book IV, Rabelais) are proverbial French references used to describe excessive gullibility.

nevertheless in the line of demarcation between commercial sculpture and the art of sculpture as we no longer have it in Europe.

In this statement we find Rodin being quite dignified in the face of enormous criticism, yet extremely sensitive to it—"the artist does not always realize his dream. . . ."

The issue was quickly politicised; it became the Dreyfus affair of the art world, no small thing during the summer of 1898 when the survival of the Third Republic seemed to hinge upon the fate of Dreyfus. Those who were prominent in the defense of Dreyfus, especially Zola and Anatole France, defended *Balzac*. Protests were mounted, signatures collected. Rodin's supporters included Monet, Toulouse-Lautrec, Claude Debussy, André Berthelot, Georges Rodenbach, and Georges Clemenceau. As Judith Cladel has pointed out:

> The events of 1898 produced a situation quite different from that which Rodin's enemies had expected: It won for him world-wide publicity particularly in other countries where there was now an infinite amount of interest both in the artist and in the personality of the man. Suddenly he was famous and his least actions attracted attention; his thoughts on every imaginable subject were solicited by writers and journalists. Not a week went by without several requests for interviews.[28]

It was this renown that enabled Rodin to carry out his next scheme, a retrospective for the turn of the century when the whole world would be coming to Paris for the biggest universal exhibition of all time. By July 1899, he was able to convince the municipal council that they should lease land to him at the Place de l'Alma, adjacent to the exhibition grounds. The next step was to negotiate loans. This he did with the help of three powerful financial backers.

The exhibit opened on May 18, 1900 and contained 150 sculptures, including—finally—*The Gates of Hell* (although still not finished), along with drawings, watercolors, and prints. It was an enormous success, both critically and financially.

For sheer volume of words, 1900 was Rodin's big year. And many who wrote were not typical art critics, but rather writers from other fields and other countries. Rudolf Kassner, a twenty-seven-year-old Viennese philologist and philosopher, is a good example of Rodin's new audience. He included his essay on Rodin *(Noten zu den Skulpturen Rodins)* in a collection of studies he published a few years later on Baudelaire, the Brownings, Kierkegaard, Emerson, and others. It is a type of book we find often at the beginning of the twentieth century in which authors tried to capture the

[28]Cladel, *Rodin,* p. 219.

spirit of the modern aesthetic. If they wanted to include a visual artist, it was sure to be Rodin.[29]

But the largest group of people writing about Rodin in 1900 was the Symbolists. They had been among his earliest supporters. J.K. Huysmans, Gustave Kahn, and Rodolphe Darzens had all written about Rodin in the 1880s. By the middle of the decade, Rodin regarded Mallarmé as a good friend. Nevertheless, 1900 is the year when he became one of them. The important Symbolist magazine *La Plume* was responsible for the most public celebration of Rodin's success. The editor, Karl Böes, gave a banquet in Rodin's honor on June 11 and initiated a series of articles that ran through the rest of the year. Geffroy, Mirbeau, Arthur Symons, André Veidaux, René Berthelot, Gustave Kahn, and many others contributed to the special edition of *La Plume* for Rodin. Some of these articles, such as Kahn's piece comparing Rodin's hands with those found in the poetry of Verlaine, provide the most insightful writing that exists on Rodin. And in Rodin's figures, the Symbolists saw a reflection of their own ideas. "There is a poignancy in the figures of M. Rodin, which extends outside them and perhaps because of their own sculptural beauty touches us so violently that in them we recognize ourselves. They are, as Stephane Mallarmé has said, '*nos douloureux camarades.*' "[30]

The young Symbolist poet Camille Mauclair, considered by many to be one of the best critics of the early twentieth century, began working on a series of psychological portraits in which he set out to reveal the innermost nature of the principal intellectuals of his time, those who were "*les centres,* the directors of conscience and of opinion." He recognized Rodin as being "in full possession of his glory" and the only artist on the face of the earth who was able to "counter the indoctrination of the academy" and create a new mode of sculpture to serve as a model for the next generation. To demonstrate the validity of his claim, Mauclair felt it necessary to bring his readers with him to visit Rodin: "What is Rodin like? Visit him; then you will know. . . . here he comes, appearing from between the gigantic mass of Hugo and an Adonis sleeping on a pale, transparent bed of marble. . . . this small man with heavy shoulders, an enormous head, and the bearing of a lion at rest" (Fig. 11). What fascinated Mauclair was the nature of the relationship between Rodin and "the silent, white creatures [who] are his companions. He loves them; he acknowledges them as having their own individual life once he has created them." It was this point that allowed Mauclair to find Rodin better off than a writer such as Mallarmé, in whose work he found many analogies to Rodin's. Mauclair found "Mallarmé was himself his best and most fully realized creation. Rodin, the more fortunate

[29]Some other examples are: Marius-Ary Leblond, *L'Idéal du XIX siècle,* 1909; George Simmel *Philosophische Kultur, Gesammelte Essays,* 1911; Royal Cortissoz, *Art and Common Sense,* 1913; Herman Bernstein, *With Master Minds,* 1912; Léon Daudet, *Fantômes et Vivants,* 1914.

[30]Octave Mirbeau, "Rodin et son oeuvre," preface, *La Plume,* June 1, 1900.

of the two, has achieved self-realization through his creatures." Here Mauclair gives us a key to the overwhelming fascination that Rodin held for the fin de siècle literary community: his method of working—the way he took pieces, fragmented them, reworked them, and reused them in new contexts—was something they understood. In his working process they recognized a method similar to their own way of distorting grammar, fragmenting phrases, and creating "polyvalent" words that could take on fresh life in new contexts. In Rodin's studio they could grasp the nature of the new aesthetic visibly and physically. Needless to say, Rodin went out of his way to make the studio accessible to them.

The innumerable fragments and the figures of *The Gates of Hell* remained the most fascinating things to see in Rodin's studio. The future of the portal, which had been exhibited in its unfinished state in 1900, was unclear. The State had abandoned its plans for a separate building for the Museum of Decorative Arts and in 1905 installed it in the new Lefuel wing of the Louvre along the rue de Rivoli. In 1904 Rodin and the State came to the agreement that the credit established in 1885 to cover the cost of casting the portal in bronze would be withdrawn.[31] It now seemed that *The Gates of Hell* would probably never be finished. On some level Rodin must have realized that there was a positive side to the situation, for it was *The Gates* that best allowed the creative process to be encountered in his studio and that drew so many writers to visit him.

Another remarkable insight available in Mauclair's essay is to be found in the section in which he establishes Rodin's relationship to the history of sculpture: "Puget, Goujon, the sculptors of the Middle Ages, of Greece, and the rules for decoration established on the Lion Gate of Mycenae as well as the Serapeum of Memphis." The first four are expected, but the Lion Gate and the Serapeum! What did anyone, let alone Rodin, know about the Serapeum of Memphis, a badly destroyed ensemble of Hellenistic sculpture? And this is the point. By 1900 there was an atavistic dimension to the myth of Rodin; people believed that on some near mystical level Rodin was in touch with all the sculpture that had ever existed. It became standard in writing about Rodin to mention Hindu sculpture, Assyrian, Persian, Egyptian, and whatever else an author wished to include. It was broadly accepted that "Rodin's art marks the last logical evolution of statuary through the ages."[32]

All this—the fame, the myth of the man, the marvel of the work—was received and put into its finest form by one of the greatest poets of the twentieth century. Rainer Maria Rilke went to Paris on August 28, 1902 to write a book about Rodin. He was familiar with the sculptor most im-

[31] Tancock has reproduced the letter of February 20, 1904 concerning the agreement about the funds for the casting costs, p. 106. In the 1920s Jules Mastbaum of Philadelphia commissioned the first two bronze casts that were ever made of *The Gates*, one for Philadelphia and one for Paris.

[32] André Veidaux, "La Race de Rodin," *La Plume*, July 1, 1900.

mediately through his wife, Clara Westhoff, who had been Rodin's student in 1900. He prepared throughout the summer, having written to Rodin on June 28 announcing his intention to come to Paris to do the book and asking Rodin for references to the best works already in print.[33] By the time Rilke arrived in Paris, he had completely absorbed the Rodin myth.

The romantic imagination of the young Rilke was such that he was able to give those he held in highest esteem a reality even before he met them. Thus it had been with Tolstoy. In 1899 and 1900 Rilke had gone to Russia, a land of simple people very different from the sophisticated bourgeoisie of Western Europe, to find a genius unworldly enough to dress like a peasant and to work in the fields. Rilke was a pilgrim in search of a divine force worthy of his total surrender, but Tolstoy did not welcome this surrender and Rilke returned to Germany. How strange that he then turned to a sculptor; but Rodin was not simply the world's greatest sculptor; he was "an element, a force of nature," as Mauclair had written the summer preceding Rilke's departure for Paris.

Ten days after first meeting Rodin, Rilke wrote him a letter: "You are the only person in the world who has the equilibrium and the force to rise in harmony and to stand beside his own work. . . . It is not simply to write a book that I have come to you—it is to ask you: how should I live?"[34] Rilke, like everyone else, spoke of the man and the work in the same breath. He, too, thrilled to the idea of the artist standing beside his own colossal production, a creative life that could be penetrated physically.

Within a few months of the meeting, Rilke began his book.[35] It partakes of the myth, but, more, it ennobles it. "Rodin was solitary before he became famous. And Fame, when it came, made him if anything still more solitary. For Fame, after all, is but the sum of all the misunderstandings which gather about a new name."[36] The first question Rilke asked was "Who is this man?" He quickly acknowledged that "the time may come when the history of this life will be invented, its ramifications, its episodes, its details."[37] He then put Rodin into a historical context—antiquity, the sculpture of the Middle Ages, the Renaissance, and the modern era, when

[33]The letter is in French ("Je vous prie de pardonner le style . . .") and it was written from Schloss Haseldorf in Holstein. He informed Rodin that it would be in a new series of art monographs published by Professor Richard Muther. Rainer Maria Rilke, *Briefe aus den Jahren 1892 bis 1904* (Leipzig: Im Insel-Verlag, 1939), pp. 227–29.

[34]Letter dated September 11, 1902. Rilke, *Briefe*, p. 266.

[35]The first part of Rilke's book was published by Julius Bard in 1903 (Berlin); it was published again with the second part, which was written in 1907 by Insel Verlag, in 1913 (Leipzig). Jessie Lemont and Hans Trausil did the first English translation, published by Sunwise Turn in 1919 (New York). It has been reprinted several times. There is a better translation by G. Craig Houston in *Rainer Maria Rilke, Selected Works* (New York: New Directions Books, 1967), 1, 95–160, which is the translation that I have used. All the passages quoted here were written in 1902.

[36]Ibid., p. 95.

[37]Ibid., p. 96.

The arts had in some way become renewed, filled and animated by eager expectation; perhaps it was just this plastic art, still hesitating in the shadow of a great past, which was destined to find that which the sister arts were feeling for gropingly and with a great desire. It surely possessed the power to bring help to an age tormented by conflicts which lay, almost without exception, in the realm of the invisible. The language of this art was the body. And when had this body last been seen? Layer upon layer of clothing had been laid upon it like constantly renewed varnish, but beneath these protecting incrustations the living soul, breathlessly at work upon the human face, had transformed the body too. It had become a different body. If it were now uncovered, it would probably reveal a thousand forms of expression for all that was new and nameless in its development, and for all those ancient secrets which emerging from the Unconscious, like strange river gods, lift their dripping heads from out the wild current of the blood. . . . Here was a task great as the world itself. And he who stood facing it was a man unknown, whose hands sought blindly for bread.[38]

Once Rilke had established the drama of the coming of Rodin, he turned to the work: *The Man with the Broken Nose,* which showed "Rodin's understanding of the human face," through the *Man of Early Times* (*The Age of Bronze*), which demonstrated "his complete mastery of the human body," to "the tremendous *Gate of Hell,* with its *Thinker,* the man who sees the whole immensity and all the terrors of this spectacle because he thinks it. . . ."[39] Rilke ended by describing Rodin's maquette for *The Tower of Labor* (Fig. 12): "On the slowly rising relief will be shown the history of labour. . . . New life means for him neither more nor less than new planes, new gestures. So simple has life become about him. He can no longer go wrong."[40]

Rilke's experience of Rodin had the "aura of the divine" about it. He had gone to Rodin for salvation. Rodin's work bore within it an experience of a reality that was beyond the senses. Even more important, Rodin was the artist-hero, the lonely, the suffering, the hardworking artist who lived on the highest spiritual plane, who had been lovingly depicted by writers since the 1880s. Rilke's Rodin was a powerful version of the Rodin myth.

Rilke always acknowledged his debt to Rodin; later in life he made it clear that it was Rodin who taught him to work. A Rilke critic has pointed out that

Stripped of its origin, of the magical aura with which the name of Rodin surrounded it, the counsel of hard work is seen as a very simple recipe, one which would have been given him by a hundred people—by people, even outside the world of art. But for Rilke, only a man admired almost to the point of worship, a man whose majestic prestige invested even his simplest words with oracular properties, could administer the lesson; a man, above all whom

[38]Ibid., pp. 98–99.
[39]Ibid., p. 116.
[40]Ibid., pp. 134–35.

Rilke could watch putting the grand concept into practice, who proved precept by example.[41]

Here then are the elements that attracted numerous writers to Rodin at the turn of the century: Rodin the artist, the philosopher, the humble craftsman, the solitary sage; Rodin the creator of works able to reveal man's soul through forms that lived as symbols with a special kind of intensity and grandeur. How they loved finding words with which to express this! Huysmans, Kahn, Geffroy, Rilke, all of them adored writing about Rodin's work with words that could exist as literary equivalents to the sculptor's forms. He was their equal and they his; he worked as they did. Through associations and an intuitive grappling with the medium, meaning emerged from Rodin's work. "He endeavours to represent life in all its mystery, not to penetrate the mystery of life. He gives you a movement, an expression; if it has come straight from life, if it has kept the living contours, it must mean something, and he is but your comrade in the search for that meaning." (Symons)

By the early twentieth century, some of Rodin's works came to have deep significance for an even broader and more bourgeois public. The best example is found in *The Thinker.* The enlarged version, made in 1902–03, was Rodin's first work to considered for a prominent public spot in Paris. Once out of the context of *The Gates of Hell,* where the muscular giant assumed his place as contemplator of mankind's sins, *The Thinker* assumed a variety of new meanings: "he . . . instructs the workers, in workshops, on the farms, in the mines, all those to whom no effort is worthy of more attention nor of more resourcefulness than that of thought."[42] When the enlarged figure (Fig. 13) was unveiled in front of the Panthéon on April 21, 1906, Dujardin-Beaumetz, the Undersecretary of State for Fine Arts (Fig. 14) told the crowd that they had come there on this day in order to salute an "unknown" *Thinker* much as a politician later might speak of an "unknown soldier." *The Thinker* was "one with the people . . . a hundred years ago, [he] made the weapon of vengeance a tool of freedom. He is the arduous worker who successively has broken in and tamed the materials provided by nature and has used them for social progress. Finally, he is the one who, through his labor, builds the modern world. . . ." Here we find the beginning of that kind of popular interpretation that has been applied so often to a number of Rodin's works, to *The Kiss, The Three Shades,*[43] *Adam* and *Eve,* as well as to *The*

[41]K.A.J. Batterby, *Rilke and France, A Study in Poetic Development* (London: Oxford University Press, 1966), p. 54.

[42]Pierre Baudin, "Le Penseur," *Le Journal,* Paris, May 20, 1904. See Tancock, p. 119 for the entire text.

[43]One of the most interesting and amusing was the Republican party's choice of *The Three Shades* to symbolize "Peace, Progress, and Prosperity" for their 1956 convention in San Francisco. Before the program that had a photograph of the group on its cover was actually used, someone discovered that the original meaning associated with it was the line in Dante's *Inferno:* "Abandon all hope, ye that enter." A new program was designed.

Thinker. They have been capable of absorbing a greater diversity of meaning than perhaps any other group of sculptures ever created.

A work that fits into this category and that conspicuously reveals the influence of contemporary criticism and the press on Rodin is *The Tower of Labor.* On March 21, 1898 Armand Dayot (Fig. 15), critic and Fine Arts administrator, published an open letter in *Le Journal* calling for a monument "to the glory of Labor." Out of this grew the idea for a collaborative project along medieval lines, with Rodin as the principal artist. The maquette (Fig. 12) that Rodin developed during that tense spring, just before the opening of the salon of *Balzac,* remained in his studio, however, and was only occasionally referred to by writers such as Rilke during the early years of the twentieth century. It was only after a serious mining disaster in the spring of 1906 that several writers urged Rodin to take up the project again, for they believed that Rodin would be able richly to interpret the "glories of labor."[44] Rodin, ever pleased to recognize himself through their eyes as the only one capable of creating the "purest symbol of our time," went back to the project, now rephrasing it and giving it a kind of monstrous Wagnerian grandeur. It would be over 100 meters high, and *The Gates of Hell* would serve as the entrance. The Italian journalist Ricciotto Canudo spoke of the "immense cyclical poem celebrating all of humanity's striving to rise slowly from the suffering of harsh material existence, from the agonies of the flesh and the daily misery of work in an attempt to attain the beautitudes of apostolic thought." Canudo wanted to make sure he was right in his interpretation of the work, so he asked Rodin to read his article. Rodin assured him that what he had written was exactly what he had in mind.[45] Canudo and Rodin must have had long conversations about it, walking back and forth in the garden at Meudon, which the Italian found so "clearly intended to receive pilgrimages in celebration of art."

The same month (August 1907) that Canudo published his article, Charles Morice, poet and critic, ever-ready apostle in the artist-hero cult, wrote about Rodin as being our "guardian of Glory." Like Rilke, he could find but one suitable comparison—Tolstoy. The two were similar not only in terms of genius, but in the hardship of their lives. It is difficult not to suppress a smile when we imagine the two men standing in the garden at Meudon with Rodin solemnly telling Morice of his conscious desire to follow in the footsteps of Rousseau. After 1900 there were few affectations the literary community would not permit to Rodin, but notions such as this have, in fact, entered into our thinking about Rodin. In Tancock's catalogue of the Philadelphia Rodin Museum, he describes the "two opposing views" contained within the iconographic significance of *The Age of Bronze,* and that one

[44]I owe my understanding of the development of *The Tower of Labor* to Professor John Hunisak and his article "Rodin, Dalou and The Monument to Labor," to be published in a festschrift for H.W. Janson by Harry N. Abrams, Inc.

[45]Documents of this exchange are to be found in the archives of the Rodin Museum in Paris. Professor Hunisak has shared this information with me.

developed out of a combination of Rodin's reading Rousseau and taking long walks in the forest, leading him to represent "one of the first inhabitants of our world, physically perfect, but in the infancy of comprehension, and beginning to awake to the world's meaning." The discussion sounds quite factual, until we look at the footnote and find that the sources for it are a letter Rodin wrote to the director of the Kunsthalle in Bremen in 1906 and Frederick Lawton's book on Rodin, which was published in 1908.[46] It was Rodin's Rousseau phase, and he was contributing to shaping the history of his own art.

In the wake of the 1900 exhibition, no group of critics and connoisseurs responded more vigorously to Rodin's fame than the German-speaking public. In the 1880s and 1890s they had been less receptive to his innovations than their English-speaking counterparts. But by 1900 the German intellectuals, the creators and benefactors of rich developments in the philosophy and the history of art during the nineteenth century, moved toward the Parisian sculptor with an eagerness that was stunning. Rodin, of course, was receptive. When the elegant young Prussian aristocrat Hélène von Nostitz (then Fräulein von Hindenburg) arrived at the Rodin pavilion in the Place de l'Alma in 1900, she came assuming the Master himself would not be available to her. She entered the exhibition hall to find Rodin absorbed in the contemplation of one of his works and she moved to look at *Amour et Printemps*. At the moment in which she felt "moved to tears," she turned to find Rodin "hinter mir stand."[47] It was the beginning of a deep friendship, one we can follow in a rich correspondence that lasted until the beginning of the war.

Kassner came at the same time. Rilke arrived two years later, in September, the same month that Georg Simmel published an article in the Berlin daily *Der Zeitgeist* (September 29, 1902) in which he drew parallels between Rodin and Nietzsche. Just as Nietzsche had revealed alternatives to traditional morality, so Rodin had provided alternatives to neo-Classicism. Although the comparison with Nietzsche is no longer particularly obvious, it sprang from the same impulse as the comparison with Tolstoy. During the first decade of the twentieth century, Nietzsche was the dominant force in German intellectual life and, thus, for a German audience the most suitable analogue. Rodin was very moved when he received a copy of the article from Simmel and he invited the philosopher to visit him in Paris. The invitation was accepted in 1905.[48] Simmel found in Rodin the ideal modern artist in whose works he could study the age-old problem of life as process—

[46] Tancock, pp. 342, 350.

[47] Hélène von Nostitz, *Auguste Rodin, Briefe an Zwei Deutsche Frauen* (Berlin: Holle & Co. Verlag, 1936), p. 12.

[48] When Simmel learned of Rodin's death, he published a brief account of that visit: "Erinnerung an Rodin," *Vossische Zeitung*, November 27, 1917. It has been reprinted in Georg Simmel, *Brücke und Tür* (Stuttgart: K.F. Koehler Verlag, 1957), pp. 194–99.

something always in flux—yet a process making possible objects that are not in flux but permanent forms of existence. To demonstrate the difference between Being and Becoming, he opposed the "pure body" in a Michelangelo figure to the movement in a Rodin figure. "Movement invades his every domain; it has given him a means of expression that is completely new. . . . This movement reveals man's inner life, his feelings, his thoughts, and his personal vicissitudes, more wholly and completely than has ever been possible."

Georg Treu, who was responsible for the large collection of Rodin's work in the Dresden Albertinum, published an important essay in 1903 in the *Jahrbuch der bildenden Kunst,* and in 1905 Paul Clemen published an essay in *Kunst für Alle* (April 1) in which he discussed Rodin's work as the alternative to that of the most outstanding contemporary German sculptor, Adolf von Hildebrand (1847–1921). He focused upon Hildebrand's notion of the importance of the single distant view *(Fernbild)* from which a work of sculpture should be seen, and then pointed out that once one had become acquainted with Rodin's work such a concept seemed trivial and rigid.

The Hildebrand/Rodin controversy became a staple of German art history; Hildebrand himself entered into it when he wrote a short essay on Rodin in 1917. He spoke of his admiration for the Frenchman, considering Rodin to be a "natural phenomenon," but to speak of him as a professional sculptor—that was a different matter: "Everybody who has ever worked directly in stone must realize that Rodin perceived the traces of work in Michelangelo's partially-hewn marbles in a purely superficial manner, and that he used it in and for itself." When Hildebrand looked at works such as Rodin's *Victor Hugo* "or any of his many-figured works," he found "most of them fall apart." Early in the century the majority of sophisticated French and English writers were sympathetic to Rodin's subtle interweaving of Naturalism and Symbolism, and such ideas would have appeared rigid. But in the course of the 1920s and 1930s, as more and more sculptors began to carve directly in stone and to attempt to be "truthful to their materials," Hildebrand's ideas became increasingly credible. In 1971 the Rodin/ Hildebrand competition was brought up again by Rudolf Wittkower. He opened his Slade lecture on nineteenth-century sculpture by saying: "As the century drew to its close, the fate of European sculpture became the responsibility of two men: one name is obvious, Auguste Rodin; the other does not come so easily to mind—I mean Adolf von Hildebrand."[49] An unusual point of view in the latter part of the twentieth century, but the comparison, made by a scholar who was at the University of Berlin in the 1920s, serves to remind us of the enormous importance the discussion of Rodin vis-à-vis Hildebrand had in Germany.

If Rilke wrote the most poetic essay in response to Rodin's work,

[49]The lectures have been edited and published by Margot Wittkower. Rudolf Wittkower, *Sculpture: Processes and Principles* (New York: Harper & Row, 1977), p. 232.

another German wrote the most comprehensive critical discussion of Rodin's place in the history of sculpture from the viewpoint of the early twentieth century. This was Julius Meier-Graefe, the critic and aesthetician most responsible for making Impressionism available and comprehensible for a German audience. Meier-Graefe worked on his great *Die Entwicklungsgeschichte der modernen Kunst* while he was living in Paris in the opening years of the century. He and Rodin had met during the 1890s and Meier-Graefe exhibited Rodin's work in his gallery, La Maison moderne. Thus, his essay on Rodin, included in the second volume of *Die Entwicklungsgeschichte,* developed out of a real knowledge of both artist and work. Meier-Graefe recognized that Rodin, like the Impressionists, had a particularly profound and personal view of nature: "There is not a single detail in his work which is not the outcome of a natural impression." Meier-Graefe began his discussion by indicating that he found Rodin to be a weaker artist than Michelangelo, but by the time we read his analysis of the *Monument to Victor Hugo* it is difficult to believe he found Rodin second to anyone. "The man who could conceive such a thing may scorn all honours: he can withdraw from the world and from mankind; all humanity is within him. The genius who can give corporeal and comprehensible form to such a conception is divine. . . ."

In his essay of 1911, Simmel looked at Rodin's work in the context of the two major properties of a work of art—form and content. His thinking about these elements with regard to Rodin's work differed somewhat from that of most writers in the early twentieth century, for he believed Rodin "did not give sculpture new content, but for the first time he gave it a style in which to express an attitude about the modern soul. . . ." For Simmel the notion of content bore within it the old-fashioned idea of subject matter. Obviously, he did experience new meaning in Rodin's work in that it was an "attitude about the modern soul." As we have seen, most of Simmel's contemporaries put great stress on the appeal of Rodin's work in terms of its range of meaning. It was exactly this quality, as well as the complexity of his forms, that younger sculptors and new critics wanted to cast aside. When André Gide compared Rodin and Maillol, he clearly preferred Maillol's figure because "She is beautiful and she does not mean anything." Roger Fry, too, was more disposed toward Maillol's work, finding that "Rodin has used all his ingenuity to seize the figure in moments of critical intensity; for him the figure becomes most expressive at moments when the soul is beside itself in an ecstasy of despair, or agony or of joy . . . ," whereas "Maillol has taken the other direction, he has endeavoured to show what meaning there may be in the figure at its moments of placid self-possession. . . ."

Every sculptor who came to Paris after 1900 had to come to terms with Rodin. He was the patriarch presiding over the sculpture section of the Société Nationale. Whether or not he chose to notice a débutant's work counted. It counted too much, and they all had to work away from him. In

Brancusi's words, ". . . nothing grows under big trees." The direction they took—all of them, Bourdelle, Maillol, Despiau, Lehmbruck, Brancusi, Matisse, Duchamp-Villon—was toward simplicity, stillness, and a new kind of permanence. Bourdelle felt that in his own development his *Head of Apollo* (1900) represented the big break:

> Rodin's manner held a strong influence over my studies. But, having penetrated to the very interior of his way, I suddenly knew how to make that knowledge serve me in order to proceed in an opposite direction. I departed from the accidental plane in search of the permanent plane. I looked for the essentials of a structure, leaving in second place the transient waves. Moreover I sought universal rhythms.[50]

This statement could have come from any number of sculptors at work in Paris during the first decade of the twentieth century. Matisse explained his lack of desire to continue discussing his work with Rodin after their first meeting (probably in 1898): "Already . . . I could only work on the general architecture of the whole, replacing exact details with a lively suggestive synthesis." But once Matisse was more developed as an artist he was able to express admiration, and later wrote to Rodin from London after seeing *The Burghers of Calais* on the lawn of the Houses of Parliament, "Each figure has gotten into my head as if I made it myself."[51] An elderly Brancusi knew perfectly well his debt to Rodin, even if he had not wanted to work with him: "Thanks to him . . . sculpture became human again, both in dimensions and in its spiritual content." And Maillol in later years looked back and remembered: "Rodin is the genius who has given movement to his whole epoch; he is a man whom I could never be. . . . Rodin was a god." But these remarks (with the exception of Matisse's) were made after Rodin's death when the modern movement was firmly established.

There was something else that held younger artists at a distance from Rodin in the period preceding World War I. Rodin was at odds with a great deal of modern art and life, and increasingly he said so. The shift in Rodin's energy late in his life—he passed more and more hours discussing art with writers and fewer making art in the studio—was an intensification of his life-long love of ideas and meaning in art and of the words used to express concepts and perceptions. He felt an ever greater urgency that his ideas be put down on paper. As he pointed out to Judith Cladel, "Coming from me, whose opinions carry some weight, they are repeated when I am no longer on the spot."[52] Camille Mauclair, Judith Cladel (Fig. 16), and Bourdelle were

[50] Ionel Jianou and Michel Dufet, *Bourdelle* (Paris: Arted, Editions d'Art, 1965), p. opposite Plate 20, *Head of Apollo*.
[51] Professor Daniel Rosenfeld has made a transcription of this letter in the archives of the Musée Rodin in Paris and has made this information available to me.
[52] Judith Cladel, *Rodin: The Man and His Art, with Leaves from His Note-book,* Translation by S.K. Star (New York: Century, 1917), p. 231.

all preparing books about Rodin in the middle of the first decade and they quoted his thoughts liberally.[53] Essential to their studies was their deep sympathy and personal rapport with Rodin. Bourdelle's situation was the most difficult, for at the same time that he was writing his praise of Rodin's work he was trying to escape from his influence in his own sculpture. It is no surprise that the book was not published during his lifetime. Cladel was moving into her position as Rodin's principal biographer. She was undoubtedly the only person who could exactly transcribe Rodin's thoughts on art. Moreover, she wrote her articles in his presence, almost sentence by sentence.[54] Rodin felt that "Judith Cladel exactly understands my thought and my soul!"[55] She paid dearly for this prize as it forced her into an adversary position with regard to others in Rodin's jealous entourage, and it probably resulted in her giving up more personal and creative writing projects.

At first others did the writing as well as the polishing, but increasingly Rodin began to write down his own thoughts. He would do so in the same manner that he once grabbed pieces of clay in order to fashion quickly apprehended views of life. Writing was an extension of sculpture for Rodin. As he told Marcelle Tirel, one of the secretaries of his later years: "It is very difficult to write a book. It is like sculpture."[56] Anthony Ludovici, also his secretary in 1906, was surprised to find, after joining the household at Meudon, that "Rodin was not in the least averse from bearing the whole burden of the conversation at the table himself. . . . I soon realized that he was as original and vigorous a thinker as he was a sculptor, and was not in the least surprised when later on I discovered that he would fain have been an author."[57]

Before 1908 Rodin was working on a book that would bear his own name, *Les Cathédrales de France* (1914). He worked on it with Charles Morice. Rodin shared with Symbolist writers such as Morice a strong taste for the Middle Ages, and at times it is difficult to know what is Rodin and what is Morice in *Les Cathédrales de France.* But there is no doubt that Rodin worked with extreme diligence on the book. Tirel remembered how she "recopied

[53]Camile Mauclair first published an article on Rodin in 1898, and his first book-length study appeared in 1905 (in English before it came out in French): *Auguste Rodin: The Man—His Ideas—His Works* (London: Duckworth). Judith Cladel's first publication was "Le Sculpteur Auguste Rodin pris sur la vie" for *La Plume* in 1902. She was much praised for this by reviewers, who recognized her as not being a professional critic but someone who was close to Rodin and was able to report truly "les paroles de Rodin." Cladel's *Auguste Rodin: L'Oeuvre et l'homme* (Brussels: G. Van Oest 1908) was a major work and became a standard reference for everyone who wrote about Rodin. Bourdelle conceived of the idea of writing a book about Rodin in 1908. It was considered ready for publication in 1922 and was to have come out with the collaboration of Anatole France, but did not do so until Claude Aveline worked again on the various texts and published it eight years after Bourdelle's death: *La Sculpture et Rodin* (Paris: Editions Emile-Paul Frères, 1937, reprinted by Arted, Editions d'Art, 1978).
[54]Marcelle Tirel, *The Last Years of Rodin,* translated by R. Francis (New York: McBride, 1925), p. 110.
[55]Ibid., p. 111.
[56]Ibid., p. 99.
[57]Ludovici, pp. 50–51.

fragmentary phrases of his ideas on sculpture, on the sky, the earth, trees; on anything and everything that passed through his mind. . . . The tedious and eternal revision went on for months and months. . . . Often when I read a passage over to him which was more or less in shape, he would exclaim: 'Beautiful! beautiful!' "[58]

The important years for Rodin's literary activity were 1905–14, when, in addition to working with Mauclair, Cladel, Bourdelle, and Morice, he was engaged in discourses with Gustave Coquiot, Paul Gsell, and Dujardin-Beaumetz that were to be published.[59] This body of work contains Rodin's most all-embracing statements about art, particularly the art of the past. It is also rich in information about Rodin's own art, and it reveals him as the elder statesman more and more out of step with his own time. "The search in modern life is for utility; the endeavor is to improve existence materially. Every day, science invents new processes for the feeding, clothing, or transportation of man; she manufactures poor products cheaply. . . . But—the spirit, thoughts, dreams—these are no longer the issue. Art is dead."[60]

Little wonder that the most enthusiastic response to Rodin's writing did not come from contemporary artists but from the likes of a professor of medieval art history. Emile Mâle assured the readers of the *Gazette des Beaux-Arts*, in his review of *Les Cathédrales*, that "When a man who has created masterpieces tells us that the cathedrals are sublime and should be contemplated through tears of joy, we can take him at his word." During the first two decades of the century, Rodin's audience was not only larger, it was changing in character. He was no longer in the avant-garde.

Rodin's last years were extremely difficult. He was sick, he could barely work, and he was surrounded by sycophants. His life ended during a war that tore apart those countries that had been so mutually hospitable to him and to his work. But even the war did not prevent a memorial service from being said in Westminster Abbey and the adjourment of the Berlin Academy on November 24, 1917, the day of Rodin's funeral at Meudon.

There was magic in Rodin. He was an overwhelming personality. What happened once he was gone? He left behind an enormous body of work. In some respects it was equaled by none because, with the creation of the Rodin Museum in Paris, it continued to exist as a body of work. With the

[58]Tirel, p. 99.
[59]Rodin installed Gustave Coquiot at the Hôtel Biron for a period to work on his official biography, but, as with so many people he worked with in this kind of capacity, Rodin broke with him. Nevertheless, Coquiot published *Le Vrai Rodin* (Editions Jules Tallandier) in 1913. Paul Gsell also had great difficulty working with Rodin, but he managed to get his book out after only a year's work: *L'Art: Entretiens reunis par Paul Gsell* (Paris: Barnard Grasset, 1911). Sometime after the unveiling of *The Thinker,* at which he presided, Dujardin-Beaumetz, Undersecretary of State for Fine Arts, began making notes of his conversations with Rodin. When he died in 1913, they were not quite edited; nevertheless, they were published the same year: *Entretiens avec Rodin* (Paris: Paul Dupont, 1913).
[60]Rodin, *L'Art: Entretiens reunis par Paul Gsell,* p. 5.

Master gone and the art that became the dominant style of the 1920s and 1930s so cool and abstract, we would expect a marked drop of interest in Rodin. In the catalogue of the Rodin Museum in Philadelphia, the director noted: "Philadelphia's Rodin Museum was opened with appropriate fanfare to the public in 1929; yet the following twenty years were quiet ones for the museum. That this should be so was not entirely surprising because, as so often happens after the death of a powerful and revered personality such as Rodin, there was a period of intense reaction against his work."[61] This is true, but what *is* surprising is that there continued to be a great deal of publication about Rodin throughout this period. And still it was the personality that inspired the writing.

The majority of books and articles published in the twenty years following Rodin's death were written by individuals who knew him. The interest came to a head in the 1930s. In 1933 there was an exhibition of Rodin's sculptures and drawings in Paris (at the Galerie Braun), and on that occasion *Beaux-Arts* published an interview with Rodin's old assistant Charles Despiau. His words reveal that he still lived as a true disciple. "One cannot explain genius . . . Rodin was not just my employer. He was my spiritual father. . . ."[62] Rodin was even more a spiritual father to Bourdelle, whose book on Rodin was published posthumously in 1937. Bourdelle had prepared it for publication in 1922, writing to M. François Laya, who had asked him to do the study, that this was a task he would

> carry out with much intense emotion that I shall make the Great Worker reappear as he was in Person, as the man at work (Fig. 17). I am awakening in my memory the powerful head of the Master, a head cut from stone. The physiognomy, a corpulent descending movement, a torrent cut from obstacles, and that abundant reddish beard. The basic structure of this man, the pale green eyes directed by the spirituality of his gaze, all this attentive force remains present in me as I remember the haloed mark about the prophet.[63]

But the most important book to be published in the 1930s was Judith Cladel's *Rodin: sa vie glorieuse, sa vie inconnue.* Since its appearance in 1936, it has been the standard biography. But it is a very strange book. It is carefully researched and documented—"reeks of truth" as one reviewer put it. "Does it explain the work of a great sculptor?" asked Paul Firens. "No, not in the sense that we see his talent, his genius as it was able to transcend the determining factors of his age and his milieu; but yes, if it is to know better his character, to understand the man. . . ."[64] This is the story of "la passion d'un homme de génie."[65] It is also an autobiography, a witness to Cladel's

[61]Evan Turner in the Foreword to John Tancock, *The Sculpture of Auguste Rodin*, p. 8.
[62]Philippe Diolé, "Despiau nous parle de Rodin qui fut 'son père spirituel,' " *Beaux-Arts*, no. 45, November 10, 1933.
[63]Bourdelle, *La Sculpture et Rodin*, p. 161.
[64]Paul Firens, "Causerie Artistique," *Feuilleton du Journal des Débats*, August 18, 1936.
[65]Jean Babelon, "Bibliographie," *Gazette des Beaux-Arts*, 16 (1936), 204.

profound emotional investment in Rodin and his legacy. Although her reviewers praised her stoicism and self-sacrifice, we are brought, in fact, to feel with full intensity the degree of suffering she experienced on Rodin's account. In the final chapters she reveals Rodin's vanity and cruelty. We hear, too, of the way in which others victimized him. Cladel did this in a fashion so believable that "we close this book with a sense of humiliation and disgust at human perfidy."[66]

Cladel's total admiration for Rodin and her strong desire to tell the truth about him combined to produce a strange book, which has given a peculiar edge to our view of Rodin. Her work has become the funnel through which the myth of Rodin has come into the second half of the twentieth century. It is the major source for our general feeling about Rodin as a tragic figure—in terms of the opposition to his work, the way he was used by others, and his own weakness. Hundreds of reviews followed the appearance of Cladel's book; her picture was often in the journals through the spring, summer, and fall of 1936, and she was always being interviewed. "The most beautiful thing about my existence is that I knew Rodin and that I spent as much time with him as I did."[67]

There can be no doubt that, at least in France, Rodin's personality survived his death. Had it not, there could never have been the kind of response there was to Cladel's book.

Now, what of the work? How did it find its way, so to speak, into the history of art, once free of Rodin? After Rodin's death this matter was primarily in the hands of writers who did not know him. Elie Faure wrote shortly after Rodin's death, "I would not like to have known Rodin." In his essay, as in the fourth volume of his *History of Art,* which appeared a few years later, Faure tried to establish some kind of balance in the way he explained Rodin's art. He pointed out that many of Rodin's figures could not stand on their own, that everything was "too fragmented and tormented, and too little detached from the compulsive need to astonish. . . ." But he could not quite escape the personality, and he ended the essay by conceding; "And yet this is a great artist—a monster. . . . Bloodied though we be, we must hail Rodin as one of those tyrants of the spirit who may reign longer and more despotically over time than conqueror over geographic extent, a tyrant who forces centuries of drama upon our curiosity in order to nourish us."

Elie Faure was still too close to the nineteenth-century romantic sensibility to establish a totally new evaluation of Rodin. The Swiss sculptor Carl Burckhardt had more distance. For him, Rodin's nineteenth-century naturalism was a problem; it got in the way of understanding the true language of sculpture. He felt the same about the literary content in Rodin's work. What he wished to focus on were elements such as light, air, and space.

[66] H. Granville Fell, "New Books Reviewed," *Connoisseur,* February, 1940, p. 86.
[67] *Toute l'Edition,* May 30, 1936.

To do so, Burckhardt directs our attention to such works as the enlarged *Walking Man* where powerful formal elements clearly dominate.

No study of modern sculpture was more important during the first half of the twentieth century than Carola Giedion-Welcker's *Modern Plastic Art* (1937). It was the first serious and general look at the artists who were committed to the new sense of the object, of space, and of kinetic volumes. Giedion-Welcker owed much to her compatriot Burckhardt, whose book on Rodin she so admired and which aided in her discussion of the new plastic values. For Giedion-Welcker, Rodin's position was no longer pivotal; he was simply one of several artists (the rest were painters for whom sculpture was a secondary activity) in whose work could be found the baroque sensibility for light and movement that was so critical to the new "optical vision" of the twentieth-century sculptors. Like Gide and Fry before her, she preferred Maillol, who "was to redress the balance of Rodin's superb one-sidedness."

Rodin's reputation was at its lowest in the late 1930s and early 1940s. During World War II, the Rodin Museum in Paris closed its doors, sending the marbles and plasters out of the city for safekeeping. General interest in Rodin's legacy waned, and the inaccessibility of his major works did not help. When Rodin sculpture was on view during the 1940s, the context of its exhibition and the tone of the discussion of its merits at times seemed shockingly removed from what had once been. The Gallery of Fine Arts in Columbus, Ohio, organized an exhibition called "Rodin Revisited" in 1944. In the catalogue, the director of the gallery declared that "No one denies Rodin's failure, but now in the middle of the 20th century the heroism of that failure seems more evident, and more momentous. . . ," and that "His Gate of Hell is, absurdly enough, no more than an enlarged Louis XV doorway plastered over with unrelated sketches, the farthest imaginable remove from the cosmic order underlying Dante's vision."[68]

The loss of esteem suffered by Rodin's work was so total that when a change in temper came in the 1950s, it constituted a revival. "The modern sculptor most in view today is not Alexander Calder, nor Picasso, nor Henry Moore. It is Auguste Rodin . . . whose work appears to be enjoying a notable revival. . . ." wrote Aline Saarinen in the *New York Times* in 1955.[69] Critical to the "Rodin revival" in America was the role played by the most influential dealer in modern sculpture, Curt Valentin, who began to exhibit Rodin's work in the 1940s and who circulated a major Rodin exhibition throughout the United States in 1954–55.[70] Equally important was the

[68]Philip R. Adams, *A. Rodin*, Columbus Gallery of Fine Arts, Columbus, Ohio, October, 1944, pp. 1–4.

[69]Aline B. Saarinen, "Revival of Rodin—And of Sentiment," *New York Times Magazine*, March 20, 1955, p. 28.

[70]Curt Valentin was the director of the Buchholtz Gallery in New York for which he organized "From Rodin to Brancusi" (1941), "Homage to Rodin" (1942), and "The Heritage of Auguste Rodin" (1950). When he opened his own gallery, he organized a major exhibition of Rodin's works in 1954 and sent it to six other American cities.

beginning of scholarly interest in Rodin's work.[71] The fruit of the new interest matured in the 1960s and from Zagreb to Helsinki, Tel Aviv to Tokyo, Rodin shows were everywhere. The most important in the United States was held in 1963 at the Museum of Modern Art in New York. Albert Elsen, the organizer of the exhibition, stated that it was no longer necessary "to champion Rodin's rescue from oblivion." He wanted to "restore to the sculptor some of his historical context. . . ."[72] Leo Steinberg pointed out in the catalogue of a show that went to eleven cities in North America from 1963–65 that "now, forty-five years after his death, it is his relevance that astonishes us as we look again."[73]

By the 1960s, the Rodin revival was firmly established. Much of the good writing that accompanied it has the enthusiasm of real discovery, even when authors recognized the oldest truths about Rodin's work. Scholars like Elsen and Steinberg love Rodin's fragments with an intensity equal to that of Gustave Kahn, but what they see and how they express it represents a considerable shift. For Kahn a twisted hand by Rodin was "a violent attempt to hold on to money, or a woman, or truth. . . ."; for Steinberg, such hands betray the "full measure of life . . . by multiplied surface incident . . . , by the ceaseless serpentine quiver of bone and sinew, as if the sum of gestures which a whole body can make and all its irritability had condensed in these single hands. . . ."

Once Rodin had become relevant, it was time to sort out ideas about his work. The 1960s rejected a great deal that had been fundamental to Rodin's nineteenth-century fame, while elevating elements that earlier audiences had seen as awkward, imperfect, or that they had not seen at all. The new critics did not want to be bothered with the heroics, the rhetoric, or the sentiment. The marbles and most of the groups were put aside. Some suggested forgetting Rodin's public commissions altogether. Even the portraits were considered inferior to his "private creation"—those unfinished fragments, the odd assemblages, hastily done and put aside in the process of working on *The Gates of Hell.* "For half a century it has been sequestered, or simply obscured by the renowned exhibition pieces. Move these

[71]The most notable scholarly work of the 1950s was done by Albert Elsen, Cécile Goldscheider, Joseph Gantner and J. A. Schmoll gen. Eisenwerth. Elsen began doing research on *The Gates of Hell* in 1949, published "The Genesis of Rodin's *Gates of Hell*" in the *Magazine for Art*, March 1952, and *Rodin's Gates of Hell*, (Minneapolis: University of Minnesota, 1960). Goldscheider's major articles of the 1950s were: "Rodin: l'influence de la gravure anglaise sur le projet primitif de la 'Porte de l' Enfer,' " *Bulletin de la Société de l' Historie de l' Art Francaise*, 1950, "La Génese d'une oeuvre: le Balzac de Rodin," *Revue des Arts*, 2, March 1952, "Rodin et le monument de Victor Hugo," *Revue des Arts*, 6, October 1956, and "Rodin en Belgique," *Médicine de France*, 40, 1958. Gantner published *Rodin und Michelangelo* in 1953 (Vienna: Anton Schroll), and Schmoll's "Zur Genesis des Torso-Motivs und zur Deutung des fragmentarischen Stils bein Rodin" appeared in a symposium on *Das Unvollendete als kunstlerische Form*, (Bern: Francke Verlag, 1959).
[72]Albert Elsen, *Rodin* (New York: The Museum of Modern Art, 1963), p. 11.
[73]Charles F. Slatkin Galleries, *Auguste Rodin, 1840–1917, An Exhibition of Sculpture and Drawings*, May 6, 1963–January 10, 1965. Introduction by Leo Steinberg, p. 10.

aside—if only for now—and it is marvelous to see Rodin's art stride into the present."[74]

In the second half of the twentieth century we are completely at home with sculpture that lacks finish or has no base. We are fascinated by imperfections that can reveal a work in the making, and we particularly like fragments that can function as objects as well as figures (Figs. 18 and 19). What once appeared to be a mistake, particularly Rodin's way of bringing compositions into existence through accidental combinations, now looks bold and interesting. Rodin could combine figures that were in radically different proportions, or he could take the opposite tack and assemble several casts of the same figure to arrive at a group (Fig. 20). Rodin was capable of placing his figures and groups in precarious and elusive relationships to the ground, a characteristic full of implications for the sculpture of the 1960s and 1970s.

But perhaps no aspect of Rodin's art has so fascinated modern viewers as the way he went about his work. His approach to sculpture was additive; he never stopped improvising and changing his mind. Recent writers on Rodin have focused attention on his working method, his way of casting multiple examples of the same piece, breaking it up, retouching it, adding a slip of plaster to a finished piece. For us the idea of a process has become central to our fascination with sculpture in general. A contemporary audience does not demand a beautiful object, but it does want something it can relate to physically and empathetically. When William Tucker turned his attention to the little figures of dancers Rodin made around 1910, he found that their small size "suggests they were made wholly in the sculptor's hand, and they enjoy the freedom of orientation, the identification of the handling of this soft material with structure that this process allows. It is no longer anatomy but the action of the hand in clay that determines the structure of the figure. The idea of 'making' could not be more plainly fulfilled."

At the beginning of the twentieth century, the grandeur of Rodin as a man and as an artist fascinated the entire world. He had struck out on a bold path of sculpting in a way that not only revealed his intense relationship to nature, but that revealed his ideas about national heritage, about decay, lust, sin, even the apotheosis of Man as Rodin would have shown it had he been able to realize his *Tower of Labor*. The world then was attentive to a man such as this, able to make the most profound pronouncements in clay, plaster, bronze, stone, and in words.

When the enormous, certainly exaggerated, love for the man was absorbed into time and respect for his work born again, it was into a world

[74]Leo Steinberg, *Other Criteria* (New York: Oxford University Press, 1972), p. 236. The first time a large number of unfinished studies was exhibited was at the Louvre in the winter of 1962–63 in a show organized by Cécile Goldscheider, *Rodin inconnu*, December 1962–January 1963. The notion of a private and a public Rodin, with the private creation being infinitely better, was exactly the point that Hildebrand had made in his essay in 1917.

that cared little about Rodin's thoughts on love and lust. Albert Elsen asked Henry Moore about the nature of his enthusiasm for Rodin's work, so different from his own. Moore replied that it was the way Rodin "helped open the eyes of modern sculptors to the fragment, the sketch, the accident, and the importance of much older sculpture that was being ignored." When Moore looked at his own cast of Rodin's *Walking Man* (Fig. 21), he spoke of his admiration for "its springiness, tautness and energy." He thought about how Rodin had paid attention to the figure as a whole and how it was, in fact, Rodin's own nature that made possible a figure of such unity. "The unity comes from Rodin's own virility . . . it is a kind of self-portrait." There is no doubt that we still are much attached to Rodin the man, but the man known to us now through his sculpture.

THE AGE OF BRONZE

The first life-size work Rodin ever exhibited was *The Age of Bronze* (Fig. 1). In January 1877 he showed it under the title *Le Vaincu* at the Cercle Artistique in Brussels where he had been living since 1871. In May he sent it to the Paris Salon as *The Age of Bronze* and shortly thereafter he returned to Paris to live.

Anonymous
Review of the Exhibition at the Cercle Artistique (1877)

M. Rodin, one of our most talented sculptors, who thus far has attracted notice at the Salon only through his busts, now shows a statue at the Cercle Artistique that is destined to figure in the next Paris Salon.

It will not go unnoticed there. If it initially attracts attention by its oddness, it holds it by a quality that is as rare as it is precious: life.

What part casting from life has played in making this plaster we can not discuss here. We simply want to bring this figure of a man, in which the state of physical and moral collapse has been so expressively portrayed, to your attention. Without having any indication other than the work itself, it seems to us that the artist wished to represent a man on the verge of suicide.

Anonymous, *L'Etoile Belge,* January 29, 1877. Reprinted in Judith Cladel, *Rodin, sa vie glorieuse et inconnue* (Paris: Editions Bernard Grasset, 1936), p. 115, and in John Tancock, *The Sculpture of Auguste Rodin* (Philadelphia Museum of Art, 1976), p. 350.

Jean Rousseau
Review of the Exhibition
at the Cercle Artistique (1877)

M. Rodin has shown a statue which has made a sensation among artists. It has now left for the Paris Salon where, without doubt, it will be much noticed. It represents a young man, nude and standing as though he were overwhelmed, his eyes are half-closed, one hand is on his head, the other hand closed and raised up. Being so completely taken up with style and execution, as is every true artist, the sculptor has forgotten one thing: that is to baptize his plaster and thereby reveal its subject. Naturally there are questions, even strong criticism: what is the meaning of the half-closed eyes and the raised hand? Can this be the statue of a sleep-walker?

But be reassured: everything is clearly and logically explained by the title: *The Vanquished,* and it is sufficient to add that the raised hand was to have held two spears.

From the point of view of art the work is very beautiful and extraordinarily original. This is realism, a realism that comes directly from the Greeks: it has that kind of modeling in broad planes, the balanced and firm accentuation, the skillful and profoundly understood anatomy, indicating nature with exactly the right movements, and sometimes even surpassing nature. This is an anatomy studied in the gymnasium, and not, like that of the Florentines of the sixteenth century, on the skinned anatomical figures of the studio. This realism is not only truthful, but it has distinction and style. If M. Rodin has had masters, they are certainly not among contemporary realist sculptors who make only servile copies. Rather he is inspired by the powerful metopes that still decorate the west pediment of the Parthenon, those entrusted by Phidias to the realist sculptors of the Dorian schools, and by the supple and robust Ilissus created by Alcamenes.

Jean Rousseau, "Revue des Arts," *Echo du Parlement,* Brussels, April 11, 1877.

Charles Tardieu
Review of the Sculpture at
the Paris Salon (1877)

Sculpture that is completely realistic is not much in evidence [at the Salon of 1877], except for two prominent works: the *Neapolitan Fisherboy* of M. Gemito which is particularly ugly with its strikingly truthful movement in a repulsive crouching urchin, and *The Age of Bronze* of M. Rodin which has been greatly debated. Why "The Age of Bronze?" M. Rodin wanted to symbolize the trials of war. But he forgot to give his statue an attribute that would make the meaning clear. Still, leaving unfavorable remarks aside, the tension in the muscles, the expression in the face, the gesture of the arms are all sufficient to explain the intention of the artist, and we would have accepted the title without objection had it not been for those who maintained that this work, so remarkably real, bore within the traces of a cast from life. We are convinced of the emptiness of this reproach, and we can call upon disinterested testimony in favor of the sculptor's honesty. But without insisting upon the point, we must agree with one thing that does explain, though without justification, the insinuations or the feelings of jealousy toward him: the work of M. Rodin is a study rather than a true statue, it is a slavish likeness to a model that has neither character nor beauty, an astonishingly exact copy of a commonplace individual. But if M. Rodin appears to be little troubled by the notion of style, he is extraordinarily preoccupied with life, and that is a great deal. In this respect his work is most interesting, and it would only have to undergo the slightest modifications—the head a bit more noble, the legs a bit less spindly—in order to overcome the criticism of which it has been the object.

Charles Timbal
Review of the Sculpture at
the Paris Salon (1877)

We want to praise another example of anatomy—this one is by M. Rodin. But Rodin should be cautious, because the artists are suspicious;

Charles Tardieu, "Le Salon de Paris—1877—La Sculpture," *L'Art,* 1877 (Vol. 3), p. 108.
Charles Timbal, "La Sculpture au Salon," *Gazette des Beaux-Arts,* July 1877.

perhaps they are even a little jealous. The reason is that sometimes people who make casts are given the qualification of sculptor. The public, however, sees no malice, and when they stand in front of this sickly nude fellow, if they are curious about anything it is to know the reason the sculptor calls the piece *The Age of Bronze*. But let us accept it for what it is: a curious *atelier* study with a very pretentious name.

1882 AND 1883—*SAINT JOHN,*
THE PORTRAITS, AND THE PORTAL

Rodin showed a great deal in the official salons of the early 1880s. He sent casts of *The Age of Bronze* and *St. John The Baptist Preaching,* his major work of 1878, to many European exhibitions—in Paris, Antwerp, Brussels, Vienna, Munich, and London. In these various shows he also won recognition with the busts he had made of several friends. At the Paris Salon of 1882, he was represented by a bronze cast of the bust of J.P. Laurens, the painter, and a terracotta bust of his former employer, Carrier-Belleuse. The following year he sent a bronze cast of the head of Danielli, created in 1878, along with one of the painter Legros, done in 1881. But Rodin's main work during that decade was on the large commission that he had received in 1880 to create a pair of bronze doors for the new Museum of Decorative Arts in Paris. He began exhibiting individual figures that were to be part of the portals during the winter of 1882–83.

Arthur Warren
Review of the Exhibition at the
Royal Academy (1882)

By far the finest thing, however, is a grand *Head of St. John* [Fig. 2] by Auguste Rodin, French sculptor who has worked for forty years unknown [sic] in the people's studios, and even now does not seem likely to receive the attention which his work undoubtedly merits. His *St. John* is a major statue of

Arthur Warren, "Our London Letter," *Boston Transcript,* May 20, 1882. The letter is a report on the 114th exhibition of the Royal Academy and was sent from London on May 2.

heroic size and, what is more, truely heroic feeling; but only a reproduction of the head is exhibited at the Academy. It represents the evangelist preaching; and for nobility of treatment and beauty of expression is superior to any other piece of modern sculpture I know. The same sculptor, I may add, has another splendid head in the Grosvenor Gallery—a head which may be said without exaggeration to approach very nearly to the best art of Greece.[1]

Louis de Fourcaud
Review of the Paris Salon (1882)

M. Auguste Rodin. Among all the young sculptors, he is the one I would place in highest rank. For him I have not only high regard but the most honest admiration. Last year, he showed a bronze statue of *Saint John the Precursor,* a figure old and thin, rude and nervous, with incomparable energy. This year he is showing a bust of the painter Jean-Paul Laurens. With his nude shoulders he is severe, proud, alive and accentuated like a Gothic sculpture of the very best period. I respect this and the religion of such an integrated art, one that is powerfully and profoundly human. I expect of M. Rodin masterpieces which will proclaim to all his robust individuality, and I am counting on him to help me prove that true modernity in sculpture consists in intimate human expression, the most characteristic gestures, and persistent observation of the living body.

Paul Leroi
Review of the Paris Salon (1882)

What if the medal of honor is the least serious thing in the whole world, the question of art still weighs in the balance, and, this being true, there would

[1][*Man with the Broken Nose.* —Ed.]

Louis de Fourcaud, "Salon de Paris," *Le Gaulois,* July 1, 1882.
Paul Leroi, "Salon de 1882," *L'Art,* 1882 (Vol. 4), p. 188.

only be two possible competitors for painting and sculpture: M. Léon Lhermitte, the painter of *la Paye des Moissonneurs,* and M. Auguste Rodin, the sculptor of the *Portrait of M. J. P. Laurens* [Fig. 3], a bust that gives glory to one of the greatest masters of all time. The head, the chest, the back are all marvels of modeling and constitute one of those accomplished ensembles for which there only exists one name—that of chef d'oeuvre. Remember the name of Rodin; it will go far. I wait impatiently for the monumental portal he is doing and in which he wants to embody the poem of Dante. It is a commission given to him by the former Under-Secretary of State for Fine Arts, M. Edmond Turquet, who has held him in the highest regard.

The two creations of Lhermitte and of Rodin will hand their names down to posterity for praise, a public acknowledgement just as desirable as all the medals there are in any class.

Philippe Burty
Review of the Sculpture at
the Paris Salon (1882)

[Rodin's] bust of *M. Jean-Paul Laurens* is a pungent work. I understand that the model does not actually have quite such a ravished look. Let me explain: it is apparent the M. Rodin's attention to the rendering of muscles—to the way they ripple, create depressions, and to the way they are attached—leads him to emphasize certain details. What most artists indicate with a slight touch, Rodin's implacable fingers scoop right out. Such rendering is rare at a time when most sculptors come from the same studios and have acquired more or less the same approach to detail. It is exactly this quality that serves Rodin so well. But he loses a great deal of ground in a sketch like his *Carrier-Belleuse* in which he has simply massed the direction of the whole. In the *J.P. Laurens,* however, everything is surprising: the lines of the temples, the hair, the neck at the onset of the ears, the way the ears are attached to the back of the head. The shortcomings are in composition: a certain immobility, the nudity that deviates from the idea of a contemporary portrait, the open mouth, the way the chest is lengthened in order to become the surface of the base. In spite of these reservations, we stand before a very determined artist, one who is capable of succeeding over all the other débutants who smell of an academic eclecticism that leaves them powerless to respond to the modern spirit's pressing demand for truth.

Philippe Burty, "La Sculpture," *L'Exposition des Beaux-Arts* (Paris: Librairie d'Art, 1882), pp. 263–64.

This approach, which is sometimes referred to as naturalism, is that which Rude and David d'Angers have represented most eminently.

Gustave Geffroy
Review of the Exposition des Arts
Libéraux in the rue Vivienne (1883)

M. Rodin has sculpted female figures in tormented forms [Fig. 5]. People are saying wonderful things of these works in which Rodin seems haunted by the memory of Delacroix's sketches. Let us wait until his path becomes clear and this kind of creation has truly asserted itself.

Paul Lefort
Review of the
Exposition Nationale (1883)

Before we finish we must repair an oversight and an error. Our readers do not know the name of Rodin very well. He is a sculptor, however, of very personal talent; at the time of the Salon of 1881 we misspelled his name in our column. Since then there has been no mention of his work. Now M. Rodin, who is finishing an important commission for the State at the present time, has two statues, two great bronzes at the Exposition nationale: a *Saint John Preaching* and *The Age of Bronze,* both of which are singularly powerful and original, but, the latter is of a particularly tragic character, of an expression singularly troubling. This nude figure has no attribute to explain it. His turned head is half-hidden by his right arm. Is he the son of order brought out of chaos, the symbol of the first-born of creation? What does he hope to find at the center of his thoughts, thoughts without doubt still vague,

Gustave Geffroy, "Chronique," *La Justice,* March 3, 1883.
Paul Lefort, "Exposition Nationale de 1883," *Gazette des Beaux-Arts,* December 1883.

obscure and unconscious, and why is his face so distressed, by what fierce agony? Has he just awakened to life, or is he shaking off some afflicting nightmare? We cannot say. But it will remain that this strange figure, disquieting and full of enigma, astonishes and draws back our gaze.

The austere work of M. Rodin, much like the tumultuous and incomplete illusions of Auguste Préault, has the rare ability to seize our spirit and to immerse it in endless dreaming.

G. *Dargenty*
Review of the
Exposition Nationale (1883)

Love of the pretty, the affected, the polite, love of pleasant painting and smooth sculpture can still be found. But the love of things of beauty, and the understanding of what they are, of wherein lies their worth, that is finished. And if by chance an artist in the true sense of that word lets himself go; if he follows his temperament's impulses; if he refuses to watch what others are doing, for fear of becoming too much like them; if he maintains his integrity, if his qualities and his faults are quite his own and not those of a school, if he naively comes to you and says "judge me, I am what I am," he is held to be mad, backs are turned on him in a hurry, his presumption is laughed at, he is pitied, then left to starve to death with nothing but his talent to contemplate. How many examples I could give of so many such doves, fallen into the owl's den! But I don't even have to look very far—here, in this very salon, which swarms with the pretty objects of clean, elegant, correct sculpture, there is a man who presents himself with the aforementioned incongruities. This man has not been to school, he belongs to no clique, he has no master, he sculpts because one day his thought flowered in that idiom. Amidst all this stereotyped elegance, all these distinguished trinkets, he launches two first-class figures in which simplicity and magnitude are translated into exceptionally large, daring, vigorous shapes. Perhaps you think that with such rare qualities he will be openly exhibited, that a special place will be reserved for him, that he will be honored, given a medal! What a mistake! Monsieur, you are a troublemaker—someone who works as you do might just as well stay home. What are your big wooden shoes doing here

G. Dargenty (pseudonym for Arthur d'Echerac), "Le Salon Nationale," *L'Art*, 1883 (Vol. 4), pp. 37–38. Translated by John Anzalone.

among all these dainty dancing pumps? Your naked men, Monsieur Rodin, are in all honesty just not presentable; how can you expect the ladies to find them charming? Well, since you're here, we won't be so vulgar as to put you out; no, not out, but as close to the door as possible. And this is how it happens that Monsieur Rodin's *Saint John,* clearly the strongest, most personal work of this salon, is relegated—and amongst poor company at that—to the darkest corner of the most obscure bay. At first it stood side by side with *The Age of Bronze,* another of the author's works; and without the influence of an indignant artist friend, who softened in part the effect of this unjust classification by bringing *The Age of Bronze* to light, these two beautiful statues of Monsieur Rodin would have languished and rotted away like lepers in their prison, a living but impotent protest against the unworthy prejudice of a blind jury. Fortunately the artist, who has teeth and claws, will not delay in taking a striking revenge for the persistent ill will he has been shown. It is to his honor that while Under-Secretary of the Beaux-Arts, Monsieur Edmond Turquet dared to commission Monsieur Rodin to do a monumental bronze door whose subject is taken from Dante's *Inferno.* We are pleased to be able to present to the readers of *L'Art* several of the powerful sketches that express the artist's early visions of this important work [Fig. 4].

We add to these several other sketches of models requested of Monsieur Rodin by the *Manufacture nationale de Sèvres,* which display the suppleness and variety of his talent. *The Vision of the Sculptor,* in which the author has attempted to express the diversity of the ideas and forms that flutter before him as he works, is a more picturesque than sculptural conception, but it bears nonetheless the stamp of Monsieur Auguste Rodin's talent.

Charles Frémine
Review of the Salon and of the
Exposition des Arts Libéraux (1883)

In our time an innovator in poetry is Charles Baudelaire, to whom Victor Hugo wrote: "You have added a new thrill to the lyre"; in painting there is Edouard Manet, who had "Manet et manebit" proudly engraved on his bust; and in sculpture we find Auguste Rodin, of whom it can be said that he has sent new tremors of excitement into bronze.

Charles Frémine, "Salon de 1883," *Le Rappel,* November 28, 1883. Translated by John Anzalone.

This artist is now exhibiting two life-size statues, one of which is astonishingly simple, the other singularly strange; both are captivatingly original in their total nakedness, for they find their strength and character entirely within themselves and not in any kind of external attributes.

The first of these statues is a *Saint John,* which is at once rugged and gentle. But more than that, he is great. I do not abuse this word, indeed, I do not know if I've used it even once—fully and with no restrictions—elsewhere in this study. With his harsh, vigorous, prominently muscled body, *John* seems a sower in motion, his right hand fully extended, his left energetically cast toward the earth, as if to emphasize the words that fall from his half-open mouth. He goes forth, preaching the Word, his beard and hair are unkempt, and a flame has ignited his eyes. Totally absorbed by his prop-agandistic task, unposed and wholly undistracted, he walks straight ahead, full of the greatness of his mission and the truth of his doctrine. He is a believer and a seer, a gentle and fierce man, unable to abjure the faith that will cease only with his martyrdom, so he tries yet to win over to his cause the stupid executioner whose axe will cut off his head.

The second figure is entitled *The Age of Bronze.* A mysterious personage holds himself erect, as though enshrouded in terror. Who is this unknown man? Where does he come from? He seems to step out of a terrible dream, and stretches, his hand at his pained forehead. Does he try to tear away the last confining swaddles, to deliver at last his brain, ready to burst into intellectual awareness? Or, is thought already too heavy a load to bear, so that his head rolls and nods as he tries to shake off its weight? Who is the precursor—this first fugitive from dark nature's dungeon? Many times I have stopped before this figure that one would swear has been molded out of suffering and dreams. I find it more than impressive. It troubles me, follows me. I can see it—there—right in front of me as I write—just as clearly as if I were standing before it in the garden walk. And what is most astounding is the sobriety the artist has made use of to attain such intensity of expression. Nothing but a naked man, a rough, blackish bronze, summarily and primi-tively wrought.

These two figures, the last one especially, seem to participate in a world heretofore unknown to sculpture. I do not think it possible to go much further into this world. Let Monsieur Rodin be warned: every art has its limitations. It seems, in fact, that those of statuary are more restrictive than others. To attempt to exceed them is to flirt with impotence.

Saint John and *The Age of Bronze* date from 1880–81. Since then, in fact last winter at the exhibition of the Cercle de la rue Vivienne, I have seen two new works by the same artist that make me fear for his talent: two statuettes, one of marble—*The Age of Stone*[1], I think, the other of bronze, whose precise meaning escaped me. Both are distorted, tormented pieces; both display violent and excessive energy, the first seemingly crushed beneath a rock it

[1][*Fallen Caryatid Carrying Her Stone* (Fig. 5).—Ed.]

carries on its back, the second twisting, agonizing in some hideous nightmare. I told Monsieur Rodin then what I thought of these two works, and my opinion has not changed since. Contortion does not make character any more than a grimace makes expression, and sometimes the originality one goes so far to seek is, after all, nothing more than candor and simplicity.

<div align="right">

Anonymous
Review of the *St. John*
at the Royal Academy (1883)

</div>

In our last illustration we give an engraving of what, all things considered, was certainly the best piece of sculpture in last year's exhibition at the Royal Academy—the *St.-Jean* [Fig. 2] of M. Auguste Rodin. This statement may surprise, inasmuch as it is more than probable that most visitors never saw M. Rodin's bust at all. It was badly placed in the background amidst a number of sugary nothings and lifeless ineptitudes, where the public never wander—where, too, that remarkable person the newspaper critic rarely ventures, and then only to disregard or to condemn. In short, it attracted little notice, least of all from the critics; and this is the more unaccountable because, in spite of its being in a bad light, and at a scarcely proper distance from the ground, its union of vigour and dignity and intensity could not fail to fix the attention of any one who had eyes to see. A bronze replica of the head of a complete statue, it is as striking in its technique and in its conception as anything we know of produced in this century. Considered as modelling pure and simple, it appears a masterpiece of delicacy, truth, and understanding. The sculptor's method—his handling, his style—is at once sensitive, broad, and expressive, and is founded upon, if it does not attain to, that of the purest and noblest practice of the Renaissance. In this respect, indeed, M. Rodin has assimilated the master-quality of all great art—simplicity; and to this he allies an insight at once delicate and keen, a fine distinction, and an imagination of the loftiest and most vivid type. Nothing in modern sculpture, unless it be his own work, can be found to equal the subtlety and refinement, the delicacy and reality of the features in this St. John; just as the head, with its simple and strenuous virility, its imposing truth of gesture, and its intensity of expression, is a real and great creation. . . .

Anonymous, "Current Art," *Magazine of Art*, 6, London, 1883, 175–76.

Of M. Rodin himself there will presently be much to say. For the moment we shall but note that he is a pupil of Barye, and that—after years of toil and obscurity—he made his first great stroke at the Salon of 1880, with an *Age d'Airain* a superb nudity: of a man in the prime of years and the fulness of strength. It was designed and modelled with irresistible authority; it was instinct with imagination and the quality of style; it revealed a great sculptor. But it was savagely criticised for all that: as realism, naturalism, and a score of "isms" beside. It was succeeded, in 1881, by the *St.-Jean,* exhibited in the Salon, and again last year at Vienna. In Paris it attracted a good deal of attention, and was visited with a good deal of enmity and respect; at Vienna it was ill placed, and had to yield to work of no more account than Idrac's *Salammbô.* It is larger than life, and entirely naked; the hand is raised in a large and imposing gesture—as of one who sways a listening multitude; the head is thrown back, and the mouth is open in the act of speech. It is the presentment of a kind of inspired santon, a desert saint, a wild and awful eremite, sunburned and savage, desperate with fasts and vigils and the possession of a great, implacable idea. Last year M. Rodin exhibited nothing but portraits. In Paris those of MM. Carrier-Beleuse and Jean-Paul Laurens were prodigiously successful; in London that of Professor Legros, its extraordinary merit notwithstanding, was hardly seen. Just now the artist is engaged upon a pair of colossal bronze doors for the Palais des Arts Décoratifs. The subject is the *Divina Commedia,* and the work will be in relief. Some parts of it exist already in the round:—a superhuman "Dante"; a lovely and affecting "Paolo and Francesca"; a terrible "Ugolino." There is nothing like them in modern sculpture.

THE GATES OF HELL AND
THE BURGHERS OF CALAIS

When Rodin received the commission for the doors of the Museum of Decorative Arts in 1880, he was invited to select his own subject; he took one that had been on his mind for several years—Dante's *Inferno*. In July the State gave him a studio at the Dépôt des Marbres, 182, rue de l'Université. It was there that the great number of people who have written on *The Gates of Hell* first got a sense of the ensemble. In July of 1885 Rodin wrote to the Ministry of Fine Arts that the model in plaster would be ready "in about six months."[1] But, in fact, it was never finished. The first serious distraction from *The Gates* was *The Burghers of Calais*. Rodin began working on the group in 1884, won the commission in January 1885, and spent most of his time late in that year and early 1886 on *The Burghers*.

Octave Mirbeau

"The Future Museum
of Decorative Arts" (1885)

Among the commissions that have already been handed out is one for a monumental portal. The sculptor Rodin is now finishing the studies for this project. It is not yet known whether the door will be set inside or outside of

[1]See Albert Elsen, *Rodin's Gates of Hell* (Minneapolis: University of Minnesota Press, 1960), p. 71.

Octave Mirbeau, "Chronique Parisiennes," *La France,* February 18, 1885. Translated by John Anzalone.

the Museum; what seems clear, however, is that the door constitutes an important and magnificent work. Those who have been able to admire the finished studies in the artist's atelier, as well as those now being completed, agree that the door will be the principal work of the century. We must go back to Michelangelo to find an idea as noble, as beautiful, as sublime.

Auguste Rodin is practically unknown; he is not a quarter as famous as Chapu, and there are several reasons for this. Rodin is a great artist. He hates cliques and rarely ventures into society. He does not seek publicity, so publicity does not come his way. Like the strong and the solitary, he lives in relative obscurity, amidst the creations of his imagination and the dreams of his genius, and in his scorn for the fleeting type of glory that comes in through the door in the morning and leaves by the window at night, he finds satisfaction in creating masterpieces that his friends respect and that posterity—which is never wrong—has already stamped with its lasting hallmark.

Who but Rodin could have had the following adventure, one that so strikingly and definitely underscores the dishonesty and stupidity of the juries? He had sent his *Age of Bronze* to the Salon. But there was such power in this work, such an elegant expression of the strength and beauty of the body, and, forgive me the word, such a frank odor of humanity, that the jury decided the statue was nothing more than a cast from life and rejected it. The jury refused to accept that art could take so perfect, so true a form from nature, that man's genius could be creative enough to make a block of marble come alive in such a way, to give with so much intensity the shiver of flesh and the radiance of thought. However, the following year the jury was forced to accept an admirable bust of Victor Hugo, for it was rather difficult to claim that the great poet had had wet plaster spread over his face without knowing it, or, at least, without complaining.

Rodin speaks of such things with no bitterness and a calm, resigned smile; he is only surprised that people who call themselves artists could display so much blind and malicious passion toward a man whose entire life is one of conscience, respect, and sacrifice.

And yet, the juries will have to swallow their prejudice and bow before the gigantic work Rodin has undertaken, which will provide us a counterpart to the Baptistery portal in Florence, the work of Lorenzo Ghiberti that Michelangelo said deserved to be called the gate of paradise. This will be the portal through which Rodin, despite the academicians, will enter into immortality.

The subject the artist has chosen is Dante's *Inferno*. It is framed by two exquisite mouldings whose style belongs to that vague and captivating period that is no longer Gothic but not yet Renaissance, a period that retains the mysticism of the one and anticipates the pagan elegance of the other.

Rodin has allowed his imagination to wander unrestrained among the frightening circles the Florentine poet traced in undying flames and eternally bubbling lava. In addition to its principal grouping, this vast lyrical

composition includes more than 300 figures, each portraying a different attitude or feeling, each expressing in powerful synthesis a form of human passion, pain, and malediction. When we examine the twisted mouths, the clenched fists, the heaving chests, the desperate masks upon which the tears flow endlessly, we seem to hear the resounding cries of eternal desolation.

Below the capital, in a slightly vaulted, impressed panel, the figure of Dante detaches itself from the background in a pronounced, projecting position. Surrounded by bas-reliefs, which represent his arrival in hell, Dante's pose recalls, to a degree, that of Michelangelo's *Thinker* [Fig. 6]. He is seated, his body leans forward, his right arm rests on his left leg, giving his body an inexpressibly tragic movement. His face, like that of a terrible avenging god, rests heavily in his hand; the hand sinks into the flesh near the corner of his compressed lips, and his dark eyes plunge into the abyss that exudes the moaning of the damned on sulfurous winds.

Each of the double doors is divided into two panels, separated by a group that seems to form a knocker, Ugolino and his sons on the right, Paolo and Francesca da Rimini on the left. Nothing is more frightening than Ugolino. Thin and wasted, his ribs jut against and through his skin, his empty listless mouth seems to foam like that of a famished wild animal upon contact with flesh. Like a hyena that has dug up carcasses, he crawls across the fallen bodies of his sons, whose inert arms and legs hang over into the abyss.

At the left, Francesca da Rimini, entwined around Paolo's body, provides a most tender, elegant contrast to the Ugolino group and its synthesis of the horrors of hunger. With her young, charming body, in which the artist has combined with evident pleasure all the delicate, sensual beauty of woman, with her arms wrapped around her lover's neck in a passionate yet chaste motion, she gives herself completely to his embrace and kisses. Paolo's flesh trembles with pleasure, and his young athletic strength shows in his elegant, powerful muscles. He typifies masculine beauty, just as Francesca typifies that of womanly grace.

Above these groups, Rodin has composed bas-reliefs from which figures and scenes detach themselves in varying degrees of relief. This gives his work extraordinary perspective. Each of the double doors is crowned with tragic masks, heads of furies, and the terrible or gracious allegories of sinful passions.

Below each group, there are still more reliefs. Centaurs gallop along a river of mud, carrying off women who struggle, roll, and twist upon their reared-up bodies. Other centaurs fire arrows upon the unfortunate who try to escape; women and prostitutes who collapse as they are carried away can be seen falling head-first into the flaming mire.

The pilasters also consist of admirable reliefs. The one on the right displays the forbidden accursed lovers who endlessly embrace, but never find satisfaction; on the left a limbo in which horrible old women can be seen, together with children tumbling through a kind of misty vapor.

Although he has taken his inspiration from the Italian poem, it is impossible to grasp how much personal imagination the artist has used in order to develop a different expression or attitude for each face and each body. There is movement and passion in all these compositions, and a greatness of action that astonishes and dominates.

Each body ruthlessly obeys the passion that animates it, each muscle follows the soul's impulse. Even in their strangest, most twisted contortions, the characters remain faithful to the destiny the artist has decreed for their rebellious and punished humanity. Rodin fires us with his genius and makes us breathe the tragic vibrations of this atmosphere. Fear, anger, and despair light the eyes, turn the mouths, twist the hands, and force heads forward on stretched necks. The anatomical equilibrium decreed by the Academy is disturbed, and beauty based on stupid and weak convention, like that taught by the schools and demanded by the clock, fades away.

And that is precisely what Rodin cannot be forgiven—he gives to beauty the elegant and true accent of humanity; he makes bronze, marble, and clay throb with great, strong life; he brings to life inert blocks, and with his hot panting breath makes movement flow in these dead objects.

Félicien Champsaur
"The Man Who Returns from Hell: Auguste Rodin" (1886)

Rodin, the eminent, almost unknown sculptor, is finishing the plaster model of a bronze portal for the future Museum of Decorative Arts. It is to be built upon the ruins of the Audit Office. But, whether or not the building itself is ever constructed, the portal exists. Something of a poem with more than 150 characters, it translates Dante's work in a strikingly new creation that even those unfamiliar with Dante will appreciate. Earthly misery unfolds in this intensely personal imaginative work, whose greatness moves one to the point of obsession.

• • •

The portal proceeds as an extension of the Italian poem's horrendous circles. Three characters dominate the whole and seem to embody the

Félicien Champsaur, "Celui qui revient de l'Enfer: Auguste Rodin," *Le Figaro*, Supplement, January 16, 1886. Translated by John Anzalone.

phrase which they point to on the pediment: "Lasciate ogni speranza, voi ch'intrate." All along the capital, amidst the boiling lava, mouths laugh derisively, arms threaten, hands clench, and bodies shiver; faces contract in anguish and are wet with endlessly flowing tears. Projecting from a bas-relief, having arrived in Hell, Dante Alighieri sits in thought, his chest thrust forward, his elbow on his knee, his chin resting on his hand. His inspired gaze seems to plumb the depths of the abyss where hisses and the gnashing of teeth mingle.

The souls of the damned embrace on the right hand pilaster in odd, eternally unsatisfied couplings. It is the unknown their bodies seek to grasp and penetrate. On the left, amidst the vapors of Limbo, children come tumbling down. It is truly a complex, harmonious epic poem. Each of the doors is divided into two panels, separated by a group: Ugolino on one side, Francesca da Rimini on the other. Like a hungry animal, Ugolino drags his wasted body over the corpses of his sons. Across from him, as though she were his antithesis, Francesca da Rimini, in whom her creator has placed all the gracious sensuality of woman, wraps her arms about the neck of her tenderly beloved. Then, above them, countless furies, tragic masks, terrible and delightful allegories; and below, in a bas-relief, centaurs carrying off naked women who struggle or faint on their backs. The eternally damned try to escape from a burning river of mud into which exquisite prostitutes plunge as other centaurs rain arrows down on them.

A colossal, perfectly executed concept, this monument stands as a surprising evocation of Dante's cantos and communicates the thrill and shiver of the sovereign passions. The sculptor possesses the chaste, believing spirit of a Gothic artist of the great era, a profound faith in art, an imposing authority, and the grandiose and simple conviction of the former architects of the cathedrals. How bitterly superb!

> "Oh hoary shaper of stone
> To see you one would think you had never laughed."

It is time that the man has achieved this masterful work—all that remains is for it to be cast in bronze, and the 60,000 or so francs granted by Monsieur Turquet, a most understanding and artistic minister, will hardly be enough to cover the enormous expenses incurred since the initial sketches—it is time that he receive his wages in the form of fame.

• • •

The life of this valiant man, of Auguste Rodin, lover of the abstract, a small, shy blond man with a flowing beard, short hair, and very soft blue eyes, has been quite simple. Born in Paris, he had a poor, wretched childhood. He competed for entrance to the Ecole des Beaux-Arts, which rejected him. Dalou, his comrade, congratulated him for it in this way:

> You're lucky . . . whenever I'm going badly it's because everything I was taught there comes back to me. . . .

This paradoxical remark notwithstanding, Rodin had to work in industry for his living. For a time he was a practitioner, then he worked at the national factories at Sèvres on models for Monsieur Carrier-Belleuse. It must have been difficult to have so many projects in mind for which time and genius are needed, difficult to feel the presence of such ideas, and have to bottle up one's imagination to devote the entire week to earning one's daily bread. Sundays are left, and these days of feverish research are holidays.

After the war, Rodin spent several years in Belgium and in Holland, where he participated in the decoration of several monuments. At last, in 1879, he exhibited two statues in Paris: *The Age of Bronze* and *Saint John the Precursor*. Both are now in the Luxembourg, but the battle was harsh and it still goes on.

The Age of Bronze is so eloquently expressive that the author was accused of having cast from life. The polemic filled the papers, and Rodin had to go looking for the Belgian soldier who had posed to convince him to be cast so that the jury could compare the results. Something indefinable is added to a complete knowledge of anatomy, something that gives movement and captures breath within a bronze body.

As for *Saint John the Precursor*, he speaks and teaches. In a pose that recalls a democratic tribune, his arm extended and his hand open, he turns his bearded, enlightened, brutal face toward heaven. An apostle's gaze shines in the eyes of this thin grasshopper-eater. Why is he naked? Clothes were worn in Judea.

Much discussion has accompanied these works. Some have acclaimed a robust talent and others have denied it. Such is the discouraging rule.

Since then, Rodin has taken up once more a fragment of an early idea in his statue *The Creation of Man*. This is a male who awakens to life, astounded to find himself in the world. But I do not like it as much. All the muscles, all their successive movements, all their attachments, protuberances, and depressions can be seen in great exaggeration. Leonardo da Vinci's advice to his students to avoid making their figures look like sacks of nuts is still good. In any case, perhaps the greatest praise of Rodin is that one cannot see his work without thinking in one way or another of Michelangelo. Rodin's work is not smothered by the comparison.

• • •

An artist who started out by spending a million to roam the world in search of a new sensation, a master engraver whose originality and talent are not without rapport to those of Rodin, M. Felicien Rops used to say, "One must throw away money, the way a balloonist drops his ballast, to rise. . . ."

Rodin has never had that problem. Several years ago, at a time, however, when he had already passed thirty, the time when success is supposed to accompany an ambitious man like a hound—sometimes ahead of him, sometimes behind—Rodin, absolutely unable to afford a block of stone, bought himself a statue by an academician at a cheap price. Conquering the

difficulty he had in making the scraggy shape of the old man contain his imagined form, working directly in the marble, in the manner of the old sculptors abandoned since Canova, out of the previously used stone he drew a lascivious Bacchante.

• • •

The sculptor's profession is an austere one for which a powerful vocation, continuous energy, ardent faith, and difficult work are needed.

In a kind of hangar, in worker's clothing, the sculptor struggles with clay or marble to make matter under the pressure of his thumb or under the blows of his chisel express life's agitation. No fancy studio full of extravagances where the master welcomes the lovely ladies, where an usher presents the visitors' cards on a gold salver. For the sculptor, goodbye easy success: it is a long time coming. Indeed, this art is understood by only a few people, and a certain initiation is necessary. Barye once said to a painter who complained of his fate

—I, on the other hand, thank my lucky stars, for I've been a sculptor for forty years . . . and I haven't died of it.

Rodin, who avoids cliques out of pride and advertises out of modesty, starts to work in his home at dawn. He has a studio at the national marble warehouse in the rue de l'Université. But he can't wait. The idea he has had during the night immediately takes on a clay form. And in the evening, after a stubborn struggle to perfect the two monuments at hand, he is working still. Baudelaire's book stands open on his table, and he leafs through it, savouring it, illustrating it in the margins with sketches of unheard of dimensions that already possess a sculptural allure. From such shadows a vision of marmorean clarity is born. Then, suddenly, he asks for clay. This was how he translated the magnificently lesbian poem *Les Femmes Damnées*.

• • •

Rodin also does busts of his contemporaries, illustrious personages or, quite simply, of his friends; of Victor Hugo, among others, the realistic, aged face of a god retiring; of Monsieur Dalou; of a handsome man, Monsieur Antonin Proust, which Madame de Rute called "a calumny in bronze" because the bust is sincere. The bust of Dalou, an ecstatic, ascetic head, radiates the intensity of life. The bony forehead, haunted by deep thought and the memory of exile, the energetic look, and the furrowed neck all attest individuality, controlled passion, and mystical willpower. The details are refined, the whole remarkable.

He executes these busts, which show such intimate, concentrated detail, as a respite from his great works, his portal, or the group commissioned by the city of Calais. Rodin is portraying the six burghers, Eustache de Saint-Pierre, Jacques de Wissant, Pierre de Wissant, Jean de Fiennes, Andrieux d'Ardres, and Jean d'Aire, exhausted by the privations and fatigue of

a long siege, at the moment when they are about to leave for Edward III's camp to be hanged. They suffer the anguish of departure. It was certainly no easy matter to do something with six men in shirts with a cord around their necks. The attitudes are quite diverse. They encourage one another, say their adieux; some are afflicted, others exalted. There is nothing conventional or academic about their heroism. They do not go to glory, like Polyeuctus, but to death. Of the six, several rise to their punishment with nothing more than resignation. They sacrificed themselves for their co-citizens at the feverish climax of a siege mentality, but the reaction is upon them, and it is so very human.

• • •

What Rodin seeks above all is expression and life. His work is of the first order when compared to that of other sculptors. There are exceptions of course, but each year it seems to the visitor who tours the sculpture salon that he is walking in a dead forest. And yet, in that wood, under those naked branches stripped by winter, he feels that the sap has flowed and that April will come again.

Most sculptors are like the Parnassian poets, who write impeccable, dispassionate verse. It is all quite honorable and lacks nothing but the *je ne sais quoi,* which is everything.

As for Rodin, he is not satisfied with the creation of noble forms. He wants thought to animate them. In a word, this artist of integrity, who scorns money, has no other passion than the attainment of his creative dream. And that is rare in a time when so many sacrifice everything to the Golden Calf, a venerable old god indeed.

Edmond de Goncourt

"Visiting Rodin's Studio" (1886)

Saturday, April 17

During the afternoon Bracquemond takes me to visit the sculptor Rodin. He has the features of a man of the people, a fleshy nose, clear eyes blinking under lids that are sickly red, a long yellow beard, hair cut en brosse,

Paris and the Arts, 1851–1896: From the Goncourt Journal, edited and translated by George J. Becker and Edith Philips (Ithaca; N.Y.: Cornell University Press, 1971) pp. 232–34. Copyright 1971 by Cornell University. Used by permission of Cornell University Press.

a round head, a head expressing gentle and obstinate stubbornness—physically a man such as I imagine the disciples of Jesus Christ to have been.

We find him in his studio on the Boulevard de Vaugirard, an ordinary sculptor's studio with walls splashed with plaster, a sad little cast-iron stove, a cold humidity emanating from all those big objects made of damp clay wrapped in rags, and all those casts of heads, arms, legs—in the middle of which two emaciated cats look like effigies of fantastic gryphons. And there too I see a model with bare torso who looks like a stevedore. Rodin turns on their tables the life-size clay figures of his *Six Burghers of Calais,* which have been modeled with a powerful realist thrust and which have in human flesh those beautiful hollows which Barye put in the flanks of his animals. He shows us also a robust roughcast of a nude woman, an Italian, a short and supple creature, a panther as he puts it, which he says with regret in his voice he cannot finish because one of his pupils, a Russian, fell in love with her and married her. He is a true master of flesh, yet in the most beautiful and accurate reproduction of anatomy there is one detail of extraordinary disproportion—almost always his women's feet.

A marvel done by Rodin is a bust of Dalou executed in wax, in a transparent green wax which has the quality of jade. You can have no idea of the light touch of the sculptor in the modeling of the eyelids and the delicate flaring of the nose. The poor devil has really had bad luck with his *Burghers of Calais!* The banker who held the funds absconded, and Rodin does not know whether he will get his pay. However, he has gone so far with the work that he must finish it, and in order to finish it he will have to spend 4,500 francs on models, a studio, etc.

From his studio on the Boulevard de Vaugirard Rodin takes us to his workshop near the Ecole Militaire to see his famous doorway destined for the future Palace of Decorative Arts. On the two immense panels there is a jumble, a confusion, a tangle something like the interlacing of a mass of madrepores. Then after a few seconds the eye perceives in the apparent madrepores of its first glance the projections and recesses, the protrusions and cavities of a whole host of delicious little figures, bustling, so to speak, in an animation and movement which Rodin seeks to imitate from *The Last Judgment* of Michelangelo and certain mob scenes in Delacroix's paintings—all this in unparalleled relief, such as only he and Dalou have dared to attempt.

The studio on the Boulevard de Vaugirard is filled with lifelike humanity; the one on the Ile des Cygnes is like the domicile of a poetic humanity. Choosing at random from a heap of casts spread out on the floor, Rodin gives us a close look at a detail of his doorway. There are admirable torsos of small women, in which he has excelled at modeling the flow of the back and, so to speak, the wing beats of the shoulders. He is also imaginative to the highest degree in reproducing the joining and intertwining of two amorous bodies clinging to one another like those leeches you see coiled one on the other in a jar. One of the most original groups represents his conception of

physical love, but the concretization of his idea is not obscene. It shows a male holding against the upper part of his breast a female faun whose body is contracted and whose legs are drawn up in an astonishing similarity to the stance of a frog which is about to jump.

This man seems to me to have the hand of a genius but to lack a conception peculiar to himself, to have in his head a *mishmash* of Dante, Michelangelo, Hugo, Delacroix. He strikes me also as a man of projects, sketches, fragmenting himself in a thousand imaginings, a thousand dreams, but bringing nothing to complete realization.

Robert Louis Stevenson
"Rodin and Zola" (1886)

Sir—Mr. Armitage, R. A., repeating (by his own confession) in ignorance that which he has gathered from the lips of the undiscriminating, comes before your readers with a strange account of M. Rodin. That gentleman, I read, is called "the Zola of sculpture," and his "work is too realistic and coarse even for the strong stomach of the French public." I will not deny that he may have been called the Zola of sculpture, but I should like to know by whom. The point of such a phrase lies in the authority, and a byword is no argument: or which of two popular views are we to accept of Mr. Gladstone, and which of the Academy?

M. Zola is a man of a personal and fanciful talent, approaching genius, but of diseased ideals; a lover of the ignoble, dwelling complacently in foulness, and to my sense touched with erotic madness. These defects mar his work so intimately that I have nothing further from my mind than to defend it. I do not think it can often have a good influence; I am inclined to fear it will always have a bad. And on this I would say one word in passing to Mr. Armitage—that national comparisons are seldom wise; and he will find (if he look around him) the dainty stomachs of the English supporting M. Zola with a fortitude hardly to be distinguished from gratification, and that in a translation from which the redeeming merits of the original have fled.

To M. Rodin the first words of the above description may be applied, and the first words only. He, too, is a man of a personal and fanciful talent, and there all comparison is at an end. M. Rodin's work is real in the sense that it is studied from the life, and itself lives, but it has not a trace of realism in the

Robert Louis Stevenson, "To the Editor of *The Times,* London, September 6, 1886.

evil, and that is in the privative sense. M. Zola presents us with a picture, to no detail of which we can take grounded exception. It is only on the whole that is false. We find therein nothing lovable or worthy; no trace of the pious gladnesses, innocent loves, ennobling friendships, and not infrequent heroisms by which we live surrounded; nothing of the high mind and the pure aims in which we find our consolation. Hence we call his work realistic in the evil sense, meaning that it is dead to the ideal, and speaks only to the senses. M. Rodin's work is the clean contrary to this. His is no triumph of workmanship lending an interest to what is base, but to an increasing degree as he proceeds in life the noble expression of noble sentiment and thought. I was one of a party of artists that visited his studio the other day, and after having seen his later work, the *Dante,* the *Paolo and Francesca,* the *Printemps qui passe,* we came forth again into the streets of Paris, silenced, gratified, humbled in the thought of our own efforts, yet with a fine sense that the age was not utterly decadent, and that there were yet worthy possibilities in art. But, remark, it was not the sculptor we admired, nor was it of his skill, admirable and unusual as that is, that we talked as we went homeward. These questions of material talent had fallen below our thoughts, and the solemn fact of the Dante over the great door still spoke to our imagination.

The public are weary of statues that say nothing. Well, here is a man coming forward whose statues live and speak, and speak things worth uttering. Give him time, spare him nicknames and the cant of cliques, and I venture to predict this man will take a place in the public heart.

I am, &c,

ROBERT LOUIS STEVENSON
Skerryvore, Bournemouth

Rodolphe Darzens
"A Visit to Rodin's Studio" (1888)

"You provide a new thrill," Victor Hugo once wrote to Charles Baudelaire, and indeed, through his complex art, the poet of *Spleen and Ideal* was able to awaken curious sensations within us. We do not allude here to

Rodolphe Darzens, "Chronique d'Art," *La Jeune France,* January 1888. Translated by John Anzalone.

what some have called Baudelaire's penchant for the macabre, but rather to his new vision of moods, which makes almost all of the poems of *Les Fleurs du Mal* precious psychological studies, so suggestive of the world their author conceived.

What Baudelaire created for the world of literature, two other artists—two *seers*—one in drawing, one in sculpture, have dreamed into being with at least equal poetic intensity; while Felicien Rops evokes the spell of the soul with his pencil, Auguste Rodin draws forth this same magic out of stone and immortalizes it in unforgettable contours.

Auguste Rodin has restored sculpture to life, the first and almost the only sculptor to study *movement*. He noticed how unnatural gestures seemed in modern statues, how they remained close to conventional forms from which no one dared deviate. Thinking back to the gothic shapers of "Ymages," he has dared to set in stone the very different, often fleeting movements of life, which, as he asserts, are as many as the stars.

The truth of this affirmation becomes palpable, upon entering the sculptor's *atelier*, when one observes the countless studies accumulated there: plasters, waxes, marbles hardly worked on, with the result that these sculptures are only an impression—but how true and persistent!—of life and of the gestures that express it.

But Rodin does not capture gesture alone—he sets in stone the fleeting, almost elusive character of thought. It shows through all of the sculptor's creations and makes us believe in the possibility of a soul, palpitating in the depths of the clay or the stone. And this fills us with a bizarre sensation in which we find a shameful uneasiness and unacknowledged regrets.

Doesn't she stand there, naked, this young woman whose bent right arm and hand hold up and seem to protect from punishment her falling head, while her extended left arm refuses to confess? Is this not the soul on the day of the Last Judgement, accused, yet denying the crime for which it feels guilty? For hell is there: eternal damnation from which no excuse nor vain oath can save.

Slowly, the ultimate Resurrection, its divine trumpets blaring, awakens every being. Here, out of ashes and putrefaction rises a pitiful boney pus-laden body, which upon awaking thinks of its past joys, stretches its arm, and grasps after the gold which GREED never forgets. And what has been paid for with this gold, LUST, lies wallowing beneath that outstretched arm, with flaccid breasts, a distended wrinkled belly, legs spread wide, and its sex gaping in the ignoble posture that recalls still embraces and spasms, bought and sold.

Nearby, a Danaide; in her stunned weariness collapses, her members flailing, across a never to be filled barrel.

Then, a group of lesbians: kneeling in an adroit pose of curving gestures, which embrace and captivate a young woman:

"Strong beauty, on her knees before beauty so frail" holds in her arms a

frightened child who hides her nakedness, both arms tight, her elbows joined to hide her nervous young breasts, her legs held tightly together to defend her unconscious virginity.

But her lips are already pursed, and—is it Delphine or Sappho?—the initiatrix watches for the coming moment of her victory, and, as in the lines of the poet

> She seeks in her victims pale eye
> The gentle song soft pleasure sings
> Sublime gratitude, ever lingering
> She finds on her eyelids, like a sigh.

Seated on the rocks, which the harmonious waves hide from the imprudent sailor, we find three sirens singing hypnotic melodies that the gracious, diverse gestures of their right arms express exactly, while their left arms form a parallel, unbroken chain to stress the notes of an eternal harmony. And he has listened to them; he has not known enough to fill his ears with wax to resist the temptations of their song. In his confidence, he sits like a new Arion upon the back of one of them and already, as he repeats the magic words of her song, she dives and disappears!

But to give examples of all of Rodin's studies is a hopeless and, worse yet, a vain task. The pen cannot explain the chisel or the sketch of the sculptor. What we need is a special exhibit that will bring together various groupings. Like that of the Man who seizes with helpless arms the inert form of Beauty, who rejects his embrace, a grouping which sings for us those painful verses, superfluously inscribed upon its base

> I am beautiful, oh men, like a dream of stone.
> And my breast, where you are bruised
> One and all, can inspire the Poet with
> Love as lasting and silent as matter.

And others: studies of sexual excitement, busts like those of Henri Rochefort, Dalou, and Victor Hugo, and the magnificent and slender head of a young woman whose natural movement seems to listen and to prepare an answer, which Rodin is now finishing.

While waiting for these, both artists and poets take pleasure in admiring the sculptor's masterpieces and in loudly proclaiming his victorious and undeniable genius.

1886–1889—MAJOR SUCCESS AT GEORGES PETIT, IN THE SALONS, AND AT THE EXPOSITION UNIVERSELLE

By the mid-1880s, Rodin's interest in the official salons had waned considerably, although he continued to show one or two works a year in these annual events. But he found the atmosphere of the International Exhibitions of Painting and Sculpture at the Galerie Georges Petit in the rue de Sèze far more hospitable to his groups and figures from *The Gates*. Important selections of his works were to be seen there in 1886, 1887, 1888, and 1889. In 1889 Georges Petit organized a large exhibition of thirty-six works by Rodin that included a full-size *Burghers of Calais*, seen there as a complete group for the first time. The exhibition was in conjunction with Monet, who was represented by 145 paintings. In 1889 Rodin also exhibited seven works at the Exposition Universelle.

G. Dargenty and Armand Silvestre
Review of the Exposition
Internationale at Georges Petit
(1886)

The June 31 issue of *Correspondance belge* contains one of Monsieur Armand Silvestre's "Causerie d'Art," which quite accurately states that the present salon will occupy "no more than a mediocre place in the history of our annual exhibitions." The article then dwells on the work of the famous

G. Dargenty (pseudonym for Arthur d'Echerac), *Courrier de l' Art*, July 1, 1886. Translated by John Anzalone.

sculptor Auguste Rodin, now on display in the Georges Petit gallery in the rue de Sèze. We quote Mr. Silvestre:

"I would place beyond compare the beautiful marble figure dedicated to Auguste Vacquerie, which shows a naked woman hiding her head beneath her arms in a curious expression of terror and shame.[1] It is something of a masterpiece, for never has marble seemed so responsive beneath the chisel, even as it maintains its superb hardness and olympian serenity."

He turns next to a "magnificent plaster group, figuring an energetic man raising up to his lips an enamored and conquered woman, whose thighs are folded into her torso. I find it impossible to describe the disturbing passion in this movement of simultaneous victory and defeat, the spirit with which this savage idyll is treated, the pungent, sensual perfume and the wild voluptuousness that bathe this scene. Engraved upon it is this verse to beauty from *Les Fleurs du Mal:*

> I am beautiful, oh men, like a dream of stone.

What melancholy there is in another desperate figure below which I read these lines:

> Many a flower sorrowfully releases
> its softly secret perfume
> in profound loneliness.

Is this Ariadne, weeping for her lost one? I rather think it is Sappho with Phaon, having won her over to virile love. This is but the threshold of the temple into which Monsieur Rodin leads us before living idols of flesh crucified by desire. And here I must give up any attempt at description. Never have the elements of physical love been treated with such impetuous truth in an expression of violence and despair. For there is such unsated hunger and deadly melancholia in these interwoven bodies straining toward those insane kisses, which burn the lips without refreshing them. The august brotherhood and the mysterious relationship of Love and Death are incessantly proclaimed in these strange figures upon which the nobility of expression confers a relative chastity. For the beautiful is always chaste, as Diderot said in an infinitely more picturesque way. Now, all of these small groups possess an incontestable beauty. Monsieur Rodin proves himself a greater artist than ever, and this is what counts, despite the cries of shocking! one is sure to hear from the sentimental misses lost in these little plaster mazes.

If a work is small, especially in sculpture, the dangers are indeed great. In such an instance the eye is no longer forced to see, nor the mind to contemplate. It is easy to pass before a small masterpiece without giving it any more attention than a common knick-knack. This is the trap that must be avoided. Whoever believes in the public's intelligence is deluding himself. Its intelligence must be forced the way one forces a heavy, resisting door—with

[1][*Andromeda.*—Ed.]

one's shoulders or with a ram. When violent means have worked, when the gate is wide open, oh! then anything can be made to pass through. Those whose minds have been stirred wait breathlessly; the artist is master. Having shown his strength, he cannot simply caress them with gracious little compositions; he must be totally daring. He will certainly be seen, and his qualities, even the lesser ones, will be glorified. Monsieur Rodin has not yet struck this great blow. His dynamite has not yet been unwrapped. But it will blow soon, and the detonation will be thunderous. The repercussions of his great composition will be heard in the four corners of the art world. The bronze portal for the Museum of Decorative Arts, an extraordinary work whose execution is equal to its majestic conception; a dream shaped by the great Florentine writer, divine comedy of forms, one of the strangest epics to be shaped by a poet-sculptor, and one that will surely be the major artistic event of our time. This nearly finished masterpiece will mark the latter half of our century as did *La Légende des Siècles* and *Salammbô*.

That is my thinking concerning Rodin's as yet unknown work, and that is why I am sorry that this artist, who possesses a trumpet capable of shattering walls, wastes his time playing the ocarina.

Alfred de Lostalot
Review of the Exposition
Internationale at Georges Petit
(1887)

This exhibition is one of the most interesting that we have seen in the gallery of M. Georges Petit. It is certainly agreeable to ascertain once again the principal role France continues to play in European modern art; if all those of talent whom we have are not represented here; nevertheless, the daring, innovative, and most pleasing tendencies of this branch of our school are shown with magnificence. . . .

Sculpture is represented at the rue de Sèze by an artist who does not show much at the Salon and whose fame has not yet penetrated the circle of professional people and connoisseurs whose curiosity, nevertheless, is strongly aroused. I cannot analyse such a powerful and original talent as Rodin's in a few lines. All that I can say is that there will be a glorious uproar

Alfred de Lostalot, "Exposition internationale de peinture et de sculpture," *Gazette des Beaux-Arts,* June 1887.

in our world of art the day the monumental door he is making for the Museum of Decorative Art and the group of *Burghers of Calais* are made public. While waiting we recommend that you go to the Galerie Georges Petit and take a look at the plasters, which are fragments of these great works, along with some finished sculptures: the *Bust of Mme. Roll* and a group in bronze that Houdon would have called *The Kiss.* The value of these works immediately strikes you; one feels they emanate from the brain of an artist haunted by the grandest and most original thoughts, and the least thing in his hands can take on a new and imposing direction. Rodin, who is fortunately not without faults, has found in this exhibition an ambience that suits his temperament, for he is a seeker and a revolutionary, who aspires to deliver us from the Greeks and the Romans. Let us bow to such conviction and wish him good luck.

J. K. Huysmans
Review of the Exposition
Internationale at Georges Petit
(1887)

At last Rodin, heaving the feverish cries of a man in heat, moulds carnal embraces as violent as the splendid phallus-bearers of Félicien Rops! Entwined couples crush one another, faint, howl in one another's face, their bodies clenched, their eyes crossed in frenzy. The furors of the bacchantes of antiquity, knocked over by stags rearing in their lascivious jousts, live again beneath the furious touch of the sculptor who, at the present time, is the only artist able to make marble pant and shriek.

J. K. Huysmans, "Chronique d'art," *La Revue Indépendante,* June 1887. Translated by John Anzalone.

Octave Maus

Review of the Brussels Salon (1887)

I hasten to speak of sculpture, for in the hubbub of burlesque plasters and grimacing bronzes, three pearls shine forth by the master, the greatest French sculptor and perhaps the most astounding contemporary artist, Auguste Rodin. *Francesca da Rimini,* locked in the most tender and chaste bodily embrace that art has ever brushed with its wing, the savage legend of *Ugolino,* and the marvelous *Idylle,* whose reflection of pagan antiquity enlightens graceful modernity, while giving us rest and consolation from the surrounding banality. The *Francesca da Rimini* grouping is so infinitely superior to everything around it that it is disconcerting. It seems less a piece of sculpture than the conception of a higher art, as yet unknown, brought to life through poetry and dream. One is amazed to find these two figures motionless under the whiteness of the plaster, amazed that they do not unfurl wings of fire and fly away from their pedestal, united in the kiss that chains them to one another. The perfection of the lines is forgotten, as is the suppleness of the shape and the masterful accuracy of the artist's hand; for Rodin's art is marvelous because perfect execution—the alpha and omega of the mediocre—is for him but a springboard to the high regions of thought.

Having purified our vision in the light of such admirable works, we regretfully examine the busts, figures, groups, and other compositions that clutter the halls. They seem to fall into a prodigious retreat, and their failings stand out instantly and out of all proportion.

Gustave Geffroy

"The Sculptor Rodin" (1889)

Auguste Rodin's fame can hardly even now be said to have reached its zenith. Marking his upward flight, it is curious to glance back upon his early

Octave Maus, "Chronique Bruxelloise," *La Revue Indépendante,* October 1887. Translated by John Anzalone.

Gustave Geffroy, "The Sculptor Rodin," *Arts and Letters,* London, 1889, pp. 289–304. This translation is a slightly condensed version of Geffroy's essay for the catalogue of the Monet/Rodin exhibition.

struggle. For the somewhat noisy homage of to-day was not always his portion. At the outset, his earnings were hardly more than a labourer's wage, certainly less than the salary of a clerk. His young promise was shackled not only by the necessity of much uncongenial toil, but by the extraordinary hostility that greeted his first efforts. Some among us will remember the storm that was raised by Rodin's maiden contribution to the Salon. Fantastic as the charge will read in some future history of art, he was roundly accused of having built his work upon a cast from the living model. But it will be time enough to discuss this characteristic incident some few pages further on, in the rapid sketch we propose to make of Rodin and his career. The probationer is now hailed a master, and breathes the bracing air of independence. Feasts have been given, speeches made, and toasts drunk in his honour. The red ribbon peeps from his button-hole. And the uninitiated, puzzled by the shifting hubbub of blame and adulation, ask, with a not unnatural impatience, what manner of man this really is, what the meaning and the value of his work.

Let us satisfy this legitimate curiosity as far as we are able.

● ● ●

We shall have to thread our way along the Rue de l'Université, through the long boulevards and wide avenues that intersect and run parallel round about the Invalides. Passing the stately old houses, the venerable trees, the quiet little English-looking dwellings with neat gardens, so familiar to every Parisian who has learnt his Paris, we come to a point not far from the Champ de Mars, and close upon the Eiffel Tower, where the physiognomy of the neighbourhood suddenly changes.

We are at No. 182. A great *porte-cochère*, like the wide cartway into a farm-yard, leads us into an immense court, paved with moss-grown flagstones, the corners green with grass. A flock of children are playing some boisterous game, but their shouts are scarcely heard in the vast space, and only emphasize the silence. Tall branches that have scaled the wall stretch over the peaceful spot, and throw cool shadows as in a park. On every side lie massive blocks of marble of every conceivable shape, recalling, in full daylight, a stone-mason's shed, and in the pink and purple glow of sunset, or under dim twilight shadows, some rock-strewn moorland. This is the master's store-house. These cold white stones, with their jagged sides and delicate blue veins, are the raw material of his merchandise. In these unmeaning blocks slumber captive statues, that to-morrow's chisel shall set free, unbinding the fettered limbs, loosing the cramped torso, shaking out the close-laid hair, parting the sealed lips, raising drooping lids over eyes in which immortality indeed succeeds to death.

On the opposite side of this field of stones, the doors of many studios open on to the *al fresco* warehouse, or, to be quite accurate, shut on to it. For the denizens of these ground-floor rooms with their lofty ceilings and wide bays of glass are grudging of their time, and surly to a certain class of visitors.

The unwelcome guest will have to take himself off at last, with no response but the stolid wooden stare of the inhospitable barrier. Letter J. This is our goal. The key grinds in the lock, and the door swings back. A glance round shows us that we have disturbed no favourite model, straining every nerve in the effort to pose motionless as a mass of petrified humanity. Rodin is alone. Look well at him. It will help you in the comprehension of his work.

The man who stands before you, his hands covered with wet clay, his clothes splashed with plaster, is short and sturdy as to figure, peculiarly tranquil as to manner. He has no specially salient features, yet his physiognomy as a whole is full of character. Framed by the close-cut hair and the long fair beard that floats upon his breast, we see a mobile face, that in a few minutes passes from absorption to anxiety, from anxiety to smiling calm. The mists of preoccupation roll away, and a cheerful kindliness beams out upon us. The brow, of a somewhat mystic cast, and sharply arched, but wide and well developed, is that of a thinker. The gently aquiline nose completes a profile that recalls the profiles of sculptured monks in cathedral porches. But this is a monk full of human sympathies and subtleties, armed with critical faculty and force of will, and haunted, in his artist cell, by modern questionings, and also by modern solutions. There is a curious harmony between look and voice, the former keen and brilliant, and seeming to draw light and even colour from the eye; the latter, soft, vibrating, and tender, with a genial ring that loses nothing from a certain note of caustic humour specially manifest in its laughter.

• • •

In this brief sketch of an artist's career it will be needless to dwell with a novelist's minuteness upon purely personal details. It is of course of supreme interest to learn how the great minds of the earth have lived and loved, hated and suffered, like other men. Yet how hard it is to read the riddle of such hearts and brains, except in so far as they unfold themselves in the familiar gossip of confidential letters, self-revelations which echo like voices from the tomb. We shall therefore set down nothing here but the bare facts of the artist's life, as they have been manifested in his creations. Names and dates, design, modelling, and plastic conceptions, must stand for passions, joys, grief, and moral crises.

Rodin was born in Paris in 1840. So much for his age and ethnography. As to his artistic genesis, is it not written in the official catalogues of the Salon: "Pupil of Barye and of Carrier-Belleuse." It is one of those curious cases of contradiction between a man's origin and his development, of which one might multiply instances *ad infinitum*. Of course, catalogues must say *something;* but as a fact Rodin was to a very slight extent only a pupil of Barye, in the strict sense of the term, and of Carrier-Belleuse he cannot really be called a pupil at all.

He passed indeed into the studio in the Museum in which Barye carried on his silent teaching. There, with a number of other young fellows,

he enjoyed the mute instructions of the sculptures and anatomical models that stood about, stimulated now and then by a theoretical dictum or practical direction from the *patron*. On certain days, the studio of the great *animalier* was open to visitors. These visitors, alas! came knowing nothing of what they were to see, and were deaf to the music of the sublime menagerie created by the master. The plaintive belling of the stags, the neighing of the heavy destriers, did not reach their ears. They had no eyes for the spring and crouch of the great cats, for the muscular involutions of the boa, for the delicate mobility of the gazelles, nor for the heavy roll of the iron-clad pachyderms. Most of Rodin's co-disciples are still insensible to all this. But he himself, in these latter days, both sees and hears, and if he was never a pupil of Barye before, he has become one now.

With Carrier-Belleuse, his relations were much more definite. Here it was not a case of master and pupil, but of employer and employed. For six years, Rodin worked in that studio whence have issued so many creations of facile grace, from figures to decorative arabesques. His share in their development was, no doubt, considerable, but he is not likely to claim his tithe in their author's fame, and we need not therefore attempt any such division of property on his behalf. But if Rodin brought away from Carrier's studio some of the master's prodigious manipulative skill, he paid for it in kind. He was a journeyman waiting resignedly for the day when he too should take rank as a creator. And Carrier has just cause for pride in his apprentice.

This page in Rodin's story is dated 1864–1870. From 1871 to 1877, he worked in active partnership with the Belgian artist Van Rasbourg, and the curious in such matters who pass through Brussels may pay a visit to the Bourse, and pick out traces of Rodin's chisel among the colossal sculptures of the facade, and the caryatides of the interior. His own most vivid memories of these days of mechanical completion are of the happy hours of solitude he was free to revel in after his day's work was done. His mind had not yet begun to formulate a personal conception of his art, and was keenly alive to impressions from without. He recalls with delight those first tastes of liberty, his long rambles among shifting lights and ever-changing vegetations, through the drift of fine rain that, in those northern, canal-cut provinces by the sea, seems, even when the sky is brightest, to be lurking in the atmosphere. It was in these days of mingled concentration and reverie that both the man and the artist were being formed. Alike in his silent hours of work between the studio walls, and in his communing with nature, he was perfecting his capacity for noble and independent work.

And then at last began the period of tentative essays, by a hand not yet altogether sure of itself. The touch is now feeble and hesitating, now almost brutal in its vigour. As early as 1864, attention had been directed to a new and powerful individuality by his exhibiton of the bizarre but vigorous study, *The Man with the Broken Nose*. The inspiration came from a chance face that had stirred the artist's fancy. At last, in 1877, *The Age of Bronze* was sent to the Salon.

The accusation that at once followed its reception was one that had never been brought in numerous cases where it might notoriously have rested on more solid grounds. The justly indignant artist was charged by certain members of the Jury with having submitted to them what was no more than a cast from a living model. The reason given for the belief was the extraordinary precision in the modelling of certain parts of the body. An official commission, appointed to examine into the matter, came to the conclusion that there had been at any rate a partial use of some such method. The charge soon gained ground, and it needed all the weight of reiterated testimony from an expert like M. Paul Dubois, and from other sculptors, after examination of Rodin's first sketches, to establish his honesty with the authorities of the *Beaux-Arts*. By way of compensation, a medal of the third class was adjudged *The Age of Bronze* when it returned to the Salon in 1880, in its final material. It was bought by the State, and placed in the gardens of the Luxembourg, near the Orangery, in a position that shows the nervous modelling of the figure with fine effect. [Fig. 1]

It seems, therefore, that the official inspectors had not looked with discriminating eyes either at this *Age of Bronze* or at another figure in the *atelier* of the Rue des Fourneaux, a *St. John Preaching*, which was exhibited later on. The anchorite, spare and lean, but with iron muscles, stands with upturned face, his gesture that of the preacher burning to convince, his expression full of the rapt illumination of the visionary. The knotted, sinewy torso, the horny wayworn feet, are perfect in their vitality. Could such effects as these have been won by the mechanical proceeding with which the sculptor had been charged? Compare the bluntness of feature, the nerveless inertness of limb in any actual case of casting from life, and there can be but one verdict. What is there in common between this vigorous, breathing realism on the one hand, and that transcript of temporary death on the other? The bronze *St. John* was exhibited at the Salon of 1881, together with another fine figure, *The Creation of Man,* and in the years following, down to 1885, Rodin was represented in the nave of the Palais de l'Industrie, by busts of Jean-Paul Laurens, Carrier-Belleuse, Victor Hugo, Dalou, and Antonin Proust.

● ● ●

We have anticipated somewhat, and so to keep up a semblance of chronological order, we must linger here for a few moments over an event that has largely influenced Rodin's artistic career. This was the conception and execution of the Gate for the Museum of Decorative Art. The unjust odium cast upon the master in *The Age of Bronze* incident had had the effect of raising him up many partisans. The originality of his dawning genius was pointed out and insisted upon by several writers. Others followed. We have already spoken of M. Paul Dubois' generous championship. Finally, to his honour be it written, M. Turquet gave him the commission for the Gate.

We shall find it standing in the *atelier* of the Rue de l'Université, where

we have received Rodin's pleasant greeting, and watched him at his work. The Gate, indeed, pervades the whole studio. The statues on the top, certain groups on the panels, the side posts, and some of the lower bas-reliefs are in their places. But throughout the vast room are scattered pell-mell statuettes of every dimension, upturned faces, twisted arms, contorted legs. Behind the Gate, which is about twenty feet high, stretches a vista as of some phantasmagoric cemetery, peopled by a mute yet eloquent crowd, each unit of which we feel impelled to examine, as in the conning of a book that has to be deciphered page by page, paragraph by paragraph, sentence by sentence, word by word.

And indeed the work has its counterpart in a profoundly suggestive book. In these studies we find prodigious observation and lofty metaphysic, every shade of human passion, evoked by means of a gesture, attitude, expression of feature, turn of head. The subject which will give a name to the Gate is one that had taken captive the imagination of the dreamer, before it suggested itself to the sculptor. It is Dante's *Inferno*. Sublime as is the theme in itself, the artist made choice of it merely as the necessary framework in which to set forth a complex tragedy of human life and feeling. On this "Gate of Hell" he has brought together, in tumultuous action, a whole cycle of passions, a manifestation of all the instincts, fatalities, desires, despairs, that groan and travail in man. In Rodin's hands the great Ghibelline's poem has lost its Florentine element to take on a wider significance. Local colour has been fused into vast synthetic outlook, and we stand face to face with the changeless humanity of all countries and of all time.

To give a coherent description of the Gate in its present state is of course impossible. The sculptor has yet to finish the arrangement of parts, and an orderly presentment of episodes is interrupted by perpetual solutions of continuity in the most imposing features. Only the frame of the sculptured poem is as yet complete. But we may trace some general idea of the principal divisions. Two low reliefs are let into the base above which rises the principal composition. In their centres are carved faces mirroring every phase of suffering, brows furrowed by long cares, features contracted with pain, and tremulous with unshed tears. These heads are bordered by a band of women, satyrs, and centaurs, in which a fine contrast has been got by the blending of supple grace with lusty vigour.

The narrow spaces of the uprights on either side imprison a long ascending line of delicate flowing figures, modelled with a combination of high and low reliefs. These represent the gentle sinners, the happy criminals doomed for snatching at unlawful joys, lovers whose pangs are sweetened by unity and suffering. Here too are wrinkled women, in whom life has burnt down to a last dying flicker, and new-born infants, as yet scarcely conscious of being, though already marked by its miseries.

Crowning the structure are three male figures over the pediment. They lean against each other for support in attitudes of supreme desolation; their extended arms and warning fingers all point to one spot, with a gesture

of despairing certainty. They seem an embodiment of the Dantesque inscription: *Lasciate ogni speranza*. Below them, apart from the crowd that throngs the first circle of hell, Dante [Fig. 6], or rather the Poet, stands meditative, but with the air of a man of action in repose. It is a nude figure, bearing no sign of nationality or of epoch. The muscular limbs are formed for strife and movement, the vigorous face, ravaged by the fierce emotion of an absorbing idea, speaks of pity, indignation, all the tumultuous depths of feeling that rouse the dreamer to enthusiasm, or move him to passionate tears.

The musings of the seer may well be vast and mournful, for here, at his feet, beneath his gaze, lies the whole wild vortex of humanity. Poor humanity, hurled through space, grovelling in the dust, maimed of limb, and sad of soul, yet clinging obstinately to life and suffering; crying aloud in its agony, yet smiling through its tears, and weaving into song its feverish anxieties, its shadowy joys, its frenzied woes. In these tremendous panels the master has sought to trace a panorama of carnal suffering, and with it the more silent torments of the martyrs to love, ambition, unattainable ideals. He has placed side by side the cruel symbols of physiological fatalities, and of futile intellectual struggles.

• • •

Such is the rapid summing up of a keenly observant mind deeply tinged with a poetic pessimism. We come away from the contemplation of such a work deeply impressed by its author's profoundly mournful judgment of man's activities, by his passionate worship for grace and power in the human body, by his perfect sympathy with expression.

We must not forget—indeed it is impossible to forget—that the dreamer is a sculptor, a being in whose mind form springs up simultaneously with idea, if indeed it does not precede idea. The great draughtsman and transcriber of character and passion, Gavarni, used frequently to let the real types he had produced tell their own tale, and furnish him with an argument for his drawing. In like manner, a face that has grown under Rodin's hand speaks to him with gentle insistence, like nature herself, tells him what feeling moves it, what bodily bliss or mental anguish has left a hall-mark on it, whispers him by what name he must give it to the world. Thus the embodiment of the artist's thought is primarily a work of art. Truth has not been subordinate to rhetorical effect; no vague literary significance, or unsubstantial essay in illustration has crushed all vital animation. All is full of balance and precision. The symbolism is natural and unrestrained, the living idea in the work breathes and moves, the patience and ingenuity of the sculptor betray themselves in that highest triumph of modern thought and skill, a pose that is new.

Looking at his works from the purely technical point of view, it is in this matter of novel attitude that Rodin's bold originality is chiefly manifest. In these latter days sculpture, as any frequenter of our annual exhibitions must

have noticed, is content to repeat *ad nauseam* half-a-dozen well-worn poses. The causes of this monotony are no doubt partly the tradition of the schools, and the uniformity of commissions, partly the fatal habit of resting content with a received idea. Every one will hail the following as old acquaintances: body erect, one knee bent, one arm upraised; recumbent figure, raised on elbow; figure with hands clasped behind the head to throw the bust into relief; head resting on one hand, the other hand clasping the elbow.

But Rodin, comparing together the forms of nature and of art, was astounded at the countless possibilities of pose. He contends that their variety is infinite and boundless, that every movement of the body, every turn of a limb is endlessly suggestive. His difficulty lies, not at all in the perception of novel attitude; rather is he depressed by the impossibility in one brief life, of seizing and fixing in marble or bronze the countless combinations of line and shade of expression that strike the seeing eye. Rushing into vivid and unhackneyed metaphor, we might say that, for him, the variations of the human body are as the waves of the sea, as the sand of the shore, as the stars of the heavens for multitude! Life passes in array before the observer, and the tumults thrill his soul. Some one most subtle of its vibrations becomes incarnate, takes visible form in a statue, just as a sudden deep-felt thought, written in an immortal page, has borne strange fruit, making an epoch in the story of mankind.

• • •

In the sketches, studies, and finished works piled up in the sculptor's studio, we can follow the continuous effort of his brain. The creations of every moment lie there, visible to the eye in the natural order of their development.

This seated woman, with a mass of stone on her shoulder [Fig. 5], proclaims her despair by the droop of her head, by her closed eyes, by her look of final resignation, by the collapse of her dorsal muscles, by the general langour of her pose. Another, crouching, her limbs gathered under her and her chin resting on her knees, retains her passive, mysterious look as she is lifted in the strong arms of a man whose face comes close to hers. Here, frantic couples enlace one another, there, with light caress, they pass nervous hands across one another's cheeks. The group called *Paolo and Francesca* is the apotheosis of love's preliminaries, of the confidences, hesitations, and modest shrinkings which precede surrender! How tenderly the man's hand, a hand made to strike or grasp, how tenderly it lies upon his mistress! The woman too, settles on him like a bird, clings to him like a tender spray of ivy, gives herself up to her love with a last flutter. Here again, in the arms of a satyr, we find a woman plunged in the deep slumber which follows satisfied desire. A woman with a wild mass of tangled hair, drags herself along on hands and knees, screaming like a cat, and lifting a nightmare face to Heaven. A woman lies stretched on the ground, her face all swollen with tears, deaf to the call of a companion, with arms tossed wildly over her head,

her mouth parted in a bitter cry. A woman defends herself against a satyr, her limbs stiff and tense with the struggle, her face convulsed with shame and horror at contact with the hairy, thick-lipped monster; the same woman has yielded, and heedless of her possessor who watches her uneasily, she stands aside erect and self-absorbed, twisting her hair with tranquil coquetry. A female figure with proud head, lofty carriage, and fixed eyes, rushes by, carrying on her back a slender stripling, fainting from the wild course through the air. She clasps him with arms straining behind her back, and he lies inert as a corpse along the supple loins of her ravisher. Three sirens, of different height and posture, sing, with arms entwined, forming an irregular sloping group like the reeds in a Pan pipe. A danaïd falls and lies prostrate on the earth. The dead awake on the day of judgment, with all the passions and desires of their past lives. The miser clutches his gold pieces. The pleasure-loving woman, still half-asleep, her lips swollen with her long torpor, extends her arms. An Eve, vigorous and muscular, a creature formed for love and maternity, of massive contours with delicate attachments, shadows her face with her crossed uplifted arms. A kneeling fauness rocks her spare and supple body like a flower-stalk, with a feverish gesture full of seductive raillery, and laughs all over her gruesome deathly face, half-woman, half-animal [Fig. 8].

And we pass on to others, and others again. We might fill a whole book with enumeration and description. But incredible as it seems, we shall find that throughout the long procession, we never come upon two creations that are alike. The bodies that bend, straighten, or entwine, are each distinguished from the other by some sudden, natural, and yet amazing flexion of the torso. Arms and legs are drawn up, extended, or entwined, sometimes with a naïve ungainliness that has its own charm. Faces are upturned or hidden, clear-cut or indistinct in proportion as they submit to the law that governs the creation as a whole, the dominant expression that asserts itself from crown of head to sole of foot. And all this mass of animated matter seems to challenge comparison with nature by its multiplicity of forms, its divergence of types, its startling mobility of gesture.

• • •

Love, though not sole sponsor of the forms and postures adopted by the artist, has been one of his chief inspirers. The passionate expression of desire, the ecstasy of possession, have found in Rodin a poet at once comprehensive and sternly true. But it would be a mistake to fancy that even in the most realistic of these frenzied groups, the artist has pandered to base instincts, or joined hands with obscenity. The sentiments expressed throughout this saturnalian dance of furious lust is profoundly mournful. Rage, melancholy, physical langour, all tell the same tale of joys that fail to satisfy, of transports that leave the soul still athirst. As Daudet has said, the same key-note of suffering in its sexual manifestation, is struck throughout.

The master shows us in varied guises the first man of the Hebrew mythology, and the woman fashioned from him. One in their essence, indivisible though divided, and yearning, endlessly and impossibly, to cast aside their duality, and melt into union once more.

The sculptor's intention, moreover, is visible in every creation of his hand. The mingled pain and passion that informs his modelling, the caressing tenderness that tempers his virile strength, speak eloquently of an overflowing pity for humanity, of a loving solicitude for every form of beauty. Dreamy, tearful, submissive, or frenzied and rebellious, the woman of his creation is still a proud captive, restless and ill at ease in her abasement. Whether warring against the suggestions of her senses, or sinking, with mirthless laughter, to the very depths of carnal pollution, true grace and imperious beauty are still alive in her. In the rich development of his Eve, as in the long legs, the thin arms, the heavy hips and bust of his fauness, we trace the same wrestling with nature for her secrets, the realization of that charm of untamed grace, vigorous yet delicate, that haunts the sculptor like a spell.

● ● ●

Other methods and other aims have been called into play by Rodin's treatment of contemporary portraiture, and his busts have been strikingly successful both in likeness and expression of personality. The same keen powers of observation came to his aid here as in the symbolization of passion, but it was further necessary to strike a decisively individual note, and not merely to reproduce a man's feature, but also to give a reflex of his mind.

And here again the artist can point to triumphant achievement, so great is the force of a perfect harmony between hand and brain, so absolute the certainty of result obtained by a habit of resolute and unflinching toil. Is not the sobered age of Hugo's fiery genius plainly stamped upon this weary yet serene face? Can we not read Dalou's tenacity and clearness of intellect in the nervous modelling of the head and the sharp outline of the profile; Rochefort's defiant scorn of destiny, and ironic vigour in these arched brows, these candid, preoccupied eyes, this mouth that we see can both bite and smile; the voluptuous exotic beauty of a tropical flower in this bust of Madame——, a fair Peruvian who was wise enough to credit this sculptor *par excellence* of violent emotions with artistic delicacy and a feeling for feminine grace?

Rodin's gifts as historian and painter of character, so striking in his imperishable portraits, are not less apparent in his marvellous dry-points. His plates of Victor Hugo and Henry Becque were received with acclamation by all engravers who were not blinded by professional jealousy.

We might linger long over these engraved portraits, and over the marvellous rendering of anatomical and osteological phenomena in countless drawings, but it is time to pass over on to another of the master's great works. In his colossal group of *The Six Burghers of Calais* we see Rodin in two

fresh aspects, as chronicler and as the sculptor of public monuments. The essential qualities of such work—originality, decorative effect, and an intellectual grasp of history—are all conspicuous. To study these six Burghers (of whom only three were exhibited in 1886), we must leave the Rue de l'Université for the Boulevard de Vaugirard, No. 117, a second studio, which the master's rapid rate of production necessitated. It is a large room lying between the Boulevard and one of the little gardens one finds in the less aristocratic quarters of Paris. The light that falls mournfully on a confusion of scattered objects, cartoons, clay models in miniature, is cold and grey as in a chapel. The central figure in the room is a "Vanquished Fatherland" with broken wing drooping tragically, and from out the chaos around rise, larger than life, the figures of the six Calaisiens, destined some day to take up their station in the old town by the sea, and look down on the angry swell of waters imprisoned in the strait.

By the force of an intense sympathy with his subject, and keen perception of the historic narrative, the artist has been enabled to build up the whole drama, and set before us time, place, attitude, and above all, the chords of human feeling vibrating in the scene. With the eyes of his mind he saw those six men marching along a road of briars and flints. His inspiration rebelled at the idea of the conventional treatment of such a theme, the heroes of the story grouped in a pyramid, the supernumeraries silhouetted against the pedestal. He insisted strongly upon the slow procession, grouping his figures at certain distances from each other, so as to preserve the character of a death march of men desperate or resigned, accentuating the slow weary gait of the old, the feverish haste of the young. The victims must pass to the gallows as they had passed in his dreams, in straggling file, their eyes fixed on the goal. Eustache de Saint-Pierre, Jean d'Aire, Jacques and Pierre de Wissant, and the two anonymous heroes whose hard fate it has been to share the danger without the immortality, all confront us in this *cortège* of civic Christs, marching to death for the common weal, humiliated to outward seeming, yet burning with the proud consciousness of their sacrifice. They pass along, the old man with shaking head, stiff limbs, lean wrinkled hands, knotted muscles, and swollen veins; the quadragenarian, robust and sturdy, who might be marching musket on shoulder; the young man with drooping head and hand outstretched in the gesture of a last farewell, and this other, last in the procession, with the rugged head, the close-cropped hair and iron mouth, grasping in his hand the key of the city, and attesting his stern willingness to die and his indignant sense of outrage in every limb and in every wrathful feature. Through each of the six contrasting types runs the same synthetic expression of human feeling at white heat; renunciation, pride, disdain, and anguish culminating in a mute paroxysm of emotion, in which speech itself is less eloquent than the wandering gesture of the hand, the rapt exaltation of the face.

• • •

We have now glanced at Rodin's *oeuvre* both as a whole and in some of its most prominent details. To see something of the inner workings of his mind, looking into that spiritual laboratory where he moulds the first impalpable forms of his creations, we should have to weigh opinions, transcribe conversations, and analyse the liberal education Rodin has given himself by books and by travels.

Such a process lies outside our present province. It will be enough to point out that his wide range of reading, even his enthusiasm for his favourite authors, Dante, Baudelaire, and Flaubert, and for two or three contemporaries, has been without prejudice to his originality as a sculptor. He has never degenerated into an illustrator. Nor have his travels among ancient monuments effaced his individuality or caused him to bow down in slavish worship of the antique. What Rodin has best assimilated in the great masters of past ages is their authoritative assertion of independence, and in literature his favourite studies have been those profound analyses of life and character that correspond with the symbolism of forms. Laying aside the axioms of professors, he has caught the reality of Greek art in defiance of rules and cannons. He proclaims himself the admiring brother of the great architects of the Middle Ages, the builders of cathedrals, the hewers of stone. His admiration for Chartres, Rouen, Beauvais, Amiens, Saint Michael's Mount, Notre Dame de Paris, amounts to enthusiasm. The effect upon him of the elaborate flamboyant gate of Rheims, he says, in a bold and happy metaphor, to be as that of the setting sun. He admires the great Assyrian beasts which spread their wings and stretch their limbs in the British Museum, and also those built up by the genial hands of Barye. He has seen Genoa, Siena, Naples, Florence, and Rome, and from each he has brought back some undying impression. But he is further the implacable foe of imitators and restorers, of the professors of æsthetics.

A familiarity with literature and rural landscape, the perpetual observation of humanity, an amazing power of fixing fleeting attitudes, a knowledge of anatomy that enables him to keep account of the most unconscious movements of his models, such are some of the forces of Rodin's mind, some of the characteristics of his work. Like all great artists, his genius is open to definition: it is a personality wrestling with the powers of nature.

Félix Jeantet

Review of the Monet/Rodin Exhibition at Georges Petit and Rodin's work at the Exposition Universelle (1889)

Rodin has just opened an exhibit in the rue de Sèze gallery that deserves to be considered an artistic event, the Exposition Universelle notwithstanding. At a time when the public's attention is so enthusiastically drawn to and taken by the events on the Champs-de-Mars, we must thank Monsieur Rodin for having dared to seek a presentation of his work.

For this is indeed the most complete exhibit he has yet offered. Those who have had the honor to visit his atelier are already aware of what a more complete exhibit might someday soon include; nonetheless, we have before us today a collection that will allow the public to understand and appreciate the artist's extraordinary worth.

He is represented at the Exposition Universelle by his *Age of Bronze*, and by one of his first works (rejected at the Salon of 1864, now a classic), *The Man with a Broken Nose*. While they are superb, they are not enough. We have undertaken on the Champs-de-Mars a retrospective of our artistic production of the last hundred years. We may review the steps taken over a century on that road. Well, it so happens that Rodin is without doubt the last word in sculpture. And he ought to have been granted the space due a master in this exhibition. But who dared hope he would have this space? For powerful and original masters rarely experience easy victories.

What is the result of all this? The Centennial Exhibition of sculpture attempted in the Fine Arts Pavilion is not complete. Its ultimate extension can be found on the rue de Sèze, hosted by Monsieur Georges Petit. So much the better! In such surroundings the master's work is closer to us. We can study it more intently, we are less distracted when trying to understand it, and, to tell the truth, we prefer seeing it here, away from a family clearly not its own.

Indeed, we must emphasize the dominant characteristic of Monsieur Rodin's art. He is a Gothic. His real artistic family is in the Musée du Trocadéro, and we must jump back in a single bound, over several ages of our sculpture to connect the sculptor of *The Burghers of Calais* to his true ancestors.

It is this grouping, more than any other, that shows the Gothic character. Certainly, it is from the Gothics that Rodin has taken that apparent lack

Félix Jeantet, "Exposition des oeuvres de Rodin," *Le Blanc & Noir*, June 1889. Translated by John Anzalone.

of composition, which is in reality the science of life for sculpture. Like them, he understands perfectly the role of air, playing about the human form. For him, like the Gothics in their most beautiful figures of the late thirteenth century or in the statues of the Cathedral at Reims, moral expression is entirely made up of gesture; for a general sense of suffering, when it involves a painful sentiment, can be perfectly suggested by the least detail in a work—by an extended finger, a tensed foot, or even the folds of the backdrop. The Gothics were not naïve as they appeared to some, in reality they were faithful observers of all that happened around them, and their seeming naïveté is nothing more than a thoroughly knowledgeable simplification, a synthesis that is in itself a true sacrifice to the moral expression.

In shaping his *Burghers of Calais*, Rodin has lived the life of the "Grands Ymagiers" of the ancient tombs and cathedrals. Like them, he has created more than a sculpture or a group of six figures. His vision has recreated the full extent of a true, tragic, and simple drama, just as it must have occurred in another time. And he has done it with such boldness, with such newly found modernity! Where are the formulas and rules without which nothing can be beautiful, if the Academy is to be believed? One need only enter the gallery in the rue de Sèze to become aware of all this and more, which lack of space prevents us from discussing. But to savor in all its effect this true to life, painful composition, we must imagine it in a public square, in that square in Calais where it will be erected; we must see this beautiful stone work in life, in movement.

Painfully lifelike, too, is the monumental *Gates of Hell,* which fills the back of the studio of the Ile des Cygnes. The conscientious craftsman has not allowed its exhibition this year, but he has detached several details for display, which are themselves completed works and reveal the master's genius in a different way, one stamped with the suffering and torment of the modern soul.

It is here, in these smaller groups, in these figures that are born in pain from the material, that unfurl themselves, as from a veil, or jump forth with a sort of anguish, that Monsieur Rodin seems the most to be a poet in three dimensions, who has profoundly penetrated and translated the aspirations and powerlessness of flesh and soul. It is here we find the expression of the doubt and desolation that have always been apparent in man and that have been so well traced in the art of the century of Chateaubriand, de Vigny, and Baudelaire.

What is the use of giving names to these figures? They express moods, basic feelings; they are, more accurately, like splendid sonnets or longer poems—true symbols beneath the names the master or his friends have given them.

With the *Danaïde*—a wonderful piece of shimmering flesh, shaped in light—we witness the soul's despair before the ever unfinished work, the inconsolable regret for the unrealizeable dream, the impotence of the finite before the infinite.

In *Man*, lifting his arms to embrace *Beauty*, we see the same effort, the same overwhelming defeat, the same furious, desolate cry, uttered this time by Love, by Strength in the face of Beauty, by the Spirit before Form:

> I am beautiful, oh men, like a dream of stone
> And my breast, where you are bruised
> One and all, can inspire the Poet with
> Love as lasting and silent as matter.

The frenzied *Hecuba*, howling like a she-dog on the beach—is she a metamorphosis or a metaphor?—we find the verse of Euripides and Dante fixed for all time in unforgettable sculptural creation, a statuette no larger than a finger.

Held back still by the Gorgon's hand, as he rushes forth on winged feet in his savage, stupified joy, here is the living arabesque of *Perseus,* carrying off Medusa's head as a trophy: "He flew with the speed of thought," in Hesiod's words. An ancient myth, intimately perceived, boldly translated, comes alive before our eyes.

And all around us, embracing and shivering as they seek each others' mouths and their bodies mingle, the *Damned* of both sexes sing and weep beneath the stony gaze of the *Thinker,* in an undying poem to the inescapable frustrations of passion.

We have traced in the broadest of terms the work of a man whose inspiration—and this is rare!—has been adequately translated in his forms. We would have done well to emphasize this sculptor's admirable command of his art or his prodigious technique. But we could hardly do more than suggest a few general indications in the limited space we have. We beg the reader's indulgence for this inadequate study. But these few words seem useful in explaining the astonishment of the traveller who visits the Fine Arts Exhibit in the Champ-de-Mars.

André Michel

Review of the Exposition
Universelle (1889)

Rodin possesses great strength. Along with *The Age of Stone,*[1] he is exhibiting his handsome busts of Antonin Proust, Dalou, and Victor Hugo. I will not hide that several of his friends were somewhat disappointed by the absence, at this exhibition, of the door for the Museum of Decorative Arts, which several talented journalists have so often and so colorfully celebrated. Its decisive appearance was counted upon to confirm before the general public the authority and mastery of a powerful artist. We must continue to wait—but we are among those who wait confidently.

Yet we must be careful lest, in celebrating this bronze portal, we only prevent its completion. I am afraid, to tell the truth, that the men of letters have invaded this *atelier* of work. Several weeks ago one of them told us how he and some friends had revealed Baudelaire to Rodin; another (he who put his name to this stupefying affirmation: The gothic cathedrals were born of the loving glance which a wayfarer cast upon the long, great paths of our forests) presented us with so extraordinary a description and showed us such unforeseen things and disconcerting intentions, that we come to wonder—and to worry—whether all this isn't some tremendous misunderstanding. We wonder whether, if by pushing Rodin towards an outrageous posturing of Baudelaire, his noisy friends do not risk troubling his mind, or leading him into a kind of decadent romanticism to which his true talent must at length be sacrificed. Had I the right to give him one bit of advice, I would tell him to shut his doors, to stop reading the papers, and to work alone, face to face with nature and life, for which he has such keen feeling and such intense passion . . . And now he has been commissioned to do the monument to Victor Hugo. A long time ago, I published my wish that this great work be granted to Monsieur Rodin. In congratulating him, we must also compliment the administration that chose him.

André Michel, "Exposition Universelle de 1889, La Sculpture," *Gazette des Beaux-Arts,* September 1889. Translated by John Anzalone.

[1][*The Age of Bronze.*—Ed.]

RODIN ENTERS THE HISTORY
OF SCULPTURE

After the great successes of 1889, Rodin's life and career entered a new phase: he was able to take up residence outside of Paris (first at Bellevue, then in 1894 at Meudon), to travel more, to focus less on exhibitions and more on commissions, particularly the *Monument to Victor Hugo,* which he had received in the fall of 1889, and the *Balzac,* given to him by the Société des Gens de Lettres in 1891.

It was now impossible to write a history of art without reference to him, and his work became a standard held up by those who wished to proclaim sculpture to be the equal of the other arts, an idea often doubted during the nineteenth century.

<div align="right">

W. C. Brownell
"The New Movement in
Sculpture" (1892)

</div>

. . . M. Rodin has definitively triumphed—to the unwise attempt to define him in terms heretofore applicable enough to sculptors, but wholly inapplicable to him. It failed to see that the thing to define in his work was the man himself, his temperament, his genius. Taken by themselves and considered as characteristics of the Institute sculptors, the obvious traits of this

W.C. Brownell, *French Art* (New York: Scribner's, 1892), pp. 208–16. Brownell dedicated his book to Rodin. For the most part, this chapter was written during the late 1880s. It was first published as "Two French Sculptors: Rodin—Dalou" in *The Century Magazine,* November 1890. Brownell's book came out in new editions in 1901, 1905, and 1908.

work might, that is to say, be adjudged eccentric and empty. Fancy Professor Guillaume suddenly subordinating academic disposition of line and mass to true structural expression! One would simply feel the loss of his accustomed style and harmony. With M. Rodin, who deals with nature directly, through the immediate force of his own powerful temperament, to feel the absence of the Institute training and traditions is absurd. The question in his case is simply whether or no he is a great artistic personality, an extraordinary and powerful temperament, or whether he is merely a turbulent and capricious protestant against the measure and taste of the Institute. But this is really no longer a question, however it may have been a few years ago; and when his Dante portal for the new Palais des Arts Décoratifs shall have been finished, and the public had an opportunity to see what the sculptor's friend and only serious rival, M. Dalou, calls "one of the most, if not the most original and astonishing pieces of sculpture of the nineteenth century," it will be recognized that M. Rodin, so far from being amenable to the current canon, has brought the canon itself to judgment.

How and why, people will perceive in proportion to their receptivity. Candor and intelligence will suffice to appreciate that the secret of M. Rodin's art is structural expression, and that it is this and not any superficial eccentricity of execution that definitely distinguishes him from the Institute. Just as his imagination, his temperament, his spiritual energy and ardor individualize the positive originality of his motive, so the expressiveness of his treatment sets him aside from all as well as from each of the Institute sculptors in what may be broadly called technical atittude. No sculptor has ever carried expression further. The sculpture of the present day has certainly not occupied itself much with it. The Institute is perhaps a little afraid of it. It abhors the *baroque* rightly enough, but very likely it fails to see that the expression of such sculpture as M. Rodin's no more resembles the contortions of the Dresden Museum giants than it does the composure of M. Delaplanche. The *baroque* is only violent instead of placid commonplace, and is as conventional as any professor of sculpture could desire. Expression means individual character completely exhibited rather than conventionally suggested. It is certainly not too much to say that in the sculpture of the present day the sense of individual character is conveyed mainly by convention. The physiognomy has usurped the place of the physique, the gesture of the form, the pose of the substance. And face, gesture, form are, when they are not brutally naturalistic and so not art at all, not individual and native, but typical and classic. Very much of the best modern sculpture might really have been treated like those antique figurines of which the bodies were made by wholesale, being supplied with individual heads when the time came for using them.

This has been measurably true since the disappearance of the classic dress and the concealment of the body by modern costume. The nudes of the early Renaissance, in painting still more than in sculpture, are differentiated by the faces. The rest of the figure is generally conventionalized as

thoroughly as the face itself is in Byzantine and the hands in Giottesque painting. Giotto could draw admirably, it need not be said. He did draw as well as the contemporary feeling for the human figure demanded. When the Renaissance reached its climax and the study of the antique led artists to look beneath drapery and interest themselves in the form, expression made an immense step forward. Color was indeed almost lost sight of in the new interest, not to reappear till the Venetians. But owing to the lack of visible nudity, to the lack of the classic gymnasia, to the concealments of modern attire, the knowledge of and interest in the form remained, within certain limits, an esoteric affair. The general feeling, even where, as in the Italy of the *quattro* and *cinque centi*, everyone was a connoisseur, did not hold the artist to expression in his anatomy as the general Greek feeling did. Everyone was a connoisseur of art alone, not of nature as well. Consequently, in spite of such an enthusiastic genius as Donatello, who probably more than any other modern has most nearly approached the Greeks—not in spiritual attitude, for he was eminently of his time, but in his attitude toward nature—the human form in art has for the most part remained, not conventionalized as in the Byzantine and Gothic times, but thoroughly conventional. Michael Angelo himself certainly may be charged with lending the immense weight of his majestic genius to perpetuate the conventional. It is not his distortion of nature, as pre-Raphaelite limitedness glibly asserts, but his carelessness of her prodigious potentialities, that marks one side of his colossal accomplishment. Just as the lover of architecture as architecture will protest that Michael Angelo's was meretricious, however inspiring, so M. Rodin declares his sculpture unsatisfactory, however poetically impressive. "He used to do a little anatomy evenings," he said to me, "and used his chisel next day without a model. He repeats endlessly his one type—the youth of the Sistine ceiling. Any particular felicity of expression you are apt to find him borrowing from Donatello—such as, for instance, the movement of the arm of the *David,* which is borrowed from Donatello's *St. John Baptist.*" Most people to whom Michael Angelo's creations appear celestial in their majesty at once and in their winningness would deny this. But it is worth citing both because M. Rodin strikes so many crude apprehensions as a French Michael Angelo, whereas he is so radically removed from him in point of view and in practice that the unquestionable spiritual analogy between them is rather like that between kindred spirits working in different arts, and because, also, it shows not only what M. Rodin is not, but what he is. The grandiose does not run away with him. His imagination is occupied largely in following out nature's suggestions. His sentiment does not so drench and saturate his work as to float it bodily out of the realm of natural into that of supernal beauty, there to crystallize in decorative and puissant visions appearing out of the void and only superficially related to their corresponding natural forms. Standing before the Medicean tombs the modern susceptibility receives perhaps the most poignant, one may almost say the most intolerable, impression to be obtained from any plastic work by the hand of man; but it is a

totally different impression from that left by the sculptures of the Parthenon pediments, not only because the sentiment is wholly different, but because in the great Florentine's work it is so overwhelming as wholly to dominate purely natural expression, natural character, natural beauty. In the Medici Chapel the soul is exalted; in the British Museum the mind is enraptured. The object itself seems to disappear in the one case, and to reveal itself in the other.

I do not mean to compare M. Rodin with the Greeks—from whom in sentiment and imagination he is, of course, as totally removed as what is intensely modern must be from the antique—any more than I mean to contrast him with Michael Angelo, except for the purposes of clearer understanding of his general æsthetic attitude. Association of anything contemporary with what is classic, and especially with what is greatest in the classic, is always a perilous proceeding. Very little time is apt to play havoc with such classification. I mean only to indicate that the resemblance to Michael Angelo, found by so many persons in such works as the Dante doors, is only of the loosest kind—as one might, through their common lusciousness, compare peaches with pomegranates—and that to the discerning eye, or the eye at all experienced in observing sculpture, M. Rodin's sculpture is far more closely related to that of Donatello and the Greeks. It, too, reveals rather than constructs beauty, and by the expression of character rather than by the suggestion of sentiment.

Louis Gonse
"Contemporary Masters" (1895)

It is moreover in the flexibility and movement of his forms and through the expressive intensity of his ideas that the style of M. Rodin, author of *The Kiss* and of the forthcoming *The Gates of Hell*, is to be distinguished. I hail M. Rodin as a great, a very great artist. I have only to consider the power and spontaneity of his touch to recognize in him a marvelous sculptor's temperament, born for the acute observation of tangible realities, a shaper of flesh, a thoroughbred practitioner full of fire and passion. Why did he have to let himself go to such length in capricious refinements, which

Louis Gonse, *La sculpture française depuis XIVᵉ siecle* (Paris: 1895), pp. 323–24. Translation by John Anzalone.

his advice-givers complacently indulge? As I have already had the occasion to note, this industrious, naïve man—and I mean these words in the highest sense—was not made for subtleties. He has had the indiscretion to open wide his atelier doors to the writers. There are some, like M. Geffroy and M. de Fourcaud, whose keen critical sense must have been of precious assistance to him. I do not refer to them, but to those others who have unthinkingly tried so hard to marry Michelangelo to Baudelaire and Félicien Rops in Rodin's mind. The press has been almost fatal to Rodin for wanting to serve him too well. Fortunately, his robust, tough nature has already shown itself able to triumph over disconcerting problems. M. Rodin need only remain faithful to his own genius to move us. Even had he only created a few brilliantly inventive pieces, such as his marble masterpiece *The Kiss,* or the tragic models for *The Burghers of Calais,* or the *Man Coming to Life* in the Luxembourg Garden, or again the realistic *Saint John the Baptist* and the voluptuous little *Danaïde* in our National Museum of Living Artists; had he sculpted only these, even then, without waiting for *The Gates of Hell* that he has been working on for years and which will be quite unique, judging by the details we have seen, we would proclaim him as one of the masters of our time.

Lorado Taft

"Rodin's Fame in America"[1] (1896)

Auguste Rodin has been the most conspicuous figure in French sculpture during the last fifteen years. He is by no means a favorite with his brothers in the craft, but they no longer deny the genius of the man who persisted from the first in expressing his own individuality in everything he has done. With all their skill the sculptors of Paris seem closely related; they belong to one school. Rodin is the exception. He has always stood alone, as unmoved by the adulations and flattery of the present hour as he was by the sneers and opposition of those younger days. This sturdy self-confidence and power are recognized and appreciated now, and those best fit to judge speak of him respectfully, as a very great master.

Lorado Taft, "Auguste Rodin," *Arts for America,* February 1896. I am grateful to Josephine Withers for bringing this article to my attention.

[1]Editor's Title.

The first figure which he sent to the salon was *L'Age d'Airain*—the bronze age. Up to this time he had been unknown, a hired workman in the studios of more popular little sculptors. The statue was so remarkable in conception and so perfect in modeling that the jury were dumfounded; it was the work of a master, but signed by an unknown name. In their bewilderment the author was accused of having cast it directly from nature. He had no difficulty in disproving the charge, and the incident made him friends.

●　●　●

A year or two later his *John the Baptist* was exhibited. In this figure the artist breaks loose from all tradition. He represents "a sort of ferocious anchorite, a man of powerful frame made gaunt by fatigues and fasts. He walks with long strides, very erect upon his lean legs. His feet are calloused by the stones and burning sands of the road. And preaching as one does battle, he makes a violent gesture which seems to scatter anathemas. His face is illumined with a mystic light, his mouth vomits imprecations."

Probably you or I never thought of John the Baptist in that way, but then we are not Rodins. History, like nature, translates itself variously, seen through different temperaments. Strangely enough, this revolutionary work—now one of the features of the Luxembourg gallery—attracted but little attention for the time being in Paris. It was too strong, too virile to please, and so strange that the critics probably did not know how to take hold of it.

Next followed, however, a series of busts which could not be neglected; wonderful works which wrung admiration and that highest flattery—imitation—from friends and detractors alike. Among these heads one recalls vividly the portraits of Victor Hugo, Rochefort, Jean Paul Laurens, the painter; Dalou, the sculptor; Puvis du Chavannes, and that incomparable *Head of a Woman* in the Luxembourg.[2] There are two things especially noticeable in all of these busts, the incisive characterization, that intensity of life which unmasks the very soul, and—almost equally important in a great work of art—that masterly neglect of non-essentials, which Rodin understands better perhaps than any other living sculptor. There is no "frittering away of the general effect in useless details." With him cravats and buttonholes are of small importance compared with the face. *The Head of a Woman* has some of the most delicate, mellow modeling that I have ever seen—the perfection of marble cutting. The neck and bosom, likewise, are nothing else than soft, white flesh. Art can go no further. Then the master considered his work done. With a sort of noble petulance he has scratched the suggestion of drapery into shape. For a moment he has played with the clay and pressed the loose scraps into semblance of flowers. And he has been very careful that the marblecutter should not carry them any further. The

[2][*Mme. Vicuna* (1884).—Ed.]

tooth of the tool has left its mark on all this subordinate portion of the bust. It is rendered purposely uninteresting that the face may have all attention. The result is one of the greatest works of sculpture of our time.

I cannot say as much of the heads shown at the Champ de Mars this year.[3] Both seem to me a little affected. A life-size woman's head projecting from the top of a rough block of marble as big as a Saratoga trunk on end is a little too original to be pleasing at first sight. Even a great genius makes mistakes once in a while, especially when he is expected to astonish the public every year.

For a long time Rodin has been at work upon a great composition—a pair of immense bronze doors ordered by the government. No one has ever seen the design as a whole, which is inspired by Dante's *Inferno,* but the fragmentary studies which have been shown betoken a work of prodigious power. Occasionally one of these studies is copied into marble, and these little figures and groups have a perfection of modeling seldom, if ever, seen in small sculptures. Mr. Yerkes' *Orpheus and Eurydice,* in the Art Institute, will illustrate the method if not the subject. To avoid academic poses the sculptor has given the little couple most awkward positions, entirely without grace, the bodies are not symmetrical, and the limbs are of impossible proportions. And yet they seem to feel—do these little marble people. They are not puppets, nor even skillful actors, but real, loving, suffering humanity. You cannot help feeling with them. Then, too, if you are an artist you will return again to admire the perfection of the modeling of their tiny figures. Though sometime careless, as here, in his proportions, Rodin never fails to show an extraordinary knowledge of construction. No sawdust dolls here, no bottle legs. You feel the very bone and the muscle underneath the marble skin; there is nothing finer in that hall of modern sculpture at the Institute.

[3][*Le Pensée* and the bust of Octave Mirbeau.—Ed.]

THE LATE 1890s:
A CRITICAL BACKLASH

Félicien Champsaur
"The Failure of Genius" (1896)

It is not possible to pronounce the name Rodin without prostrating one-self. Critics stand guard over the greatest genius of this century—what am I saying?—"of all time" as a very personal, animated journalist once wrote, and brandish their pens at those who refuse to grovel without questioning their tyrannical pronouncements. With words of artistic respect, they humiliate the formidable splendor of Michelangelo before the sterile master they acclaim only as a mark of their own originality. The snobs of literature, journalism, the salons and the boulevards, the partisans of the "one hand washes the other" philosophy have this clever habit of attracting attention to themselves by setting up camp with very modern artists; and since they are unable to create strong, everlasting works, they create momentary gods of little or no consequence like Rodin or Monsieur Mallarmé, the prince of poets and a literary puppet. Rodin is especially famous for *The Gates of Hell*, which will never be finished, better yet, which no longer exists, for the magnificent dream that gave it form has only taken it back, and, lastly for a statue of Balzac he can't seem to produce.

Here is the story. In 1885—eleven years ago,[1] time does go by—I wrote a series of sketches for *le Figaro* under the title "Literary and Artistic Life." Still, it was with some difficulty that I had an article accepted called "The Man Who Returns from Hell: Auguste Rodin," for the artist was totally

Félicien Champsaur, "Un Rate de Génie," *Gil Blas*, September 30, 1896. Translated by John Anzalone.

[1][Champsaur is wrong here—it was 10 years past, 1886.—Ed.]

unknown at that time. In Monsieur Périvier's absence, Monsieur Marcade hesitated in publishing it, saying, "Rodin? What's that? I'm familiar only with *The Wandering Jew. Le Figaro,* my dear fellow, has never mentioned this Rodin." And I replied, "Well, it will be to its honor to be the first to speak of him." A handsome assurance is always somewhat imposing. Marcade smiled and, as though dealing with an imaginary character, said: "Well, after all, it's interesting." Monsieur Rodin once worked for the Sèvres manufacturers, producing models for Monsieur Carrier-Belleuse, and I wrote: "It must have been difficult to have so many projects in mind for which time and genius are needed, difficult to feel the presence of such ideas and have to bottle up one's imagination to devote the entire week to earning one's daily bread. Sundays are left, and these days of feverish research are holidays." Having seen the plaster sketches, I also described *The Gates of Hell,* intended for the Museum of Decorative Arts, a "future" poem in bronze, in which humanity in rebellion and despair, with its bad conscience, its frenzies, its curses, its vulgar appetites along with its desires for the infinite and the ideal, a work destined to set for us and for future generations the thrill of art—all by this prodigious artist.

Now, eleven years later, where is the portal? It seems to be competing with strolling pumpkins. Its gigantic pilasters have become two monstrous legs to which several damned women still cling, and it has gone off, who knows where, to be lost in the dream where a sculptor with the beginnings of genius has taken it—an Icarus whose wings melted and fell off close to the sun, and not a Buonarotti. Since then the critics—with the exception of some sly ones, for personal reasons—have lined up single file to follow the lead of Panurge's sheep to jump into the sea, like Dingdong's flock. They ceaselessly celebrate Rodin's apotheosis, and if the public were not indifferent to empty uproars, it would be surprised by such fanatic admiration for masterpieces it has never seen.

Well, yes, it has seen *The Burghers of Calais,* a group of giants in shirtsleeves, with the bizarre gestures of Javanese dancers, a group that still stupefies the passers-by of Calais. And there is a woman's head in the Luxembourg Museum, a bust of M. Puvis de Chavannes exhibited one year in plaster, the next in marble, and yet another slab, which apparently represents Octave Mirbeau, the vibrant novelist of the marvelous book *Le Calvaire.* Thus, seated on a pedestal of articles, Rodin has become God. . . .

And so, Rodin who was a humble artist before nature, like an image-maker of the medieval cathedrals, Rodin who, in those days of silence on the part of the critics, worked on his portal from Dante, interrupting his task only to reread one of Baudelaire's sonnets; Rodin was too soon troubled by sudden instant acclaim. A horde of subservient supporters settled in around the unfinished portal, shrieking with enthusiasm. And when he reflected that the pressure of his thumb in the clay was a startling manifestation of the synthesis of human thought, or that his white plaster silhouettes, those victims of lust comtemplated every afternoon with little cries from ecstatic

worldly snobs or fainting hysterics, were blows struck for the renewal of art in an exhausted world, the poor sculptor began to demolish his portal in a morbid pursuit of tormented Michelangelo-like effects. He was no longer an innocent sculptor, struck by the splendor of life. And ultimately, his brain first intoxicated, then softened by all the hosannas, he could do no more than pronounce memorable words, worthy of a man definitively installed as resident genius.

M. H. Spielmann
"Sculpture at the Paris
Salons" (1897)

Lastly we have M. Rodin—a very Titan among the strong men of his own class. But it is impossible to realise that he intends the great plaster of his forthcoming monument to Victor Hugo to be accepted as finished. If it were, it would be understood by the ordinary beholder as representing rather some memorial of a leprous group, in which not only quality of surface is ignored, but any sense of completeness is deliberately withheld; indeed, one would rather say that in appearance it is simply an enlargement of the first sketch-model in the clay [Fig. 11]. There are the elements of extraordinary rugged power in the group; mere beauty is not sought for, even in the figures which may be supposed to be the angels of the poet's inspiration. What is of particular interest is the original distribution of the work seen as a mass; and it is to be remembered that the conception of the figure behind the poet's nude form recalls an attitude first invented, we believe, by Carpeaux. M. Rodin's other works in marble are as small and highly finished as the plaster is coarse and roughly wrought, for all the respect for form which it displays. Into these smaller works whether the *Dream of Life* or the *Cupid and Psyche,* the sculptor infuses an astonishing amount of passion and sweetness, and reveals a sensuousness of which no one knowing him only by his Hugo or his Calais monument would believe him capable. Herein he displays hot sympathy with the erotic passion; but he proves a love not less deep for the marble, which he caresses into flesh or flowing hair and even voluptuous movement. In spite of any criticism to which M. Rodin may lay himself open, he remains one of the greatest figures

M. H. Spielmann, "Sculpture at the Paris Salons," *The Magazine of Art,* October 1897.

in French art of the present day. But he is himself, and none can hope to follow him. He thus becomes a danger to the skilful youth whom he dazzles, and who is always on the watch for some new divinity to adore, some other master to imitate—provided that he possesses artistic vices enough to be mistaken for originality, and faults enough to be accepted as modernity. M. Rodin can have no disciples; his aspect of art without himself could but produce anarchy, and one more element of chaos would be introduced into the distracted, if fascinating, republic of the arts which bewilders France to-day.

Jacques Daurelle

An Interview with
Sarah Bernhardt (1897)

The interviewer, Jacques Daurelle, asked Miss Bernhardt what she thought of her fellow sculptors. She replied she liked Mercié, Falguière, Dubois, Guillaume, Saint-Marceaux, and Peuch. "And what about Rodin?"

"Without any doubt a great deal of talent, but Rodin exaggerates. He makes people ugly and grimacing. His art has something of mystification in it; when one sees it one thinks of caricature. It is far more difficult to reveal beauty than it is to show ugliness."

Paul Leroi

"The Truth About the Salons
of 1898 and 1899" (1899)

Since I find myself writing Auguste Rodin's name again, let me digress long enough to point out how far astray this dissident member of the Société

Jacques Daurelle, "Mme. S.B.," *Le Figaro*, September 22, 1897.

Paul Leroi, "La Vérité sur les Salons de 1898 et de 1899," *L'Art* (Vol. 2), 943–45. Translated by John Anzalone.

des Artistes Français has gone. His pride has forced him to become president of the sculpture division of a Société Nationale des Beaux-Arts made up mostly of foreign artists.[1] He has discouraged all the true friends of his brilliant beginnings.

Monsieur Rodin started his career in the hardest possible way. He suffered much, far too much in fact, from the cruel pain of working for others for virtually nothing. In short, he has known real slavery.

But since the day he sent to the Salon that masterful figure, which he or someone else later christened *The Age of Bronze,* he has attracted the sympathy of some friends. They are neither many nor vociferous, but they are deeply devoted and quietly efficient. . . .

But the *Gate,* which is supposed to be inspired by Dante's *Inferno,* remains unfinished year after endless year, thanks to the paternalistic administration of the Fine Arts ministry. Forgetful of the sums already paid the sculptor, it neglects its duty to the country by not forcing him to complete and, at long last, deliver his work. On the contrary, it has heaped new commissions upon him and has gone so far in its weakness as to request not one but two monuments in honor of Victor Hugo.

The statue of *Claude Lorrain* provides a timely demonstration that, although M. Rodin deals marvelously with detail, he possesses not a trace of creative genius and will never be able to claim groupings as his strong point. I can still hear Louis François, a man whose good taste it would be hard to contest, privately deploring that the city of Nancy had to accept it as hommage to the illustrious landscape painter. In his official role as president of the Committee, he had to grin and bear it, but in Nancy people are not pleased.

And now, in March 1899, it is announced that M. Rodin has expended much energy in the form of literary eloquence in accepting the commission, granted him after the *Balzac,* for a statue in honor of M. Pierre Puvis de Chavannes. I would much prefer a sculpture of authentic lasting quality to all this hollow-sounding enthusiasm. . . .

The ceaseless ballyhoo has had the inevitable result of influencing Panurge's sheep. In other words, commissions have been heaped upon M. Rodin without delay. As clumsy at handling a chisel as he is expert at shaping wax or clay, Rodin, whose own debuts were so difficult, has set out to inflict a similar fate upon several poverty-stricken artists whose fine talents he has tirelessly exploited. It is repeated in every *atelier* that this is what happened to Mlle. Camille Claudel and M. Jean Escoula and Victor Peter. All three ultimately broke with Rodin after having executed in their entirety a considerable number of statues for him by interpreting his very rudimentary sketches. . . .

[1] [The Société des Artistes Français had been the official organization of French artists under the direction of the Institute. It sponsored the annual Salons at the Palais des Champs-Elysées. In 1890 a number of artists, Rodin among them, formed the rival Société Nationale des Beaux-Arts, which held its exhibitions at Champ-de-Mars.]

By signing works he has not so much touched with a chisel, Rodin—and he is unfortunately not the only one—has not helped his reputation, for the exploitation of others never remains a secret in the art world. It is true that he has thus obtained a comfortable position, if not a brilliant fortune. He has become a landlord in Meudon. But he would have earned more in terms of esteem and admiration had he made it a matter of honor to keep to commitments left outstanding before undertaking any new work; and had he conscientiously completed with all his talent, if not genius, the earlier commissions that have long remained unfinished, because, as in the case of the many episodes of *The Gates of Hell,* he produces only fragments.

It is by straying from this most honorable path that M. Rodin was woefully reduced to the deplorable exhibition of 1898. It is charitable not to talk of the *Balzac.* The work is neither finished nor unfinished, although M. Rodin, in his staggering arrogance, has gone so far as to commission an engraving[2] of this formless figure, which does not even have the crude advantage of being plumb.

I have hardly more respect for the marble statue, which was seemingly exhibited in order to confound those who claim that the sculptor doesn't even know how to fashion a nude properly. This grouping, called *The Kiss,* is also wide open to criticism. While its artistic qualities are few indeed, there is an abundance of flaws: an ignorance of the attractive lines of composition, a scorn for the conventions of the subject, a constant use of sleight of hand to make details the artist found troublesome disappear. Graver still is the lack of structure, and in many places, of anatomical accuracy. That kind of form, which is more clever than accurate and which Rodin successfully used at times during his early career, is notoriously weak in this instance. It has been replaced by a facile kind of execution called *chic* in the *ateliers.* But one would have to be blind not to see that the anatomy of the left arm is debatable. The muscles are not in the right place and are poorly integrated at the elbow. The hand is thick and heavy and could not move. The right hand is at once hard, dry, and flabby. From a certain distance, the accented features of the back, shoulder blades, and ribs seem formed of too-even touches that lack shape. It is as uniform and without truth as a pastiche of a decadent like Baccio Bandinelli. Yet *The Kiss* is hardly a new work—so many have contributed to it—and its long gestation has lasted years.

[2]It is to be engraved by M. Leveillé, for a study to be done—I am told—on Rodin's total *œuvre.*

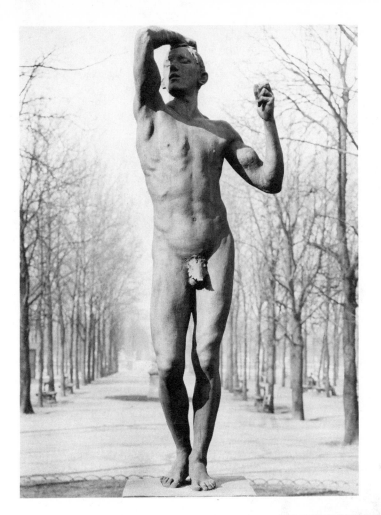

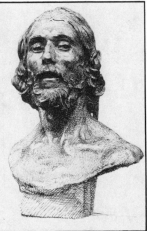

Fig. 1 (above)
RODIN:
The Age of Bronze (1875–76)
Photographed in the Luxembourg Gardens, where it
stood from 1884 to 1890
(Musée Rodin, Paris)
Photograph, N. D. Roger-Viollet

Fig. 2 (right)
RODIN:
Bust of St. John the Baptist
(drawing) 1877–78
(Musée Rodin, Paris)

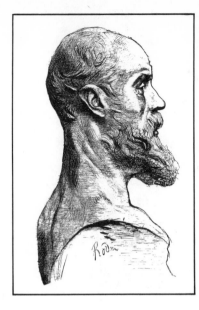

Fig. 3
RODIN:
Bust of J.-P. Laurens (1881)
(Wood engraving from *The Magazine of Art*
(vol. 6), London, 1883)

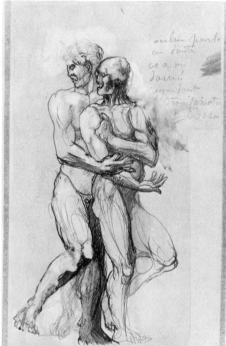

Fig. 4
RODIN:
Study for the Gates of Hell
(drawing) c. 1880
(Fogg Art Museum, Cambridge, Mass.)

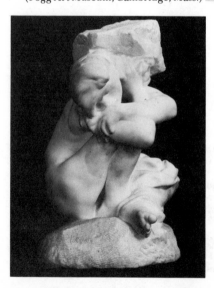

Fig. 5
RODIN:
Fallen Caryatid Carrying Her Stone (1880–81),
marble
(Hirschl and Adler Galleries, Inc., New York,
N.Y.)

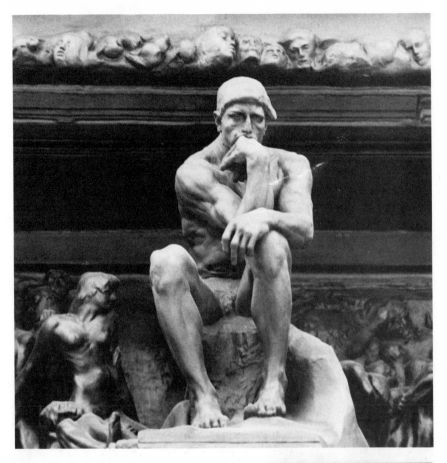

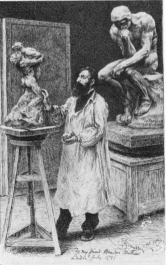

Fig. 6 (above)
RODIN:
Detail of *The Gates of Hell*
(Kunsthaus, Zurich)
Photograph, H. W. Janson

Fig. 7 (right)
WILLIAM J. HENNESSY:
Rodin in His Studio
(drawing)
(Whereabouts unknown)

Fig. 8 (left)
RODIN:
Kneeling Faunesse (1884)
(Musée Rodin, Meudon)

Fig. 9 (below)
The *Vernissage* of the Salon of 1898
on May 1.
C. Meunier's *Sower* is in the
foreground and Rodin's *Balzac* in the
background.

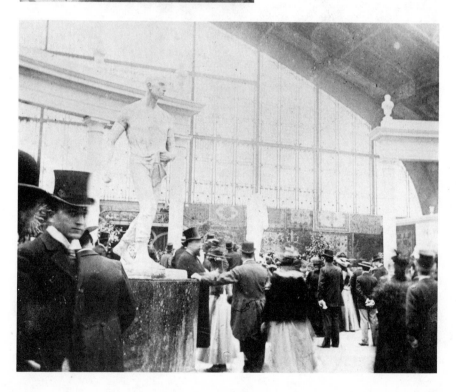

Fig. 10 (right)
RODIN:
Balzac (in the Salon of 1898)
(Musée Rodin, Paris)

Fig. 11 (below)
Rodin with his *Victor Hugo* in
his atelier in 1899
Photograph, N. D. Roger-Viollet

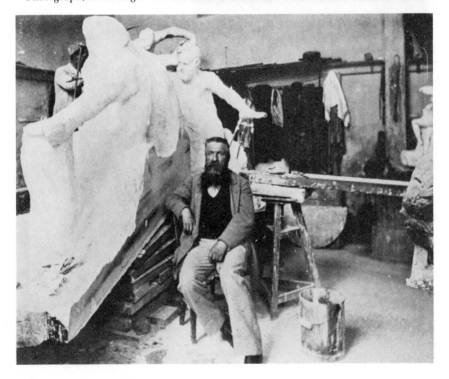

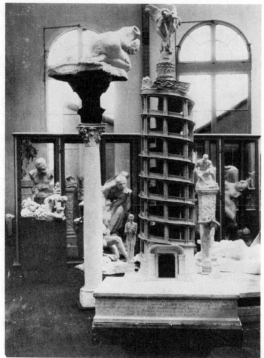

Fig. 12
RODIN:
The Tower of Labor
In Rodin's atelier at Meudon

Fig. 13
RODIN:
The Thinker
In front of the Pantheon, Paris

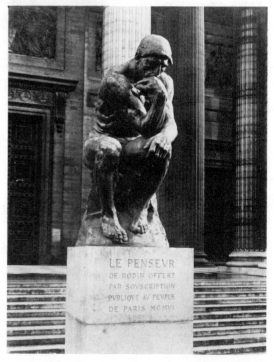

Fig. 14 (top)
Dujardin-Beaumetz reading his speech at the inauguration
of Rodin's *Thinker* in front of the Pantheon on April 21, 1906

Fig. 15 (below)
Rodin with Eleanora Duse and Armand Dayot in 1905
Photograph, N. D. Roger-Viollet

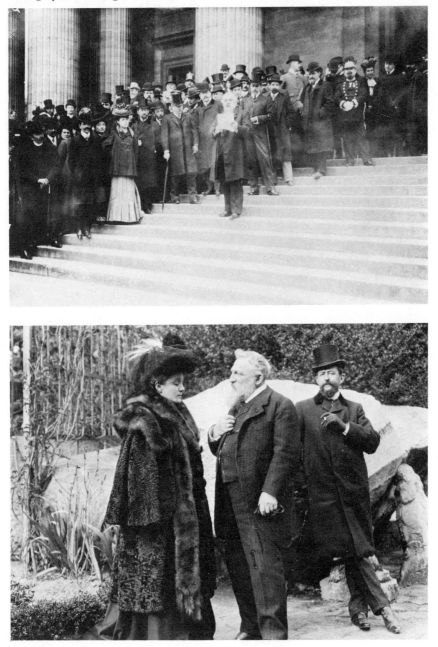

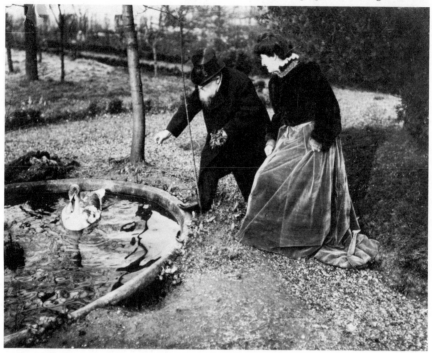

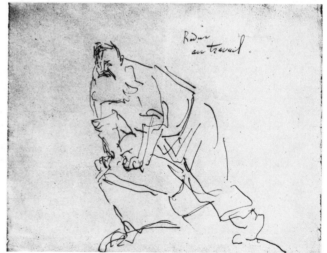

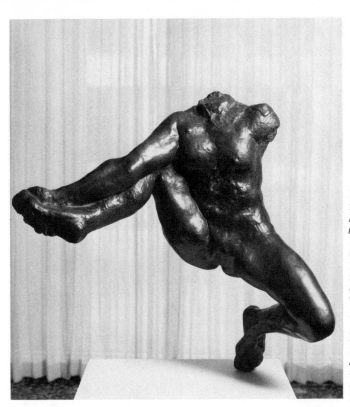

Fig. 18 (left)
RODIN:
Iris, Messenger of the Gods
(1890–91)
(Hirshhorn Museum and Sculpture Garden, Washington, D.C.)

Fig. 19 (below)
RODIN:
Flying Figure
(1890–91)
(Musée Rodin, Paris)

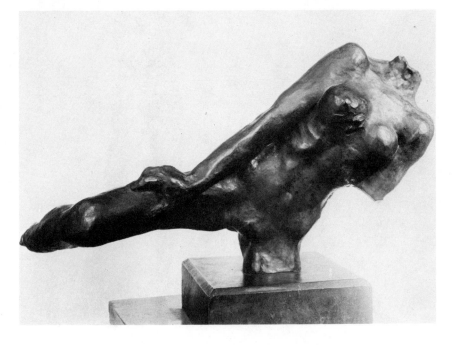

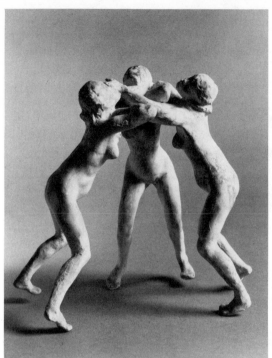

Fig. 20 (left)
RODIN:
Three Faunesses (1882)
(Musée Rodin, Paris)

Fig. 21 (below)
RODIN:
Walking Man (1877–78)
(Collection of Henry Moore)

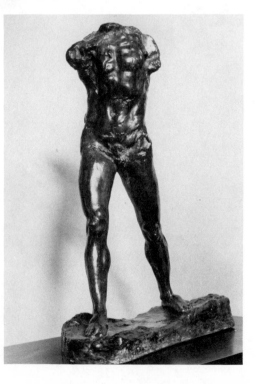

BALZAC: PUBLIC BATTLE

When Rodin received the commission for the *Balzac* from the Société des Gens de Lettres in July 1891, he promised to complete the monument in eighteen months. But his way of working, just as with *The Gates,* was such a long process of search and testing that months turned into years. Also he was not well during the mid-1890s and work went slowly. The Société des Gens de Lettres put a great deal of pressure on him, and anticipation of his work was a matter of lively interest in the press. The *maquette* was finally finished in April 1897. It was enlarged and the plaster was exhibited at the Salon de la Société Nationale, which opened on May 1, 1898 [Figs. 9 and 10]. Eleven days later, it was made public that "The Committee of the Société des Gens de Lettres . . . refuses to recognize the statue of Balzac." Rodin withdrew his *Balzac* from the exhibition to place it in his garden at Meudon.

Jean Villemer
"Le Vernissage" (May 1, 1898)

Noon—A rush for the buffet, ground for reconcilation between the two Salons that are being prepared. . . .

Over there is the artists' corner: M. Bouguereau, M. J. P. Laurens, M. Aimé Morot, M. Demont, M. Gérôme, M. Mars, that clever designer; M. Rochefort at his table, and still others.

And no one could talk of anything but Rodin's *Balzac.* . . . Four

Jean Villemer, "Le Vernissage," *Le Figaro,* May 1, 1898.

o'clock—High tide. The nave is full, the rooms are full. . . . People are suffocated and pushed about and don't know where to go.

Numerous groups have formed however. There are more than two thousand people in front of the *Balzac* of Rodin and each gives his opinion. I am obligated to reproduce faithfully these impressions:

—Admirable!

—That is to say that I have found Rodin too inward until this moment; and now, I understand him.

—But it is appalling!

—No, it's a madman.

—It's Balzac at Charenton, in his hospital gown.

—No, it's Balzac being woken up by a creditor.

—That, Balzac? But it's a snowman! Look, it's melting! It already is leaning to one side: it's going to fall.

—That, Balzac, it's nothing but a big side of beef.

Oscar Wilde
A Letter to Robert Ross (1898)

I dined with the Thaulows the other night and on Saturday I went to the *vernissage* at the Salon. Rodin's statue of Balzac is superb—just what a *romancier* is, or should be. The leonine head of a fallen angel, with a dressing-gown. The head is gorgeous, the dressing-gown an entirely un-shaped cone of white plaster. People howl with rage over it. A lady who had gazed in horror on it had her attention directed to Rodin himself who was passing by. She was greatly surprised at his appearance. "Et pourtant il n'a pas l'air méchant" was her remark.

The Letters of Oscar Wilde, edited by Rupert Hart-Davis (London: Rupert Hart-Davis, 1962), p. 732. Reprinted by permission by Mrs. Vyvyan Holland.

Jean Rameau
"Rodin's Victory" (1898)

We've had Zola's victories. For three days now we have Rodin's victory.
What a glorious year! They've not yet had nearly as much in New York. So,
M. Rodin has conquered. He himself said as much to one of our colleagues:
"I believe I won quite a battle!" He is supposed to have said at the close of the
memorable opening. Oh yes, he won, certainly! And we are humiliated and
will be for some time. M. Rodin triumphs. The week belongs to him. It is
impossible to speak of anything but him. He is the King of the moment; and
why stop at King? The God my friends, the God! For we now have "the
Rodin religion," as one of his incense-bearers put it. "Don't touch Rodin!"
exclaimed one of our women colleagues—a prophet by profession—some
four years ago already. Let's touch him anyway, what do you say?

I must begin by saying that I do not have the advantage of knowing
God. I'm told he's a good fellow, and I have no trouble believing it. I am
assured that he has some merit and am persuaded that he never lacked any.
But there is certainly something else. M. Rodin must be cunning without
seeming so; he must be unknowingly a great diplomat. For his person we
have the most sincere esteem. He could have had a military medal, or he
could have made an excellent night watchman, or even a well-decorated
senator. Who knows? he might even have made a half-decent sculptor!

But he didn't want to. Or, rather, others didn't want him to. Being
good-natured, he has never been able to refuse his entourage anything. He
was told, "Don't be talented, dear master. Talent is hardly worth anything
since the Empire!" And he renounced his talent. He was told, "Make us some
fellows who can't stand up, dear master; it's so much more amusing, and
besides, it will annoy everyone . . ." And he sculpted them some fellows who
can't stand up. A heart of gold, I'll say it again!

Ah! I confess that I ought to have made his acquaintance. It would have
been interesting to study his present mood, to see how his brain is carrying
on under the influence of the strong fingers that are deforming it; to know if
he roars like the caged lion that he is between the jumps that he is made to
perform. Two or three times people have tried to take me to him. But I've
never felt myself worthy of entering the temple. I didn't have faith. Oh, and
Lord knows how hard I've tried: the many pious stations, all the mortifica-
tions before *The Burghers of Calais,* before *The Bust of a Young Woman* in the
Luxembourg, indeed, even before last year's *Victor Hugo!* "Oh Lord, Oh

Jean Rameau, "Le Victoire de M. Rodin," *Le Gaulois,* May 3, 1898. Translated by John An-
zalone.

Lord, give me faith," I cried, beating my breast, "Help me find something beautiful in these goiters, these growths, these hysterical distortions!"

I did not, and I've covered my forehead with ashes. I shall never belong to the Religion.

Auguste Rodin
Rodin's Defense (May 12, 1898)

There is no doubt that the decision of the Société is a financial disaster for me, but my work as an artist will continue to be my supreme satisfaction. I am anxious to recover the peace and tranquility that I so badly need. I tried in *Balzac*, as in *Victor Hugo*, to render in sculpture what was not photographic. People may find errors in my *Balzac*; the artist does not always realize his dream; but I believe in the truth of my principle; and *Balzac*, rejected or not, is nevertheless in the line of demarcation between commerical sculpture and the art of sculpture as we no longer have it in Europe. My principle is to imitate not only form but life. I search in nature for this life and I amplify it by exaggerating the holes and lumps in order to gain more light, after which I search for a synthesis of the whole. . . . I am now too old to defend my art, which has sincerity as its defense. The taste of the public has been tainted by the habit of making casts after the model, to which it has grown accustomed.

Arsène Alexandre
Rodin's *Balzac* (1898)

One comment seems to have recently gained particular favor among those artists who are detractors of the statue. Technical aspects of it are most apparent, and they had to latch on to something. So they said, in the jargon

"X," *Journal*, May 12, 1898.

Arsène Alexandre, *Le Balzac de Rodin* (Paris: H. Floury, 1898), pp. 27, 28, 43. Translated by John Anzalone.

of the profession, that the figure "doesn't carry." In other words, it can't stand up and will fall. But what really doesn't stand up is this comment.

The body is obviously perfectly steady on its legs, despite the accented backward movement. But at any moment you can find yourself face to face with people who bend backward during a heated conversation without falling over. (Why, I was just a moment ago an example of this.)

But it is most annoying to have this criticism formulated by sculptors who find it regularly quite natural to portray in marble or bronze figures who fly, run at a gallop, hold themselves upon one toe or, better yet, stand on their head. Sculpture in the modern Salons is the most amazingly complete repertory of artificial movements imaginable. Just look at them and compare them with those of people around you, compare them with your own movements, and you will see how few sculptors are justified in making such a criticism. Obviously, amidst all these conventional, ridiculous, and unharmonious movements, a truly authentic one had every chance of striking those who feel nature and shocking those who do not.

And then, no sculptor will ever again make a movement natural under the pretext that it is not to be found on the list of those allowed by the studio routine.

We may conclude, therefore, that in terms of movement, the Balzac statue was confusing precisely because it was simple and authentic.

• • •

Have we succeeded in demonstrating that the *Balzac* is an admirable work? Alas! we are sure we have not, for such things cannot be demonstrated like a mathematical proposition. Put an insensitive being face to face with the most beautiful ancient statue, or Raphael's most beautiful painting, and all the speeches in the world will not give him the necessary sensitivity and grace. But should he be gifted with this sensitivity, you can sometimes suddenly reveal to him with a word or a gesture something he hadn't perceived before, or had mistaken.

If only, with all our words, we can have offered but one such useful word, we would find consolation not only in having served Monsieur Rodin's new statue, but in having helped in the appreciation of a whole group of works and ideas in which this statue participates.

All the rest is misery.

<p style="text-align:right">Henri Rochefort
"Precious Ridiculousness" (1898)</p>

Under this title, Rochefort has published an article in *l'Intransigeant* as full of good sense as it is witty, one that successfully refutes the absurd theses of a handful of more or less "Dreyfusard" intellectuals, misunderstood esthetes as ricidulous as they are pretentious:

"With regard to Rodin's *Balzac,* I have already received so many letters asking for opinions and consultation that I feel obligated to answer. I believe that by responding to them candidly, I will prove to be a more genuine friend of the eminent sculptor than those terrible esthetes who, once they have crushed him beneath their adoration, will bury him entirely at last.

His *Balzac,* which has so clearly come to light in this strange thin air does not indicate impotency, but is, at the very least, a mistake. In art, as in politics, there are always a certain number of amateur anarchists who specialize in replacing everything with nothing. . . .

It was no doubt the artists and critics of this negative school who persuaded Rodin that he drew too well and that he absolutely had to correct this nasty flaw as soon as possible. So, of course, when they saw the image of the author of the *Comédie Humaine* the way they had dreamed it, they fell over backward in their enthusiasm. Falling over backward is, of course, one more of these specialists' gifts.

I was not present at the scene of the unveiling, but it is nonetheless easy for me to feel that I was, so simple is it to reconstruct the scene. . . .

Everyone was ecstatic over the synthesis of the great novelist's work to be found reproduced in the rictus of the mouth, the shrug of the shoulders, and the folds of the gown.

At last! this is how Balzac must be understood! George Sand, Hugo, Sainte-Beuve had only seen fire; Rodin alone—by means of who knows what X-ray vision—has peered into the great writer's skull.

And beneath such an avalanche, the sculptor probably felt himself becoming God. Only, it seems to me urgent to explain to him that if philosophers are not asked to sculpt, neither are sculptors asked to philosophize and especially as concerns 'synthesis.' The word is hopelessly outdated and is usually used by esthetes to give the impression that they have found meaning in things that have none."

Henri Rochefort, "Les Précieux Ridicule," *L'Anjou,* June 10, 1898. *L'Anjou* republished this article, which had appeared in *L'Intransigeant* several weeks earlier. Translated by John Anzalone.

Frank Harris
"A Masterpiece of
Modern Art" (1898)

It was a morning in June when I walked up the Champs Elysées on my way to the Salon in the Champs de Mars. The Place of Peace was bathed in white sunlight, and there was something fresh and hopeful in the cool, thin air. The gibbering ghosts that at nightfall and in the early dawn crowd about the central fountain and mock the effort of the cleansing waters to wash away the blood-stains, had all vanished, and the little victorias whisked about and the people smiled and chattered as if the past and its enthralling life had no existence. Everything was lightsome and gay; nature seemed to have lent man the quickened pulses of her renewed youth. The great white road drew me, and as I walked I saw the shadowy legions winding up the long hill, and the crowds that rushed together behind them were like the waters seething in the wake of a great ship. At the next moment I was admiring the avenue of chestnut trees with their tiny lamps of waxen blossom.

In half an hour I was to see Rodin's statue of Balzac. What would it be like? Rochefort, whose instinct in matters of Art is almost as fine as his vision of Politics is false, had lectured Rodin, and sided with the Society of the Gens de Lettres, who rejected the artist's gift. His article in the *Intransigeant* had ended with the words, "Literature in painting is bad enough, but the whole of the 'Comédie humaine' in one plaster figure is absurd." But was Rochefort to be trusted to criticise Rodin? True, he had bought Goyas when no one else cared to look at them, and bronzes of Barye when the sculptor's name was only known to the keeper of the Jardin des Plantes as that of an importunate visitor, who wanted to spend the night as well as the day in studying the great cats. Blake's phrase—

> . . . "Nor is it possible for thought
> A greater than itself to know"

came into my mind and put Rochefort out of it.

But our own wonderful critic D. S. M.[1] had praised Rodin's work without, however, describing it. Perhaps I was to have a new artistic sensation and my steps quickened. How I got to the Salon I do not know; it surely was not I who put down a coin and asked the way; yet here I was passing swiftly through a forest of marble figures with dry throat and leaping heart. For there IT stood at the far end, and my excitement was so great that I could not face the hope that sprang to life in me as I peered furtively with

Frank Harris, "A Masterpiece of Modern Art," *The Saturday Review*, July 2, 1898.

[1][D.S. MacColl.—Ed.]

myopic eyes. I stopped before Rodin's *Baiser: that* I had seen before, three years before in the sculptor's studio. But the impression was the old one: the figures are wonderfully modelled; the muscles on the shoulders of the man are knotted and gnarled like oak-tree roots and the great tendon of the leg is strained till the strands begin to separate as the strands of a cable strained to the bursting. And the woman's figure is even finer in its lovely curves of swooning abandonment. "All our modern literature," said St. Beuve, "is sensual," and he might have added, "all our art too." But sensuality here, as in life, has its compensation in a passion of tenderness. Notice how the man's hand only dares to touch the tender flesh and how his arm supports her head and neck. The thing is a masterpiece; but it does not satisfy me as a masterpiece should, and by patient looking I find the reason. The contrast between the man's form and the woman's is striking, but the attitude does not bring out the higher characteristics and beauties of the man's figure as it should. The attitude is conceived in a passion of admiration for the woman's figure, and that is superbly and characteristically rendered; but the man's figure is of necessity huddled and dwarfed. I should prefer to see the woman's figure alone and receive from it the single imperious impression. After all, the kiss is the life of woman but not of man. With a lingering glance of admiration I turn to the Balzac and approach it from the front as it is meant to be approached.

The first impression made upon me is that of an extraordinary grotesque, a something monstrous and superhuman. Under the old dressing-gown, with its empty sleeves, the man stands with hands held together in front of him and head thrown back. There is something theatrical in the pose, something uncanny in the head. Yes, uncanny; the great jaws and immense throat that seems to rise out of the chest and form a part of it; the cavernous hollows of the eyes without eyeballs or sight, and above, the forehead, made narrow by the locks of hair—a grotesque of extraordinary power. The personality of the figure is oppressive: there is in it a passion of labour and achievement, of self-assertion and triumph, which excites antagonism and vague fear. Here is a Titan who has made a world, and could unmake as well. There is something demoniac in the thing that thrills the blood. But, after all, that is the first impression left on one by the author of *La Comédie Humaine.* A mighty workman was Balzac, who wrote forty volumes that have fallen into oblivion and been lost, lost beyond hope of recovery, and then wrote forty more that constitute the greatest dramatic achievement ever produced by one intelligence, except perhaps that of Shakespeare, and then sat coolly down and told the world that he had now learned his art and meant to do extraordinary things, books that should have form as well as meaning, books that—suddenly Death held the restless hands to stillness, and froze the eager brain. Did Rodin mean his work to give this impression?

I moved round the statue, and was struck by the profile. Here the grotesque vanished and the living face appeared. Seen sideways the statue

shows a wonderful likeness to Balzac as he undoubtedly was. True, the moustache curls upwards cynically, but otherwise the face is the face of Balzac himself, with the large jaws and bulbous, scenting nose and eager eyes—a face instinct with a devouring vitality and intelligence.

At length I became aware of Rodin's meaning. Looked at from the front, his statue shows the soul of Balzac, the boundless self-assertion of the great workman, the flaming spirit of one given to labour and triumph. True, there is something theatrical in it, something of conscious pose in the crossed hands and the head thrown backwards; but the pose itself is of the man and characteristic. The profile, on the other hand, is the outward presentment of the man, Balzac in his habit as he lived, the leaping spirit thralled in "this muddy vesture of decay."

I know that some critics, good critics too, will tell me that this statue, which seen in front, gives, as it were, the soul of Balzac, and, seen sideways, gives his very form and image, is and must be an outrage upon all the canons of art. Did not Sir Joshua Reynolds say that "the attempt to unite contrary excellences (of form, for instance) in a single figure can never escape degenerating into the monstrous but by sinking into the insipid; by taking away its marked character, and weakening its expression." All this theoretic stuff may be right enough and even valuable, but what has it to do with me upon whom this monstrosity, this grotesque, has left a deathless impression. In all the range of plastic art I can compare this statue to nothing save the great figure of Michelangelo, which some speak of as the "Day," and others as the "Morning." It will be remembered that Angelo has left the forehead unhewn, uncouth, but by this trick the rest of the face is plunged into deep shadow, and it looks as if the light of the dawning were on the forehead. Here too is a grotesque with a fulness of meaning not to be reached by ordinary forms. Here again is a divine chance rewarding the workman of genius. "Chance," I call it; for it was chance and nothing else that made Angelo finish the lower part of the face first; chance, too, the happy chance that befalls the maker of a hundred busts that gave Rodin this grandiose idea. Here at last is a statue of a great man worthy of the man's genius, and naturally enough it was rejected by the most eminent society of amateurs in France. Right, too: "I came to my own, and my own received me not."

1900: WORLD RENOWN

Wanting to recover from the *Balzac* debacle, Rodin set his sights on 1900 and the Exposition Universelle that was to take place in Paris. He decided to set up a large personal exhibition in conjunction with the great world's fair in the tradition of Courbet and Manet. He borrowed the money and opened his show in a pavilion in the Place de l'Alma that he had especially constructed for the occasion. On May 18, 1900, it opened with more than 150 sculptures, including *The Gates of Hell* and dozens of drawings, watercolors, and prints. The catalogue, with its essay by Arsène Alexandre, was prefaced by comments about him from artists he counted among his best friends: Eugene Carrière, Jean-Paul Laurens, Claude Monet, and Albert Besnard. He sold 200,000 francs worth of sculpture and in the fall dismantled the pavilion and moved it to his home in Meudon where it continued to house his works.

Claude Monet
Letter for Rodin's Exhibition
Catalogue (1900)

You have asked me to tell you what I think of Rodin in a few words.

You know what I think. To say it really well I would need a talent I do not possess; writing is not my business. But that which I can tell you is of my

Claude Monet, *Exposition de 1900; L'Oeuvre de Rodin* (Paris, 1900), p. v.

great admiration for this unique man of our time; he is great among the greatest.

The exhibition of his work will be an event. Its success is certain; it will be the definitive consecration of a beautiful artist.

<div align="right">CLAUDE MONET</div>

<div align="right">

Edmond Picard
The Exposition Universelle
(1900)

</div>

What a strange contrast is the quiet authority of this *musée Rodin* to the tormented spectacle of the Exposition Universelle with its astonishingly bizarre monuments arranged, one might say, according to the caprice of a most restless and abnormal spirit. In its turbulence, its impatience, and its whimsical character the ensemble offers the world the ephemeral result of a baroque fantasy which will set all the brains in Paris on fire for a few months.

Next to this you have this isolated and patient man who lives only to realize the miracles he believes in and which he proposes to offer to this same world: an art touched by the marks of eternity such as has made the statues of ancient, Gothic, and Italian masters live without perishing.

<div align="right">

Rudolf Kassner
"Notes on Rodin's Sculpture"
(1900)

</div>

Rodin is now exhibiting his work in a pavilion at the Place de l'Alma. Here we are able to trace the work of the sixty-year-old master from *L'Homme au*

Edmond Picard, *L'Echo de Paris,* July 19, 1900.

Rudolf Kassner, *Motive Essays* (Berlin: S. Fisher Verlag, 1906), pp. 79–85. Translated by Sabina Quitslund. By permission of Dr. Eugen Rentsch.

nez cassé to the sketches for his visionary work *Le Travail* [Fig. 12]. I shall refrain from listing the names of his works; the catalogue, I believe, gives one hundred and fifty pieces.

We are at an exhibition; yet one has the feeling of entering a workshop. These are works that do not permit any other space around them save that which they create themselves. They are so lively that they seem to be everywhere, yet so lonely that they always look out of place. They do not really represent anything, nor do individual works draw attention to themselves; we are alone with them; knowing one of them we know all the others, and to look at them for long is to get the feeling of looking at oneself. And still we have the feeling of being in a workshop; we can never forget that someone has been here and worked with stone, that something has happened to the stone, and that something has come into being from the stone.

We see nude figures, as well as busts. The latter, when they are clothed, give the impression of being on their way to the street, to a stage, or to a masquerade. Nothing is more dispensable to this show than the catalogue. The titles can, in most cases, be interchanged, altered, or even omitted. Like many titles for works of art, or like the philosophical aphorisms of Victor Hugo, they are simply commonplace.

As I have said, here we have nude bodies—single, in pairs, or in groups—bodies that embrace each other, that cling to each other, that grapple with one another in love or in hate, that kneel in front of each other, that hover or fall down. I shall provide no more description. It would be foolish to attempt to express something in words for which music alone can give new interpretation. These limbs are only suggestions of gestures; they are like strings on an instrument.

These figures are under the influence of something more powerful than they themselves. It is difficult to know whether they should die or whether they should come alive. With animal heat they twist about each other, with their eyes and mouths expressing the shame of beings not allowed to rest. As I mentioned, they are either groups or are single figures. And strangely enough most of the single figures are torsos. They seem so natural you almost fail to notice they are fragments. It is as if they had to be this way! As if something was inevitably missing! They seem as though torn from a group, from a harmony; they have lost something, or left it behind. In general we can say Rodin is the creator of lovers and of torsos.

The bodies are not free, or at least the better portion of them is not free. Something of the uncut stone always remains. Rodin's reliefs are similar to his torsos. They are natural reliefs in that the human figures always remain part of the relief, of the matter from which they have been created. We know not whether these bodies break out of the stone or turn back into it. Gestures remain in spite of love and death, and illusions in spite of fate. When they are free they are trembling, feverish, or blinded, as if they wanted to retreat back into the silence from which they have been forced to emerge. They are like fish thrown onto the beach! Then they search for

something, they find another body, twist around it as if they wanted to indent themselves into it. And the artist? He writes beneath such a group "Love." On account of Rodin I feel I must rewrite Plato's *Phaedrus*.

Do not look for eyes in these beings. The eyes are blind as the stone from which they have been cut, and as blind as the music in which the bodies dissolve. Only the torsos and the busts have eyes. Rodin's busts are torsos by necessity and not by convenience as we usually see in busts. Their eyes are not looking at us, they do not focus, but they look; their whole being becomes an eye watching for life, for completion, for love, for the impossible. Never before Rodin have eye sockets alone held such life. They exist as if we were to look through their eyes with our own, and as if our knowledge was to complement their longing. The position of a body can have something indefinite about it, something out of the ordinary, immediate, intentional in the pose. It reminds me of Rembrandt's self-portrait in the Louvre, which shows eyes no longer having the serenity of youth that can render each object in a painting clear and then put a frame around it; here are eyes that see through things, toward something that no frame can contain; the head and upper part of the body are unstable, almost accidental. We find in it the same kind of wisdom we find in Rodin's sculptures, a wisdom reached through different paths.

But I must not forget: at one point Rodin did provide eyes for one of his heads. It is the head of a young woman resting on a block, that is, the chin grows out of the stone. You must stoop to see the eyes, which are looking downward. They are like two small flowers that let their blossoms hang toward the earth. Rodin calls this head *La Pensée—Thought*.

In such works I can discern two virtues that are interdependent: the virtue of the material from which they are made and the virtue of the creator who has made them. The essence of art has never been more purely nurtured than by Rodin. Here his concept of art reveals itself completely; it becomes transparent enough that we can easily read the message. So, the virtue of the stone is the powerful emotion that renders these forms sightless, and the virtue of the creator is the ideal, the reach for the impossible. What they hide is their style; in solitude they find unity, and their beauty is, how shall I say it, something so eternal and so immediate as we expect to find only in music. Here we have two eternal and clashing opposites, two impossible desires for forms that embrace by chance, without their knowledge, and then against their will are forced into separate resounding forms. It is like the prelude to *Tristan und Isolde*.

Like Wagner, Whistler, and Swinburne Rodin is a dialectic thinker and a musician, and his intellect is equal to his creative powers. He is wary, yet he is a revolutionary; he is perverse, yet natural; he is the last in a long tradition and at the same time the first representative of a future art. In the effects he strives for he is poet, painter, and etcher; yet he shows fidelity to the material under his hand. His entire body of work is new and surprising, yet it is an unending variation on eternal themes, which I wish to name: nature and

spirit, life and poetry, love and death. Rodin is never more concrete nor more sensuous than when choosing those abstract titles for his works. In the most natural way he calls them "Evocations" or "Illusions" in order to describe their essence. Rodin is both magician and sage, and therefore his pieces are both evocations and illusions. His portraits have something of the mask about them, with clothes thrown about them as if they were going to a masquerade.

Rodin has been called a Symbolist. He certainly is if that means that his work is sensuous. Symbols represent an intensification of nature, and no one knows better than Rodin how to focus on those aspects of nature that are symbolic. And just as his works can be seen as "Evocations" or "Illusions," they can also be called "Fulfillments." Rodin, magician and sage, emerges in the end as the pure artist.

Rodin is the most modern among living artists. From the standpoint of history, he is the only one who is necessary. It is not empty phrase when I claim that the development that starts with the Greeks and reaches its midpoint with Michelangelo would not be complete were it not for Rodin. Rodin is literally epoch-making, something that one cannot claim for Meunier or Klinger. Next to his work most modern artists appear to be merely imitating the Greeks or the Renaissance artists. Rodin was needed. What was still metaphorical or romantic in Michelangelo's work has become real in Rodin's work; in him the Greeks find an opposite force, one equal to their own. As with the Greeks, where the best of life was found through art, here all life is consumed in order to produce a few works. I can well imagine an individual who might love the Greeks only after having seen and comprehended Rodin's work. This individual would loudly and knowingly proclaim the *Doryphorus* and the *Venus de Milo* as eternally beautiful once he had understood the truth of Rodin's *Le Sculpteur et sa Muse* and *L'éternelle Idole*. I know no work possessing so little serenity as Rodin's. The serenity of the Greeks ceases to be commonplace when we look at his work; in other words, no one can talk about the serenity of the Greeks without having known Rodin, unless the feeling he has toward life be equal to that of Rodin himself. For the serenity of the Greeks was not the carefree life about which dim-witted people talk, those people who are barely able to scan the *Iliad* or read Sophocles. Rather the Greek's serenity was their belief in stone, in the human race, in what was in them, and in their consciousness of what was to come after them. In contrast Rodin's human beings see nothing above or below them, and know nothing of the things that will come after them. They are frighteningly lonely in the arms of their lovers and in the face of their ideals.

Perhaps I am wrong. But recently, when I stood in front of his sculptures, the master himself was there giving instructions to his assistants. This then is the man, I said to myself, whom some of the "officials"—for that is how they are called here—consider mad; he, who along with Daumier, is the greatest artistic genius of modern France. He looks like a master-mason

in Sunday clothes: stocky, with broad shoulders, his hands like a laborer's, his movements full of heavy carelessness, and only the wide mouth under the dense beard betrays his extraordinary energy, the energy of a man of will, but one who is not without a sense of irony and who is cognizant of what he has overcome. Perhaps this is serenity.

Anatole France
"The Gates of Hell" (1900)

The work of Rodin, exhibited in a pavilion at the corner of the avenue Montaigne and the quai de Billy, is stunning in its beauty, which is simultaneously new and traditional. . . .

Auguste Rodin seems at the present time to be exactly what he is: the equal of the greatest. He is a deeply learned artist and an ingenious innovator; his work naturally takes its place among the masterpieces of the past, ranking easily with the highest creations of art. And he enters into glory amidst the croaking of frogs. So, formerly, did his peers. New beauty is always offensive to the eyes; an insufferable insult to common mediocrity, it troubles the facile complacency of vulgar souls. Insult and outrage have always been the price of genius, and Rodin, after all, has paid no more than his legitimate dues. . . .

Only a sculptor of movement could express ardent immobility.

It is in this respect that Auguste Rodin is so expressive, and in this respect his *Gates of Hell* is so touching. Even in its present state—moulded in plaster with its panels devoid of the figures that are to be placed in high relief upon them, it is a work of profound meaning and powerful expression. I know of nothing more moving. The initial idea is from Dante; if we look into this world of voluptuousness and pain, we can find Francesca, Ugolino, and Virgil. But Rodin's Hell no more resembles Dante's Hell than the thinking of our era resembles that of the thirteenth century. The supple forms that descend along the pilasters, the couples softly intertwined, the groups that desperately writhe are indeed carried along once more by the invincible wind, "la bufera infernal." And when the wind dies down, these souls tell us, as Francesca told the Florentine poet, of "the sweet thoughts and desires

Anatole France, "La Porte de l'Enfer," *Le Figaro,* June 7, 1900. Translated by John Anzalone.

which led them to this painful passage." But compare this modern hell to that painted on the walls of the Campo Santo in Pisa or in one of the chapels of Santa Maria Novella in Florence by the Tuscan painters who were inspired by the *Divine Comedy*. Recall the damned placed at the left hand of God in the magnificent portal of Bourges. In these representations of theological hell, sinners are tormented by horned devils who often have two faces. . . . In Rodin's hell there are no more devils, or at least the devils are hidden within the damned. The evil spirits who make these men and women suffer are their passions, their loves, and their hatreds, their flesh and their thoughts. The couples "who pass so lightly in the wind" cry out

> Our eternal tormentors are within us.
> We hear within the burning fires.
> Hell is earth and human existence,
> it is the passage of time and it
> is the life during which we are
> always dying. . . .

Even without trying to understand too deeply what this sublime masterpiece is saying, it is impossible not to recognize the sadness and unhappiness in this creation of a master who knows how to explain with incomparable power the touching weariness of flesh endlessly worked upon by movement and incessantly devoured by life.

It is to discover with sympathy that Rodin's Hell is no longer one of vengeance; it is a hell of tenderness and pity.

<div align="right">

Gustave Kahn
"Hands in Rodin's Work"
(1900)

</div>

Verlaine, among other delightful discoveries, is the poet of hands. It is he who first set them to music. They are delicate tender hands that soothe the sick man when they are placed upon his brow; little hands that give so much pleasure and pain in that single caress, which ends in the swipe of a claw; and his own terrible brutal hands, his own long, thin, grey hands, covered with

Gustave Kahn, "Les Mains chez Rodin," *La Plume*, 1900, pp. 316–17. Translated by John Anzalone.

coarse hair, hands that hurt him so one evening when, in fixed and penetrating vision, he saw them to his right and to his left as if detached from himself and brandishing before him sinister projects that he knew nothing about, but was able to recognize by their clenched look. Those who have spoken of hands in poetry since Verlaine have done no more than develop the variations on a theme he virtually exhausted at the outset.

And Rodin is the sculptor of hands—furious hands, clenched hands rearing in their damnation. Here are hands that writhe as though to grasp the void, gather it up to knead and shape it into an ominous snowball to be cast down upon the happy passerby. Here is another crawling violent hand, an enemy on bloody stumps. And another, crushed upon a smooth empty surface, a decidedly heavy hand, its grip useless, its fingers sliding across the emptiness like protestations of innocence in the mind of an executioner. Still another seems at first twisted in a violent attempt to hold on to money, or a woman, or truth, and then, giving up and letting the iridescent bubble float away, suffering and trembling still from the effort contracting it.

The hands by the great sculptor have presence and life like those of the poet Verlaine. They are sad hands, furious and tired hands, hands full of energy, or sagging in fatigue; they are hands of one who has embraced chimeras or passions, the hands of heroism or the hands of vice.

Gustave Geffroy
"The Centennial Exhibition of French Sculpture" (1900)

At the Centennial, Rodin is represented by *The Age of Bronze,* the *Head of Saint John the Baptist,* the *Creation of Man,* one of the *Burghers of Calais,* and the busts of Jean-Paul Laurens, Dalou, Victor Hugo, and Mme. Russell; at the Decennial he shows *The Kiss* in marble. But for a comprehensive view of his work, you must go to the pavilion he has had constructed near the Pont de l'Alma. Those who really wish to see, who come as innocent lovers of art and not as pedants with a conceptual axe to grind, will find there a great naturalist sculptor in pursuit of an infinite variety of forms in motion. Related by the strongest ties to the great sculptors of ancient Egypt and

Gustave Geffroy, "L'Exposition Centennale de la Sculpture française," *La Vie artistique,* vol 7, 1901, pp. 239–41. Translated by John Anzalone.

Greece, he is also the brother of the Gothic cathedral builders; relentless study has taught him the secret of concentrated force as it was enjoyed by the great Renaissance artists, and he is a portraitist in the same measure, with the same lucidity that has been maintained by artists of our race in the face of every change in taste. Like it or not, he must be included in the history of sculpture where his name assumes the importance of a date, a revolution, a renaissance.

Moreover, he has been especially criticized, not so much for his genius, as for the explanations of it that writers have attempted to give. Along with other artists, he has been designated a "victim of literature!" and he is pitied for having become the prey of enthusiastic writers and exaggerators. It is a criticism that has been printed, and it was formulated by sculptors and painters who themselves would like very much to be "victims of literature." In other words, they would very much like to be artists written about in this literature they despise! Not everyone can be a "victim of literature!" If Rodin has been chosen for this particular martyrdom, it is for the simple reason that his work is among that which best represents the creative force of art and the incessant production of new forms. Each of these forms, born of a vision or a sensation, can be seen to correspond inevitably to a world of feeling and ideas. Naturally then, much has been written about Rodin; in all likelihood this will continue.

Camille Mauclair

"Auguste Rodin, His Work, His Life, and His Influence" (1901)

Today Auguste Rodin is in full possession of his glory. When you consider his tireless production over forty years, you can understand the degree to which he has had to wait for this fame. Out of the rough blocks of indifference and blind injustice, the artist has brought forth this glory each day with the blows of his chisel; only now does it awaken in its purity, though still recalling the difficult times in a fashion similar to the trembling muse who emerges from the darkness behind the shoulder of Victor Hugo in the

Camille Mauclair, "Auguste Rodin, Son oeuvre, son milieu, son influence," *Revue Universelle*, August 17, 1901. Translated by John Anzalone.

magnificent homage the sculptor has paid to the poet. It has been ten years now since the elite first hailed Rodin. Three years ago the mob was still laughing at him; and it is only very recently that they have dared to do so no longer. Only now does the writing of certain critics cease to seem excessive, or distorted by friendship, when they recall the ancients, the Gothic sculptors, Donatello, and Puget in referring to this man who carries on without flinching in their shadows. Certainly Rodin's influence is enormous. Today everyone understands that in Europe in this century there is only one sculptor who has shaped *Saint John the Baptist* and erected *The Gates of Hell*, and that he has been powerful enough to grasp all of sculpture and to lift it out of the rut into which it threatened to sink. Perhaps one man can counter the indoctrination of the academy; if so, Rodin is the only one who can do so. The sophistry of "finished" work, the dangers of elegance, the prejudice favoring "noble" statuary, the distortion of vital truths for the sake of convention, and the depreciation of art in favor of anecdote—all these have not only been dispersed by Rodin's example, but have become tacitly forbidden to the new generation of sculptors. The decisive lesson regarding the inanity of these notions has been written with calm and lucid mastery into the least important of Rodin's bronzes.

What is Rodin like? Visit him; then you will know. Let's enter his atelier at the Dépôt des Marbres. The chestnut trees in the courtyard cast soft green shadows through the cold windowpanes. Four bare walls, a few ordinary chairs, worn, plaster-spattered tripods, smocks hung on nails, a cast-iron stove and a floor littered with dusty maquettes, come now! Can this be the place of one so famous? We must have entered by mistake into the studio of a poor beginner. Not at all. A glance at the scattered statues tells us that we would find them in only one place: we are indeed "chez Rodin." And here he comes, appearing from between the gigantic mass of Hugo and an Adonis sleeping on a pale, transparent bed of marble. He rushes forth, this small man with heavy shoulders, an enormous head, and the bearing of a lion at rest. We see best what is above the torso: his head with its strong nose, the flowing gray beard, the protruding forehead, the two small pale gray eyes that are wide open and lighter than the skin of his face. The first impression is of a man with a truly lionlike constitution: he is all bust, the legs are short, the hands strong, though not without delicacy, and always this impression of power, accentuated by the easy movement in his hips, the strong look of his troubled forehead, the bony thickness of his aquiline nose, and finally by the massive, twisting beard, which seems somehow contradicted by the ironic, reticent crease of the mouth and the timid, naïve, myopic look that is at once penetrating and malicious (this is one of the most composite looks I have ever seen), and, finally, by the voice. His is a deep voice and yet he has difficulty with low-pitched inflections, then suddenly he reverts to pronouncing words through his teeth while nodding his head in a very special manner that further modifies the meaning and sense of the conversation. A simple man, or so he appears; he is cordial without being in any way playful.

No, rather, one would say he is courteous, precise, and reserved. Little by little, the initial impression of timidity becomes one of authority, one that is very calm and special. Nothing in this man is bombastic. He is not awkward either. When you enter you naturally bear him a deferential respect in response to everything you know of his fame and worth. When you stand before the man himself this respect asserts itself even more strongly; yet he never pontificates, he seems more sober than inspired. An immense, latent energy emerges in his sober gestures and is revealed in the measure that commands them. The very deliberateness of his language and the absolute sobriety of the terms he chooses gives a special value to what Rodin says. He is one of those men whose pauses in the midst of an explanation are full of significance. In this he resembles Mallarmé who, compared to Rodin, possessed more eloquence. But there is the same gravity, the same veiled language, spoken with serious circumspection, emerging suddenly in several crisp sentences with just enough words to circumscribe a thought without overloading it. Standing before a statue Rodin has a very curious way of making you understand his intentions; it is at once elliptical and perfectly clear. . . .

The silent, white creatures in Rodin's studio are his companions. He loves them; he acknowledges them as having their own individual life once he has created them. He feels he has moral obligations toward them. Basically, the only source of adoration for Rodin—and it is also the source of his genius—is the life of permanent forms. His ideas are restrained, his opinions vague. He perceives other people only marginally, and his cordiality is a matter of form, a quick way of fulfilling his social obligations towards them. His very delicate moral antennae are all he needs to recognize those he loves. I do not wish to suggest that he is not capable of friendship, of course; but to my way of thinking, this friendship is limited to tact and to conscience. The rest, for Rodin, is a matter of what is called social relations, and he grants minimal importance to the psychological nuances of people and to their ideas about their position. He doesn't put his faith in people, rather in broad ideas. He loves only his work; the rest he tolerates with polite boredom. Sketches and schemes—things that can be translated into marble: that for him is his moral universe. He has read very little and loves only a few books, but these he loves passionately: Baudelaire, for example, whose poems he has so marvelously illustrated with his drawings for M. Paul Gallimard. He loves the grand, the somber, or that which seems to be, or even the reflection of the things he loves. (I note a curious characteristic: Rodin who is such a fanatic for Baudelaire's poems responds enthusiastically to the musical scores that M. Rollinat sometimes appends to them.) For outsiders Rodin never appears to be a brilliant "intellectual." He has lived as a poor worker without means. Once upon a time, so people say, he worked for Carrier-Belleuse fussing with decoration and the epaulettes on official busts that were entrusted to that mediocre sculptor. Whenever he dons the coat of the Legion of Honor and is forced to recall that he is a famous man and the

president of the sculpture jury of a powerful society, he becomes uneasy. He finds momentary, transitory things disappointing and painful. He avoids them whenever possible and does so with an ironic smile. He would not seem like an artist at all to someone who was used to the type of the British painter who is elegant in dress and speech, who is literate, informed, and aristocratic. People approach him expecting to find a master of the energy and the graces of life, the incarnation of the nervous, worrisome artist. Instead they find a simple, unpolished man, an artist whose gaze is full of sly good-nature, and who detests arguments and disturbances. When all the hue and cry went up over the *Balzac,* his friends came running, full of advice: "Don't give up," they told him. "Impose yourself and your work. Right is on your side and the statue itself demands that you assert yourself." He listened, was always pleasant, and then he withdrew the statue. The matter was closed. Rodin cares only for his atelier.

He is as an element, a force of nature. And his simplicity is the source of his simplifications. He reduces everything to a question of values. He sees only the outlines both in morality and in art, and he lives according to two or three basic principles, which are all rooted in the same aversion to everything that is not essential. This characteristic explains the intimate connections between his life and his work. For such a simple man, only formulas are intelligible. And what are the formulas for this man who expresses himself in sculptured figures? They are symbols.

When we touch upon Rodin's symbolism, we touch upon what is the most clearly original trait of his genius. Rodin is a symbolist and he is also a man of tradition, which is quite a different thing from belonging to a school. People praise him as a revolutionary, but to do so is to miss the point completely. He reacts against the false tradition of degenerate Italianism, which has poisoned French taste from the time of the School of Fontainebleau to the Ateliers Julian. His reference points are Puget, Goujon, the sculptors of the Middle Ages, of Greece, and the rules for decoration established on the Lion Gate of Mycenae as well as the Serapeum of Memphis. And what does this revolutionary innovator, this man shamed by defensive academicians, bring us? Mythological sculptures. He has created Adonis, Icarus, Fauns, Danaïdes, naiads, Psychis, and chimeras just as they do at the Ecole des Beaux-Arts. He does an Orpheus, illustrates Dante's hell, and sculpts Ugolino. But he alone has "la manière." He has understood perfectly that sculpture is the art of creating dense mythological images and that myth and life can meet most naturally in a nude figure, one that is both permanent and human. Rodin expresses everything in the naked human body just as Mallarmé did with a few elliptical images. I have already joined these two names in writing because it seems to me that important analogies exist between the two artists. Mallarmé was himself his best and most fully realized creation. Rodin, the more fortunate of the two, has achieved self-realization through his creatures. And I emphasize the union of the two names only to point out that what has been so unjustly called an extremely

decadent artfulness in Mallarmé's work is synonymous with extreme simplicty in Rodin's work. The kind of mythology that both adore and consider as the supreme expression of emotive thought, that inexhaustible treasure trove of primitive symbols, is certainly not the mythology of M. Bouguereau or of any of the honorable mediocre sculptors. It is a synthetic psychology of human feeling, and this synthesis comes to the strong as simplicity, to the weak as a source of astonishment.

Gustave Moreau, Puvis de Chavannes, Mallarmé, Rops, and Rodin have all taken up mythological subjects that are right out of the academic repertory, subjects one would have supposed to be utterly worn-out. And yet they have found in them the source of a flow of new impressions: Moreau in his accumulation of details of mysterious luxury and oriental symbolism, Chavannes in the simplified serenity of a pure, heroic nudity, hardly strengthened by accessories, Mallarmé in the rhythmic harmony of his imagery and the studied choice of rare epithets, and Rops in modern neurosis. As for Rodin, he gives myth a new life through his personal aesthetic, through the particular meaning of gesture, through the strange psychological intensity of the mask, through his unpredictable groupings. He is at once masterful and restless. He sees people as drawings: a line traces the basic silhouette, which is filled in with a watercolor tint that gives volume to the forms. For Rodin that is sufficient. Psychologically he conceptualizes in the same manner: a group is colored by the dominant feeling in the person with whom he is involved. His sculpture is obedient to this extraordinary synthetic force. . . .

Rainer Maria Rilke
Letters (1902)

TO ARTHUR HOLITSCHER

Westerwede Bei Worpswede
July 31, 1902

I am completely taken up with Rodin who grows and grows upon me the more I see and hear of his work. Is there anyone, I ask myself, who is as great as he is, yet still living (often it seems to me as though death and

Selected Letters of Rainer Maria Rilke, Translated by R.F.C. Hull (London: Macmillan & Co., 1946), pp. 2–9.

greatness were but one word; I remember when I fist read *Niels Lyhne* years ago in Munich, how I took it upon myself to seek out the man who had written it . . . later I heard him spoken of as one long since dead . . .)—and Rodin *is* still living. Quite apart from his art I have the feeling that he is a fusion of greatness and strength, a future century, a man without contemporaries. In such circumstances you can imagine how impatiently I am awaiting the first of September, the day I set out for Paris . . .

TO CLARA RILKE

Paris, 11 Rue Toullier
Tuesday, 2 September 1902

. . . Yesterday, Monday afternoon at three o'clock, I was with Rodin for the first time. Studio rue de l'Université 182. Went there on the Seine. He was modelling. A girl—he had a little plaster thing in his hand which he was scratching at. He stopped working, offered me a stool, and we talked. He was kind and mild. And it seemed to me as though I had always known him. As though I were only seeing him again; I found him smaller and yet greater, kindlier and more sublime. The forehead, the way it stands in relation to the nose, which goes out from it like a ship leaving harbour—is very remarkable. There is something sculptural in this brow and nose. And the mouth has a speech whose sound is good, friendly and full of youth. His laugh is like that too, the embarrassed and at the same time joyful laugh of a child receiving a fine gift. I like him very much. I knew that at once. We spoke of many things (as far as my queer French and his time allowed of it). . . . Then he went on with his work and bade me examine all the things standing about in his studio. Which is not a little. The *Hand* is there. *"C'est une main comme ça,"* he said, and made with his own such a powerfully clinging and forming gesture that you fancied you could see things growing out of it—*"C'est une main comme ça, qui tient un morceau de terre glaise avec des . . ."* And pointing at the two wonderfully deep and mysteriously united figures: *"C'est une création ça, une création."* . . . Wonderfully he said that. . . . The French word lost its "charm" and had none of the elaborate heaviness of the German word: *"Schöpfung"* . . . it had detached itself from all languages, gained its freedom . . . was alone in the world: *"création".* . . .

And now today: today I travelled by the nine o'clock train to Meudon (gare Montparnasse, from there a twenty minutes' journey). The villa, which he himself has called *un petit château Louis XIII,* is not beautiful. It has a three-windowed front, red bricks with yellowish window and door frames, a steep grey roof and a high chimney. The whole "picturesque" disorder of the Val Fleury is spread out before you, a narrow valley where the houses are poor and look like those in Italian vineyards (and vineyards are probably here too, for the steep dirty street of the place you go through is called Rue de la Vigne . . .); then you pass over a bridge, another bit of street, past a small, thoroughly Italian-looking osteria. On the left is the gate. First a long

avenue of chestnuts strewn with coarse gravel. Then a little wooden trellis-gate. Again a little wooden trellis-gate. Then you come round the corner of a small red-and-yellow house and stand—before a miracle, before a garden of stones and plaster-casts. His big pavilion, the same that stood on the Pont de l'Alma at the exhibition, has been set up in his garden, which it appears to fill completely, together with some more studios where there are stone-masons and where he himself works. Then there are rooms for clay-firing and for every kind of handwork. It is a tremendously great and strange sight, this vast light hall with all its white dazzling figures looking out from the many high glass-doors like the denizens of an aquarium. The impression is immense, terrific. You see, even before you have entered, that all these hundreds of lives are *one* life, vibrations of one force and one will. Everything is there, everything. The marble of *la Prière:* plaster-casts of almost everything. Like the labour of a century—an army of work. Some gigantic glass-windows are entirely filled with wonderful fragments from the *Porte de l'Enfer.* It is indescribable. Acres of fragments lie there, one beside the other. Nudes the size of my hand and bigger, but only bits, scarcely one of them whole: often only a piece of arm, a piece of leg just as they go together, and the portion of the body which belongs with them. Here the torso of one figure with the head of another stuck on to it, with the arm of a third . . . as though an unspeakable storm, an unparalleled cataclysm had passed over his work. And yet the closer you look the deeper you feel that it would all be less complete if the separate bodies were complete. Each of these fragments is of such a peculiarly striking unity, so possible by itself, so little in need of completion, that you forget that they are only parts and often parts of different bodies which cling so passionately to one another. . . .

TO CLARA RILKE

<div align="right">

Paris, 11 Rue Toullier
5 September 1902

</div>

. . . I believe that in the last few days much has become clear to me concerning Rodin. After a déjeuner which was not less disturbed and strange than the one recently mentioned, I went with Rodin into the garden, and we sat on a bench which had a wonderful view right out over Paris. It was quiet and lovely. . . .

He spoke of art, of art-dealers, of his own solitary position and said many very fine things which I felt rather than understood, for he often spoke very indistinctly and very quickly. Always he came back to the beauty which is everywhere for anyone who truly understands and wills it, came back to *things*, to the life of these things—*de regarder une pierre, la torse d'une femme*. . . . And always, again and again, to work. Ever since the physical, the really heavy work of the craftsman has been regarded as something inferior, he said, work has ceased altogether. I know five, six people in Paris who really work, perhaps a few more. There in the schools, what do they do year

in and year out—they "make compositions." In this way they learn absolutely nothing of the nature of things. *Le modelé . . .* I know what that means: it is the science of planes as distinct from contours, that which fills out all contours. It is the law governing the relationships between these planes. You see, for him there is *only* the *modelé . . .* on all things, on all bodies, he detaches it from them, and after he has learnt it from them he makes of it an independent entity, that is, a work of sculpture, a work of plastic art. For this reason a piece of arm and leg and body is for him a whole, a unity, because he no longer thinks of arm, leg, and body (that would seem to him too thematic, you see, too *literary,* as it were), but only of the *modelé,* which is self-contained, which is in a certain sense ready and rounded. . . .

THE MEANING OF RODIN'S ART

With the 1900 exhibition Rodin became an international star—"une grande vedette"—sought out by important people from all over the world. He traveled more than ever and he received distinguished visitors at Meudon: the king of Cambodia came in 1906 and the king of England in 1908. And Rodin received honors: the presidency of the International Society of Painters, Sculptors, and Engravers in 1904, and honorary degrees from the universities of Jena and Oxford in 1905 and 1906. He was made a Grand Officer of the Legion of Honor in 1910. With such attention we find an ever wider audience wanting to know how such a great artist interpreted the meaning of life both through his work and his words. And they felt that his views of life had relevance to society at large.

Arthur Symons
"Rodin" (1902)

Rodin will tell you that in his interpretation of life he is often a translator who does not understand the message which he hands on. At times it is a pure idea, an abstract conception, which he sets himself to express in clay; something that he has thought, something that he has read: the creation of woman, the legend of Psyche, the idea of prayer, of the love of brother and sister, a line of Dante or of Baudelaire. But more often he surrenders

Arthur Symons, "Rodin," *Fortnightly Review,* London, June 1902, pp. 963–66.

himself to the direct guidance of life itself: a movement is made before him, and from this movement he creates the idea of the movement. Often a single figure takes form under his hands, and he cannot understand what the figure means: its lines seem to will something, and to ask for the completion of their purpose. He puts it aside, and one day, happening to see it as it lies among other formless suggestions of form, it groups itself with another fragment, itself hitherto unexplained; suddenly there is a composition, the idea has penetrated the clay, life has given birth to the soul. He endeavours to represent life in all its mystery, not to penetrate the mystery of life. He gives you a movement, an expression; if it has come straight from life, if it has kept the living contours, it must mean something, and he is but your comrade in the search for that meaning.

Yet he is never indifferent to that meaning; he is rarely content to leave any single figure wholly to the chance of interpretation. Rodin is a thinker, as well as a seer; he has put the whole of his intelligence into his work, not leaving any fragment of himself unused. And so this world of his making becomes a world of problems, of symbols, in which life offers itself to be understood. Here is a face, fixed in an attitude of meditation, and set aside unfinished, to which a hand, lifted daintily to the temples, has found its way out of another study; and the man's hand waits, giving the movement which completes the woman's head, until the hand of the same model has been studied in that position. Here two lovers, on the back of an eagle, are seen carried to the same point of heaven on the flight of the same desire. Christ agonises in the Garden of Eden, or it may be Prometheus; he is conquered, and a useless angel, who cannot help, but perhaps comes as an angel of glory, hovers down to him. A shoal of rapid Muses, hurrying to reach the poet, swim towards him as upon carrying waves. A great Muse, swooping like an eagle, hurls inspiration into the brain of the poet. Another figure of inspiration, an Iris, meant for the monument of Victor Hugo, is seen arrested in a moment of violent action, which tears the whole body almost in two. With one hand she grasps her foot, drawing the leg up tight against the body; the other leg is flung out at a sharp angle, in a sudden, leaping curve. All the force of the muscles palpitates in this strenuous flesh; the whole splendour of her sex, unveiled, palpitates to the air; the messenger of the gods, bringing some divine message, pauses in flight, an embodied inspiration.

In a group meant for some shadowy corner of a park, among growing things, dear to Pan and the nymphs, a satyr grasps a woman with fierce tenderness, his gay animal face, sharpened with desire, the eyes oblique like the ears, appearing over her shoulder; his hoofs clutch the ground; one hand catches her by the hair, the other seizes her above the knee, as if to lift her in his arms; she pushes him away, startled, resisting the brutality of instinct, inevitably at his mercy. Here are two figures: one, a woman, rigid as an idol, stands in all the peace of indifference; the other, a man, tortured with desire, every muscle strained to exasperation, writhes in all the ineffectual energy of a force which can but feed upon itself. She is there, before

him, close to him, infinitely apart, and he could crush but never seize her. In an exquisite and wholly new rendering of the Temptation of St. Anthony, the saint lies prostrate, crouched against the cross, which his lips kiss feverishly, as he closes his pained eyes; the shoulders seem to move in a shuddering revolt from the burden which they bear unwillingly; he grovels in the dust like a toad, in his horror of the life and beauty which have cast themselves away upon him. And the woman lies back luxuriously, stretching her naked limbs across his back, and twisting her delicate arms behind her head, in a supple movement of perfectly happy abandonment, breathing the air; she has the innocence of the flesh, the ignorance of the spirit, and she does not even know what it is to tempt. She is without perversity; the flesh, not the devil; and so, perhaps, the more perilous.

It is interesting to compare this version of a subject which so many artists have treated, always in a spirit of perversity or of grotesque horror, with all those other versions, from Hieronymus van Bosch, with his crawling and swooping abortions, in whom there could lie no possible temptation, to Rops, with his woman of enticing flesh spread out mockingly upon the cross, from which she has cast off the divine body. To Rodin it is the opposition of the two powers of the world; it is the conflict of the two rejections, the two absolute masters of the human will. St. Anthony cannot understand the woman, the woman cannot understand St. Anthony. To her, he seems to be playing at abnegation, for the game's sake, stupidly; to him, she seems to be bringing all hell-fire in the hollow of her cool hands. They will never understand one another, and that will be the reason of the eternal conflict.

Here is the Balzac, with its royal air, shouldering the crowd apart, as it steps into the final solitude, and the triumph. It is the thinker of action, the visionary creator of worlds, standing there like a mountain that has become man. The pose is that of a rock against which all waves must dash themselves in vain. There is exultation, a kind of ferocity of enjoyment of life and of the making of life, in the great beaked head, the great jaws, the eagle's eyes under the crag of eyebrows. And the rock which suggests the man, the worker wrapped in the monastic habit of his dressing-gown, all supple force under the loose folds of moulded clay, stands there as if growing up out of the earth, planted for the rest of time. It is the proudest thing that has been made out of clay.

It is Balzac, but it is more than Balzac; it is the genius and the work of Balzac; it is the "Comédie Humaine," it is Seraphita and Vautrin and Lucien and Valérie; it is the energy of the artist and the solitude of the thinker and the abounding temperament of the man; and it is the triumph of all this in one supreme incarnation, which seems to give new possibilities to sculpture.

Dujardin-Beaumetz
Speech delivered for the Inauguration of Rodin's *Thinker* in front of the Panthéon, April 21, 1906 [Figs. 13 and 14]

Ladies and Gentlemen,

The Government of the Republic, in deciding to erect Rodin's *Thinker* on the threshold of the national shrine, has chosen to honor a great artist.

It has also felt that this location allows the moral significance of a work of art that fuses grandeur of idea and beauty of form to be most clearly comprehended.

I wish to thank those citizens who, at the initiative of the directors of *la Revue des arts de la vie* and by means of a public subscription, have today presented the State with this noble statue, one of the finest examples of modern French Art.

Facing this work, we must recall the fine works that have preceeded it: *The Age of Bronze,* which seems to have issued from the chisel of a Greek master, *St. John the Baptist Preaching* and the *Monument to Victor Hugo,* busts that are already famous, and *The Call to Arms,* which, with arms stretched out in a final appeal, fists convulsively clenched, a wing broken and falling, desperately claims victory or death.

The same master who has so illustrated the nature of tragedy has known how to reveal the enveloping and seductive charms of the sweet embraces of a creative life.

Like the great sculptors Rude and Carpeaux, and under the same clear light of day, Rodin gives us a feeling for a moral life, but one not unconnected with the urges of the life of the flesh. His *Gates of Hell,* at once so dreadful and so tender, shall remain for us as the synthesis of his genius.

No one has studied better the masters of the past; no one has understood better the serene grandeur of classical sculpture and the expressive beauty to be found in the images of medieval France.

Rodin's professionalism, which is fitting to recall today as we honor this artist, has revealed to him the beauty that lies hidden within the raw material available to the sculptor. Out of this inert matter, his ardent imagination has made art burst forth like an oak emerging from the depths of the earth to spread its boughs.

Rodin is a man of the people. After the long battle he fought for recognition during the many years when he was misunderstood, this truly

There is a printed copy of this speech in the archives of the Musée Rodin in Paris. Translated by John Anzalone.

creative artist, so shaped by humanity and conviction, is finally able to work peacefully in the shining light of universal admiration.

On this spot where the *Thinker* has been erected, a monument now proclaims the nation's gratitude toward the illustrious men who have made our land just, proud, and free.

In the superb pediment above, another great aritst [David d'Angers] depicted France awarding crowns to artists, to savants, to military leaders, to orators, and to philosophers. This tableau symbolizes the effort of everyone by showing us the most worthy examples, but in the shadows along the borders we also find the unknown masses. The group of soldiers, from the most youthful drummer to the most noble grenadier, recalls the heroic ride of an inspired but nameless multitude that fought so humbly for glory and freedom.

The *Thinker,* whom we salute today, is also unknown; he is muscular like an athlete, vigorous like a pioneer of the native land. His is a calm strength and he will use it only for just ends. If his attitude betrays fatigue, it is because he remembers long centuries of struggle and oppression. Being of the people, he does not forget that he bent to the soil, cast the first seeds, and harvested the first corn. He is the one who, a hundred years ago, made the weapons of vengeance into tools of freedom. He is the arduous worker who made materials manageable and then disciplined them that they might be used for social progress. Finally, he is the one who, through his own labor, built the modern world that it might become worthy of his great effort.

Rodin has indeed completed the work begun by David d'Angers. Firmly seated upon the rock, the *Thinker* now gazes at the immense city before him. He hears it shudder and leap.

Before this great mute bronze man, the generations will pass and succeed one another. His questioning gaze will ask them what they have done for the happiness of people. He will plumb the depths of their consciousness.

The *Thinker* of Michelangelo, in the quiet tomb walled behind stone, under his broad marble helmet, ponders the profundity of eternal things; our *Thinker,* on the other hand, is in the open air and looks at the earth and at life as his mind probes the depths of unknown mysteries.

Often the art of France has bowed to the will of the State. How much more instructive it is for our nation to have the the citizens' support for the artist! By erecting Rodin's *Thinker,* ladies and gentlemen, you have set an example. With more force than an imposed doctrine would have, you have shown your fellow citizens that no country has built itself, has prospered, or become great without calling on art to express the feelings and hopes of its people. Moreover, is it not art that helps us to understand nature? Does it not reveal to us the poetry of our native soil? Artists play the admirable and sacred role of making comprehensible the beauty of our homeland.

The need to love and admire nature has always been felt in the hearts

of the French people. Never has nature been better understood; its worship has survived every kind of destruction.

We are the descendants of those who, disdaining the temples of stone, have constructed their country's altars with the greenery of spring and celebrated their mysteries in the vast silence of the forests under thick and lofty vaults of foliage.

Then, through the centuries, nature revealed the unknown forms that shaped the great cathedrals. Its flowers and leaves have been sources for the infinite variety of architectural ornament. The humanly conceived, beautiful statues of the cathedrals were created upon the model of nature.

This sentiment, so pure and so true, has inspired our poets, protected our schools, and given our race its two primordial qualities: clarity of vision and sincerity of expression.

From the first hours of our national being, nature has inspired us to love our country. It has taught us the gentleness of its forms and the charm of its tender hues.

Moreover, it has taught us of reason and happiness. Nature has made us understand the need for a better life by revealing both harmony and beauty.

Ricciotto Canudo
"Our Trajan's Column: Rodin's *Tower of Labor*" (1907)

A manifesto soon to be issued in the intellectual circles of Europe and America reads as follows:

> Every period, every race has left monuments as the highest form of representation of its history, activity, and religion. It is as if each felt the need to assert and specify an ideal with the help of the plastic arts. Will our age lack a monument worthy of expressing its own fecund activity? After having erected admirable cathedrals to religion and columns and arches of triumph to military glory, will we not erect a monument celebrating the glory of labor and creative thought, an homage to our tireless workers and fertile thinkers?

Ricciotto Canudo, "Notre Colonne Trajane: La 'Tour du Travail' de Rodin," *Le Censeur*, August 3, 1907. Translated by John Anzalone. The same article was published in Italian in March of the following year in *Vita d'Arte*.

It is a monument we *must* erect. It corresponds exactly to the state of mind of our present day; this monument will be the highest expression, the purest symbol of our time.

The firm and sure will that is revealed in these lines indicates the absolute confidence of the signers of this document in the eventual success of this mammoth enterprise, which may require their every effort for many years to come. M. Armand Dayot [Fig. 15] is the animating force of the movement; this has been so since the day he stood before the sketch for Rodin's strange tower [Fig. 12] and there conceived the idea of bringing to life—in stone, in bronze, in iron, in marble, in color, and in line—the dream of the greatest modern sculptor.

We no longer live in those happy times when a single man, a Pericles, a Trajan, or even a Julius II, could commission men of genius to transform their most splendid dreams into tangible reality and to erect for the future a Parthenon consecrated to the Virgin Athena, a column consecrated to an emperor, or even a church dedicated to a fisherman-apostle. The complex and overlapping issues of force and feebleness in modern times have dictated that today the will to create must come from the artist himself. Rodin is a man of genius. He has summarized the abstract ideal and established a belief in generalization. This ability to summarize is the essential characteristic of his art and marks his place in the history of modern aesthetics as the outstanding representative of our age. He has conceived the *Tower of Labor* as the apotheosis of contemporary life seen in terms of one particular abstraction: work. No king, no pope can serve as patron of this wonderful new dream of stone that is to blossom over Paris and the world. But this blossoming should be delayed no longer.

The collective willpower of an elite has already enveloped this unrealized work. It will emerge from the soil of the City that found it possible to erect the final triumphal arch to the glory of the last army worthy of the glorious deeds of antiquity.

M. Armand Dayot formulated the project for this colossal monument, which will stand as a solemn symbol of our time: "What we seek is a monument to the *glory of labor* and not simply a monument celebrating the worker. In the sculptor's finished work the figures of great genius—the savant, the orator, the philosopher, and the artist—must shine radiantly over the masses of unknown collected workers, all grouped together to bring about the accomplishment of the work of eternity."

Indeed, the *Tower of Labor* has been conceived as an immense cyclical poem celebrating all of humanity's striving to rise slowly from the suffering of harsh material existence, from the agonies of the flesh and the daily misery of work in an attempt to attain the beautitudes of apostolic thought. Thus, the moving spirit of the monument passes through all the intermediate stages of the organic activity that unites the worker, *the man in contact with raw matter,* to the artist and to every kind of thinker, that is to say, *the man*

in contact with a matter that is as vibrant and as subtle as light itself, the very matter of spirit.

Rodin has been able to realize this vision in sculpture, and his sketch for the *Tower* reveals that this is true.

At the base of the sketch Rodin has written words that have already been given form in his sculpture: "Project for a monument to Labor. In the crypt will be miners and divers. Around the column will be the tradespeople: masons, carpenters, forgers, woodworkers, potters, etc., all in the costumes of the period. On the top, Benedictions descending from Heaven. *One should think of a Beehive or a Lighthouse.*" Another of the master's notes reads: *"The Tower of Labor.* Endless spiral, like Progress". . . . Just as modern musicians no longer need to clothe their music in either the happiness or the terror that comes from Faith, that ever since Beethoven they have been free to seek their inspiration in every realm of pure thought, so too with Rodin, the most accomplished among modern artists, we find an art developing toward horizons that until now seemed reserved for the most superb achievements of poetry and philosophy. Yet, despite what people appear to want to think, Rodin's work is not "literature." It is a plastic art, its boundaries enlarged through the transposition of his most extravagant and meaningful conceptions into pure sculptural form—Rodin sees Man as being both slave and master of Instinct. This pushes him toward couplings and conquests of every sort, from those of the flesh to those of space. Man's passion runs from the most elementary quest for sexual harmony, a quest common to every being in creation, to the titanic quest for the harmony of the universe, which he discovers, conquers, and arrests through science and art; in so doing Man acquires rights hitherto reserved for the gods. Rodin is the first genius to have understood the apotheosis of this passion as an abstraction of all human undertaking, both secular and eternal, and to call it, simply, Labor. *The Tower of Labor* is, then, the apotheosis of *Man himself.* We need not emphasize the absolutely modern character of this apotheosis. We need hardly remind ourselves that it could only be born of a great mind, that it most assuredly could only find its fitting artistic expression in the twilight of an era, or at the still unbroken dawn of a new civilization in which twenty-five centuries of faith continually buffeted by spiritual tides from the Orient, will culminate in Man's most exasperated and exasperating desire to recognize his own divinity. . . .

• • •

The *Tower of Labor* rises in a soft, spiraling rhythm. It rises from the depths of the earth. The walls of the crypt are to be painted in fresco and adorned with bas-reliefs depicting men exhausting their proud lives in subterranean work. The tower rises to the surface and light, and humanity is symbolized in all its passions. At the entrance of the monument seethe the pains, terrors, and wild joys of the flesh. This entrance will probably be *The Gates of Hell,* which Rodin has been composing ever since his mature genius

enabled his hands to shape beings of stone and to give to raw matter an anthropomorphic eternity. . . .

We cannot see from the outside of the monument the tragedy that is depicted in relief on the inside. The flattened arches, which seem to be a far-off dreamy evocation of the great stairway at Blois, open before the line of ascent, and give the impression of a beehive. The tower's great circular height creates the impression of a lighthouse. We must climb the stairs to the ground level. As we cross the threshold we pass between two symmetrically placed statues: *Night*—an owl on its arms and in its hair, having an enormous belly swollen with a world that sleeps and becomes fertile, and *Day*—shining like a creature awakening in the sun, expressing delighted amazement through simple gestures. Passing between these two symbols of life's total rhythm, between Night and Day, Darkness and Light, the sun's dispersal of activity and the heavy nocturnal concentration of every being, we enter a world where Art has enclosed all of life in a dream. It is not that this dream reproduces in stone the *Truth* of our countless actions, rather it arrests their unchanging meaning, that true and special individuality of our life force.

For the top of the tower Rodin has composed one of the purest of his masterpieces: two Beatitudes, or *Benediction* as he calls this group. It is composed of two angels, winged human figures, liberated from the slavery of gravity, crowning the cupola and the entire tower. . . .

● ● ●

I have seen Rodin in all the different parts of his proud hermitage. During friendly banquets in the little sun-lit dining room, so beautifully adorned by Falguière's pastoral painting, this quiet patriarch gives the impression of a man of long ago, a man whose mind truly flows between an infinite past and an indefinite future. His snowy hair and beard along with the signs of genius tempered by long labors and bitter struggle seem to have removed him from the daily contingencies of our noisy, loud existence. He seems deeply joyous in his garden, which is clearly intended to receive pilgrims in celebration of art. . . .

Ever since Wagner, Art has generally displayed infinitely simpler and yet more profound tendencies. M. Claude Debussy seeks in music the pure and simple emotions of Maeterlinck's plays in which an *almost motionless* idea replaces the theater of Action. Cézanne and Gauguin are those artists who have simplified painting and brought it to its furthest limits of plastic expression.

Unlike Michelangelo, Rodin is *at the beginning, not the end, of a civilization.* For several reasons he is the great joining link between Western and Eastern art, and he has at last expressed in one colossal synthesis the collective Idea that represents our era. . . .

There exists in France today a school of young sculptors destined for triumphs that no critic can yet define, though such triumphs can easily be predicted. Young artists of every kind are waiting for a simple signal to

channel their efforts towards the great common goal of uplifting the meaning of our lives in a manifestation of ultimate beauty.

It is certain that it will be a great day when *our* humanity can inaugurate this collective work before the eyes of the world. It will be accomplished by a phalanx of artists under Rodin's spiritual direction, just as Phidias directed a phalanx of workers who erected the sovereign Parthenon before nature. . . .

The Tower could be erected in the suburbs towards which Paris creeps each day. It will dominate a square that might serve for the performance of tragedies of the sort that are becoming more general and imposing and that portend a glorious future for our dramatic arts.

In this way Paris will have realized the first monument to the new age, and one that is worthy of the greatest periods of creativity. Paris owes this to herself and to the world whose eyes are ever upon her.

Charles Morice
"Auguste Rodin" (1907)

I should like to avoid appearing topical, but with Rodin this is impossible. His name is so consistently associated with current events that we feel an almost sacrilegious conflict between the extraordinary wonder he provokes and the banal regularity with which we feel compelled to sing his praises. So I would just like to declare my personal religious admiration for this extraordinary artist.

Rodin is, for us, the guardian of Glory.

We have no lack of celebrated and illustrious writers, artists, and scholars. But we have only one man of glory.

If I search far and wide, I find but one other who, like Rodin, looms large on the horizon—he who was once a writer and who is now an apostle: Tolstoy.

And how much greater is our countryman! Since the very beginning, all his energy has been channeled into the pursuit of a single goal, a single idea that only grows with his effort. One can surely pay tribute to Tolstoy, to the rising curve of a destiny increasingly and heroically disengaged from itself and its own interests, one that stands today in its purest form as a

Charles Morice, "Auguste Rodin," *L'Action Humaine*, August 1907 (Vol. 1, no. 14). Translated by John Anzalone.

magnificent configuration of the destiny of the entire human race. But when speaking of Rodin we pay homage to the harmony that exists between the thought of man and the thought of nature. Rodin's initial surge is more definite and his successive leaps higher. Tolstoy tried in turn to paint his soul across the curtain of time, to cure the sick souls of our time. The second of these two gestures denied the first. Rodin brings them together. He sanctions them in his calm yet passionate search. By joining man's consciousness to the force of the elements, he expresses himself while inviting us to seek redress through hope and desire, to repent for having maimed ourselves by separation from nature, and to determine to be worthy of our life's mission as we again seek alliance with nature. If only Tolstoy had been able to relate his charitable undertakings to his literary endeavors and had thus been able to show that his evangelism was the logical and inevitable consequence of his poetry! Rousseau, whom Tolstoy admired most, was an evangelist because he was a poet; his charitable work and his writings formed an inseparable whole. Tolstoy believed that his poetical works were harmful and that his evangelical writings were not the work of a poet. On this point only posterity can judge. And despite any admiration, I fear that posterity will not always be in agreement with the author of *What Is Art?* and *The True Life*.

Rodin travels a road mapped out by his gifts; his every step consciously recalls Rousseau.[1] The artist is now formulating in the doctrine of the writer, adding a splendid plastic dimension to the arguments of the intuitive logician and, with the irresistible authority of genius, forcing us to see clear proof that humanity's truth and nature's truth are one and the same. The combined voices of so many moments of collective, balanced action, these human cases in history, ring out in this man's voice. They swear that he is right. This unique sculptor's works all direct us toward strength and union. Man must join his soul to the elementary soul in order to learn to read the lines that explain the mystery of his own destiny and in order to understand the eternal condition of life.

[1]*And Rodin knows this:* the memory of a conversation with the master allows me to be very sure on this point.

RODIN'S GERMAN PUBLIC

No national group responded more keenly to Rodin's 1900 exhibition than did the Germans and the Austrians. Visits to the pavilion in the Place de l'Alma made it possible for Rudolf Kassner and Hélène von Nostitz to meet and to write about him. Rodin was acquainted with Julius Meier-Graefe, the critic who founded La Maison Moderne, the Paris gallery where he showed works by Rodin early in the century. In the years following the great exhibition, Rainer Maria Rilke, Georg Simmel, Stefan George, Paul Clemen, Stefan Zweig, and Otto Grautoff all came to Paris and sought out the great master. Their visits (with the exception of those of Stefan George and Stefan Zweig) were followed by important essays about Rodin and his work.

Georg Simmel
"Rodin's Work as an Expression
of the Modern Spirit" (1911)

Every work of art may be considered from two points of view: form and content. The freedom with which evolution takes hold of content without touching form, and then seizes upon form without effecting content permits us to postulate a division in the unity of a work of art, and in its capacity as the

Georg Simmel, *Philosophische Kultur; gesammelte Essays* (Leipzig: W. Klinkhardt, 1911), pp. 185–203. The entire work was translated into French and published as *Mélanges de Philosophie Relativiste* (Paris: Librarie Felix Alcan, 1912). Both were used by John Anzalone in translating this selection.

127

mirror of civilization, it is capable of revealing this. Genius, which makes progress possible, demonstrates how the traditional forms of art can include a content that until now seemed completely inaccessible. Or, we find that without thought to the originality of content, a form may be created that portends to be only a new mode of expression, but is, in fact, a new method of creating form that is capable of expressing an infinite variety in the content. There are two sculptors who reveal the newness of our time through the newness of their work. Each has a different meaning for our civilization. Through one the plastic arts acquire new content, through the other a new form of expression—that is—a new style. One interprets an original thought in art, the other interprets new feelings. The two sculptors are Meunier and Rodin. . . .

[In his portrayal of workers] Meunier discovered a new subject matter that could give increased artistic value to life, but he did not create a new form or stylistic principle that would allow us to consider life from a wholly new artistic point of view. This was Rodin's contribution: he did not give sculpture new content, but for the first time he gave it a style in which to express an attitude about the modern soul in the face of life. . . .

Standing before Michelangelo's bodies, one thinks that they can only move as they do. On the other hand, their psychological reality, the proposition that explains the movement, so to speak, can have no other subject than the body itself. Despite all its power, even its violence, the movement never extends anywhere beyond the body's well-defined contours. Michelangelo expressed that which constitutes the material structure and the form of the body as an immobile substance, but he also expressed it in terms of movement.

If we situate ourselves from this point of view, we can then say that the mobility of bodies is the element that predominates for Rodin. The balance he achieves between bodily movement and bodily substance must be calculated on a different scale, one that demands a far greater amount of movement. The condition, the fundamental harmony that is thus obtained—that which was "pure body" for Michelangelo—is movement for Rodin. Movement invades his every domain; it has given him a means of expression that is completely new. By creating a new flexibility for joints and by giving the surface a new mode of being, a new vibration, by finding a new way to make us feel the contact points between two bodies or in a body curled up upon itself, by discovering a new distribution of light in the dynamic interplay of colliding surfaces, Rodin has brought to the human figure an extraordinary variety of movement. This movement reveals man's inner life, his feelings, his thoughts, and his personal vicissitudes, more wholly and completely than has ever been possible. Similarly, by detaching itself from the stone in which it remains partially emerged, the figure conveys an immediate sensation of Becoming that is now its raison d'être. Each figure is caught at one of the stations along an infinite road that could be traveled without any barriers, but it is stopped at a station so close to its point of departure that its contours

hardly seem visible as it detaches itself from the block. It is here especially that the principle of movement is transmitted from the work to the viewer. Because of the fact that the incomplete realization of form excites a high degree of activity in the viewer, the contemplation of the particular work of art is extremely suggestive. If the theory of art which holds that the viewer inwardly duplicates the artist's creative process is at all true, it must occur most energetically at the moment when our imagination completes what is unfinished by interposing its productive mobility between the work and its final effect upon us. Movement is uncontestably the most perfect mode of *expression* at our command, for it is the single attribute of our entire being shared by the soul and the body. Mobility is the common denominator for those two worlds that are otherwise quite separate. One and the same form envelop two incomparable realms of existence in their respective content. This is true of the soul itself: it is because sensation and imagination, will and fantasy are *movements* of the soul that the *movement* of the body is capable of conveying the expression that brings them together within the soul. . . .

We find in Stefan George a manifestation of the same evolution of the modern spirit as in Rodin. In his lyric poetry, it is the poem's music—its inner music, not just its sensual surface rhythm—that becomes the dominant motif. Content is in no way sacrificed, but the poem behaves as though it flowed directly out of the music's rhythmic and melodic mobility. Similarly, the motif of movement seems to be the dominant element in Rodin's compositions, the one that somehow contributes to the plastic structure in the medium itself. He clearly seeks to convey an impression that is just the opposite of mechanistic naturalism or conventional modes of representation. Although it seems paradoxical, he seeks to convey the impression of something that transcends the momentary; he seeks the timeless impression. He does not wish to reveal a particular aspect or moment of a thing, but the thing itself; not a purely visual impression, but one of the whole man. Just as Stefan George's great merit has been to give a monumental form to the lyrical expression of subjective life, Rodin, too, is evolving toward a new monumentality—that of Becoming, that of mobility, which hitherto seemed bound to the idea of Being and the substance of the classical ideal. Rodin claims that he is in the habit of having his models assume a variety of poses according to their whims. Suddenly his attention is brought to bear upon a particular turning or bending of a limb, a certain twist of a hip, a bend in an arm, or an angle of a joint. And it is the movement of this part of the anatomy alone that he sets in clay, without sculpting the rest of the body. Then, often long afterwards, an intimate intuition of the whole body looms before him. He sees it in a characteristic pose and he knows immediately and with certainty which of the many possible studies is the appropriate one. Without doubt, that single gesture, by continuing to grow in the sculptor's unconscious, has created a body for itself so to speak, and a movement has found life. The difference separating Rodin from the sculptors of antiquity, and even from Michelangelo, could hardly be defined more clearly. For, as

perfect a unity and balance of elements as he may have attained, Michelangelo's point of departure remained the classical ideal: the substantiality and immutability of anatomical form, which he first brought to life through the ardour and impulsiveness of his feeling, and into which he then infused movement until these elements totally absorbed one another. So it was that by seeking to give a constant value and an atemporal importance to movement, Michelangleo rendered movement almost stable. Despite the consuming passion of his movements, they are nonetheless always captured at a point of relative arrest, in a state of equilibrium that the figure could maintain for some time. This is Michelangelo's way of giving movement an eternal significance. But this is precisely what Rodin's most important figures reject. Their movements are truly those of a fleeting moment. The very soul of these beings is concentrated in these movements, so clearly expressing all that is timeless in them; they convey what heretofore seemed attainable only in the most substantial and invariable form of the human body. Michelangelo, too, found the coincidence of the two forms of our bodily existence—those of being and of movement—to have their common origin in the spirit of his epoch, a spirit possessed by the idea of a harmony of all essential elements (no matter what the distance may be between his fingers' aspirations and this ideal); in like manner for Rodin the center of the visible and the corporal is to be found in the modern spirit, a spirit far more unstable, for more changing in its dispositions and its self-generated destiny. And, therefore, it is a spirit more sensitive to movement than that of Renaissance man. . . .

If one maintains that the purpose of art is to deliver us from the swirling troubles of life and to grant us peace and repose from change and contradiction, then it must also be remembered that the artistic liberation from life's cares and unbearable aspects can be obtained not only by taking refuge in whatever represents the contrary of such agitation, but first and foremost in the highest stylization and the purest rendition of the content of this reality. Primitive sculpture lifts us above the fevers, and problematic changes of our existence because it represents an absolute negation of them. It has no contact with us. Rodin delivers us because he traces with such precision the most perfect image of life absorbed in the passion of movement. One of his countrymen has said of him: "He is Michelangelo with three centuries more of misery." By permitting us to relive the deepest part of our lives in the sphere of art, he delivers us from life as we experience it in the sphere of reality.

Michelangelo and Rodin are congruous phenomena, but this parallelism is not determined so much by the obviously kindred elements as by the mysterious destiny common to their arts. The later master is certainly the weaker of the two, yet not as a personality, but as the product of his age and country. The world is three hundred years older, and proportionately richer—that is to say, fuller, more complicated, and consequently less vigorous. The will is the same—indeed, it has perhaps gained in intensity—but it is as intent on internal things as was that of Michelangelo on externals, in comparison with our art. It aims from the small to the great. Or rather, space has become so circumscribed in the world that art must be content to essay the effects of the ancients with a fragment of their means.

This fragmentary quality springs from the same root in each, and harmonises with the other relations between the two. In the case of Michelangelo, it was excused to some extent by external conditions, such as his wrath with the Medici and Julius II, who spoilt the Moses, and by the political misfortunes, which interrupted his Florentine labours. Rodin, too, had his moments of tribulation: the refusal of his first piece, *L'Homme au Nez Cassé*, by the Salon Jury; after some years of arduous labour again, the intelligence of critics who accused him of having cast his *Age d'Airain* from nature; and finally, towards the close of the century to which he had given its greatest sculpture, the stupid insolence of the Société des Gens de Lettres who scorned his *Balzac*.

But were not these irritations perhaps beneficial after all: safety-valves, which helped to save from the deeper tragedy of internal conflict; fortunate pin-pricks spurring the victim to resistance?

Michelangelo found a point on which he could lay firm hold, an order for which he was able to substitute another. His successor hovers in mid air, and even if he had the strength of the giant who raised the dome of St. Peter's, he could not repeat the experiment. All his strength only serves to increase the disorder of the age which has produced him. His very wealth makes his insufficiency. His genius will drive him from form to form, and at best he will sink down there where he should have begun in order to reach his goal. His destiny resembles the prancing horses that rush forward from the pedestal of the splendid monument at Nancy, snorting with ardour and with the fury of their course, and ever urged onward by the genius, who, his

Julius Meier-Graefe, *Modern Art* (London: William Heinemann, 1908), 2, 9–19. Translated by Florence Simmonds and George W. Chrystal. The last four pages of Meier-Graefe's chapter on Rodin have not been included in this selection.

gaze turned away from the direction they are about to take, stares heaven-
wards to the light that dazzles them.

Rodin has essayed every path on which artistic instincts have travelled,
and on some of these has come to the same issue, which many tendencies in
modern painting have sought and found so successfully that we almost
might believe we had reached the utmost limits of art, of the moderns. Is
there not but one solution to all the riddles? That our age has no longer the
desire of former periods to avoid extreme consequences. With the magic
word Nature it extends to all boundaries, even those of the unnatural.

On the way thither, and especially towards the end, there are sublime
moments.

There is an early Greek Rodin of the first decade of the Phidian
century, an Egyptian one like the faces found in tombs on the Nile, which
look like modern portraits. He is to be found in the drawings of the middle
period; for instance, the head of St. John, which he repeated so often, where
the eyes are black holes, as in the old bronzes, and yet look at us with the
utmost intensity, because the whole face is governed by an admirable plastic
law; or in those little figures which the Greeks made in bronze, but which
Rodin often left in plaster, that the delicate language of the limbs might not
be exposed to rough hands.

In the monument to President Lynch he has all the nobility of a North
Italian equestrian statue of the early Renaissance. This air of distinction is
also found in many of his male busts. In *Le Baiser* he seems to simplify
Michelangelo. In the *Eve* he continues him. The French Renaissance pro-
claims itself in details of the *Porte d'Enfer*. The Angel of War, stretching
threatening wings and arms into the air on a lofty rock, reminds us of a
rejuvenated Rude; the old woman, *Celle qui fut Heaulmière,* recalls Daumier,
who is still more strongly suggested in many drawings. In others Ingres
makes himself felt. The *Bourgeois de Calais* are humanised Gothic; his por-
traits of women the purest expression of gentleness in the midst of pride that
the sculptors of the eighteenth century could have allowed a modern
sculptor to produce. In the little studies of movement in marble and bronze,
L'Amour qui passe, La Fille d'Icare, Eternel Printemps and many others, he seems
to personify the convolutions of French Baroque of the finest period; but
Rodin's Baroque seems to have taken over only the poetry, the tenderness,
the sweetness of the mock pastoral age, without an atom of its typical form.

Finally, in his *Balzac* and kindred works he completed Carpeaux.

Thus the development of genius in all ages shows itself in a single
personality. And the wonderful part of it all is that it is only Rodin one
enjoys. His is not the thin, decorative manner of the perennial clever artist of
our day, who moves us by reminiscences. Here we have nothing of the
antique form, nothing that could have been the work of the ancients. All is
Rodin. He has not reached his development in due historical sequence, but
has the power to bestow his gifts upon us after the manner of a Greek, of a

Renaissance master, of a Frenchman of the eighteenth century simultaneously, bringing the charms of all periods together in a single work.

Rodin is no stylist; he is less so even than Michelangelo, much less so than Goujon. He conceals the division of masses, for which his predecessors involuntarily made use of a remnant of mathematical thought, beneath the wealth of his forms. The effects are so numerous that those among them which make for rhythm complete the work imperceptibly. He naturalises the style of the earlier masters, so to speak. Where a Puget gets his result by emphasising the muscle, he puts the movement into the limb and gives the muscles only their normal relief, or he makes a single direction in flesh into a great many, and works with complex systems where his predecessors were content with a primitive unity of form. His art, like every other—nay, more than any other—impresses by means of exaggeration, and the older he grows the more clearly he recognises this truth. Compare his *Age d'Airain* with the *Eve* of a few years later, or his *Baiser* of about the end of the eighties with the *Victor Hugo* of 1897, his *Antonin Proust* of 1885 with the head of Falguières of 1899, and note how the technique increases in breadth, becomes more and more penetrating, permeates the material more and more. But what he gains thereby by the suggestion of material he loses on the other side. The flesh is monotonous in *Le Baiser,* but who can give a thought to the flesh before this magnificent structure of limb? The conception of these lovers silences all other demands; from whichever side we contemplate them, they are instinct with the loveliest poetry, and an ideal beauty of lines, revealing only the divine elements of human passion. Compared with other groups, in which he multiplies his wealth of movement a hundredfold, and shows us attitudes of unimaginable grace, a tenderness of line which Ingres merely indicated in the form of barely visible arabesques on paper, *Le Baiser* may seem a solid, prosaic work; but the sublime calm with which we gaze here is lost when we approach the others. We stoop and twist to follow their beauties in all their curves and hollows; the poetry of these marble rhythms makes the gestures of the spectator an ugly travesty. It is not always possible to conceal the reverse of all this beauty. Painting may succeed in the task, as Fragonard has shown us. Imagine his bathing women in sculpture! Even in his pictures, skillfully as he conceals it, we are conscious of the impossibility of certain compressions of the limb which the convenient frame or the arm of a neighbour cuts off at the decisive moment. Such manœuvres are denied to sculpture. The arm which appears at a certain point must reappear at another, and threatens to quarrel with the leg with which it harmonised so deliciously at first. Rodin achieves the inconceivable in escaping this danger in some of his most daring essays, but this forces him to adopt arrangements of the utmost complexity. He has been reproached for his method of leaving large surfaces in the rough when he works on a mass of marble, and his critics have condemned it as a puerile straining after originality. Such strictures are barbarously ignorant. It is Rodin's very earnestness which impels

him to what sometimes looks like trifling. What he does he must do. He needs the mountain in whose hollows the nixies dance; he is impelled to the amazing tours de force, which seem at times a kind of jugglery, in order to play his piece to the end. We may wrangle over his scenery, but that which is going on in the cavern is worthy of the magician; we never follow him without profit.

His magic breathes Nature, that is its strength. There is not a single detail in his work which is not the outcome of a natural impression. He repudiates the charge of literary sculpture vigorously; no reproach, indeed, could be more unjust. He has always seen what he represents, with a marvellous eye that seizes just the most unusual elements; he has never compromised, and his limitations perhaps lie solely in his inability to compromise. In his axioms, recorded in Judith Cladel's charming book, his boundless veneration for Nature finds continual expression.

"He who thinks himself greater than Nature, and imagines he can make it more beautiful, will never do more than juggle. It is not Nature that is imperfect, but the mind which so conceives of it. It is just as impossible to improve the human body as to transform an element. To alter is to destroy it. Such notions are due to the idealists. I am now able to admire Nature, and I find it so perfect that if God asked me what it would be well to alter, I should say everything is right, and nothing must be touched," and so on.[1] It might be Courbet speaking.

But it depends upon what a man makes of Nature, his handiwork is everything; he must see and represent the thing seen. Before he went to Carrier-Belleuse, Rodin was a pupil of Lecocq de Boisbaudran. Young as he was—fourteen years old—Lecocq's teaching gave him a basis he never lost, a rational manner of observing Nature.

"If I lay my hand flat on a stone," says Rodin to his pupils, "flat upon flat, I have the old unaccented relief; whereas, if I do so"—resting his wrist on the stone and spreading his fingers in the air—"the hand appears in perspective, and gets value. If a sculptor does this, he is acclaimed a genius. All it really means is that he can see."[2] This was the creed of the Renaissance sculptor. For Rodin too—for him more than for all others—modelling (le modelé) is the relfex of life. His work gains in richness as he grows older: this youngest of all artists looks upon youth with suspicion; no one works when he is young. He grows like a tree: in the beginning we admire the slender bole, and gradually it sends out innumerable shoots, a wealth of foliage, spreading out its mighty superficies farther and farther to the beneficent sunshine.

Thus he approaches the tremendous cosmos of his monument to Victor Hugo.

[1] Auguste Rodin, pris sur la Vie (Paris, La Plume, 1903).
[2] Judith Cladel, "Auguste Rodin," p. 40.

There have been three momentous works in Rodin's career, three stages: his *Porte de l'Enfer,* his *Victor Hugo,* and his *Balzac.*

The *Porte* was the audacity of youth, always hovering round the impossible, and mated in this case with an almost incredible energy. It was the impulse towards a great organisation of the enthusiasm he felt for the works of his predecessors in Italy and France, an immeasurable, unparalleled creation, with a thousand details in which the many-sided and episodic seems of more importance than great and powerful unity, the nerve of ripe creations. The work became almost his life. The first idea of it came to him in 1875; he has gone on toiling at it ever since. It is a work of youth, the source of the most varied studies, and in its completion will be the joy of the artist's old age. The scheme was such that Rodin could only distinguish himself by a brilliant treatment of details. For as a gate, as a concrete object, it has the immensity which makes it difficult to appreciate the Sistine wall-paintings of Rodin's prototype. Like these, it is a welter of precious things, and one might spend one's life in bringing its various fragments into port.

The *Victor Hugo* is altogether different. Here the mystery of a thrice happy inspiration brought about the realisation of Rodin's loftiest aims. The gate will never be finished, even when it has at length been cast, for in addition to the hundreds of beauties that adorn it, it might just as well receive a hundred more. The *Victor Hugo* was finished at the moment that the marvellous attitude of the poet was conceived—the Zeus-like pose of genius, a great and clear expression, absolutely rounded and homogeneous in spite of the deep and many-sided impressions this work also makes upon the eye. The diagonal motion of the soaring whispering genius above the poet's mighty body towards the widely outstretched hand is decisive. Thus did Michelangelo create: a titanic synthesis, the creation of an idea, the suggestion of the manner in which a work of art arises. Rodin has made a profound symbol of this, of import far wider than his design, than the significance of the personality to which he does homage, and even than the art he symbolises. It is the glorification of the mind, universal as the art of a Phidias, the glorification of the body. That such a "literary" idea could take form, losing nothing of the colossal significance inherent in such a symbol in this age of ours—the world that rules the world—that we can stand amazed before it, convinced, as we are convinced of the beauty of the world the Greek imagined—this it is which ensures immortality to the creator of this monument.

The skull is enthroned in this cosmos. It is no longer the small Greek head, the capital of the shapely column, but rather the centre, the mighty shrine of life, for which the subservient body is a mere pedestal. The Greeks stood or walked, and floated in space when they walked. This figure sits; in the attitude best adapted for the bearing of burdens, one leg supported and bent at an angle, the other stretched out, to give as wide a base as possible. So he creates, this deep-breathing priest of beauty. But creation stirs these limbs mightily. Round the head—a battle-field of thought—a cyclopean form

hovers as genius, grasping the idea with a powerful gesture, and driving it into the poet's consciousness: the terrible, fruitful dæmon of conception, the frenzy of will, that enfolds the world. Behind the two appears the divine form of measure, of reflection—a Greek woman. The conflict is revealed in the poet's vigorous face: everything non-essential is silent, even gravity seems dead, that evolution may not be arrested. The hand is thrust out firmly, balancing the two powers, and groping for the nascent work. A miracle is wrought.

The man who could conceive such a thing may scorn all honours: he can withdraw from the world and from mankind; all humanity is within him. The genius who can give corporeal and comprehensible form to such a conception is divine, and, with that same expressive gesture with which the outstretched hand controls the elements, it quells the doubts that divide our homage between this beauty and that of tradition, and compels a voiceless adoration. Rodin can only be compared with Rembrandt.

• • •

Rodin represents his art as a result of nature, mathematics and taste.

I have dealt with the first of these three factors; it is the basis of the Hugo monument. But it must be understood that it is inconceivable without the other two, as indeed is any one of the three factors.

He often emphasises the mathematical element of his sculpture: this, and not the poetry of the invention, is the soul of his *Victor Hugo*. It obtains the space-effect by means of a cube with obtuse and acute angles set diagonally in space. The upper narrow side is formed by the kneeling genius. The outstretched arm gives the longitudinal direction, the draperies follow the corresponding parallel direction, and the end of the outstretched foot completes the cube, this being cut off by the base, which is foreshortened on the side of the draperies. The cube is, of course, irregular, but the fundamental directions are observed throughout, or indicated by decisive points. A system of parallel planes divides the form. The wonderful arc formed by the body of the kneeling genius runs in the same direction as the arm which supports the poet's head, and the shrouded leg. These three parallels lie in three different planes one above the other, outwardly brought together by the drapery, and losing themselves inwardly in a rich complexity of minute planes. As a result, the light flows in a marvellous torrent from the broad curve of the genius over the poet's head to the outermost hand, and also over the other front portions of the group, playing among them with a rich variety of movement.

This symbolism, which paints the idea of the genius who enfolds the poet and urges him to creation with the purest medium of art, light, is irresistible. It gives the design a depth far beyond any significance built upon convention. We cannot think such lofty thoughts as this; the spectator feels it flowing into him like some material thing; an example that will live as long as

the sun illuminates it. There can be nothing more natural than such mathematics.

The Muse of Meditation behind the group is an addition which hardly seems indispensable to the composition. But it is most beautiful, more beautiful than the rest, to which it bears but a dreamy relation; it is all pliancy, abundance, and masterly curves, where the other imposes itself with iron power. It might be a symbol of mourning grace, which always seems half-concealed in modern art, and has not a very audible voice. It is perhaps an embodiment of Rodin's third factor, taste.

Rodin's taste is in externals that of his times; we will admit its limitations. But fundamentally it differs widely from the elements that make up contemporary taste. It is a result of admixture. The conflict between the stimulating divinity and the Muse of repose depicts the chequered fate of this inventor. Like Carpeaux, he has made thousands of drawings, which reveal the "Rodin intime" better than his axioms. They quiver with life; they are nearly all studies of movement, not so much studies for a definite purpose as manual exercises, vehicles for throwing off impressions. The likeness to Michelangelo in the borders commissioned by Gallimard for his copy of the *Fleurs du Mal,* and many other drawings, is amazing. But pain is more spasmodic with Rodin; his drawings twitch like nerves, and the filling in of the outline with his marvellous aquatint washes seems to exist merely to give resonance to this inarticulate moaning of agony. In the magnificent *La Force et la Ruse,* reproduced in "L'Image,"[3]—the galloping centaur, clasping the woman in a wild embrace—in the design for the cover of *Die Insel,* etc., Delacroix' energy is out-distanced. Rodin is not more powerful, but he is more strenuous; the spontaneous, simultaneous flight of the highest effects both of draughtsmanship and of thought is more astounding. Rodin presents gesture and deed at once, so to speak.

Still greater is the speech of the latest drawings, where complexity is discarded, and only a few lines, occasionally even a single one, give the exquisite contour. In his earlier days Rodin sought a single direction in ten feverish strokes; now he draws a single line with all Ingres' certainty, and succeeds in giving this one all the quivering life of his earlier designs. There are outline drawings by him in which he absolutely suppresses light and shadow, after the fashion of the Japanese. In the majority he uses a few splashes of wash, or touches of chalk; Maillard has reproduced a marvel of this kind in his book on Rodin,[4] the three *Figures du Purgatoire,* graceful as the forms the Greeks painted on their vases, and so natural that I am

[3] For September 1897, with an essay by Roger Marx on Rodin's drawings.
[4] Léon Maillard, "Auguste Rodin," Paris, 1897, so far the most comprehensive work on Rodin, with many fine illustrations. The *Figures du Purgatoire,* after p. 84 in Maillard, are not so perfectly reproduced at the beginning of the present chapter, unfortunately. There is a beautiful etching of the composition in Gustave Geffroy's "Vie Artistique," Série II (Paris, Dentu, 1893), which contains an elaborate study of Rodin.

tempted to speak of carnations in describing these few strokes on tinted paper. Involuntarily we recall the Three Graces of the Cathedral Library at Siena before this arabesque. If among the many wooers of the famous prototype those who have tried to come nearest to it have been just those who have failed most signally, here we find a living artist who has achieved a rhythm not similar, but of the same enchanting quality.

Rodin is one of those people to whom we may look for a multiplication of our material sum of forms. Even in these three figures on the paper, the lines, naturally as they seem to run, form a complex design, which out of the three figures makes a fourth embracing all three. The arms of the central figure, which rest on the other two, are continued in the outlines of these as if it were another body, and this new body is of captivating beauty.

This is also his method in space. It will be, of course, understood that the whole object of this method is to secure the compactness of the mass, which is the basis of all monumental effect. This Rodin had already sought on the principle of the ancients, when he drew the well-formed outline of his *Baiser*.

But he carried the principle farther. The ancients had considered the definition of limbs within their groups as no less essential than the contour of the mass. But Rodin suppressed this more and more. A fantastic pair of lovers kneel upon a rock, breast to breast, lip to lip; a deep emotion welds them together; their arms lie close to their bodies, their hands seem to melt into the stone, there is no aperture anywhere. To this end the bronze has been kept as soft as possible. Everything sharp and angular is resolved into yearning desire and soft abandonment; an exquisite patina overlies the forms like a veil drawn over the two. Thus in the penumbra of the studio, new, almost atmospheric bodies arise, in which the mathematical sense of the artist makes successful use of his fancy. We reproduce the seated figure holding her foot in her outstretched hands, *Le Désespoir*. Its compactness of form gives it a certain affinity to a beautiful vase, and it might almost serve to demonstrate that all beauty, even that of utilitarian objects, has a deep—as yet but dimly presaged—connection with the lines of the human body. Rodin, indeed, formerly designed vases for the Sèvres factory.

Here the quality Rodin calls taste enters upon its decisive phase. It drives him to conclusions in which the exact calculations of effects ceases, and restrains him when logic would lead him too far. "Taste is everything," he once said. "He who has a knowledge of sculpture or painting without taste will never become a sculptor or a painter. I have often found that my science could not carry me any farther. I had to set it aside and to trust to my instinct to arrange things for which reflection was insufficient.

"Strange to say, even the things which apparently belong purely to the domain of the exact sciences follow the same rule. A naval constructor who is a friend of mine told me that, to build a great iron-clad, mathematical combinations alone will not suffice. If the parts are not disposed by a person

of taste, capable of modifying mathematics intelligently, the ship will not be so good, the machine will be a failure.

"There are no hard and fast rules. Taste is the highest law, the compass of the universe."

But he added musingly, "And yet there must be absolute laws in Art, since there are such in Nature."

So speaks the modern.

Adolf von Hildebrand
"Auguste Rodin" (1917)[1]

In his recent essay about me Professor Wölfflin mentioned my objections to Rodin in a manner that was not entirely relevant. So I am happy to take this opportunity to discuss more fully the differences that stand between us in our general approach to art. Rodin is a phenomenon. His work has such extraordinary potency that it can only be of value to criticize it while acknowledging full understanding and admiration for its power. I admire Rodin as if he were a natural phenomenon and, therefore, I feel that I can openly articulate some critical views of his work.

If I had but a torso or a leg from Rodin's hand, I would be filled with the greatest distress that there remained only this glorious fragment; how wonderful the complete figure must have been! Not since the Greeks or since Michelangelo would I have seen something that gave this kind of intense feeling for organic life. Of course, I would then have looked for a complete figure by Rodin. Then the disappointment would set in. Either he left his works as more or less finished studies of nude figures that do not fit

Adolf von Hildebrand, *Gesammelte Schriften sur Kunst* (Cologne: Westdeutscher Verlag GmbH, 1969), pp. 425–30. Translated by Sabina Quitslund. Reprinted by permission of Westdeutscher Verlag GmbH.

[1][Hildebrand wrote this as a response to an article by H. Wölfflin ("Adolf von Hildebrand zu seinem siebzigsten Geburtstag," which appeared in *Kunst und Künstler*, 16, 1918), although Hildebrand's essay remained unpublished during his lifetime. Wölfflin must have sent the manuscript to Hildebrand sometime in 1917 as Hildebrand wrote to thank him for it on September 16, 1917 (see *Adolf von Hildebrand und Seine Welt, Briefe und Erinnerungen*, edited by Bernhard Sattler, 1962, pp. 670–71), which means that he had formulated his thoughts before Rodin's death in November 1917—Ed.]

into any traditional categories, or he completed works, such as the *Monument to Victor Hugo*. When I saw it I recoiled in the face of such boundless ignorance of the quality that can make a cohesive whole. I recoiled in the face of his inferiority of feeling for architectonic structure and, in general, for true artistic culture.

How is it possible? How can such contradictions coexist in one brain? Herein lies a problem that goes far beyond Rodin. It is a general question of principle. I could not have believed in the possibility of such a one-sided development and one that was so strong an attainment. Yet here was the factual proof before me. I saw further that beyond his astonishing feeling for organic life, he employed means that were meant to create an effect, and that these means came from a process that did not take place in the work of art itself, but that were employed artistically to stimulate, indeed, to delude the viewer. Everybody who has ever worked directly in stone must realize that Rodin perceived the traces of work in Michelangelo's partially hewn marbles in a purely superficial manner, and that he used it in and for itself. The way he did so immediately proves to the expert that Rodin never cut anything directly in stone himself. He works in a manner that cannot originate through a natural process. I am only drawing attention to this deceit, which is surely completely unconscious, because it shows how a superficial appearance can be made to look as if it had meaning, that is, to look as if it is an expression of a process of life and of creation. It can also be seen as a superficial stimulus for the eye, as a component, just as a word might be taken purely as a sound without considering its meaning. Normally we find the poetic import that a word attains in its meaning, and its sound represents an artistic value quite distinct from that of a word which has no meaning. It is not unknown in the modern movement to misinterpret the principle of *l'art pour l'art* by carrying it to a nonsensical extreme wherein the word is only used as a sound without meaning. Such poetic meanderings were probably meant to imitate certain countertendencies that initiated with the visual arts. (After the destructive influences of poetry on the visual arts during the last century, where appearances were valued as illustrations of poetic imagination, came the great revolution and the struggle for the innate value of appearances as a kind of art in their own right.) It was the French who brought about this healthy revolution. But as with all mass movements that are only able to capture truth in a one-sided and extreme way, so this one immediately turned into something false. . . .

The head is a particularly problematic part of the nude because it introduces a prosaic and personal note, potentially an awkward reality with which the imagination must deal. For this reason the head is often omitted. The use of fragments excludes other claims to a unified figure and makes the task more difficult by detracting from the experience of a body as a whole. One does not ask what the figure is doing or what it means. It is a slice of life. What more could we desire, given Rodin's way of accomplishing it?

This is the Rodin about whom I am enthusiastic. If only there were no other Rodin. How much greater he would be.

Take, for instance, the *Burghers of Calais,* which were conceived as individual figures and then placed in that unbelievable composition. But the bronze figures in Berlin are still fine and highly accomplished works of art, even though they be closely modeled on the work of others and do not demonstrate a sense of independent creation. As soon as he follows his own path, however, Rodin becomes modern in the bad sense: he is French. Whether it is the *Monument to Victor Hugo* . . . or any of his many-figured groups, most of them fall apart. We cannot find the angle from which to grasp them in their unity. And in those cases where he strives for a spiritual frame of mind, we find a forced superficial appendix, as in the case of a bad actor.

A real work of art is based on a completely different conception and on a totally different attitude toward the subject. Whether it deals with an architectonic feeling, with a sense of the situation that will be the basis of conception, or whether the artistic unity, as such, must be created, the work of art should not depend on an impression that has been arrived at accidentally. It must be both felt and understood from various angles and in terms of content as well as composition. Here we are dealing with a different context for what the work of art should be, one that is not just a physical and organic unity. The whole culture of imagination and the type and coherence of inner stimulation plays a role. Here Rodin's power fails him. He had nothing to say; he becomes trivial. His inventions are spiritually banal and their total composition is immature. The organic power he possesses, needless to say, cannot become a substitute for basic flaws in conception.

Though we have drawn attention to Rodin's weakness as well as his power, he remains an artistic phenomenon without equal, and if he had done nothing but his improvised fragments, he would be a tragic figure while remaining a first-rate artistic master. But his other works show that he is not this tragic figure. But in his own way, as a phenomenon, he achieved something astonishing.

There are two Rodins and they must be discussed separately: one is the genial improvisor of nude studies, the other the sovereign creator of complete works of art. The distinction points to the different aspects of artistic talent in general. One aims to catch strong impressions that are accidentally perceived. The essence of this experience is the way a piece is modeled, and the impression is dependent on accidental movements. This harmony between individual parts and the movements generated by a body results in an effect that is an accidental gift of nature requiring the special eye of an artist to grasp its existence. In such cases the work of art has already been drafted by nature and is simply realized by the artist. Therein lies its worth. When dealing with this kind of artistic unity of natural appearances, the artist should renounce the figure as a whole for it is hardly possible that nature will

be unified artistically throughout. It will therefore be the fragment, which, once captured, remains as the work of art. The principle of Rodin was derived from the portrait. Just as in the act of portraying a certain form in which position and expression become a unity, so Rodin made his figures depend on such a unity. We should not assess this in a petty manner, considering only incidental details, but we must see it in its totality. In this fashion, and with any conflict between the figure's position and the model eliminated, Rodin finds himself on secure ground, for his total artistic task is restricted to catching the impression of a powerful nude. With such a simplification of the problem, the solution was all the more worthwhile and pervasive. Here all other questionable intrusions of imagination were excluded from the working process. It was a safe path. And yet he overlooked one point: nature herself played a trick on him, for with further execution it became clear that the magic of the impression referred to one aspect of nature alone, while other aspects of nature disrupted the conception as a whole. What was to be done? If the artist was not to abandon the principle and open the door to the dangers of subjectivity, then nothing else remained but to renounce the unity of the whole and to cut away that which did not fit. The work of art culminates in the unity of the impression, even if the nature of the human body, that other unity, remains irrelevant. This is also a way in which we might interpret *l'art pour l'art*. The fragment was legitimate as a solution to all evils. That which remained was real, well-padded art, like the best of it. Art was saved, and ultimately the viewer was in the same position as when he looked at fragments of ancient art. One, thus, adjusted to the situation and all was well.

But, how did matters stand when it came to a complete work of art such as a monument in a particular setting? There the beneficial principle no longer played in favor of the work. Rodin had to proceed in another way, and other factors played a demanding role. Art was suddenly something altogether different, and the beneficial remedy no longer sufficed to save the work of art. Its reverse aspect came to light. Here Rodin lost his orientation and found himself in a totally alien world. He made do like an ordinary man of the people, unsuspecting, barbaric, and his artistic gift changed into a grimace. We have only to think of the *Monument to Victor Hugo*. When he had to deal with an architectonic sense of form, with a unity under diverse demands, his power subsided. He lost his comprehension and was like a fish out of water. It would not have been bad if this had been beyond his reach, but he should have recognized his weakness and he should not have undertaken anything of this sort. Then he would have stood there, one-sided, but pure—an artistic phenomenon without equal. But the picture is clouded. If I should continue to talk about his weakness, then another aspect must play a role—namely, his relationship to materials, to bronze and stone. Marble, with its attractiveness and possibilities, is but a superficial matter for him. He exploits marble by retaining the block in an artificial way that makes no sense to the knowledgeable person. His blocks simply convey an impres-

sion of being freely carved. The contrast between delicate execution and coarsely cut blocks was such that they could be attractive in themselves with no real basis in the creative process. Anybody who has worked in stone can tell immediately that they could not have evolved in this manner, that they were superficial tricks for the eye. Most certainly he never carved himself, but instructed his assistants to treat the stone as he did for the sake of an effect. It was a mechanical process. His works were only realized in clay and his marbles were fakes stated in an untrue language. In this he was most naïve. Others have also had to resort to such means, and in the end, perhaps Rodin was the most courageous of deceivers.

RODIN AND THE YOUNGER MASTERS OF EARLY MODERN SCULPTURE

The scale on which Rodin worked demanded that he employ a large number of sculptors in his various studios. The combination of the possibilities to be found there and the vast fame of *le maitre* made a visit to the celebrated atelier on the rue de l'Université one of the great events in the life of a young sculptor. Bourdelle came earliest and stayed longest. He arrived in 1893. Rodin counted on his assistance for fourteen years and his friendship for the rest of his life. It was Rodin's old friend Octave Mirbeau who arranged for Maillol to visit in 1902 after Rodin had admired Maillol's small figure of *Leda* in Mirbeau's apartment. Matisse probably visited in 1898 (the year that he bought Rodin's head of Rochefort). Brancusi had the same experience in 1907, and he, like Matisse, thought it would be better for his art if he never went back.

Antoine Bourdelle
"A Great Contemporary Artist"
(1908) [Fig. 17]

Rodin, like all great minds is greater than his work; it is just as the ocean is greater than the millions of waves it unfurls before our gaze.

Antoine Bourdelle, *La Sculpture et Rodin* (Paris: Arted, Éditions d'Art, 1978), p. 52. Bourdelle conceived of the idea of doing a book on Rodin in 1908. It soon developed into a large project; it became a kind of guide for younger sculptors and was never published in Bourdelle's lifetime. The present edition is an exact reproduction of the book as it was first published by les Frères Emile-Paul in 1937. Reprinted by permission of Madame Dufet-Bourdelle.

And this is why, beyond the work that I admire so much, I long sought to know still more about the admirable worker.

Let us get rid of the heavy shadows cast upon this art by false masters; let us say again how completely aware Rodin is of his art and how he continually works on his sculptures in order to raise them to the level of beauty to which he has assigned them.

Rodin sculpts the way some men think numbers. He adds, he adds again, and once his mind, heart and soul have labored long enough, a freshly completed work comes forth. Look at the bee; look at the artist—they both run counter to all the theories that have ever been extolled.

Let Rodin's self-mastery, expressed in constant reworking in search of a single goal, in enlargements of volume, in reductions and tenacious multiplications of profiles and projects, appear for what it is—something that is not at all inconsequential. Rather such elements are the secret of genius and the food of beauty.

André Gide
"A Promenade through the Salon d'Automne" (1905)

In a special room on the ground floor we find the unparalleled works of M. Rodin. Some are admirable, all quiver in their restlessness. They are meaningful works that cry out movingly. Then we come to the first floor where we find a large seated female figure by Maillol in the middle of a small room. She is beautiful and she does not mean anything. It is a work full of silence. We must go back very far in history to find an artist so willingly to neglect every irrelevant preoccupation in order to dwell on the simple manifestation of beauty.

A work of art is not always the result of an emotion that has to be expressed. Or, at least, this emotion can originate elsewhere than in the artist's mind. It can come about spontaneously or it can be caused by the shock of life. The material of the work of art itself in its raw state—color, tone, word, rhythm, stone, clay—is sufficient to plunge an artist into a frenzy of creation.

André Gide, "Promenade au Salon d'Automne," *Gazette des Beaux-Arts*, 34 (1905), 476–77. Reprinted by permission of the editors of the *Gazette des Beaux-Arts*.

Now, I cannot really imagine Rodin standing before a block of marble and saying: "Will this be a god, a table, or a basin?" Rather I see him tormented by a plastic idea just as Beethoven was by a musical idea, and Vigny by a poetic idea, all of them looking feverishly for the expression of their own restlessness. I dream of the majestic impatience of Beethoven, breathless in his effort to subdue the rebellious form. I dream of a willful Michelangelo screaming before his marble: "You will surrender!"

In an opposite fashion I see an artist who maintains a quiet dignity: a Bach, a Phidias, a Raphael. The beauty of their art is the only thing that really excites them. They do not want to translate anything, they look for nothing in their work save its beauty. But quite naturally emotion comes to inhabit such a beautiful form, just as the quickening spark came to Prometheus as he modeled Pandora.

The first kind of artist is more moving, the work of the second is more impenetrable, but more solid and with greater weight.

<div align="right">

Roger Fry
"The Sculptures of Maillol" (1910)

</div>

For many years now the annual exhibitions of sculpture have produced two main classes of work. There is the ordinary merely representative and nonexpressive sculpture which we have always with us; the other class, the work of artists who attempt some serious expression, has shown almost exclusively the influence of Rodin's dominating genius. This has in some ways been unfortunate, for Rodin's style is a singularly personal one. He has arrived at it gradually; and the principles of synthesis and simplification which his later work shows can only be used effectively by an artist who has gone through his prolonged and patient apprenticeship in a completely realistic art of modelling. Moreover Rodin is a master of exceptional and exaggerated temperamental predilections, and to use his conception of pose, his idea of the relations of boss and hollow, his amplifications of form without his peculiar psychological intention is to become inevitably turgid and rhetorical; and such indeed has been the sad fate of his imitators as it was the fate of Michaelangelesque painters.

Roger Fry, "The Sculptures of Maillol," *Burlington Magazine*, April 1910, pp. 26–32. Reprinted by permission of the editor of the *Burlington Magazine*.

It was, therefore, with a feeling of intense pleasure and relief that one noted, now some few years ago, at an exhibition of the International Society a seated nude figure by Maillol which proclaimed quite other intentions and aspirations.

M. Maillol comes from Provençe and retains amidst Parisian surroundings a simplicity of outlook, an almost rustic ingenuousness which is the very opposite of that feverish and frantic vehemence of passion that marks the efforts of some of his predecessors.

Rodin has used all his ingenuity to seize the figure in moments of critical intensity; for him the figure becomes most expressive at moments when the soul is beside itself in an ecstasy of despair, of agony or of joy, and even the stillness of his *Penseur* is only the equilibrium of opposed forces each at the utmost limit of intensity. Maillol has taken the other direction, he has endeavoured to show what meaning there may be in the figure at its moments of placid self-possession, what beauty in the large unimpassioned gestures of grave and sedate self-assurance. His figures have the *occhi tardi e gravi* and the *grande autorità* of the magnanimous spirits of antiquity described by Dante, and did they speak one knows they would speak "seldom and with mild voices." But Maillol is no classicist in the old-fashioned way of Flaxman, Canova and Pradier; he is on Rodin's side as against that art of formal form and merely measured proportion. For him, as for Rodin, the figure is the expression of a state of consciousness—only that he moves in a different world of feeling. For Rodin, the figure is expressive when the muscles are tense with excitement, for Maillol when they are obedient to the placid will.

Naturally enough this leads to a totally different conception of the function of form and of unity. To begin with the latter; for Rodin, it is the unit that counts rather than the unity. His conception of a figure is always so exceptional, so extreme, that every part of the figure is instinct with the central idea, every detail of hand or foot is an epitome of the whole, and the final composition of these parts is often a matter of doubt. It is this that has led Rodin so often to exhibit fragments and "disjected members" of his figures, or to combine and recombine them in various ways. With Maillol on the contrary the unity is fundamental, is indeed the chief means of expression, and though small adjustments and alterations may be possible, the figure can scarcely be regarded except as a single indivisible whole. . . .

Maillol's figures are true statues. He has accepted, not with straining impatience, but with something of enthusiastic obedience, the limits of his art. His figures sit or stand self-centered in well-poised equilibrium, they are built on the lines of architecture and will take their place in any fair architectural whole. I do not wish to deny that Rodin, too, has accomplished this, as for instance notably in his Victor Hugo, but each time the feat appears as an effort of prodigious ingenuity not to be imitated or repeated by any lesser mind, whereas in Maillol's work this harmony of the object of art and its

surroundings appears to flow naturally and easily from the fundamental principles which govern his creation.

Thus to bring those disconsolate strangers, Architecture and Sculpture, once more acquainted is perhaps of more hopeful augury for the future than would be the revelation to an astonished world of yet another genius of the incalculable energy and originality of Rodin.

Judith Cladel
An Interview with Aristide Maillol (1930's)

My sculpture is altogether different from Rodin's. Jules Romains thinks I do this deliberately, and has written to that effect. He is mistaken. I have done what I thought, simply, and not with a view to opposing Rodin. . . . Rodin is the genius who has given movement to his whole epoch; he is a man whom I could never be. When he appeared, there was no one, except Carpeaux; sculpture was no longer anything. . . . Rodin was a god. When I went to see him I had the impression of being received by a benevolent divinity. A profound mind, who never talked nonsense. Nor did he ever speak ill of an artist. He showed with joy and without jealousy the works of his colleagues which he considered beautiful. He expressed significant ideas, or he kept quiet. I listened to him without daring to reply; I had too much respect for his genius. There was little discussion of sculpture between us; we understood each other without speaking.

Rodin's work is a perfect clay technique: "Is your clay good?" he would ask, when he found me in the midst of modelling a figure. And he would try it with his finger. He understood nothing of medium because he did not cut stone. He recognized this: "I have made cartloads of clay." He was too inclined to limit himself to the sketch. He modelled an old woman, reproducing all the wrinkles of her belly. . . . An old woman's belly doesn't fascinate me: I like health and beauty. In the Victor Hugo monument, he got to the point where he didn't know how to place the figures. I suggested that I might arrange them. He was willing, for he wasn't proud. . . . I saw his *Thinker* in

Selection from an interview that Judith Cladel had with Maillol. Judith Cladel, *Aristide Maillol, sa vie, son oeuvre, ses idées* (Paris: Éditions Bernard Grasset, 1937). Translated by Katherine B. Neilson and published in the Albright Art Gallery catalogue, *Aristide Maillol* (Westport, Conn.: Greenwood Press, 1945), p. 46. Reprinted by permission of the Albright-Knox Art Gallery.

pieces, without arms. It is a magnificent work, even more so than it appears, because the arms conceal what is beautiful.

The *Walking Man* was done in several stages; the legs were added to the torso much later, hence a certain lack of balance in the figure, something of indecision. . . . The most pathetic fragment is the *Iris*. He never finished it and it is perhaps the most beautiful thing he ever did. It quivers with life. In sculpture, he always sees the flesh first. The Ancients saw structure. At the end of his life he had a quieter vision of forms. He turned from that slightly feverish sculpture which had been his style.

One may draw from Rodin a great lesson, but one must look at him carefully. We have not yet discovered all his hidden qualities. I would gladly undertake to bring them to light. There would be much to say. . . .

If Rodin was influenced by anyone, it was by Michelangelo. He is more agitated in the modelling and less architectural in the ensembles. . . . It is impossible to take anything from an artist. Style is nothing. It is the individual way of seeing that counts, an intimate feeling, wholly personal. . . .

Henri Matisse
On Rodin (c. 1937)

I was taken to Rodin's studio in the rue de l'Université by one of his students who wanted to show my drawings to his master. Rodin received me kindly and seemed relatively interested. He told me that I had "facility of hand," which wasn't true. And he recommended that I do more carefully worked drawings (des dessins "pinochés") and that I show them to him again. I never went back. But, indeed, I said to myself: in order to do more careful drawings and to understand my own way I do need someone, for by going from the simple to the complex (simple things are so difficult to explain) when I do get to the details, I shall have finished my work, which is to understand myself.

Already my way of working was counter to that of Rodin. I did not say

Raymond Escholier, *Matisse Ce Vivant* (Paris, Librairie Arthème Fayard, 1956), pp. 163–64. The passage is from a letter that Matisse sent to Escholier, and it is probably in response to a direct question posed by Escholier some time after 1937 when he began working on his Matisse book. Reprinted by permission of the editors of the Librairie Arthème Fayard. Earlier in the century Maurice Denis told André Gide that Matisse was furious after he went to see Rodin because the master had told him to "fuss" over his drawings for two weeks and then come back and show them to him again. (Gide *Journal* for March 18, 1906.)

so, however, for I was too modest. It was simply that each day brought its own revelations.

I could not understand how Rodin worked on his *St. John,* the way he cut off a hand and fit it into a sleeve; then he worked on details while holding it in his left hand. It seemed, more or less, that he had detached it from the whole and then he replaced it at the end of the arm, at which point he tried to position it to fit into the general flow of the movement.

As far as I was concerned at that point I could only work on the general architecture of the whole, replacing exact details with a lively and suggestive synthesis.

Constantin Brancusi
"Homage to Rodin" (c. 1950)

Since Michelangelo, sculptors have sought to create things that were grandiose. All they have succeeded in creating was grandiloquence. There's no need to mention names. In the nineteenth century the position of sculpture was one of despair. Then Rodin appeared and succeeded in transforming everything. Thanks to him, man became once more the measure, the model from which the statue springs. Thanks to him, too, sculpture became human again, both in its dimensions and in its spiritual content. The influence of Rodin was and remains immense. After I had exhibited at the Société Nationale des Beaux-Arts, of which he was President, friends and patrons, among whom was the Queen (of Rumania), tried, without consulting me, to get him to take me into his atelier. Rodin agreed to take me as a pupil, but I refused, because nothing grows under big trees. My friends were much embarrassed, not knowing what Rodin's reaction might be. When he heard my decision, however, he said simply: "At bottom, he is right, he is as stubborn as I am." Rodin's attitude towards his art was a modest one. When he had finished his *Balzac,* which undoubtedly remains the point of departure of modern sculpture, he declared: "Now I should like to begin to work on it."

Constantin Brancusi, *Homage à Rodin,* Quatrième Salon de la jeune sculpture, Paris, 1952. Translated by Maria Jolas and Anne Leroy and published in Carola Giedion-Welcker, *Constantin Brancusi* (New York: George Braziller, Inc., 1959), p. 219. Reprinted by permission of George Braziller, Inc.

RODIN'S WRITING

A visit to one of Rodin's ateliers was thrilling, not only because of what could be seen, but because of what might be heard. Rodin had a way with words; he could make statements about art and life that were both simple and profound, the kind that stuck in people's minds. The "paroles de Rodin" were central to the most important books about his work that were written in the early twentieth century. It was but a short step to publications bearing his own name, although much of the actual writing was still done by others. The two most important such books are: *L'Art: Entretiens réunis par Paul Gsell* (Paris: Bernard Grasset, 1911) and *Les Cathédrales de France* (Paris: Librairie Armand Colin, 1914). Rodin had made Paul Gsell's acquaintance sometime before 1907, and in 1910 the critic confided in him that he had long wished to write down "from his dictation, his ideas about Art." At the same time the brilliant Symbolist writer Charles Morice was busy assembling Rodin's notes about the cathedrals of France for publication. It is generally acknowledged that it is difficult to distinguish what is Morice and what is Rodin in this book.

André Chaumeix
"The Movement of Ideas:
Rodin's Discourses on Art" (1911)

As in ancient times, on the banks of the Ilissus, Socrates conversed with his disciples while crickets sang, and so Rodin chats informally with those who

André Chaumeix, "Le Mouvement des idées: Les Entretiens de Rodin sur l'Art," *La Revue Hebdomadaire*, 3 (August 5, 1911), 109–28. These three paragraphs are the opening of a long and very appreciative review. Translated by John Anzalone.

visit him at his home in Val-Fleury. M. Paul Gsell has just published these interviews in an excellent book. We see the master strolling around his red brick Louis XIII pavilion or along the pillared portico, as he discusses his art. The setting is enchanting. Small marble altars ornate with garlands are seen beneath the shade trees. All about are sculptures and antiquities: a young Mithra slaughtering the sacred bull, Eros asleep on a lionskin, a clay amphora leaning against a boxwood. Further off, swans glide around a pond, tracing circles. The loop of the Seine appears on the horizon, with its reflection of poplars. Beyond the bridge at Sèvres, whose stones glow pink at sunset, the knolls of Saint-Cloud are softly contoured. It is amidst this scenery that Paul Gsell has gone to interview the master Rodin.

This somewhat neglected form of dialogue is full of the supple grace of spontaneity. Nothing is pretentious in these conversations on art. Rodin speaks simply of that which he has seen, with the fervor that informs words devoted to beloved things. Paul Gsell interrogates him wittily, provokes him, tries to trap him in self-contradiction. In a hundred ingenius ways he invites Rodin to explain himself, to let memory and imagination flow. Rodin responds without pomp, like a sage who has contemplated his career, peacefully reminiscing. Not everything in these interviews will be savored uniformly, but no one in the world of arts and letters will remain indifferent. Often, in the course of these conversations, there emerges, without plan or preconception, some observation of modest aspect. But it is so precisely formulated as to be of import, it is endowed with apparent universal value and contains some precious truth. How simple these maxims seem nonetheless, and yet they are enriched and animated in drawing from real experience and genuine life.

The essential character of these Rodin interviews lies in their empiricism. There is no grand aesthetic theory dogmatically expounded, except latently, and there is little wordiness. One is presented with real objects, facts, demonstrations. One discovers a sculptor speaking intelligently about sculpture. And beyond that, without a doubt, there are discoveries which cannot be considered new, but which possess, nevertheless, the beauty and genius of ancient truths revived by recent experience. It is as when seasons of the past are rejuvenated by the renewed reality of their sorrows and their flowerings. Here also, something healthy and robust emerges, something which does not depend on intellectual creation, or on theoretical logic, rather something that is allied with the earth and with life itself. We think of the words of Pascal: one imagined that one would find an "*auteur*," but one is astonished with delight to meet a man.

"Rodin Interprets the
Cathedrals of France" (1914)

M. Rodin's book on the cathedrals of France is not actually a book: it is a
series of shimmering notes, noble thoughts, and beautiful metaphors dif-
ficult to contain within the narrow band of any crown. Do not look here for a
history of the cathedrals, nor for the laws governing their equilibrium, nor
for an explanation of the encyclopedia of stone found on their walls. If you
do, you will be disappointed. The positivist mentality which seeks precise
facts and strong ideas that are solid enough to go anywhere will be out of
place here. Rodin gives few reasons, and those he gives seem made for him
alone. He sees architecture through a sculptor's eyes. If one were to ask him
why the cathedrals are beautiful, he would answer that they cast light and
shadow. With the cathedral, as with the human body, all things have their
place, and it is light and shadow that reveals their harmonies. Each passing
hour unveils new beauty. Modern artists have lost the secret of surface, of
depth, and of eloquent shadow. It is for this reason that their work looks flat
and dry, and without soul. When they get their hands on the monuments of
the past their restorations are criminal. Such, in essence, is M. Rodin's
doctrine.

But must Rodin give us reasons? It is enough for him to admire. When
a man who has created masterpieces tells us that the cathedrals are sublime
and should be contemplated through tears of joy, we can take him at his
word. Do we ask reasons of a prophet or seer? We simply listen and feel our
hearts burning in our breast.

M. Rodin is a witness. Like his *Saint John the Baptist,* he affirms inspired
truths and implores us to believe. I quote him, chapter and verse.

> The spirit responsible for the Parthenon is the same that created the Gothic
> cathedrals.
>
> The least bas-relief at Amiens is as beautiful as a Greek stele from the golden
> age.
>
> The artists who made this have cast a reflection of divinity into the world.
>
> The French temperament has attained perfection and covered it with a veil of
> modesty.
>
> The Parthenon defended Greece . . . This country shall not perish as long as
> the cathedrals stand. They are our Muses. They are our Mother.
>
> Why do you scorn happiness? Come and receive true life from the hands of

Emile Mâle, "Rodin interprète des cathédrales de France," *Gazette des Beaux-Arts,* 56th year (May
1914), pp. 372–78. Reprinted by permission of the editors of the *Gazette des Beaux-Arts.*

those who are no more, but have left us such a magnificent testimony to their souls.

To express what he feels, M. Rodin finds metaphors of a beauty which rival the beauty he seeks to portray. . . .

I have no doubt that Rodin's book will help us to appreciate the cathedrals, but it will also help us know Rodin better.

We can admire the inward tremors of an enthusiasm that grows with the years. We are struck by the nobility of his thought and sometimes dazzled by its flashes. This book is a testimony which proves that greatness in great artists resides in their souls. Rodin, by nature, allies himself with the most beautiful sensibilities of the nineteenth century. He feels the way Michelet and Ruskin felt. Or like Chateaubriand, in whose *René* there is a sentence full of mystery and beauty: "How beautiful are the noises one hears on top of domes." What did he mean? No one has ever really known, but all at once one of Rodin's sentences illuminates Chateaubriand's: "In the majesty which envelopes the cathedral like a great cloak, the noises of life—the footsteps, the sounds of a moving carriage or a closing door—ring out. *And solitude adjusts them according to its harmonious sense of proportion.*" . . .

The great artists do not need our books. Contemplation of nature, meditation, and dreams teach them much more. M. Rodin has arrived at the time of life spoken of by Virgil when dreams become truths. His "new friend, old age" has brought him certainties which he has communicated to us. We can and should be grateful. "What a paradise this earth is! Let us seek only to exhaust the goodness, the happiness granted us as our lot in life! We never will succeed for it is infinite." . . .

While reading M. Rodin's book, I thought about Viollet-le-Duc's books on the cathedrals. Both artists invite our admiration for their subject, but was there ever such a contrast? The first gives us intuition, metaphor, and the shout of admiration; the second the even light of a geometrician's logic. His thinking is as sharp as the point of his drawing pencil. But this marvelous, all-intelligent Viollet-le-Duc lacked one thing: he had no dream. His cathedral has no mystery and seems illumined by transparent windows. What happened? When Viollet-le-Duc created, he produced works which can satisfy logic but leave sympathy untouched. The cold light of pure reason falls upon his cathedral's mouldings. Rodin is not like this at all. To have read his book, to have shared his élan before the cathedrals, to have experienced the surprise of his constant inner palpitations is to understand why his statues never cease to quiver. And it is to understand his aphorism: "The intellect draws, but it is the heart that shapes." . . .

RODIN'S WORK:
POSTHUMOUS ASSESSMENT

Rodin bequeathed all his work to the State with the intention that it be installed in the Hôtel Biron, the magnificent eighteenth-century residence that had been the center of his life in Paris since 1908. The National Assembly voted to establish the Rodin Museum on December 15, 1916, by which time Rodin was quite ill. He died on November, 17, 1917, at Meudon, and was buried in his own garden on November 24. The funeral was organized by family and friends as Clemenceau made the decision that a State funeral would not be possible in wartime.

Elie Faure
"The Last of the Romantics
Is Dead"[1] (1918)

The last of the great Romantics is dead. That is, the most recent, but not the last if we speak of quality. Between Hugo and Byron, Delacroix and Baudelaire, Michelet and Balzac, Wagner and Schumann, Schopenhauer and Nietzsche, Daumier and Berlioz, Rodin and Zola there are, to be sure, unequal gaps, the depths and limits of which may be set by posterity, unless

Elie Faure, "Auguste Rodin," *Les Ecrits Nouveaux,* Paris 1 (April 1918), pp. 51–56. Translated by John Anzalone. Reprinted by permission of M. François Faure.

[1][Editor's title.]

the movement of minds be like that of the sea. All we can say here is that if Romanticism survives—at least through a certain number of its pinnacles, and that does seem likely—Rodin will survive.

Rodin is Romantic in two essential aspects of his work. The first is his unbelievable power of expressive projection, the ability to translate tragic sentiment and to make the object but a symbol (I was going to say moment) of that. The second is equally incredible: it is his inability to create architectonic forms in space, forms that can be walked around and in which different volumes and planes give rise to each other and penetrate one another, forms that seem unified from every vantage point and that remain unified even in our memory. It is a failing common to all the Romantics, with the exception of Baudelaire and Daumier. And Daumier, of course, was little more than a caricaturist, while Baudelaire was a mad man. Even among the greatest Romantics, form is never fully elaborated in the mind before it bursts forth in word. One could even say that form derives from the word in the dazzling flashes the Romantics obtain by striking, bruising, twisting the word as though it were a piece of metal. Yet Rodin claimed he sculpted only ensembles. Read a page or two of his "writings," for in that unfortunate hodgepodge of odds and ends, you will find remarkable insights into the necessity of elaborating form in terms of a whole, of subordinating detail to form, and of considering form through surface and profile. Having read what he has written, we might almost say that Rodin did not always understand the beautiful forms he has created.

Rodin is the master of detail. If one isolates, in any or all of Rodin's works, a face, a bust, a thigh, or an arm, you immediately think of Rembrandt. The piece not only lives, it is ravaged by life. It rolls, undulates, shivers, swells with crying and blood. As for form, the nervous influx that shapes it, expelled from within by hunger, love, or thought, breaks and bruises it as though to escape from it entirely. And yet it remains, because the shape of the surface is that single immortal second when it bursts in a passionate élan from the artist's heart and possesses the infallible sureness of the most tragic instincts. The Romantics, especially Rodin, are much like women in love. The fact that they are overwhelmed escapes them. A god lives who is to them what a man is to a woman; he toys with them for a moment. Make no mistake, the moment is the embrace. But in the embrace, man is conquered by woman, and the god by the artist. The structure of the mind stumbles or even collapses, but the piece remains standing on the road it has traveled. To tell the truth, it is so alive it blots out the horizon . . . Rodin's profound portraits, those battered, contracted faces, those volcanic masks that jut out, projecting the tense forces acting within them, are the only integral monuments the sculptor has left us. For a face is a monument that can only live if the surfaces, curves, bumps, and volumes of the skull converge from all points harmoniously to participate in giving the face a form. But beneath, the neck does not hold, or the chest is caved in. A pair of undulating female breasts, an open hand, two feet walking on the soil, these

are all portraits—portraits of breasts, hands, and feet. The *Age of Bronze,* the *Saint John the Baptist,* the *Eve,* and the *Burgher of Calais* who holds a key in his fist are perhaps Rodin's only monumental works possessing life from top to bottom. But it is still a risky business to view them from all angles. A surface gives way, a volume appears hollow from below, a body sometimes stumbles on a leg that won't hold, Rodin knew this: he sculpted magnificently unifed torsos, without head, arms, or legs. It is a trick and he was criticized for it. But I don't find it malicious. Rodin could not transcend the limits of the impression he felt. And when, in flashes, he succeeded in creating an ensemble, it represented little more than a short, highly unstable state of equilibrium between phases in the too-distracted research of his lurching genius.

But all of this notwithstanding, Rodin remains a tremendous sculptor. The life he has conferred upon disturbed surfaces seems almost torn from the depths of a matter whose heart begins to beat because of Rodin's unique power. I have spoken of Rembrandt—he was an architect moreover, one who was able to instill in a mold the life contained in the fragment of a poem describing it. It is indeed this same inflamed clay of humanity, which, through the interplay of light and shadows, can translate the silent dramas that confer a prodigious humanity upon his painterly forms. We must note that when, in his discourses, Rodin spoke of the admirable organism of the cathedrals, with their unity and coherence, their inner logic similar to the articulations of a skeleton, he emphasized especially the nuances that bring the surfaces of the monument to life. Rodin was a painter and by playing with the effects of light upon surfaces, he inflicted upon them a life so mobile and dramatic that it recalls a primitive lava swell once fixed and now brought to life by the will of a god. Look at his drawings. They are like a pool of blood, but with the form of a soul, like the shape of a red blot on the ground or on a wall in which we might recognize the traces of a shattered foot or a torn arm.

This is where we must look to find the secret of Rodin's unique glory. He was born to sculpture: take the *Age of Bronze,* for example, with its nervous jerks and involuntary deformities. That work already indicated Rodin's need to shatter form through the means of expression. It is, nevertheless, an adequately, an even strongly balanced statue. Born to sculpture, he constantly sought to wrench the spirit that lived within him and that slumbered in every object in his path from the depths of matter, the better to shower it over his moving surfaces. He was in perpetual oscillation between temporary victory over a language he tried to make stable and firm enough and to master once and for all the storms seething within him, and the momentary defeat of a constantly assailed willpower. He is of the race of the great Christians, or the magnificent damned, for they are one and the same. The struggle is eternal between the spirit that seeks to rise and the flesh that embraces it from all sides, clings to it, holds it back, and finally drowns it. The *Hand of God* swarms with larvae that are never to escape, for the *Gates of Hell* will close upon them. Rodin's loving couples can never separate, skin is fused with skin. The woman's bosom protrudes and, sur-

rounded by moving matter, ripples and wells like the open sea; a man, blind and supported by his fists, lifts his forehead like a victim who is drowning. Flesh joins with flesh to fan the flames. And the more atrocious the burning, the tighter the embrace. Desperate lust twists their muscles, raises their heads, and casts their defeated bodies beyond the pole of willpower or happiness. No one has ever written a more tragic poem to the eternal condition—and defeat—of the spirit. Unless the spirit's victory resides precisely in expressing with an ever present power, as it was from Aeschylus to Pascal, from Dante to Baudelaire, and from Shakespeare to Rodin the condition and defeat of the spirit and of all of art, it is a useless revenge of the soul, one that is always in revolt against the flesh, ever ensconced in invincible cruelty. It is up to pessimism to pronounce whether what we believe to be the superior life in the world is not, in fact, conditioned by the dramatic feeling of being condemned to turn endlessly in a circle inscribed by love and closed by death.

I would not like to have known Rodin. Listening to him, I would not have been able to perceive the blank spaces in his work, those holes I earlier mistook for mysterious abysses. Now I understand too much. He hardly spoke of anything except his profession. And he seemed not to perceive the very drama that he expressed in his work. Or he complicated it, overloading it with literary explanations and useless intentions. What did he lack that he might have been an Aeschylus or a Villon, a Dante or a Pascal, a Shakespeare or a Baudelaire? Was it intelligence? A uniform culture? A form of introspection that would have allowed him to make the struggle within him apparent? The will to come off victorious? I don't know. Certainly he left us the most powerful plastic expression possible dealing with the drama of sexuality. But does it not seem too fragmented and tormented, and too little detached from the compulsive need to astonish or intellectualize? One has the nagging impression that it exceeds the sculptor's intended goal, that the ever present spirit only escapes the matter that overwhelms it by external processes that ultimately exhaust it, and cast it back into matter, there to drown once and for all. I would have preferred an unquestionably great mind to the great sensualist. I would have preferred a more consistently great man to the great artist. The equilibrium he pursued, or rather called upon, if we are to believe those who knew him, was something he never achieved except in flashes. The shreds of the spirit spin in disarray around a fixed center he never succeeded in entirely occupying. His overturned bodies with their uplifted arms and their legs adrift like dead branches on a raging river are the symbols of a lifetime's work thirsting after a desperate intuition of the plastic architecture he never realized.

And yet this is a great artist—a monster—who has left our path, and I believe he has placed lasting markers upon it. Bloodied though we be, we must hail Rodin as one of those tyrants of the spirit who may reign longer and more despotically over time than conquerors over geographic extent, a tyrant who forces centuries of drama upon our curiosity in order to nourish

us. He has been accused of prompting decadence. Of course. So did Michaelangelo. After a summit there is only decline. It is of no importance. He forced stone to express unquestionably violent animation, one that was unknown before him. Look at his contemporaries and judge. For Rude, life was external, full of gesture, entirely capturing oratorical movement. For Barye, it was caught between harsh planes and there arrested like a theorem. It was certainly a grandiose accent, but seems applied to objects that are too defined. Carpeaux was the socialite. His women and flowers meandered through balls and celebrations. He expressed a defined but limited period with wit, verve, and the hint of a bad joke. With Rodin we rise in rebellion, but we look, and if we fall into holes, there are still prodigious ledges to cling to. *Eve* comes to mind, as do *Heaulmière, Ugolino,* almost all the busts, the *Burghers of Calais,* and the statue of *Claude Lorrain* in Nancy. The masks of god display themselves in all their horrifying cruelty. Rodin's works affirm the pessimism of other great inspired artists with a frightening similarity. From the gestures of hunger and the futile embraces, to the fading light in the eyes of heroes, these living forms all proclaim the dominion and sovereignty of death.

Rodin's animated volumes are projected outward through the means of that inner passionate force that holds the moral universe in place within a dramatic circle and compels it to seek consolation for its taunting destiny in the strength of experience. What have we done to deserve to be punished for existing? Because a woman possesses a bosom, must she hide her shame behind folded arms? Will he who hungers devour his children to delay his own death by a quarter of an hour? The hide that hangs on that emaciated carcass once had all the flow, flavor, and resiliency of ripeness. This man who offers himself in sacrifice will die so that thousands of men unworthy of him may live. That painter is dazzled by the light, but his worn-out boots stumble over pebbles. . . . Everything that must die suffers and even perishes in order to live. The volume of expression alone batters the face of the earth, and the trace of a grandiose soul alone is as permanent as the man who keeps to his path. A great artist is dead. But the echo of his cries will be heard in the silence. From their deathless solitude, the sphinx and the pyramids confirm the presence of the spirit.

Carl Burckhardt
"Rodin and the Problem
of Sculpture" (1921)

There is a prejudice against Rodin's art; in some places it has become the established point of view, particularly among modern sculptors. They regard Rodin primarily as the creator of a painterly approach to sculpture and as a genius of pictorial means who, once he strayed into the medium of sculpture, in compliance with his innate ability for productivity, lived out his error in a particularly individual and grandiose manner.

That is one prejudice. There is another that is even more widespread, according to which Rodin, with all his expressive means, is seen as a typical naturalist who no longer has the power to stir us. This evaluation is most persistent.

Rodin's art was nurtured in the soil of the Renaissance, a culture and a style that, when taken to its logical conclusion, yields an extremely naturalistic art. Today's artists aim at disentangling themselves from this view of art as they search for a renewal.

Although the origins of Rodin's art are rooted in the Renaissance and in a tradition based more upon painting and modeling than upon spatial concepts and sculptural concerns, and although Rodin, as was correct in his time, believed in the gospel of Naturalism, every attempt to explain his art solely in terms of Naturalism fails. On closer examination his inquiries into nature prove to be an all-encompassing investigation into the very laws of nature. This investigation was not concerned with the superficialities of given objects, but rather with the entire natural order, as long as this order was visible. In the final analysis Rodin strove to grasp the means through which nature created an impression similar to the work of art and the means by which such as effect could be duplicated with the materials available to the sculptor. One of Rodin's characteristics was his increasingly liberal attitude toward subject matter. At an early stage it lead him out of the circle of sworn Naturalism and gave free reign to his irresistible desire to create.

Rodin is indeed a complicated figure and difficult to comprehend through a simple formula. Although subject to all the possible influences that art could provide, his work was full of individual problems that could assume new significance in relationship to each new phase of his development. His nature was not stable, but fluid and comparable to the changing essence of artistic *Zeitgeist*.

Carl Burckhardt, *Rodin und das plastische Problem* (Basel: Benno Schwabe & Co.: 1921), pp. 9–14. This selection serves as the Introduction to Burkhardt's book and was signed "Summer 1920." Translated by Sabina Quitslund. Reprinted by permission of Schwabe & Co., Ltd.

state they expressed the most diverse insights rendered in an equally diverse formal language.

The figure of *The Thinker,* which comes out of the original conception of the *Gates of Hell,* demonstrates in its final version the new perception of form at a distance and form *en plain air.* On the other hand, the *Burghers of Calais,* which grew out of a similar early world of ideas, still exhibits, as completed later in Rodin's life, an historical and self-conscious approach to a subject viewed close-up. This approach affords a way of looking in order to emphasize details.

The statue of *Balzac,* which is most typical of Rodin's personal style, brings to a close the early period, which was so fruitful for pictorial modeling. This work can be seen as a summary of all previous achievements. It courageously reveals Rodin's new sense of stability.

A special characteristic of this period is the way Rodin's forms depend upon how light strikes them. This determines the position of the viewer within a limited field of observation. Despite all the forces that stimulate our feelings and heighten our visual perception, we remain objective in our attitude.

Complete absorption in form, undivided attention transferred into the work of art, only came into Rodin's creative life in his late years as he created spaces that were unaffected by the direction of the light falling upon the object. At the center of this late period, in which Rodin dealt with the familiar sculptural problem of space, is *The Walking Man.* Because of the novel intentions here, the special imaginative realm of poet and psychologist has completely receded in favor of a more general architectonic expression of form. Rodin was no longer compelled to characterize different human states; instead he discovered significant new relationships in the sculptural form itself. *The Walking Man* was the most perfect reflection of this. In the following pages we shall discuss in depth the nature of sculpture and we shall examine a number of smaller and lesser-known sculptures by Rodin as being new and related to our modern age. In order to evaluate this sense of newness, an element that heretofore has received little consideration, we shall make comparisons with the greatest sculptural works of earlier periods. They will provide a standard and help us to move beyond the specifics of Rodin's time, to lead us to contemplate the universal aspects of Rodin's work, which, after all, ended with his own book *Les Cathédrales* and with his own reference to the universal and unifying aspects to be found in the sculpture of all time.

We can best approcah the central core of Rodin's art by trying to remove the many layers of historical residue that enclose the most personal essence of his work. These historical influences are most clearly reflected in Rodin's early works, and for a long time his creations were saturated with the diverse stylistic elements of his predecessors. But often they also obscured the evolution of his new formal language. It is not my intention to draw the reader's interest to these historical matters—they are obvious—but rather I wish to draw attention to the organic development of Rodin's perception of form. I should like to demonstrate how Rodin arrived at new visual insights, setting out from the formal conventions of contemporary Naturalism and equipped with the almost scientific ardour of his great colleagues in painting. Further, I should like to show how he was able to take a traditional formal concept and breathe new life into it.

Although poetic suggestiveness, an incommensurable force acting in an unusual way in Rodin's work, is the new and original fruit of his search, it is the rediscovery of light and air that is the basis of his new form-determining quality. The infinite transformations that take place in an object because of a change in a viewer's distance or because of a change in the surrounding atmosphere, the ability to see a work more intensively or more delicately, depending on how light functions as a transforming agent, the difference these various factors make between a form that is observed close-up or from afar—all these things depend on Rodin's rediscovery of form *en plein air!* These insights revitalized the expressive power of modeling and they represent the most essential creative findings in Rodin's earliest and most creative period. They run parallel to similar discoveries in painting during the last century and touch upon problems that are shared by painters and sculptors. Added to this is a hitherto unknown intensification of forms and a special new emotional stability, which I see more as a result of temperament than of perception.

But it is only in Rodin's mature art that we see what can separate sculpture, in the sense of its true essence, from its sister art. It is the quality of space that resides in one and not in the other. These two periods in Rodin's art represent opposite phases. It is characteristic of the innermost essence of his artistic personality that he did not indulge in variations within a formal language once achieved, but searched continually for new forms.

If we attempt to apply order to this rich and complex life, then we must first look at the *Age of Bronze* from the beginning of Rodin's career. It represents an objective scientific search for the figure of a youth. It became Rodin's first confrontation with the problem of light as a transforming agent. Later, in his *St. John,* he treated light even more distinctly. But at this point the influences of earlier artistic periods forced him to depart from this chosen path to render an objective study of nature. Great poetic inspirations led him to do richly figured sketches for his fantastic *Gates of Hell.* These prophetic sketches became the basis for half a lifetime of work. In their late

Luc-Benoist
"Romantic Decadence" (1928)

With Rodin we encounter a powerful and complex personality. He is the last of the Romantics. Around 1854, when the movement was still lively and Rodin still young, he sought the advice of Klagmann and Maindron. And he attended Barye's classes at the Museum. Rodin drank Romanticism at its source.

And Rodin was never to repudiate it. Later it seemed that he wished to re-do Romanticism for his own purposes, to transform it into a style that was—in a word—free, free as no other Romantic sculptor, except for Géricault, had been able to be. Rodin wanted to magnify Romanticism. He wanted to make that ultimate leap in a dying style and to make use of all its favorite themes. Was he that far from Préault when he did that living cadaver, the *Vielle Heaumière*? His hommage to Dante in the unfinished *Gates of Hell*—was that not a youthful dream inherited from Félicie de Fauveau and Préault? Those fallen angels, the lovers, the Paolos and Francescas entwined upon the panels are nothing more than elements of a colossal recollection of Préault's sketch of *Dante and Virgil*. The pursuit of expression in his statues, the passion that culminates in his nudes, their erotic quality and their symbolic existence are Romanticism of the highest order. They are, as Laviron said of Moine's works, three-dimensional nightmares that have been petrified in marble. Like Géricault, who transformed a woman into a lion, Rodin played with reality: he transformed the mask of the danser Anako [sic] into Beethoven. Who could call Rodin a Realist—Rodin—this poet?

Agnes Rindge
"Realism in Sculpture" (1929)

Heretofore we have been guilty of skirmishing about the topic of realism in sculpture without really attacking it. We have referred to the way a three

Luc-Benoist, *La Sculpture romantique* (Paris: La Renaissance du Livre, 1928), pp. 161–62. Reprinted by permission of Luc-Benoist.

Agnes M. Rindge, *Sculpture* (New York: Payson and Clarke, Ltd., 1929). This selection is composed of paragraphs excerpted from Rindge's chapter on "Realism in Sculpture," pp. 99–114. Reprinted by permission of Philip W. Claflin.

dimensional perception affects us and we have acknowledged the three dimensional or real nature of sculpture.

A piece of sculpture is more or less realistic in proportion to the intention of its author. Granted, therefore, for whatsoever purpose, æsthetically justifiable or no, the artist has embarked on a realistic endeavour, what means has he at his disposal in sculpture and how greatly will those means endanger an artistic performance?

The very fact of working in three dimensions arouses the tactile sense, one knows the figure to be true to touch far more than one ever does in painting. The most prevalent type of realistic sculpture is that which tries for the closest approximation of the surface imitated. In much Hellenistic sculpture, the *Borghese Warrior,* for example, and more notoriously in Rodin's *Age of Bronze,* the most minute contours of bodily surface are transcribed. . . . Although Rodin cleared himself of the charge of using a cast from life for his *Age of Bronze,* the plausibility of such a charge indicates the dangers of realistic enterprise. Suspicion of falsification can have no place in a proper appreciation of art. Such an examination of a work belongs to the province of scientific discrimination. To arouse it interrupts and usually destroys any perception of the quality of art in the object. It is for this reason, mere artistic expediency, and for no other, that realism is employed sparingly as a convenience rather than an aim by great artists. . . .

There are two fashions of treating surface in the realistic aim: one the meticulous, imitative surface used by Rodin in the *Age of Bronze,* a surface seeking to reproduce nature in the smallest detail; the other the impressionistic chiaroscuro surface in which the planes are treated in reference to the action of light upon them, particularly for the dramatic effect of shadows and the atmospheric effect of partially revealed forms. In this mode also we find characteristic examples of Rodin's work, since, in its most extreme form, it was more or less his invention.

In the first mode the success in realism depends on the scale and the material. In sharp light the multiplicity of detail in the torso of the *Age of Bronze* distracts the eye from the realistic significance of the whole figure, not only because there is too much for the eye to attend to, but because the eye does not see and know the tenth part of these details from actual experience. The question of emphasis in a work of art is the same for sculpture as for prose style, the significant must be stressed, the supplementary material held to the unity of the whole.

This treatment of surface then runs the constant danger of becoming a catalogue of parts. It is correct in tactile perception but not in visual, and since the work was designed to be read by the eye, not the hand, it does, in a way, defeat its own aim of realistic accuracy. Furthermore, it is a stupid and clumsy way of achieving this aim. None of the directness and economy we demand of other and more practical modes of life has gone into this object. We are asked to labour over much anatomy which cannot have the slightest bearing on the subject set by the title, a somewhat poetic conception of form.

The disparity between title and content, common enough in the nineteenth century, led to the strenuous reaction of recent years which has almost banished subject from sculpture. The reaction was a salutary one, but like all ruthless methods, it has deprived us of something we want. The most serious charge to be levelled against contemporary art is its lack of idea-value. A figure devoid of any subject significance is either too abstract or too particular to become an agent for the greatest amount of creative artistry. . . .

After all is said and done, Rodin remains the outstanding figure in nineteenth century sculpture. He had originality and inventiveness. He had a poetic imagination of a rather literary turn. He certainly had earnestness and enterprise. The heterogeneous literary tastes, the extremely eclectic artistic inheritance, the *sentiment de l'homme* which he shared with Millet and Meunier make of his work, in its entirety, a cross section of the mind and heart of his time. The sturdiness, the sentiment, the *recherche du temps perdu* all furnish a striking parallel in temperament to his great contemporary and friend, Anatole France. Both men have made big enough claims upon the attention of their times to warrant a real consideration, but neither could claim the stature of the greatest genius unchallenged. One senses a lack of fulcrum, a too great expansiveness in their ideas. They belong to the age when mankind was becoming consciously socialized and such an obliteration of the spirit of the individual, no matter how intellectually acceptable, always takes heavy toll of art. Rodin was not a great sculptor, nor yet a wholly little one. On the side of society and history his gift to us is great and expressive. Not every artist can reflect so limpidly his age. He is our immediate past and part of our Tree of Jesse, we cannot afford to deny him utterly. If his faults can be an example to us, and such has certainly been the case, we shall be still further in his debt. *The Hand of God* may be taken as the most complete summary of the man and his work, both in idea and execution.

Carola Giedion-Welcker
"Rodin's Superb One-Sidedness"[1]
(1937)

Maillol's contribution was to redress the balance of Rodin's superb one-sidedness. As we look back on Rodin to-day he seems to have been most significant as a precursor precisely where he was least affected by literary or psychological influences, as in those statues in which the human body is no longer primarily an instrument of our passions and emotions, but rather a medium for the expression of proportion and movement animated by light and informed by space. It is true Rodin once wrote: *"Le corps est un moulage où s'impriment les passions,"* but also that he said: *"Le pivot de l'art c'est l'équilibre: C'est-à-dire les oppositions des volumes, qui produisent le mouvement."*

By means of *"un rayonnement de formes"* Rodin dissolved the hard outline of contemporary Neo-Greek academicism, and thereby created a vital synthesis of opacity and transparency, volume and void.

As a wielder of volumes Maillol was static in the classic sense. The new plastic simplicity he achieved presents a marked contrast to the surface complexities of Rodin's liberation or sublimation of form. In the work of Daumier, Degas, and the later Rodin we see Impressionism unconsciously modernizing the baroque tradition through its emphasis on light and movement. The important point is that modern plastic art derives its technique from both baroque and classic sources. With Matisse we find a further development of the chiaroscuro rhythms of Impressionism, and a new feeling for freedom of proportion. The Futurist Umberto Boccioni proclaimed his adherence to Impressionism in his earlier manifestoes and proceeded to expand its theories.

To-day the baroque influence, transmitted through Daumier, Degas and Rodin to Matisse and Boccioni, may be said to have fused with the classic influence handed on by Maillol. Merged in turn with the forces of modern life, they have evoked a new optical vision.

Carola Giedion-Welcker, *Contemporary Sculpture* (New York: George Wittenborn, Inc., 1955), p. XII-XIII. Reprinted by permission of Wittenborn Art Books, Inc. Originally published as *Moderne-Plastik: Elemente der Wirklichkeit, Masse und Auflockerung* (Zürich: Girsberger, 1937).

[1][Editor's title.]

THE REDISCOVERY OF RODIN

Albert Elsen
"Rodin's Modernity" (1963)

There is irony in the fact that Rodin's modernity becomes more apparent with the passing of time. His most famous, but by no means best works, such as *The Kiss* and *The Thinker,* have diminished in artistic importance and now seem dated. While alive the sculptor resisted the nomination of revolutionary, claiming that he was merely a worker who continued the great traditions of the past by steadfastly imitating nature. He never forsook naturalism, as was done by the vanguard beginning in the 1880's and continuing into this century. As a consequence he founded no important movement; on the contrary, the best sculpture of the early 20th century was made in spite of Rodin and was strongly under the influence of advanced painting. Even his personal image seems at first to resist the public myths of the modern artist. He was enormously successful financially. He was internationally honored, and would-be patrons from many nations competed for his talents. He had a small corps of assistants, and many marbles never knew his personal touch. Literature, myth and history served him for titles, and museum art provided his paradigms of excellence. It seems in many ways that Rodin has backed into this century with his eyes focused on the past.

With the formation and circulation this past year of several large and important Rodin exhibitions in France, Canada and this country, much has been done to counter or dissipate conventional and often unsympathetic images of Rodin, and to excite artists as well as critics and the public by making possible discovery of much that was unknown in his art and which

Albert Elsen, "Rodin's Modernity," *Artforum,* December 1963. Copyright California Artforum, Inc., 1963. Reprinted by permission of Albert Elsen and *Artforum.*

seems startlingly fresh and meaningful today. Rodin's contradictory and unpredictable taste and nature do not, however, lessen his claims to modernity. The passage of time has also given us new perspectives on the meaning of modernity itself. While such writers as Harold Rosenberg discount the present value of the words "modern" and "art," the past 100 years have revealed not chaos but a meaningful variety of characteristics which, as an aggregate, do distinguish the art of this period from that of the past. As in the use of the words "renaissance" or "baroque," we may still use the adjective "modern" not in a descriptive way, but as an historical handle, label, or covering word to which important associations have accrued.

Since Courbet, Manet and Degas, modern art recognizes no one style, no perpetual revolution and renewal. Yesterday's revolutionary may become today's academician, and there has been important art resulting from one artist's working out of one idea for many years. There is a continual oscillation between new and traditional forms in the work of individuals and groups. We have seen that new media do not automatically mean new forms. Modernity has come to mean the search for a personal rather than a collective style. In turn, this style may be composed of many modes or only one. Rodin's first 20 years as a sculptor, down to about 1882, involved training himself to make sculpture that had the look of another time and place. He was the last of the great sculptors who were professionals in the traditional sense. Being a professional decorator working on commission, he could model in the style of past epochs, work in many media, and utilize reportorial subject matter. After 1882, for economic reasons, he was free to develop completely according to his own needs. His style was no longer the container of content, but as we see in the *Gates of Hell*, became indistinguishable from it. Until his death in 1917, he proceeded from a single simple obsession: the capturing of the unstylized and non-reportorial in life—in short, the natural. This demanded a style that seemed lacking in style, one whose modalities were determined by the model rather than the artist.

In turning his back upon traditional concepts of style, Rodin was to embrace the enduring ethic of modern artists since Courbet, namely, fidelity to one's own experience and constant empirical search for equivalents in art to the life of the senses, intellect and feeling.

As Ad Reinhardt has recently reminded us, for the last one hundred years the content of modern art has been art itself—persistent inquiry into its character, means and processes. Rodin's unprecedented and sincere reexamination of the basis of sculpture, while differing in its conclusions from those of later, younger vanguard artists, was itself an act of modernity. He had learned to make sculpture from sculpture. But beginning with his *Man with the Broken Nose*, he realized increasingly that the living human being provided a more truthful, thorough, inexhaustible and exciting basis for good sculpture. Rodin was neither the first nor last modern artist to believe that the visible world was not alien but essential to art.

He saw the human body as consisting of masses, surfaces and profiles.

These were the ingredients of his sculpture. The body was a marvelous organism with its own logic and laws. Its numerous parts always fitted and worked together and conveyed the human spirit to eyes and hands attuned to the evidence of the flesh. The model's surface inflections were not reducible to predictable series but provided the sculptor who worked with elevations and depressions with endless ideas for sculpture. The variability and unbroken continuum of the body was imparted by Rodin to his sculptural surfaces. No two models presented him with the same form or character. Each new sculpture meant the excitement of discovering ideas appropriate to modeling. To stylize the body or follow academic rules meant making art that was less than life, incapable of its equivalence in visual richness and mystery. Still today his works challenge the eye to comprehend the density of visual and tactile ideas he could elicit from a surface. Conscious of the fact that others would misinterpret his ideal of working from the model, Rodin pointed out that there was a crucial difference between mechanical copying of the model and the results achieved by the eye and hand. One was transposition, the other transformation. In the case of the former the result was a dry, visually fatiguing effigy with no returns to the senses or feelings. He called the mind "the most certain of calculators," and ardently believed that his thoughts, emotions and sensibilities influenced the activity of his hand as he worked, although as an unself-conscious influence.

So much was love of craft the bedrock and impetus of Rodin's life work that he came to cherish the making more than the completion of art. ("Make something and the idea will come.") His concern was not with the limits of clay, but with the constant extension of its possibilities until clay sketches done forty years apart appear scarcely the work of the same man. Contrary to the practice of academic art and prophetic of later sculptors, he would work through an idea in countless figures, none of which could be said to realize completely his thought or feeling. As with painters since Courbet, Rodin alone could judge whether or not a work was completed, what completed meant, or if the work was right. The risks he took became even greater risks for his audience. The test that he used to judge a work's success was time. When it withstood months or years of study it would survive; otherwise it might be destroyed or dissected with only the promising parts preserved. Few contemporary sculptures can withstand such long and searching looking, or have a comparable memorability of individual forms.

Rodin's challenge of accepted notions of art lead to the death of the statue and monument. Instead of forcing his models into the postures of statuary and staid heroism, he pushed sculpture into the direction of living movement. With his insistence upon sincere expression of genuine sentiments, the frank disclosure of human struggle with weakness, and the necessity of finding form that preserved natural movement, figures such as *The Burghers of Calais* exposed the unreality and impoverishment of public statuary. (The Palace of the Legion of Honor demonstrated the lack of comprehension the *Burghers* have experienced by exhibiting the five small

freestanding Burghers in a pyramidal composition, against which the sculptor specifically inveighed.)

Reading Rodin's statements on art made after 1900 and seeing his sculpture are two different and often conflicting experiences. Publicly he championed to the end the conventional purposes of sculpture, which were to instruct, ennoble and edify the public. But the words of his lips were belied by the creations of his hands. There is nothing didactic or moralizing about *The Walking Man* or his Dance Movement series. To understand Rodin's work during his lifetime meant the same sacrifices demanded by the most advanced painting then and now. The beholder, in Zola's works, "had to forget a thousand things about art." Rodin's clay and pencil sketches demanded that his viewers forget the history of art as his fingers had forgotten it in their making of sculpture. He loved the imprecision of clay studies or drawings for it seemed closer to the model's action. The sketch gave freedom with little effort, to render forcibly and summarily the fugitive thought. Although he once said that the viewer's imagination could complete what the artist was searching for, we now feel that to do so would not be art, and would make us lose contact with the artist's thought processes and what was actually done!

Rodin tested the elasticity of the word "art" when he chose not to anchor many of his small torsos and hands to permanent bases so that they could be continually fondled or disposed on a table, shelf or floor according to his whim. The sculptures thus had no single irrevocable visual axis and permanent surrender to gravity. As the position was changed or the figure was coupled with others or with duplicates of itself, unexpected formal and emotional situations would spontaneously arise, like the dramatic confrontation of a second self. Few today realize that the *Three Shades* are the same figure, or observe the wonderful rhythms and shapes of the intervals between the identical bodies.

Associated with modern art is the expectation that the artist will take risks in seeking his own ideal of perfection and that such ventures will proceed from what is currently described as "anguish." (This last is not always explicit.) The creation of the *Monument to Balzac* had all of these ingredients. No artist before or since agonized more over the making and reception of his art than did Rodin in the long years before and after 1898, when the colossal figure confronted the public. During its gestation, the project came to mean not only regaining the appearance of a man the sculptor had never seen, but also the poetic evocation of the writer's imaginative fertility. (The accusation that he had literally smeared Balzac's brain over his face was not the worst Rodin received.) It took years to find the "great lines" that made the sculpture right as sculpture in the artist's eyes.

When Rodin cut off a head or limb from a full figure he seemed to the public to have severed his connection with art. For the artist this practice, which became prevalent in the 90's and thereafter, was a test of the essential

or irreducible expressiveness of his modeling as well as a demonstration of perfection in a fragment. This willful segmentation of his sculpture also meant that he could eliminate those features, the head and hands, most susceptible to affectation or stylization by his model, thus insuring only the natural in what remained. Perhaps today we can see that his step of considering portions of the human body as potentially extraneous to sculpture was in its own way as daring as Cubist sculpture.

Not the least of Rodin's claims to modernity lies in his long but, until recently, little-known fascination with imperfection. While the public knows his pathologically accurate but esthetically compelling *Old Helmet Maker's Wife,* few realize that Rodin made studies of the diseased hands and legs of hospital patients. How plausible for an artist committed to life to be drawn to its decay! But Rodin's curiosity with imperfection extended beyond the life process into that of sculpture itself. Rescued by recent exhibitions from the limbo of his Meudon studio and its basement are numerous terra-cottas and plaster casts in which the sculptor preserved the scars of casting and cutting, the untempered traces of fingerprints and facture. Never in his drawings are there erasures. Coexistent with his art of the natural there exist the signs of artifice, but in themselves they are the natural results of the making of art. No "truth to the medium" critic of Rodin during the past half-century ever exceeded such unflinching, raw fidelity to his craft.

Characteristic of the content of modern art has been its intimate and direct relationships to the artist and his environment. If the present tests of modernity are, as Harold Rosenberg suggests in his "Tradition of the New," those of psychological, ideological or esthetic relevance to our epoch, Rodin can now be understood as having applied the same measure to the art of his own time and found it wanting. Neither before nor since Rodin has any single sculptor created as extensive an image in sculpture of his society in terms of its states of feeling, or what Georg Simmel considered to be the response of the human spirit to modern life. His *Gates of Hell,* as an instance, are a spiritual panorama unrivaled even by the sculptural programs of the cathedrals. Baudelaire had said that there was a modern heroism to be found independently of official acts, and daily encountered in the private lives of anonymous individuals. Rodin gives us the unheroic or pathetic hero. What allies his sculpture with Baudelaire's sentiments and separates his art of the nude from that of the past is that he does not show us the body involved in stock beauty postures, official acts, productive enterprise or in muscular fashion surmounting tangible external obstacles as in past and present day academic sculpture. It is precisely because, by academic standards, his bodies do nothing or have "no content" that they impart such a poetic character today. Rodin made the act of a man walking high sculptural drama. Causality and goals, so fundamental to academic art, were of little importance or concern to him. The act of being fired his wonder. That we live and breathe, instinctively resisting the earth's pull were sufficient plots

for his endless dramas and view of heroism. He created an art that emulated the flux of existence: phenomena rather than fixed states or an eternal intake of breath.

Rosenberg doesn't specify who should decide relevance. But when an artist such as Rodin succeeds in imposing his vision upon us, the decision is made. That so many of his sculptures hold up so strongly certifies their esthetic and emotional durability and recalls Baudelaire's complete requirement for modernity, that not only should the artist capture the fugitive and contingent in his time, but also the poetical in the historical, the eternal, in the momentary.

Leo Steinberg
On Rodin (1971 and 1963)

FROM *OTHER CRITERIA*

I had turned ten when Rilke's *Rodin* fell into my hands, and I still have the book, now held together by a rubber band. The text, which I read word by word, did not strike me as out of the ordinary; it was, I judged, the way grown-ups write about art. But the pictures at the back of the book—the sculptor's works in sepia-toned photographs, some of them signed across the bottom "Aug. Rodin"—these were pored over in delicious disquiet hours on end, for they seemed to be of men and women, and the pictures let me in, allowing me to peer into dark adult privacies. You still get a sense of this suggestiveness of Rodin's work watching young visitors to the Musée Rodin in Paris, those especially who wander by themselves, whose gaze transforms each of these dingy exhibition rooms into a theater of passions.

That was before my art education began. I was soon taught that passion is one thing and theater another and art something else again. Esthetic judgment has responsibilities. Thanks to the infallible guides of my adolescence, above all Roger Fry, the English formalist critic, I learnt that taste in art is not a surrender to every interesting stimulus. A taste truly concerned

with quality had, I gathered, its own moral stance. It must be pure, uncompromising, and ascetic, armed not only to resist the second-rate, but every seductive interference from disturbing content.

Having at last reached seventeen, it became clear to me, as it had long been to my elders in the avant-garde, that Rodin's work did not pass the test of a disciplined taste. It failed by those criteria which alone addressed themselves to the essential formal quality of art. And as the emotions Rodin liked to represent were too sentimental and accessible, so their form was too loose to qualify as serious sculpture. Roger Fry, the revered mentor, had passed the final sentence: "His conception is not essentially a sculptural one. Rodin's concern is with the expression of character and situation; it is essentially dramatic and illustrational."

It seems to me that formalism as a gauge of quality is rarely, if ever, what it claims to be. Rather than a means of isolating the esthetic factor from all styles and manifestations of art, it is, at least in its historic record, a taste preference for certain styles against others. Formalist criticism is nearly always engaged and passionate in its championship of a particular constellation of works. Thus between 1920 and 1950, the sculpture that appealed to formalists had to be unencumbered by expressive or symbolic content, and it tended to be monolithic. It was everything Rodin was not—solid and simple, undemonstrative and imperturbable—like the art of Brancusi, or of the Cyclades.

Growing up you take your place in the world, in the world of taste as in every other. At seventeen, vacationing in Denmark, I discovered the most beautiful of all possible sculptures in Copenhagen's Ny Carlsberg Glyptotek—a male head with a broken nose, Amenemhet III, Egyptian, Middle Kingdom. The stone, the label said, was quartzite, and its hard crystalline shape was a revelation of infinite density. And that look it had of serious reserve seemed to hold other values implicit: you could tell it had been carved and polished with steadfast determination; and it was all "direct carving," all "honesty" with respect to material. Could Rodin's nervous, hasty, over-eager output stand comparison with this?

When an artist goes into eclipse, the œuvre itself by which he is known undergoes alteration. And it changes in a way that increasingly justifies the aversion of taste. As Rodin's reputation receded, the objects left behind to represent him to our minds were either such proverbial clichés as the *Kiss* and the *Thinker,* or else the expensive marbles marketed by Rodin's atelier during his final years.

Where, in those days, would you have gone for his best? Much of Rodin's boldest thought remained cellared and closeted at Meudon, where the sculptor in 1897 had acquired a modest estate. Until his death twenty years later he commuted between his Meudon studio, built out on the terrace in front of the bedroom, and the one in Paris, installed since 1908 at the Hôtel Biron. But the Meudon atelier was demolished in 1925, and though an exhibition space was subsequently raised through the enthusiasm of the

Philadelphian Jules E. Mastbaum, Meudon remains to this day one of the most desolate of unvisited public museums in the world. "Rodin is still an unknown man," wrote the sculptor Jacques Lipchitz in 1954. "At Meudon there are some 1500 molds never cast; some extremely daring representations; some, almost automatic expressions." As late as 1962, when I first penetrated that inexhaustible Meudon basement, I remember the exhilaration upon first catching sight, atop a tall vitrine, of a forest of Clemenceau busts—not spare casts but all different, thirty-four of them—one serial portrait, continuous as Monet's *Rouen Cathedrals* or *Water Lilies,* yet to this day unpublished and unexhibited.

Meanwhile, back in Paris, in the once elegant Hôtel Biron, where posthumous Rodin bronze casts were offered for sale at depressed prices year after year, the Musée Rodin was running down. Its spiritless debilitation well into the 1960's seemed to confirm its obsolescence—while modern art burgeoned around the world.

Until 1955, New York's Museum of Modern Art possessed not one of Rodin's sculptures. To see Rodin during those years, New Yorkers would have gone up to the Metropolitan Museum. But there, during the 1930's and forties and fifties, it was the glossy marble copies that were on display, serving as decorative centerpieces in the painting galleries. The Museum's great Rodin bronzes were in storage until 1957. And the unique, astonishing small plaster and terra-cotta fragments, which the Museum had received as a gift from Rodin himself—these have not been exposed again since their arrival in 1913. It was the same in Paris' Petit Palais, where a masterpiece of French art, Rodin's bronze *Torso* of 1877, was kept in the basement. In Philadelphia, the Rodin Museum created by Jules E. Mastbaum and opened in 1929 was, by the mid-1930's, in full decline. "Now only a handful of persons, and only an occasional Philadelphian, visit the beautiful Rodin Museum," runs a newspaper report of 1936. In San Francisco's California Palace of the Legion of Honor much of the magnificent Spreckels collection of early casts and original plasters was found in storage in 1963. And in the basement of the Boston Museum of Fine Arts, Rodin's bronze *Iris* [Fig. 18] was labeled "unexhibitable" until 1953, when it was traded to the late Curt Valentin in return for six small maquettes.

Rodin's real self had gone underground, and the part of him that was left showing did not seem to deserve reappraisal. In step with my generation, I could assume that my childhood susceptibility to Rodin was well outgrown.

The revision of judgment set in during the 1950's. Early in 1953 Andrew Carnduff Ritchie mounted a major show of twentieth-century sculpture at the Museum of Modern Art, New York. His gateway to the twentieth century was Rodin. In reviewing the catalogue of the exhibition (for *Art Digest,* August 1953) I posed the question of the legitimacy of Rodin's inclusion and decided in favor.

What is it that sets modern sculptures apart from their predecessors? . . . To suggest that modern sculpture shows a greater preoccupation with plastic first principles is not enough. . . . Modern sculpture is not merely more concerned with plastic form, but with a different kind of form, one answering to a radically new awareness of reality. The forms of contemporary sculpture are unstable and dynamic things; every transient shape implies a history, a growth, an evolution. . . . The question can be stated in another way. On what grounds does Mr. Ritchie claim Rodin for our century? Classifying his works as "conceived in relation to light" only relates Rodin's flickering "lumps and holes" to Monet's fleeting specks of color. It only establishes him as an impressionist. . . .

And yet Rodin does belong to us; not by virtue of his light-trap modeling, but because in him, for the first time, we see firm flesh resolve itself into a symbol of perpetual flux. Rodin's anatomy is not the fixed law of each human body but the fugitive configuration of a moment. . . . And the strength of the Rodinesque forms does not lie in the suggestion of bone, muscle and sinew. It resides in the more irresistible energy of liquefaction, in the molten pour of matter as every shape relinquishes its claim to permanence. Rodin's form thus becomes symbolic of an energy more intensely material, more indestructible and more universal than human muscle power. And it is here, I believe, that Rodin links up with contemporary vision.

Within the Western anatomic-figure tradition, Rodin is indeed the last sculptor. Yet he is also the first of a new wave, for his tragic sense of man victimized is expressed through a formal intuition of energies other than anatomical.

His first masterwork, created when he was twenty-three, was the portrait of a man whose nose had been mashed to pulp—the *Man with the Broken Nose*. But the sculpture was itself a product of breakage, since the terra-cotta Rodin submitted to the Salon of 1864 was the mask that survived when the full head he had modeled was accidentally broken. Decades later, Rodin remarked that he had "never succeeded in making a figure as good as the *Broken Nose*." The image which, he insisted, "determined all my future work," was a visage defaced by a blow. It was a face whose central feature arrests what the young Michelangelo felt when the fist of a fellow art student made his nose "go down like putty" to disfigure him for the rest of his life. An artist of Rodin's susceptibility could not have been unaware that the paragon of sculptors had been himself a man with a broken nose; as are most ancient sculptures—damaged nose first. It is as if the battered prow of the human face were the token and stigma of the sculptor's art.

Twenty years later, Rodin repeated the *Broken Nose* in [smaller scale] on the *Gates of Hell;* and the revision reveals the trend of his thinking: the nose made malleable by an act of ill-chance has become the all-determining pattern. Now the entire face is a medium in fluctuation, a churning sea.

• • •

In May 1954, Curt Valentin installed a Rodin exhibition in his relatively small gallery on New York's 57th Street. The collection of forty-four sculptures contained only one marble; the rest were early bronze casts and original plasters. This show marked a turning point in Rodin's posthumous fortune. For me it meant a loyalty renewed, and being restored to my childhood enthusiasm.

The essay that follows was written at Meudon and Paris during the summer of 1962. It was intended as a limited effort, not a full presentation, but a bid to reinsert Rodin in the stream of modern consciousness.

But that consciousness was already turning. Two European scholars, Joseph Gantner and J. A. Schmoll gen. Eisenwerth, were rethinking the meaning of Rodin's partial figures; Albert E. Elsen's work on the *Gates of Hell* appeared in 1960. In December 1962 the Louvre opened a *Rodin inconnu* exhibition, followed in 1963 by a similar showing at the Galerie Claude Bernard, Paris. In May 1963 the Charles E. Slatkin Galleries, New York, launched a Rodin exhibition which during the following two years toured twelve major museums in Canada and the United States. Cresting this new wave of appreciation was the great Rodin retrospective at the Museum of Modern Art, 1963. The Rodin revival was in full swing.

• • •

A few words must be said on the question of Rodin's share in the marble carvings that carry his name, a question on which there is still uncertainty and disagreement. My exordium failed to distinguish between the single heads—*La Pensée* and some of the late portraits in which Rodin seems to have been closely involved—and the multiple marble groups. I would still disattribute the latter almost entirely. There is of course ample evidence that Rodin throughout his life employed assistants to transfer his conceptions to stone. His own genius was that of a modeler. On the other hand, there can be no doubt that in some corner of his large nature Rodin clung to the romantic stereotype of the sculptor as a wielder of hammer and chisel, a Michelangelesque titan who imposes his will upon stone. A heroized portrait of him, modeled for bronze by his disciple Bourdelle (Hôtel Biron, Chapel), shows him with mallet and chisel—there being nothing heroic about the spatula and the thumb. In exactly this spirit romantic admirers have called Rodin "the greatest thinker in stone of modern times," though Rodin's thinking is not in stone but in pliant matter. "The most picturesque detail of his method," wrote George Bernard Shaw who had sat at length for his portrait, "was his taking a big draft of water into his mouth and spitting it onto the clay to keep it constantly pliable."

Whatever his actual practice and preference, Rodin surely wished to project himself on the world as a creator of works in stone. He may have remained over-impressed by the memory that the *Broken Nose* in its original terra-cotta was rejected by the Salon of 1864, but accepted eleven years later in a cold marble replica.

The discussion of the subject in Athena Tacha Spear's *Rodin Sculpture* remains inconclusive. Though the book is a mine of valuable information, the "eyewitness" description she quotes of Rodin actually carving is too transparently stereotyped and journalistic to be creditable. It appeared in the *New York Times Magazine* in a piece called "The Model of 'The Kiss' Talks on Rodin": "Oh, he worked very fast. Chip-chip-chip and the marble flew everywhere. . . ."

More serious are the criticisms sent to me at my request by my friend Albert E. Elsen in a letter of August 21, 1969. In fairness to him, and perhaps to Rodin, Elsen's words deserve to be quoted:

> I cannot agree that to know Rodin we must forget his stones. We know that there are marbles of very high quality, also marbles whose making he worried about, suffered over, and finally delivered with pride. I cannot agree that he had no feeling for stone or carving. . . . Admittedly the marbles are not his best. Much of the stone carving is hack work. We know that there has been no editing of his marbles on view in Paris. At least eighty per cent of them are either uncompleted or rejected pieces; many were made without his consent, and some were posthumous. (At his death, Judith Cladel reported that it was scandalous to see a number of carvers working in their own studios—without Rodin's authorization, carving from his plasters. She was responsible for the law putting a stop to this.) But can we dismiss them—can we amputate this part of Rodin? Conceiving for stone, overseeing their making and finishing them was very much a part of him. Today, when so many artists don't touch their works, not even making models, but are only giving verbal directions, can we still deny to Rodin what he was so extensively and enthusiastically involved in for so long?

Perhaps indeed my original case against Rodin's marbles was overstated. I wanted them out of the way because they obscured Rodin's genius. "Move them aside," I wrote, "if only for now." "Now" was ten years ago.

FROM *RODIN: SCULPTURE AND DRAWINGS*

. . . Rodin's posthumous place remains unsettled. The approval he sought in his youth was withheld till he was a man in his forties; no major artist served so long a period of hiddenness. When fame finally came, it came in the midst of polemics, the astonished sculptor finding himself a storm center of controversy, pitted against an official academy from whom he had asked only acceptance and fellowship.

Then the admirers came, the few and the many; the champions, disciples, assistants—and the beautiful worshippers, offering fashionable adulation and festooning the aging master in glory. By 1914, at the outbreak of World War I and three years before his death at seventy-seven, Rodin's rank as First Since Michelangelo seemed assured. Since then his greatness has rarely been questioned—only his taste, his good judgment, and his

significance in the present. For while modern art was in the making Rodin seemed irrelevant. And now, forty-five years after his death, it is his relevance that astonishes us as we look again.

But it means learning to disregard. Begin by shelving the famous marbles and stones. Having signed them, the master is legally responsible for them; and of course morally, since he ordered, supervised, and approved them for sale. But he did not make them. Marbles such as the *Hand of God*, the *Cathedral, Eternal Idol, Eternal Spring, Fall of an Angel*, or *The Kiss*— of which no less than four over-life-size versions exist—they are dulcified replicas made by hired hands. We can bring them back for special studies of Rodin's influence, of his esthetics, his sources of income, his role as entrepreneur. But for his sculpture, look to the plasters, the work in terra-cotta and wax, and the finest bronze casts. Rodin himself rarely drives his own chisel; he kneads and palps clay, and where a surface has not been roughed and shocked by his own fingering nerves, it tends to remain blind, blunted, or overblown by enlargement; rhetoric given off by false substance.

Of course, much of Rodin's own-fingered work is rhetorical too. It seeks to appeal, to afflict, to persuade—always to stir the heart up into fellow feeling. And it is on these programmatic works, with their charge of pride, craving, contrition, defeat, that Rodin's fame largely rests.

Degas has had better luck. His posthumous reputation as sculptor is not founded on what he showed during his life—the "frightful realism" (as Huysmans called it) of the *Petite Danseuse* of 1880; it rests rather on some eighty unfinished, uncompletable wax figurines, formed in profoundest privacy and never exhibited during his life. Degas even left them uncast, so that a working hive of bathers, dancers, and horses swarmed always about him like thoughts astir.

• • •

You can, as an artist, try to say something big about life; or be content to make the stuff in your hands come to life. And this humbler task is the greater, for all else merely follows.

Or this other distinction: there are objects an artist makes because he wants to be seeing them, and there are themes he invents which, in Rodin's own phrase, "awaken the spectator's imagination." Our own sympathies—I mean those of the post–World War II present—are flatly anti-rhetorical. They lean towards the object an artist makes simply to make its acquaintance, to find it out. Modern minds are repelled by the kind of advertisement which Rodin's famous works, in their impatience to rouse our feelings, give to emotion.

It is the diminished status of emotionalism as such which puts the declamatory Rodin at a disadvantage with us (and us with him, which amounts to the same but sounds better; for instead of arrogantly rejecting half his work, we merely confess our incapacity to relate to it). A modern consciousness cannot endure the heroics of a contemporary without au-

tomatic suspicion. Our commitment to irony is far too serious to enable us to suffer and judge an art of Rodin's demonstrative, humorless pathos.

But Rodin too left a private creation, richer and more daring than that of the sculptor Degas. For half a century it has been sequestered, or simply obscured by the renowned exhibition pieces. Move these aside—if only for now—and it is marvelous to see Rodin's art stride into the present.

IMMERSION IN SPACE

To begin with the space he creates, Rodin's intuition is of sculptural form in suspension. He finds bodies that coast and roll as if on air currents, that stay up like the moon, or bunch and disband under gravitational pressures. He seeks to create, by implication, a space more energetic than the forms it holds in solution.

This is the impossible concept behind the *Gates of Hell,* the project of Rodin's best twenty years, his great source work, his dumping ground and "Noah's Ark," wherein 186 figures drift and writhe like leashed flying kites. A vision of energetic immersion is also the inspiration of *Iris* [Fig. 18]—a woman unfurled, headless, lodged in mid-air; of the listing *Figure volante* [Fig. 19], whose home base is not any ground below but some vanishing pole of attraction; of that cantilevered, rock-clinging plaster *Figure Study,* so floated that all the surrounding air turns buoyant to keep it up.

Even Rodin's heads can look tossed and sudden—as Rilke saw when, in his great prose poem on Rodin (1903), he described the head of the *Balzac* as "living at the summit of the figure like those balls that dance on jets of water." It is in their aerial detachment from body and gravity that Rodin's heads (whether portraits or not) differ from, say, Bernini's great marble busts. Bernini's portrait of Louis XIV astonished the French by the commanding posture which its mere head and shoulders conveyed; they felt it showed the King marching at the head of his troops. For Bernini's busts, by their imperious suggestion of stance, imply the whole man, and through the man's implied body, the ground. Rodin's unbodied heads—the masks mounted off base, tipped and angled, the alert *Mrs. Russell,* and scores of others—they seem not poised but propelled, discharged into space by the abstracted energy of gesture alone.

Like Monet, with whom he exhibited in 1889, Rodin evolved within an unquestioned tradition of representation. Both men therefore taught themselves to project some of their most secret intuitions through choice of subject; Monet by looking deep into a lily pond, where the familiar clues of up-and-down and near-and-far watered away; Rodin by isolating restless fragments of body, such as hands—more familiar in their absolute motion than for their moorings at the nearest anatomical joint.

In the human hand Rodin discovered the only familiar existence which has no inversions, no backviews or atypical angles; which can never be seen upside down. Because hands, weightless and tireless, live in perpetual adap-

tation and transit, unlike the hard-bottomed space that supports our bodies, the space in which hands exert themselves is as fluid, as musical, as that of Monet's sky-replete water.

Rodin made some 150 small plaster hands, two to five inches long, for no purpose but to be picked up and revolved between gingerly fingers. Their modeling is of such tremulous sensibility that, by comparison, Rodin's own hand, preserved in a plaster cast at the Paris Museum, looks stiff and clodden—as would the cast of any real hand keeping still. But a living hand is in motion, and Rodin's little plasters simulate motion in two ways at least: first, by multiplied surface incident, which makes the light on them leap and plunge faster than light is wont to do; and again by the ceaseless serpentine quiver of bone and sinew, as if the sum of gestures which a whole body can make and all its irritability had condensed in these single hands; and their fingertips so earnestly probing that one credits them with total awareness and a full measure of life. There is in sculpture no surrender of privacy more absolute than when two of these small plaster hands lie together.

Bronze casts of these hands unfortunately have to be mounted. Now they stand flat-footed on platformed wrists, fingers skyward in prophetic pretentiousness. Rodin himself did not usually mount them, but left them lying loose in chests of drawers. "He would pick them up tenderly one by one and then turn them about and lay them back," writes an English sculptress recalling a visit in the year 1901. In other words, Rodin made some 150 sculptures which were not conceived to stand with their weight bearing down.

And not hands only. Among the gifts received by the Metropolitan Museum, New York, in 1912 from Rodin himself, is a flexed plaster leg, about four inches long. The toes point and the sole twists inward and up, so that the leg cannot stand, nor lie at rest, nor suggest any specific orientation. It is a typical Rodinesque form dislodged from the ground. To experience it as sculpture we must pick it up and "turn it about," restoring it to that same spatial medium within which Rodin conceived it—the mindspace of conception—the space in which most of his forms turn and return. For they have to be seen in their successive recurrences, the same figures again and again, with new roles, new titles, new partners, a new limb or two, and always a new orientation, reclaiming their affinity with a swimmer's bottomless, all-accessible space. And it is this native invertibility of his figures that enables Rodin to recast them.

His figure of the *Prodigal Son* is best known to us kneeling. Thrusting his hands up to the sky, he leans over backwards in the standard large version; plunges forward in the reduced model. Then, in the group called *Fugit Amor*, the same figure is laid back to back upon a prone, drifting female, and they glide on together trailing his kneeling legs. In the right-hand panel of the *Gates of Hell*, you may find this group twice, coursing in different orbits.

Rodin makes a playful group, representing a seated girl-mother and

child. He then breaks it up and, in a new version, a new child with its back to the girl drifts unsupported athwart her closed legs, the title changing to *L'Amour qui passe.*

Or *The Martyr,* originally a small upright female figure in the *Gates of Hell.* Enlarged to near life-size in 1885, tilted ninety degrees, and cast in bronze, it becomes a recumbent corpse pressed down on a twisted shoulder, and the legs stiffly out. Ten years later, this same figure, hugely winged, reappears, with no change of sex, as a *Fall of Icarus;* but now the body descends headlong at thirty degrees to touch ground with the face alone. Finally, fourteen years later, it returns in relief on tomb slab, upright again and entitled *Le Lys brisé,* or *Resurrection.*

How many of Rodin's inventions take to the air?

The well-known *Eternal Idol* shows a youth, with both arms to his back, kneeling before a hesitant girl to plant his lips under her breast: while she fingers the toes of a retracted foot so that her body's profile forms a triangular silhouette. Observe the pair of them again, this time in echelon as an Adam and Eve—levitating in the embrace of a God-figure that began as a dancer but now seems materialized from Michelangelo's *Creation of Sun and Moon.*

The point is not so much that Rodin puts his sculptures through these revolutions, but that they lightly lend themselves to inversions, as most figurative sculpture, conceived to rest on a supporting base, does not. His figures' compliance with ever-new angulation implies that their given postures result less from volition than from strains imposed by the medium. So that what enlivens Rodin's forms is not only the vibration of surface modeling and the quickened light, but the implication always of some pressure or spatial turbulence to which these forms are exposed.

Many of his figures are precariously balanced or hoisted, like the *Bastien Lepage* and the *Claude Lorrain* on their respective monuments. Many have to do with falling—*La Chute d'un Ange, Icarus* in several versions, *L'Aiglon, Le Rêve, L'Homme qui tombe,* etc. And then *La Belle Heaulmière,* the *Large Shades,* and the *Petit Ombre,* called also *The Precipice*—figures that gaze into abysmal depths, as if the ground at their feet were a nether sky.

This evasive relationship to a supporting ground marks a good half of Rodin's conceptions, his casual doodles, and even his failures, as much as his great, humble masterworks. They share the disturbed equilibrium, or the vain drift to find the void at its center.

And then the opposite: the monumental statues that stand planted and rooted. The *Walking Man (L'Homme qui marche)* of 1900 and its grand version of 1906; the life-size nude study for the *Jean d'Aire* (the Burgher of Calais with the key—perhaps Rodin's greatest work); the *Balzac* and the striding nude *Victor Hugo.* For these figures it is the fierce grip on the earth that becomes the whole enterprise. They stand or take one step as if they were driving piles for foundations.

L'Homme qui marche is not really walking. He is staking his claim on as

much ground as his great wheeling stride will encompass. Though his body's axis leans forward, his rearward left heel refuses to lift. In fact, to hold both feet down on the ground, Rodin made the left thigh (measured from groin to patella) one-fifth as long again as its right counterpart.

The resultant stance is profoundly unclassical, especially in the digging-in conveyed by the pigeon-toed stride and the rotation of the upper torso. If the pose looks familiar, it is because we have seen news photos of prizefighters in the delivery of a blow. Unlike the balanced, self-possessed classical posture with both feet turned out, Rodin uses the kind of step that brings all power to bear on the moment's work.

For the *Jean d'Aire,* standing his ground is an ultimate effort. His huge feet do not rest flat but turn in like a grasping ape's, clutching their clod of earth. Such actions are hard to see in a photograph, hard to see anywhere if they are not re-experienced internally; one must do it oneself and perform every one of these poses to realize how desperately these statues act out the drama of powerful bodies giving their whole strength to the labor of holding on. As though standing still were the utmost that could be asked of a man.

There is only one major work which stands effortlessly on both feet: the early so-called *Age of Bronze.* It was to become Rodin's point of departure in every sense. For his mature works depart in opposite directions from the common waking experience of equilibrium: they are either disturbed, unsettled, adrift; or else they hold the ground with rapacious tenacity, as if they would lose their limbs one by one, rather than loosen their grip. And both these extremes share in the power of suggesting that the surrounding emptiness is energetic.

Rodin's implied space equips sculpture in three distinct ways for the modern experience. Psychologically, it supplies a threat of imbalance which serves like a passport to the age of anxiety. Physically, it suggests a world in which voids and solids interact as modes of energy. And semantically, by never ceasing to ask where and how his sculptures can possibly stand, where in space they shall loom or balance, refusing to take for granted even the solid ground, Rodin unsettles the obvious and brings to sculpture that anxious questioning for survival without which no spiritual activity enters this century.

John Tancock
"Rodin Is a Rodin Is a Rodin . . ."
(1967)

There is a classic situation in silent-screen comedies when, in order to escape
detection, an intruder has to pretend he is the reflection in a mirror of the
rightful occupant of the room. Everything goes well while the movements
are synchronised but sooner or later an inadvertent deviation arouses the
latter's suspicions and the fun begins. Everybody can laugh at the situation.
But how disturbing it would be if our own reflections started behaving in a
way other than that dictated by our movements, if a figure were to step out of
the mirror and grab our right hand in its apparent left hand. To be brought
face to face with oneself in that directly physical way would be more than
anybody could bear.

We may be dissatisfied with our reflections but we always think they are
not really us, no more than the sound we hear on the tape-recorder is our
own well-modulated voice. Rodin did not let his creations off so lightly as we
do ourselves when we consider our endowments. In a strange plaster in the
Rodin Museum at Meudon, an emaciated old hag is brought face to face with
another—but it is not another, it is the same one. Two casts of *She who was
once the Helmetmaker's Beautiful Wife* are confronted but there is no communi-
cation between them, no exchange of glances, as, indeed, there cannot be.
The second cast is a three-dimensional reflection of the first and communi-
cation with a reflection is impossible.

In the work inappropriately called *The Cathedral,* the stone version of
which dates from 1908, two right hands face one another, but they do not,
through the imbalance of pressures in a handshake, communicate a differ-
ence, the will to dominate or the willingness to surrender. Nor is it the
hackneyed, pietistic image the title leads one to think it is, but something
much more disconcerting. Two identical hands hardly dare to touch one
another.

How was it that Rodin was able to create self-sufficient works from
repetitions of the same figure? It is only when one tries to imagine significant
and aesthetically successful couplings of, say, works by Donatello or Maillol,
that the remarkable nature of this achievement is brought home. In fact,
with any other sculptor it would be impossible. But Rodin's technique of
profile-modelling made possible the creation of figures that have no im-
posed symmetry but that of the body alone as a self-regulating organism.

Rodin described his method to Dujardin-Beaumetz: "When I begin a

John Tancock, "Rodin Is a Rodin Is a Rodin . . . ," *Art & Artists,* July 1967. Reprinted by
permission of John Tancock and *Art & Artists.*

figure, I look first at the front, the back, the two profiles of right and left, that is their contours from four angles; then, with clay, I arrange the large mass as I see it and as exactly as possible. Then I do the intermediate perspectives, giving the three-quarter profiles; then, successively turning my clay and my model, I compare and refine them."

In addition to inspecting his model from all sides, Rodin would study it from above and below in order to see those contours which overhang. It is a technique best summarised, perhaps, as drawing in depth. Consequently, in confronting two casts of the same figure there is no redundancy of contours as there would be, for example, in a Maillol who was concerned with effecting a compromise between the mutability of the human form and the perfection of geometrical forms. On the purely formal level, then, there is a perfectly good explanation as to how Rodin was able to do this and get away with it. But it is reasonable to go on from here and ask how the idea ever came to him in the first place.

It was the sheer quantity of sculptures of bodies and parts of bodies in plaster and bronze, rather than the number of major works near completion, that so impressed visitors to Rodin's studio during his lifetime. Comte Robert de Montesquiou gave a very vivid account of the sight that met his eyes when he visited Rodin: "Vast showcases are full of fragments; clenched hands, convulsive gestures, masks, torsos; I say again, a whole valley of Jehoshaphat, of limbs ready to join together and of anatomies full of thought and life when the God of the region, Auguste Rodin, signals the hour of resurrection with his tremendous clarion."

He worked simultaneously on a wide variety of projects, everything from important public commissions to the small, informed studies that he made for his own amusement. The actual modelling of a work might be preceded by a period of graphic notation, both the model and Rodin himself moving about the studio. After a period of time, which might vary from one hour to a week, he would pick up the clay and note down the general outline and movement. The first rough figure could then be followed by up to 20 miniature modellings, each one becoming more precise. Of each of these rough models, several plaster casts were made. One was kept intact while the others were separated or dismembered so that he could try various arrangements of the figures. Once satisfied that the most effective organisation of the group had been achieved, he would begin his work full-scale with the help of assistants. Again several plaster-casts were made; one was kept intact, the others cut apart and the sections numbered and catalogued so that they could be used again at some future date.

Through working in this way, the whole notion of "finish" was undermined, just as it had been in Impressionist painting. "Works which are called 'finished' are works which are clear, that is all." His exhibitions thus tended to be of "Work in Progress" rather than of work completed before a certain date. With so many ready-made component parts at his disposal, he had complete liberty. He could combine figures or parts of figures deliberately to

create a desired effect or he could benefit from accidental groupings. Using figures originally conceived separately, he could act like a dramatist or novelist who begins with three or four characters and lets them develop and interact to see what will happen. By inserting a given figure in a new context he could change its meaning entirely. On the other hand, he could group casts of the same figure.

But it is important to distinguish Rodin's use of repetitions from that of the Futurists with which, especially in the case of *The Dancers,* it is tempting, although misleading, to seek an affinity. Although aware of the work of Muybridge, Rodin had a very low opinion of the truthfulness of photography. He believed that the camera's arbitrary selection of one moment from among many deprives movement of its most essential characteristic— continuity. It presents a frozen image whereas the essence of movement is its flow. No amount of superimpositions of momentary images would, in his view, convey this feeling of continuity that seemed so important to him. Describing a bronze to Paul Gsell, Rodin said, "The limbs, the torso, the head, the arms are not shown at the same moment but through a succession of moments. It is not a theory I apply but rather an instinct which makes me express movement in this way. And so, unless the spectator looks from one end to the other of my works, he sees the gestures developing. Through the different parts he follows the muscular efforts from their genesis to their resolutions." Some other explanation must be found, then, for the curious couplings of identical dancing figures.

The device of repetition was in fact first used with a stationary figure, *The Shade* (1880), which is closely related to *Adam* of the same year. These are Rodin's most direct tribute to the works of Michelangelo, which so impressed him on his visit to Italy in 1875, although anguish is expressed in much more active terms. When he decided to crown *The Gates of Hell* with this figure, however, he used it in triplicate. Seen from beneath and from three different angles, *The Shade* looks so different in each embodiment that it is only with reluctance the spectator accepts them to be identical. Seemingly drawn together and down by the force of gravity, they embody a feeling of helplessness which is depersonalised by being presented in triplicate. It is like the repetition of a line in a poem which gains in force, each time it is repeated. In grouping three casts of this self-engrossed figure, Rodin ruled out any possibility of communication between them. Their physical closeness is deceptive. No consolation is possible. Quite apart from the gain in expressive power, the grouping had a purely functional reason. Situated at the top of the Gates, it was naturally impossible for the spectator to walk round them. As it is, seen from the far left, from directly in front and from the right, the spectator can gain a very full realisation of the three-dimensional reality of the figure without moving one inch. From every aspect *The Shade* has just as much right to exist as *The Three Shades.* Its right hand may be living a life of its own somewhere or might be utilised in some other figure. Rodin dispensed not only with the idea of "finish" but also of

"composition," as something fixed and permanent. Returning to the group of *The Three Shades* in 1902, he exhibited them in yet another arrangement, much further apart and enclosing a space. The suggestion now is a slow, ritualistic dance of lamentation.

Working on parts of figures or parts of monumental groups and then experimenting with their arrangement, rather than utilising the preliminary studies for the definition of a pre-existent sculptural idea, one hallowed by tradition, Rodin found himself faced with an embarrassing number of possibilities. "I find something to do on my works for years. They would be dead if they were definite." There was no limit to the ways in which a given number of figures or parts could be arranged. No arrangement was definitive just as no movement was fixed. Unlike other sculptors before him, he regarded his own work not as a series of static points in which certain problems had been solved for eternity, but as something dynamic and capable of change. He could plunder it without feeling he was committing sacrilege. Hence the reappearance and transformation of certain forms over a considerable number of years.

Yet another result of this attitude was his dissatisfaction with conventional ideas of mounting pieces of sculpture. It is well known that he hoped *The Burghers of Calais* might be placed on ground level so that the citizens of contemporary Calais might be reminded of the heroism of their ancestors in a very direct way, encountering them as they went about their business rather than doffing their hats to them on a pedestal. One of the talking points of the 1899 Salon was Rodin's *Eve* (1881), the base of which was buried in sand. The mother of us all trod the same ground as the contemporary salon-goer. With the smaller informal sculptures the question of mounting did not arise—long before Brancusi said it was his ambition to sculpt joy-giving forms and make sculptures that people could play with, Rodin was doing just that with his innumerable plaster studies.

As early as 1882 Rodin had grouped three casts of *La Petite Bretonne* from *The Gates of Hell* and entitled them *The Three Faunesses* [Fig. 20]. Not a dancing figure to begin with, the *Petite Bretonne* became one when grouped in triplicate. Rodin was clearly excited by the formal possibilities of balancing these three figures on their toes and creating a subtly articulated space. But *The Dancers* of 1911 reveal a very different concern. He was passionately interested in the exciting developments of the contemporary dance and late in life produced a number of plaster studies on this theme. The abandon of the dancers' movements was only matched by the boldness of the modelling. In their unmounted state these plaster studies retained something of the freedom of the dancers. Rodin could play with his figures and create new choreography for them. The coupling of the figures, some of which are much more successful than others, shows a curiosity on Rodin's part to see what would happen if two casts of the same figure were placed side by side rather than the desire to represent movement by serial means.

Rodin explained to Sir William Rothenstein that his plasters were

plasters and were not suitable for casting in bronze. Once this is done the work, as it were, leaves the artist's hands and is fixed for eternity. Degas felt this and so did Rodin. The pairs of identical dancers were experiments which may have been revised at any time by addition or subtraction. Casting them in bronze represents a fixation of the free-wheeling world with which Rodin had surrounded himself in his last years and one of which he may not have approved.

To Matisse in 1908, Rodin's additive approach seemed to be one of the most distressing features of his style, while to contemporary viewing it is one of the most fascinating.

William Tucker
"Rodin: The Language of Sculpture" (1973)

Although "nature" was and remained Rodin's own touchstone, and the quality of his modelling has been the aspect of his work that has elicited most attention and admiration in this century, both these strands in his sculpture, though continually present and important, overlay and often conceal the fundamental modernity of the work, its character as "making." I would now largely revise my earlier view that Rodin was primarily modelling in clay in favour of the view that he was *constructing with and within the figure;* in choosing poses and models from nature; in physically modelling; in the continuous process of casting that went on in his studio as the work proceeded, simultaneously creating a record and new components; in the process of addition or reduction of figures or part figures until they separately became "sculpture." The given structure of the figure, revealed and affirmed by a new freedom in modelling, is used at the same time as the main structural factor internal to the organization of the sculpture, and externally, as the means of identifying the spectator with the sculpture in terms of his own body responses. The experience of the virtually open-ended commission for the *Gates of Hell* from 1880, in which figures could be assembled and positioned freely without regard to gravity or particular demands of subject matter gave Rodin the confidence and freedom to develop this fundamentally abstract constructive direction. For a moment, also, it must have seemed

William Tucker, "Rodin: The Language of Sculpture," *Studio International,* January 1973. Reprinted by permission of William Tucker and *Studio International.*

likely to take care of Rodin's perennial problem, that of "where to finish," as had the exact correspondence of the natural and the invented in the *Age of Bronze*. However, as many of the separate figures from the *Gates* were detached and enlarged as independent sculptures and the *Gates* themselves were unfinished at his death 37 years after their inception, the problem had clearly re-presented itself with increased urgency.

Although Rodin claimed to "produce slowly," and indeed all his best sculptures up until the last period were plainly the fruit of prolonged effort and consideration, a great deal of work also emerged from his studio, including many substantial and physically ambitious pieces, that were vulgar, facile, unthought-out and pandered to just that Salon taste which he had explicitly challenged with the *Age of Bronze*. Almost all the marbles must come under this criticism, including such monsters as *Eternal Spring* (1884), *The Eternal Idol* (1889), *The Kiss* (1882). It is not surprising that in this category may be found the most popular of Rodin's sculptures. Rodin was here unable or unwilling to alter or modify an initially banal or sentimental conception; the grouping and disposition of the figures is dictated not by hard thought or the constructive process, and in any case, once the sculpture was in the marble no significant change could take place. Constructed groupings of existent sculptures from the *Gates*, for example, *I am Beautiful* and *Fugit Amor*, are more successful, but the individual components such as the *Prodigal Son* and the *Crouching Woman*, invariably look much better on their own. With the exception of the *Burghers of Calais* where the figures are conceived separately and hardly touch, let alone support each other, Rodin's figure groups are bad sculptures: it is not that "he could not compose," "had no sense of architecture," etc., but that composition, architecture, structure, could only "carry" within the limits of the single figure: duplication of figures cancels the distinct expressive potential of each by defining the "dramatic" too literally, i.e., in a dramatic "situation," and by sheer visual overstatement.

Both the gravity-free conception of the figures in the *Gates* and expressively violent nature of the subject-matter opened up new possibilities for structuring the figure. Up till this point, Rodin's figures had been generally upright, self-supporting, the poses derived from classical or Renaissance models, designed to display the expressive performance of an essentially Renaissance anatomy. With the *Prodigal Son* and the *Crouching Woman*, an entirely new concept of anatomy emerges, in which the human body is re-structured in terms of the posture. Thus the *Crouching Woman* assumes the compact, closed form, for example, of a bunched fist; within its arms and legs, knees and shoulders are torn from their original structural role, their forms and functions deliberately confused in a wilful re-assembly of the body as a bundle of lumps and axes. The *Prodigal Son*, though opposite in its openness and extension, is not so much a kneeling figure as a figure in which the lower legs have been folded back into the horizontal to support its total vertical-diagonal sweep. The sculpture has the character of a single

limb, an arm or leg: the proportion and structure of the torso confuse it with leg: the legs and arms penetrate and occupy the body: the arms, with the lower legs removed, also read as "legs." In both figures the head is reduced to yet another lump; the neck if anything assumes a greater expressive role.

These two sculptures were made shortly after the rhetorical *Adam, Eve,* and *The Thinker,* and before the naturalistic *Belle Héaulmière* and the studies for the *Burghers of Calais.* In these sculptures the poses, though far from "natural," were a good deal more relaxed and static than either the *Gates* or the Michelangelesque pieces. With the over-lifesize studies for the *Burghers,* and notably with the gorilla-like *Jean D'Aire,* Rodin took naturalism in terms of the "life-like" as far as it can be taken in sculpture. Like the *Age of Bronze,* it is a *tour-de-force,* and unrepeatable.

The *Torso of Adèle* was made about the same time as the *Prodigal Son* (1882), and similarly is one of the sculptures from the *Gates.* It shares the re-structured anatomy in terms of a unified overall form, this time of a small arch, but the lower legs are simply omitted, and the sculpture is detached from a continuous base. It thus anticipates the great series of partial figures—the *Torso of a Seated Woman Clasping Her Left Leg,* the *Flying Figure,* and *Iris, Messenger of the Gods,* of 1890–91, in which some or all of the extremities are omitted—in every case the obtrusive and non-structural head—and no specific orientation is prescribed. These fragments are not arbitrarily or wildly expressive, each sculpture is taut and tightly structured, with the arm or arms bonding to the leg to achieve a constructive unity, that can still, by reference to our own body experience, be felt as anatomically "real." Of all Rodin's sculptures those in this group probably appeal more to contemporary taste, both through their character as "objects," by which they were so influential on Brancusi and the next generation in Paris, and by their quality of abstract structure which relates them to the best sculpture being made today. Yet their abstractness should be taken with caution, for it resulted from a desire to express a sense of the figure with increased force: the figure functions as the vehicle of abstraction. In intention, in feeling, they are possibly no more abstract than the *Age of Bronze:* the Iris figures in fact represent a later stage in Rodin's exploration of the congruent limits of the figure with the sculpture. Although the various stages in this process overlapped—for example, the partial figure may have started as early as 1877 with the *Walking Man,* and there is an intense naturalism about several of the *Balzac* studies from the mid-1890s—nonetheless, if one leaves the major public commissions and the portrait heads on one side, together with the general mass of pot-boiling and commerical work, enlargements and repeats in marble that came out of his studio in response to his increasing public success, one can still, without forcing the facts, observe a succession of attempts, the high points of his sculpture, to deal with the single figure, his central theme, to reconcile its dual nature as invented and representational structure. The succession of these attempts is in the direction of an increasing abstractness, towards the frank acknowledgement of an *internal,*

sculptural order, which evoked, rather than represented the figure. The final turn in this development may fairly be taken to be the late small figures of dancers.

These sculptures, it should be remembered, were made after Brancusi's *Prayer* and *The Kiss* (1907) and Matisse's marvellous trio of sculptures of the same period, the first *Reclining Figure*, the *Serpentine* and the *Two Negresses*, all images of total stability and architectural unity; Rodin's dancers challenge the younger men's work with a totally liberated gestalt, and an even more violent distortion of anatomy in the interest of the representation of abandoned movement. These figures were no sudden invention, but the culmination of a prolonged series of studies, "improvisations," rapid impressions of postures which Rodin had made for many years. They seem to have surfaced, become public, during his last period, and appropriately so. The whole figure is usually represented, as in the *Prodigal Son:* but the process of re-invention of anatomy in terms of the posture is taken to the point at which the shape and proportion of the parts defy recognition. The small size of the figures suggests they were made wholly in the sculptor's hand, and they enjoy the freedom of orientation, the identification of the handling of this soft material with structure that this process allows. It is no longer antomy but the action of the hand in clay that determines the structure of the figure. The idea of "making" could not be more plainly fulfilled.

Albert Elsen
"Rodin's *Walking Man* [Fig. 21]
as Seen by Henry Moore" (1967)

I asked Henry Moore why he should admire Rodin's emulation of an antique ruin and why he should be enthusiastic about a way of work different from his own. He replied that Rodin helped open the eyes of modern sculptors to the fragment, the sketch, the accident, and the importance of much older sculpture that was being ignored. I asked Moore if his own work wasn't intended to give the appearance of ancient or older forms that had survived the elements or been shaped by them as I had so often read. He shook his head. "It's alright for Rodin but not for me . . . I like to use Hornton stone,

Albert Elsen, "Rodin's *Walking Man* as Seen by Henry Moore," *Studio International,* July/August 1967. Copyright, California Artforum, Inc., 1963. Reprinted by permission of Albert Elsen and the editors of *Studio International.*

for example, because it doesn't look new. It doesn't look like white marble or as if you would leave dirty finger prints if you touched it . . . I want sculpture that looks permanent and can stand up to nature and ill treatment so that you can still see the shape I put into it. I don't consciously make my work look like a ruin. . . . In pieces like that for the Lincoln Center I wanted an analogy with stone, to be sure . . . But the texture of my work is the result of the inter-action of tools and materials. For example, white marble requires a high finish. I am not trying to imitate eroded forms."

Since we had concerned ourselves with technical and historical problems relating to the *Walking Man,* I asked Moore to comment on those additional qualities of the work he was enthusiastic about. "I like its springiness, tautness and energy. Every muscle is braced. It all heaves upward. Rodin has put something of the archaic Greek style into it by widening the thighs and calf towards the top. The forms diverge upwards from the ankle to the knee and from the knee to the top of the thigh. This gives an upward thrust. The leg is not tired and sloppy like a sack. The knees are braced backward and the knee cap is up."

Having seen how Rodin built up a sculpture synthetically, I reminded Moore of Matisse's criticism that Rodin lost sight of the total effect by concerning himself with details, and asked if he agreed. "Rodin does pay attention to the whole. His own nature gives the figure unity. The unity comes from Rodin's own virility . . . it is a kind of self-portrait."

NOTES ON CONTRIBUTORS

Alexandre, Arsène. 1859–1937. Alexandre made his début as a critic in 1882. He wrote for *Le Figaro* for forty years. He was a strong supporter of the Impressionists and of Rodin and was always remembered for his eloquent defense of the *Balzac.* He wrote *Histoire populaire de la peinture, Ecole française* (1895) and monographs on many artists, including Donatello, Barye, Daumier, Monet, Gauguin, Raffaelli, and Malvina Hoffman.

Bernhardt, Sarah. 1844–1923. Besides being the most famous actress in the world, Bernhardt had some success as a sculptress and as a writer. She began sculpting in 1869 and made her début at the Paris Salon with a marble bust of a relative in 1875, the same year that Rodin first exhibited at the Paris Salon. She published plays, novels, a book on the theater, and her memoirs, *Ma double vie* (1907).

Bourdelle, Antoine. 1861–1929. Bourdelle was Rodin's assistant from 1893 to 1907. Although strongly influenced by Rodin, he aspired toward a more stable kind of sculptural form. He conceived of writing a book about Rodin in 1908 and lectured on Rodin's work in Prague in 1909. Bourdelle was one of the great teachers of sculpture in Paris during the first quarter of the twentieth century.

Brancusi, Constantin. 1876–1957. Brancusi went from Bucharest to Paris in 1904 and made his début there in 1906. In 1907 he apparently turned down the opportunity to become an assistant in Rodin's studio. He began several of his great series—the *Kiss,* the *Sleeping Muse, Maiastra,* and *Mlle. Pogany*—between 1907 and 1912, in them working away from naturalism toward simple, concentrated forms that were carved rather than modeled. By 1913, when he showed in the Armory Show, Brancusi was clearly a leader in a new style for sculpture.

Brownell, William C. 1851–1928. Brownell was an American author who contributed to the *Nation* and the *World.* He went to Europe in 1881 where he spent several years. His first book was *French Traits—An Essay in Comparative Criticism* (1889), and he dedicated his next book, *French Art* (1892), to Rodin. He also wrote on English and American literature, focusing on such figures as Eliot, Ruskin, Hawthorne, Emerson, and Henry James.

Burckhardt, Carl. 1878–1923. Burckhardt took up sculpture in Rome in 1901. He worked toward a simple, monumental style under the influence of classical art and of Maillol. In 1918 he opened the Rodin exhibition in his native city of Basel and began his book, *Rodin und das plastiche Problem,* in which he related Rodin to the art of the past and to sculptural issues in general.

Burty, Philippe. 1830–1890. Burty began his career as an artist, having studied printmaking with Péquignot. By the 1860s he was an active critic, writing especially

for the *Gazette des Beaux-Arts*. He became the art critic for *La République française* when it was founded by Gambetta in 1871. He was a close friend of Delacroix, a vigorous supporter of the Impressionists, and a collector of Oriental art. In 1883 he published *Japonisme*. At the time of his death he was Inspector for Fine Arts.

Canudo, Ricciotto. 1877–1923. Canudo's first articles appeared in *Corriere della Puglia* in 1902, the year he moved to Paris. By 1904 he was editor of *L'Europe artiste*. He published on the arts in general, but his particular love was music, seeing in it a religion for the future. In 1922 he founded the *Gazette des Sept Arts*.

Champsaur, Félicien. 1859–1934. Champsaur was a prolific novelist and critic who wrote regularly for *Le Figaro*. He has been seen as a "repulsive novelist who wrote baskets of gossip, but who could also be, at times, a courageous journalist." Bourdelle, whose talent Champsaur recognized very early, modeled his portrait, which was a big success at the Salon of 1891.

Chaumeix, André. 1874–1955. Chaumeix began his career as a Plato scholar. In 1901 he joined the *Journal des Débats*. For more than thirty years he directed the editorials at *Débats* and, at various times, was head of *La Revue des Deux-Mondes* and *La Revue de Paris*, as well as political editor for *Le Figaro*. He was seen as someone able to make journalism into a real literary form.

Cladel, Judith. 1873–1958. Cladel was the daughter of Léon Cladel and grew up among the most famous writers of late nineteenth-century Paris. She met Rodin in her home during the 1880s and visited his studio for the first time in 1892, shortly after her father's death. Her début as a writer was the play, *Le volant*, which opened at the Théâtre de l'Oeuvre in 1895. Other plays, novels, and historical studies followed, but she felt that only having literary masters was not sufficient and she asked Rodin to guide her explorations into art. In the end her biographical studies of him became her most celebrated works.

Dargenty (pseudonym of *Arthur Auguste Mallebay du Cluseau d'Echérac*). 1832–1919. Arthur d'Echerac was a politician who served two terms as mayor of Sèvres, an editor, and a writer, as well as a sculptor who showed busts of his contemporaries at the Société des artistes français. His major books were on Delacroix, Gros, and Watteau. Under the pseudonym Dargenty he published criticism in *La République française*, *La Justice*, and *L'Art*.

Darzens, Rodolphe. 1865–1938. Darzens began publishing in the 1880s, writing poetry, plays, novels, and criticism. He associated with the Symbolists and published *Strophes artificielles* in 1888. In 1890 he founded *La Revue d'aujourd'hui*, and in 1917 he became director of the Théâtre des arts.

Daurelle, Jacques. Daurelle was a writer associated with the group of writers around *La Plume*. He published between 1894 and 1934.

Dujardin-Beaumetz, Henri Charles Etienne. 1852–1913. Dujardin-Beaumetz began his career as a painter. He turned to politics, and in 1905 he received the post of Under-Secretary of State for Fine Arts, a position he held for seven years and during which time he vigorously reorganized the museums, presided at official functions, and made speeches such as the one at the dedication of *The Thinker*.

Elsen, Albert, E. 1927– . Elsen is an art historian who began studying Rodin in 1949. His major publications on the artist are *Rodin's Gates of Hell* (1960), *Rodin* (1963), and *Auguste Rodin: Readings on His Life and Work* (1965). He has also done studies on the sculpture of Matisse and Lipton. His most important general studies on modern sculpture are *The Partial Figure in Modern Sculpture* (1969), *Origins of Modern Sculpture: Pioneers and Premises* (1974), and *Modern European Sculpture, 1918–1945* (1979). Elsen is a professor at Stanford University.

Faure, Elie. 1873–1937. At the turn of the century, Elie Faure was a physician. Then, through visits to the Louvre, he was drawn to art and began publishing art

criticism in 1902. Between 1909 and 1921, he published his four-volume *History of Art*. In *The Spirit of the Forms*, which appeared as a fifth volume in 1927, he made his most original contribution by constructing a vast synthesis of the elements of art as a universal language that can provide humanity with transforming experiences.

Fourcaud, Louis de. 1853–1914. Fourcaud was an art historian and a critic who wrote monographs on French painters such as Ribot (1885), Bastien-Lepage (1885), Alfred Roll (1896), and Chardin (1900). In 1890 he published a general study, *L'Evolution de la peinture en France au XIXe siècle.* He also wrote a book on the sculpture of Rude (1904).

France, Anatole (pseudonym of Anatole-François Thibault). 1844–1924. Anatole France was one of the most popular novelists in France in the late nineteenth and early twentieth century. He played a prominent role in the Dreyfus affair and then, almost by extension, in the *Balzac* affair. The events of 1898 brought about his shift toward Socialism in the early twentieth century when he became very polemical. He has been seen as both skeptical and classical in his writing.

Frémine, Charles. Frémine published on travel, literature, and art between 1870 and 1905. In 1910 Rodin served on a committee formed to provide for the removal of his ashes from Paris to his Normandy home.

Fry, Roger. 1866–1934. Fry bore great responsibility for making England less insular with regard to art. He introduced French Post-Impressionism to England through the exhibitions he organized in 1910 and 1912. Fry was also a connoisseur and art historian specializing in Italian art. He was as enthusiastic about the art of Giotto as he was about that of Cézanne, and he wrote about them both in formal terms, providing a kind of criticism that has been seen as the beginnings of formalist art criticism.

Geffroy, Gustave. 1855–1926. Geffroy was a prolific writer, doing articles for every major journal in Paris. He published criticism, political essays, travel pieces, and history of art and drama, as well as his own novels and plays. He was a particularly energetic supporter of Monet, Cézanne, and Rodin. He and Rodin became good friends; they traveled to Guernsey and Jersey in 1891, and in 1905 Rodin modeled Geffroy's bust.

Gide, André. 1869–1951. Gide was famous as a novelist, a critic, an essayist, and a translator. His interest in formal diversity resulted in several accomplished and successful novels; the best known are *The Immoralist, The Pastoral Symphony,* and *The Counterfeiters.* In 1908 he helped found the *Nouvelle revue française,* the most original review in Paris before World War I and the most consistent since that time, usually taking its position a bit to the "left."

Giedion-Welcker, Carola. Gideon-Welcker is a Swiss art historian who studied with Wölfflin and Clemen around 1920 and whose *Modern Plastic Art* of 1937 (revised twice since then) was a major contribution in grouping and discussing the significant new European sculptors. Since then she has written important studies on Apollonaire, Pevsner, Klee, Arp, Brancusi, and Gaudi, among others.

Goncourt, Edmond de. 1822–1896. Edmond and his brother, Jules, began writing criticism in the 1850s. Their most famous art historical study was *L'Art du dix-huitième siècle,* published between 1856 and 1875. They collaborated on novels and on their *Journal,* which Edmond continued after Jules's death in 1870. In it he gave lively descriptions of literary life in Paris in the late nineteenth century and of his encounters with significant contemporary figures such as Rodin, whom he met in 1886.

Gonse, Louis. 1846–1921. Gonse wrote his first article for the *Gazette des Beaux-Arts* in 1872 and three years later became editor of the *GBA*. His books include: *Fromentin, peintre et écrivain* (1881), *L'Art japonais* (1883), *L'Art gothique* (1890), and *La Sculpture française depuis le XIVe siècle* (1895). He owned an important collection of Japanese art.

Harris, Frank. 1855–1931. Harris edited numerous journals including the *Fortnightly Review* (1887–94) and the *Saturday Review*, which he owned from 1894–99. He wrote stories, novels, and plays, but was best known for his *Contemporary Portraits* (1915–30), which includes a portrait of Rodin, and for his autobiography, *My Life and Loves* (1923–27).

Hildebrand, Adolf von. 1847–1921. The sculptor Hildebrand lived and worked in Italy from 1866 to 1884, when he returned to Germany. He executed some important commissions such as the *Wittelsbach Fountain* in Munich (1891–95). He was a theorist, and his most influential work was *Das Problem der Form in der bildneden Kunst* (1893) in which he discussed the importance of sculpture as an architectonic whole to be comprehended from a particular and correct distance.

Huysmans, Joris-Karl. 1848–1907. Huysmans published his first prose poems and novels in the 1870s. They were recognized as being in the Naturalist school of Zola. His work of the 1880s, especially *A rebours* (1884), a strange and decadent Symbolist work, was in a new direction, and it was contemporary with his most energetic art criticism. As a critic Huysmans was enthusiastic about the Impressionists, Redon, Moreau, and Rodin.

Jeantet, Félix. Jeantet was a journalist and art critic who published in the 1880s and 1890s.

Kahn, Gustave. 1859–1936. Kahn was a leading Symbolist writer. He was a cofounder in 1886 of *La Vogue* and of *Le Symboliste*. In 1889 he became editor of the *Revue indépendente*. He was considered an innovator in the way he worked with free verse, and he did particularly subtle analyses of Baudelaire's work. In addition to his critical writing about Rodin, he did studies of Fragonard, Boucher, Fantin-Latour, and Félicien Rops.

Kassner, Rudolf. 1873–1959. Kassner studied philology, history, and philosophy in Vienna. He published *Die Mystik, die Künstler und das Leben* in 1900, the year he went to Paris and discovered Rodin. He became a close friend of Rilke's and wrote on his work. He was drawn to persons in whom he recognized a special manifestation of spirit, thus, writing about such figures as Plato, Christ, and Kierkegaard.

Lefort, Paul. 1829–1904. Lefort was an art historian and a critic with a special interest in Spanish art. He wrote for the *Gazette des Beaux-Arts,* and his major books were on Goya (1877), Velasquez (1887), and Murillo (1892). In 1891 he published a general book on nineteenth-century French painting.

Leroi, Paul. Leroi was cofounder of *L'Art* in 1875 and served as its editor until 1891, when he published a letter to the subscribers saying that if he did not leave his job he would lose his sanity. He was a key person in the early recognition of Rodin and was a friend of Rodin's, although he became critical of him in the 1890s.

Lostalot, Alfred de. 1837–1909. Lostalot was a conservative critic and an editor of *Gazette des Beaux-Arts*. In the late 1870s, in partnership with E. Duranty, he founded *Les Beaux-Arts illustrés*. Lostalot wrote *Les Procédés de la gravure* (1882) and *L'Ecole française de Delacroix à Regnault* (1891).

Luc-Benoist. 1893– . Luc-Benoist is an art historian who received his diploma from the Ecole du Louvre in 1926, and then served as an assistant in the sculpture department of the Louvre. In 1937 he was an assistant at Versailles, and in 1946 he became Conservateur of the Musée des Beaux-Arts at Nantes. His best-known books on sculpture are *La Sculpture romantique* (1928) and *La Sculpture française* (1945).

Mâle, Emile. 1862–1954. Mâle, a medieval scholar, was professor of art history at the Sorbonne, Director of the French School in Rome, and a member of the French Academy. He is most famous for his study of medieval iconography, which came out in numerous publications beginning in 1902 when *L'Art religieux du XIIIe siècle en France* first appeared.

Maillol, Aristide. 1861–1944. Maillol turned from painting and tapestry making to sculpture around 1900. In 1905, when he showed at the Salon d'Automne, he was recognized as an important new talent in sculpture and he received his first public commission, the monument to Blanqui *(Action in Chains)*. He developed a strong style dependent upon restrained, yet fecund and full, volumes as seen in the female form.

Matisse, Henri. 1869–1954. Trained as a painter, Matisse began to re-educate himself as a sculptor in the late 1890s. He met Rodin in 1898, and in 1900 he began *The Serf*, which owes much to Rodin's *Walking Man*. Matisse had two intense sculptural periods: 1900–13 and 1922–32. He wanted to realize a kind of sculpture that could provide an alternative to Rodin and nineteenth-century Naturalism, a style that was more vital and architectonic.

Mauclair, Camille. 1872–1945. Mauclair was a novelist, a poet, and a critic. He published his first articles on Rodin when he was still in his teens. He also wrote on such figures as Puvis, Rops, Rodenbach, Mallarmé, Poe, and Heine. He emphasized the nature of criticism and how to identify the essence of a work of art, and he was considered one of the best critics of his time.

Maus, Octave. 1856–1919. Maus wrote numerous articles on culture and travel. He was extremely important for the development of modern art in Belgium and, with Edmond Picard, founded *l'Art moderne* in 1881, a journal he directed for twenty-six years. He also participated in the founding of *Les XX.* He wrote regularly for such French journals as *Gil Blas, Revue Indepéndente,* and *Art et Decoration.*

Meier-Graefe, Julius A. 1867–1935. Meier-Graefe was an important figure, not only in the German art world, but throughout Europe. He became a leading propagandist for modern art, supporting the new styles of Impressionism, Expressionism, and Art Nouveau. The nature of his writing was formalist, and he was particularly sensitive to art that gave a personal vision of nature. His most important publication is *The Development of Modern Art* (1904, English translation 1908), and he wrote studies of Renoir, Degas, Manet, Van Gogh, and Cézanne among others.

Michel, André. 1853–1925. Michel was a critic and an art historian. He wrote for *L'Art* and the *Gazette des Beaux-Arts* in the 1880s and 1890s on every subject imaginable, but his chosen fields were medieval and modern. He published an important eight-volume *History of Art* between 1905 and 1929. He was on the staff of the sculpture department of the Louvre and he reinstalled the sculpture galleries in 1912.

Mirbeau, Octave. 1850–1917. Mirbeau was a novelist, an essayist, a dramatist, and a critic. He came to Paris in the late 1870s and wrote for most of the important journals of literature and art. Mirbeau was one of Rodin's earliest defenders and best friends. Rodin made his bust in 1889 and did drawings for Mirbeau's *Le Jardin des Supplices.* Mirbeau was very influential and he was always ready for a fight in the cause

of whatever was new, difficult, or the object of unjust press, whether it be Impressionism, Rodin, Van Gogh, Dreyfus, or Léon Bloy.

Moore, Henry. 1898– . Moore is that extraordinary talent that altered the course of the history of British sculpture and who became one of the great sculptors of the twentieth century. His work is in reaction against Rodin, naturalism, sentiment, and modeling, being more in harmony with ancient and primitive sculpture, carved sculpture, as well as the simplicity of Brancusi's work and the formalist ideas of Roger Fry.

Monet, Claude. 1840–1926. Monet, the leading Impressionist, was Rodin's exact contemporary, but he found his chosen way in landscape painting earlier than Rodin found his way in sculpture. Thus, when the two artists joined for an exhibition at the Galerie Georges Petit in 1889, Monet was more ready for a real retrospective. This exhibition was so favorable to him that it allowed him to purchase the famous house at Giverny where he painted his most celebrated late works.

Morice, Charles. 1861–1919. Morice was a Symbolist poet, an art theorist, and a critic. *La Littérature de tout à l'heure* (1889) is the great critical work of his early years. Morice felt there was a religious function in art and that the poet and artist acted as priests. The writers and artists he felt closest to were Mallarmé, Verlaine, Carrier, Puvis de Chavannes, and Rodin. In 1907 Morice started his own bimonthly publication, *L'Action humaine.*

Picard, Edmond. 1836–1924. Picard was a Belgian writer and lawyer. He published poetry, criticism, historical, political, and philosophical essays, as well as books in the field of law. He was a major figure in urging the Belgian public to be more open to new artistic expression and was the principal founder of *L'Art Moderne* in 1881.

Rameau, Jean. 1859–1942. Rameau was a prolific novelist and poet. Among his best-known works of the 1880s and 1890s are *Poèmes fantastiques, La Vie et la mort, Les Féeries,* and *Le dernier bateau.*

Rilke, Rainer Maria. 1875–1926. Rilke was one of the greatest lyric poets to write in the German language. He traveled restlessly throughout Europe, going in 1899 and 1900 to Russia to find Tolstoy and in 1902 to Paris to meet Rodin. He wrote two major essays on Rodin, one in 1902, the other in 1907. They remain unique in their beauty and sensitivity to Rodin's work. Rilke always credited Rodin with being that artist who showed him how to work well, and it was during his Paris period that he began to develop a firm structure for his poems.

Rindge, Agnes M. (Mrs. Phillip Claflin). 1900–1977. Professor Claflin was Chairman of the Art Department at Vassar College for many years.

Rochefort, Henri. 1831–1913. Rochefort began his career as a theater critic during the Second Empire and became the most controversial political polemicist in France. His work was a model for vituperative journalism. In 1868 he bought *La Lantern* and the articles he published there were so outrageous that he had to flee the country. His most famous journal was *L'Intransigeant,* which he founded in 1880. He met Rodin in the early 1880s and Rodin made his portrait in 1884.

Rousseau, Jean. 1829–1891. Rousseau began his career writing for *L'Etoile Belge* in 1853. He spent time in Paris studying art and writing for *Le Figaro, Gazette des Beaux-Arts, L'Art,* and the *Revue de Paris.* After his return to Belgium he became a professor at the Royal Academy in Antwerp, and then Secretary General of the Commission of Monuments and Director of Fine Arts in Belgium. He published studies on Italian, Flemish, and Spanish art and wrote *Les Expositions des Beaux-Arts depuis 1830* (1880).

Silvestre, Armand (Paul-Armand). 1837–1901. Silvestre was a prolific writer of poetry, novels, criticism, and *contes* (à la Rabelais). His first book of verse appeared in 1866 with a preface by George Sand. He also had a career as an archivist and in 1892 he was named Inspector of Fine Arts. After his death, funds were collected for a monument to him, designed by Mercié and inaugurated in 1906 near the Grand Palais. Rodin was a contributor.

Simmel, Georg. 1858–1918. Simmel was a philosopher at the University of Berlin, where they did not quite approve of him because he wrote on everything from Rembrandt and Rodin to the Alps and money. He was a far-reaching *Kulturphilosoph* who explored every kind of form in philosophy, nature, and art. He was friends with some of the most significant people in German culture of the period, such as Max Weber, Husserl, and Rilke. Meier-Graefe was a student of Simmel's at the University of Berlin.

Speilmann, Marion Harry. 1858–1948. Speilmann was a London critic who wrote for such journals as the *Pall Mall Gazette* and the *Westminster Gazette*. He edited the *Magazine of Art*, in which he did much of the art criticism himself, for seventeen years. He published general books on British art, such as *British Sculpture and Sculptors of To-Day* (1901) and *British Portrait Painting* (1910), as well as studies of individual artists like Millais and G.F. Watts.

Steinberg, Leo. 1920– . Steinberg is a critic and an art historian who teaches at the University of Pennsylvania. His major publications have been *Borromini's San Carlo alle Quattro Fontane, Michelangelo's Last Paintings*, and the essays found in *Other Criteria*, which includes his work on Rodin. His critical writing on contemporary art has been wide-ranging.

Stevenson, Robert Louis. 1850–1894. Stevenson was born in Edinburgh, resided in England, traveled the world over, and died in Samoa. He was a prolific writer of plays, stories, novels, poems, and essays, and he is best known for a series of books that appeared in the 1880s: *Treasure Island, The Strange Case of Dr. Jekyll and Mr. Hyde, Kidnapped,* and *The Black Arrow* among them.

Symons, Arthur. 1865–1945. Symons was a critic and poet. He was a critical figure in introducing the European Symbolist movement to England. He went to Paris for the first time in 1889 and sought out such men as Rodin, Mallarmé, Verlaine, Huysmans, and Morice. He wrote for many journals and edited the *Savoy*. His book *The Symbolist Movement in Literature* (1899) was particularly significant.

Taft, Lorado. 1860–1936. Taft studied at the Ecole des Beaux-Arts from 1880–83. He opened his studio in Chicago in the late 1880s and created sculptures in an academic tradition. He also lectured and wrote on the history of sculpture. His best-known works are *The History of American Sculpture* (1903) and *Modern Tendencies in Sculpture* (1921) in which we find his antimodernist views fully presented.

Tancock, John. 1942– . After receiving his education at Cambridge and the Courtauld Institute, Tancock went to Philadelphia in the mid-1960s to take a position as curator of the Rodin Museum of the Philadelphia Museum of Art. His best achievement there was to publish the catalogue of that collection, which appeared in 1976. He is presently on the staff of Sotheby Park Bernet in New York City.

Tardieu, Charles. 1838–1908. Tardieu was a Belgian journalist and art critic. He was elected to the Belgium Academy in 1890 and became its president in 1898.

Timbal, Charles (Louis-Charles). 1821–1880. Timbal began his career as a painter, but became more successful as a critic and an art historian. His collected writings can be found in *Notes et causeries sur l'art et sur les artistes* (1881).

Tucker, William. 1935– . Tucker has been one of the leading abstract sculptors in England, working in welded steel, fiberglass, and wood. He has also written many articles and books about modern sculpture, particularly *Early Modern Sculpture* and *The Language of Sculpture,* both published in 1974. In his writing and in his sculpture we recognize his wish to redefine the experience of sculpture for the modern audience. Since 1975 he has been teaching in Canada and the United States.

Warren, Arthur. 1860–1924. Warren was a journalist from Boston who went to London in 1878. He agreed to write "letters" for the *Boston Transcript* at five dollars each. In his book of reminiscences, *London Days* (1920), he described his encounter with the work of that "unknown sculptor." After his return to America he became editor of the *Boston Herald,* a position he held until 1907.

Wilde, Oscar. 1854–1900. Wilde's first substantial publication was *Poems* in 1881, and his great dramatic achievement was realized in the 1890s, culminating in *The Importance of Being Ernest,* which was staged in 1895—the same year he was convicted for sodomy. When he was released from prison, he went to Paris and lived there the last three years of his life. When Rodin was approached in 1912 to sign a statement in favor of Epstein's controversial tomb for Wilde in Pére-Lachaise, he refused his support.

INDEX

Adam and Eve, 18, 185, 186, 189
Age d'Arain, (see *Age of Bronze*)
Age of Bronze, 1, 2, 3, 4, 5, 9, 10, 17, 19, 32–35, 36, 39,
 40, 42, 44, 46, 50, 65, 66, 74, 83, 89, 107, 119,
 131, 133, 157, 161, 164, 182, 188
Age of Stone, 42
Alexandre, Arsène, 94, 100, 192
Amour et Printemps, 20
Andromeda, 59
Apprentice abuse, 89–90
"Art for art's sake," 141–42
Assessment, posthumous, 155–67
Ateliers, Julian, 111

Balzac, the, 12, 13, 19, 78, 85, 89, 90, 91–99, 111,
 118, 131, 132, 135, 150, 162, 170, 179, 181,
 189
Balzac controversy, the, 91–99
Bartlett, Truman, 7
Bastien Lepage, 181
Baudeliare, 7, 11, 41, 51, 56, 73, 75, 82, 110, 116,
 155, 156, 158, 171, 172
Bayre, 11, 44, 51, 53, 64, 65, 73, 159, 163
Beauty, 76
Beethoven, Ludwig van, 123, 146, 163
Bernhardt, Sarah, 88, 192
Bernini, 179
Boccioni, Umberto, 166
Bourdelle, Antoine, 23, 25, 144–45, 176, 192
Brancusi, Constantin, 22, 150, 173, 186, 189, 190,
 192
Brownell, W. C., 78–81, 192
Brussels Salon (1887), 62
Burckhardt, Carl, 27–28, 160–62, 192
Burghers of Calais, The, 10, 11, 12, 45, 51–53, 58, 61,
 71–72, 74, 82, 86, 93, 107, 132, 141, 157, 159,
 162, 169, 181, 186, 188, 189
Burty, Phillipe, 38, 193
Busts, the, 4–5
 bust of *Alphonse Legros,* 10, 44
 bust of *Antonin Proust,* 10, 51, 66, 133
 bust of *Carrier-Belleuse,* 10, 36, 38, 44, 66
 bust of *Clemenceau,* 175
 bust of *Danielli,* 36
 bust of *Falguières,* 133
 bust of *Henri Becque,* 10, 71
 bust of *Henri Rochefort,* 10, 57, 71, 83, 144
 bust of *Jean-Paul Laurens,* 4, 10, 36, 37, 38, 44, 66,
 83, 107
 bust of *Jules Dalou,* 10, 51, 53, 57, 66, 71, 83, 107
 bust of *Maurice Haquette,* 10
 bust of *Mme. Russel,* 93, 107, 179
 bust of *Mme. Vicuna,* 83, 86, 89
 bust of *Octave Mirbeau,* 84, 86
 bust of *Puvis du Chavannes,* 83, 86
 bust of *St. John,* 4, 5, 36, 107, 132, 161
 bust of *Victor Hugo,* 4–5, 10, 46, 51, 57, 66, 71, 78,
 83, 86, 89, 93, 94, 107, 108, 109, 113, 133,
 134, 135, 136, 140, 141, 142, 181
 bust of *W. E. Henley,* 10

Calder, Alexander, 28
Call to Arms, The, 119
Canova, 6, 51, 147
Canudo, Ricciotto, 19, 121–25, 193

Carpeaux, 119, 132, 136, 148, 159
Carrier, Belleuse, 3, 50, 64, 65, 86, 110, 134
Cathedral, the, 178, 183
Cathedrals of France, The, 24, 25, 141, 162
Champsaur, Felicien, 6, 12, 48–52, 85–87, 193
Chapu, 2, 3
Chateaubriand, 75, 154
Chaumeix, Andre, 151–52, 193
Cladel, Judith, 13, 23–24, 25, 26, 27, 134, 148, 193
Clark, Kenneth, 1
Celle qui fut Heaulmiere, 132, 189
Clemen, Paul, 21, 127
Clemenceau, George, 13, 174
Conquered Man, The (see *Age of Bronze*)
Conversation, Rodin's, 151–54
Coquiot, Gustave, 25
Courbet, 168–69
Creation of Man, 4, 50, 66, 107
Critical backlash, 85–90
Cross of the Chevalier of the Legion of Honor, 7
Crouching Woman, The, 188
Cubist sculpture, 170
Cupid and Psyche, 86

Dance movement series, 170, 185, 186
D'Angers, David, 11, 39, 120
Dante, 5, 6, 28, 38, 41, 44–45, 46, 49, 67, 73, 76, 79,
 85, 89, 111, 116, 147, 158
Dargenty, G., 40, 58–60, 193
Darzens, Rudolphe, 7, 8, 14, 193
Daumier, 104, 155, 156, 166
Daurelle, Jacques, 88, 193
Day, 124
Dayot, Armand, 122
Debussy, Claude, 13, 124
Degas, 166, 178, 179, 187
Delacroix, 11, 29, 53, 137, 155
Die Insel, cover design, 137
Donatello, 80, 81, 109, 183
Dream of Life, 87
Dreyfus affair, 13
Dubois, Paul, 66
Duchamp-Villon, 23
Dujardin-Beaumetz, 25, 119–21, 183, 193

Ecole des Beaux Arts, 2, 10
Eisenwerth, J. A., 176
Elsen, Albert, 29, 30, 167–72, 190–91, 193
En plein air, 162
Eternal Idol, 178, 181, 188
Eternal Spring, 132, 178, 188
Eve, 132, 133, 157, 159 (see also *Adam and Eve*)
Exhibition at the Royal Academy (1882), 36, 43
Exposition des Arts Liberaux, 5, 39
Exposition Nationale (1883), 39, 40, 41
Exposition Universelle, 10, 74–76, 100–101, 116,
 127

Falguière, 2, 3
Fall of an Angel, 178, 181
Fall of Icarus, 181
Fallen Caryatid Carrying Her Stone, (see *Age of Stone*)
Faure, Elie, 27–28, 155–59, 193–94
Figure Study, 179
Figures du Purgatoire, 137

Firens, Paul, 26
Flaxman, 147
Flying Figure, The, 189
Formalist criticism, 173
Fourcaud, Louis de, 4, 37, 82, 194
Fragonard, 133
France, Anatole, 105, 165
Frémine, Charles, 5, 41, 194
Fry, Roger, 22, 28, 146–48, 172, 173, 194
Fugit Amour, 180, 188

Galerie Claude Bernard, 176
Galerie George Petit, 8, 11, 15, 58, 60–61, 74–76
Gallimard, Paul, 110, 137
Gantner, Joseph, 176
Gates of Hell, 9, 10, 11, 13, 17, 18, 19, 28, 29, 45, 58,
 66, 67, 75 ,79, 81, 82, 85, 86, 89, 90, 91, 100,
 105–6, 109, 123, 132, 135, 157, 161, 162, 168,
 171, 175, 179, 180, 181, 185, 186, 187, 188
Gauguin, Paul, 124
Gavanni, 68
Gazette des Beaux Arts, 3
Geffroy, Gustave, 5, 8, 14, 39, 62, 82, 107–8, 194
George, Stefan, 127, 129
Gericault, 163
German interest in Rodin, 127–43
Ghiberti, Lorenzo, 46
Gide, Andre, 22, 28, 145–46, 194
Giedion-Weicker, Carola, 28, 166, 194
Giotto, 80
Goncourt, Edmonde de, 7, 52, 194
Gonse, Louis de, 11, 81–82, 195
Grautoff, Otto, 127
Greek sculpture, 1, 15, 33, 132, 135, 137, 139
Gsell, Paul, 25, 151, 152, 185
Guillaume, Eugène, 2

Hand of God, The, 157, 165, 176
Hands, plaster, 180
Harris, Frank, 97–99, 195
Hecuba, 76
Henley, W. E., 4–5
Hildebrand, Adolf von, 21, 139–43, 195
Hildebrand/Rodin controversy, 21
Hugo, Victor, 11, 41
Huysmans, J. K., 14, 61, 178, 195

I am beautiful, 188
Illustration of Baudelaire poems, 110, 136
Imperfection, fascination with, 171
Impressionism, 166, 184
Ingres, 137
Iris, The, 149, 174, 179, 189

Jean d'Aire, 181, 182, 189
Jeantet, Felix, 9, 74, 195

Kahn, Gustave, 14, 29, 106–7, 195
Kassner, Rudolf, 13, 20, 101–5, 127, 195
Kiss, the, 18, 61, 81, 82, 90, 98, 107, 132, 133, 138,
 167, 173, 177, 178, 188
Klagmann, 163

La Fille d'Icare, 132
La Force et la ruse, 137
La Maison Moderne, 127
La Petite Bretonne, 186
La Porte de l'Enfer (see *Gates of Hell*)

Lack of esteem, 28
L'Aiglon, 181
L'Aivron, 173
L'Amour qui passe, 132, 181
L'Art: Entretiens réunis par Paul Gsell, 151
Le Baiser, (see *Kiss, The*)
Le Désespoir, 138
Le Penseur (see *Thinker, The*)
Le Rêve, 181
Le Sculpteur et sa Muse, 104
Le Travail, 102
Le Vaincu (see the *Age of Bronze*)
Lecocq de Boisbaudran, 134
Leonardo da Vinci, 50
Leroi, Paul, 4, 37, 88, 195
Les Femmes Damnées, 51
Les Fleurs du Mal, 56, 59
L'hermitte, Leon, 38
L'homme qui marche (see *Walking Man, The*)
Lipchitz, Jacques, 174
Literary efforts, Rodin's, 151–54
Lostalot, Alfred de, 60, 195
Luc-Benoist, 163, 196
Ludovici, Anthony, 24
Lys brisé, Le, 181

Magazine of Art, 5
Maillol, Aristide, 22, 137, 144, 145–48, 166, 183, 196
Maindron, 163
Mâle, Emile, 25, 153–54, 196
Mallarmé, Stephanie, 14, 85, 111, 112
Man, 76, 82
Man of Early Times, (see *Age of Bronze*)
Man with the Broken Nose, The, 4, 9, 17, 65, 74, 102,
 131, 168, 175, 176
Manet, Edouard, 41
Marbles, the, 176–77, 188
Martyr, The, 181
Mathematical element, 136–37
Matisse, Henri, 23, 149–50, 166, 190, 191, 196
Masks of God, The, 159
Mauclair, Camille, 14, 15, 16, 23, 25, 108–12, 196
Meier-Graefe, Julius, 22, 127, 196
Metropolitan Museum, N.Y., 180
Meunier, 128, 165
Michel, Andre, 9, 196
Michelangelo, 8, 11, 46, 47, 53, 80, 81, 82, 85, 99,
 104, 120, 124, 128, 129, 130, 131, 135, 139,
 140, 149, 159, 175, 177, 181, 185
Michelet, 154, 155
Millet, 165
Mirbeau, Octave, 5, 6, 8, 10, 14, 45–48, 144, 196
Modernity, 37, 167–72
Moine, 163
Monet, Claude, 6–7, 8, 13, 100–101, 197
Monument to Victor Hugo (see *Busts, The*)
Moore, Henry, 31, 191, 197
Moreau, Gustave, 112
Morice, Charles, 19, 24, 125–26, 151, 197

Naturalism, 4, 161, 167
Nietzsche, 20, 155
Night, 124
Nostitz, Helene von, 127

Old Helment Maker's Wife, The, 171, 183

Paolo and Francesca, 44, 47, 49, 62, 105, 163

Paris Salons (see Salon of 1864, etc.)
Periodicals and reviews:
 Der Zeitgeist, 20
 Gazette des Beaux-Arts, 3, 25
 L'Art, 3, 5
 L'Etoile Belge, 2
 Le Figaro, 12, 85
 La France, 6
 La Jeune France, 8
 Le Journal, 19
 La Plume, 14
Perseus, 76
Petite Danseuse, 178
Picard, Edmond, 107, 197
Portals for Museum of Decorative Arts (see *Gates of
 Hell*)
Portrait of Octave Mirbeaux, 10
Portrait of Omer Dervavrin, 10
Portrait of Roger Marx, 10
Pradier, 147
Préault, 11, 163
Prodigal Son, 180, 189, 190
Puget, 15, 109, 133
Puvis de Chavanne, 112

Rameau, Jean, 93–94, 197
Rasbourg, Van, 65
Reinhardt, Ad, 168
Rembrandt, 136, 156, 157
Renown, 100–115
Resurrection, 181
Rilke, Rainer Maria, 15, 16, 17, 21, 112–15, 127, 172,
 179, 197
Rodenbach, George, 13
Rodin Museum (Paris), 25, 28, 155
Rodin Museum (Philadelphia), 19, 26
Romains, Jules, 148
Rops, Felicien, 56, 61, 82, 112
Rosenberg, Harold, 168, 171, 172
Rousseau, Jean, 33, 197
Rousseau, Jean Jacques, 19–20, 126
Rude, 11, 38, 119, 132, 159
Ruskin, John, 154

Salon of 1864, 175, 176
Salon of 1877, 34
Salon of 1880, 2, 3, 44
Salon of 1882, 4, 35, 37, 38
Salon of 1883, 41
Salon of 1897, 87
Salon of 1898, 88–89
Salon of 1899, 88–89
School of Fontainebleau, 111
Schumann, 155

Segmentation, 170–72
Shade, The, 185
Shaw, George Bernard, 176
Simmel, Georg, 20, 22, 127–30, 198
Sketches for Sèvres, 41
Slatkin Galleries, 176
Societe de Gens de Lettres, 131
Space, use of, 179–82
Spielmann, M. N., 87–88, 198
St. John the Baptist Preaching, 4, 9, 36, 37, 39, 41, 42,
 43, 50, 66
Steinberg, Leo, 29, 172–82, 198
Sylvestre, Armand, 58–60, 198
Symons, Arthur, 14, 116–18, 198

Taft, Lorado, 11, 82–84, 198
Tancock, John, 183–87, 198
Tardieu, Charles, 34, 198
Temptation of St. Anthony, 118
Thinker, The, 6, 17, 18, 19, 76, 119, 120, 147, 148,
 162, 167, 175, 189
Three Faunesses, the, 186
Three Shades, The, 18, 170, 185, 186
Timbal, Charles, 2, 34, 198
Tirel, Marcelle, 24
Tolstoy, 19, 20, 125–26, 167
Torso of a Seated Woman Clasping Her Left Leg, 189
Torso of Adele, 189
Torso of 1877, 174
Toulouse-Lautrec, 13
Tower of Labor, The, 17, 19, 30, 121–25
Treu, Georg, 21
Tucker, William, 20, 187–90, 199
Turquet, Edmond, 3, 5, 38, 41, 66

Ugolino, 44, 47, 49, 62, 105, 111, 159

Veidaux, Andre, 14
Verlaine, Paul, 14, 106
Vielle, Heaumiere, 163
Vigny, Alfred de, 75, 146
Villemer, Jean, 91–92
Violet-le-Duc, 154
Vision of the Sculptor, The, 41

Wagner, Richard, 103, 125, 155
Walking Man, The, 28, 30, 149, 162, 170, 181, 182,
 189, 190–91
Warren, Arthur, 36–37, 199
Whistler, James M. 103
Wilde, Oscar, 92, 199
Wittkower, Rudolf, 21

Zola, Emile, 11, 13, 155
Zweig, Stefan, 6, 127